# Colored PICTURES

# Colored

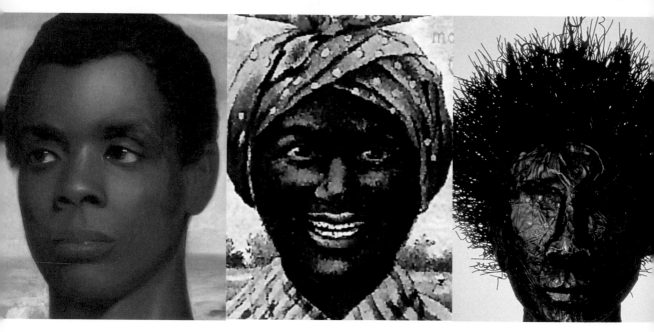

# Pictures

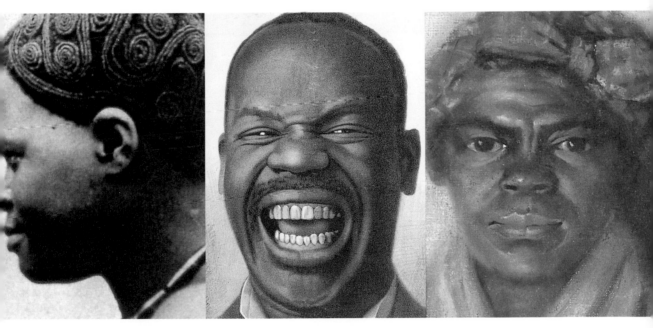

## RACE AND VISUAL REPRESENTATION

**MICHAEL D. HARRIS** FOREWORD BY MOYO OKEDIJI

The University of North Carolina Press  Chapel Hill and London

© 2003
The University of North Carolina Press
All rights reserved
Set in Stone Print, Meta, and Champion types
by Eric M. Brooks
Manufactured in China by C&C Offset Printing Co., Ltd.

Publication of this work was aided by a generous grant
from the Z. Smith Reynolds Foundation.

The paper in this book meets the guidelines for permanence
and durability of the Committee on Production Guidelines for
Book Longevity of the Council on Library Resources.

Library of Congress Cataloging-in-Publication Data
Harris, Michael D., 1948–
Colored pictures: race and visual representation /
by Michael D. Harris; foreword by Moyo Okediji.
      p. cm.
Includes bibliographical references and index.
ISBN 0-8078-2760-6 (cloth: alk. paper)
ISBN 0-8078-5696-7 (pbk. : alk. paper)
1. African Americans in art.  2. African American art.
3. African Americans—Race identity—United States.
I. Title.
N8232.H37    2003
704.9'49305896073—dc21
2002009070
cloth: 07   06   05   04   03      5   4   3   2   1
paper: 09   08   07   06   05      5   4   3   2   1

# CONTENTS

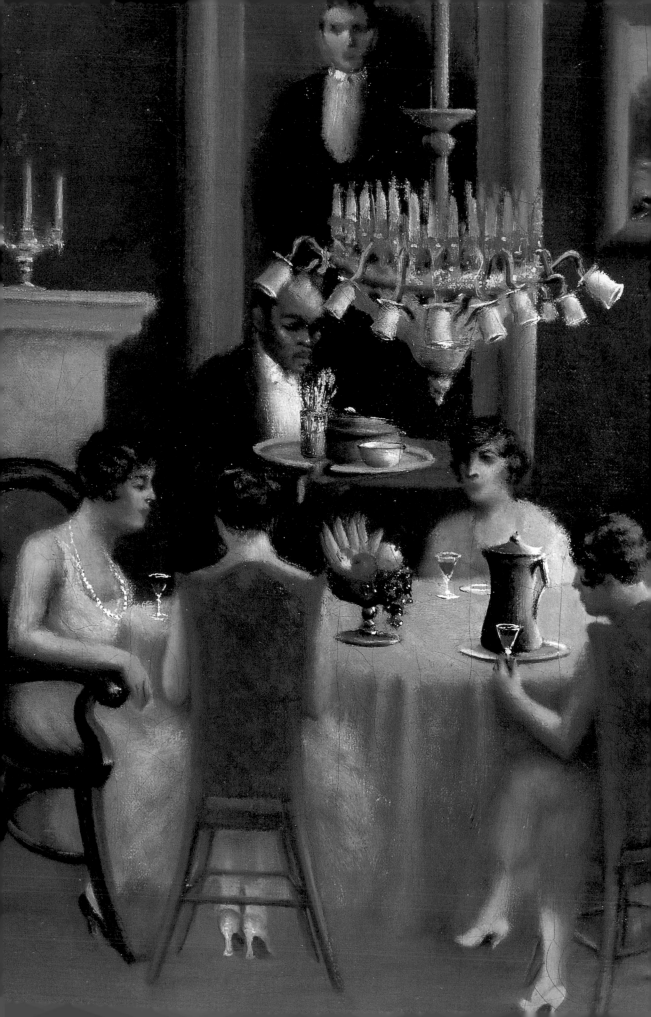

# FOREWORD

This highly diagnostic book on the representation of "blackness" in African American visual culture is reminiscent of the following African folk tale, which readers have probably encountered already in one form or another. Two friends were keenly observing a stranger who wore a pretty but funny-looking cap. Tolu, the friend standing by the left side of the stranger, declared that the gentleman's cap was white. Tola, the friend standing by the right side of the stranger, pronounced the cap black. When they began to quarrel over their difference of opinion, the stranger, who turned out to be Esu, the Yoruba divinity of interpretations, intervened. He showed them that the cap was white on one side and black on the other. In other words, even though both friends were right to insist on either white or black, both of them were also wrong because it was not an "either/or" situation. Strictly speaking, it is misleading to say that one or the other was right or wrong because they were equally right and wrong.

In this book about the representation of "blackness," Michael Harris systematically poses startling but astute questions that transcend issues of right or wrong and of good or bad. Elegantly walking the critical tightrope between these opposing values, Harris is more interested in deliberating on icons of "black" representations that strike him as *equally* right and wrong and as *both* good and bad. Kara Walker's work, for example, is to him formally rewarding but otherwise disturbing. On such risky and slippery terrain, he demonstrates that aesthetic forms have in equal measure ethical contents and that criticism should be both cultured and conscientious.

The key words here are *equally* and *both*. Based on the history of representation in general, and of "black" representation in particular, there are always two sides to any story, giving rise to the binary form of thinking called dualism. Within the realm of representation, however, the two sides of the binary scale are usually asymmetrical, that is, one side is inherently superior to the other. As examples, we may cite the following pairs of tall/short, big/small, good/bad, heaven/hell. One side is right, and the other wrong. It is that sort of dualism or imbalance that characterizes the history of the theory of representation in gen-

eral and the gamut of black representation in particular, as Harris outlines it in this book. A representation presents or stands for the views of that which it represents — that is, it represents the "right" side, at the expense of the interests of the "wrong" side. In other words, a representation is only true to that which it represents, but it is not impartial to both sides. The bias of representation is that it only includes the interests of one party and excludes those of the other party. It therefore reduces reality to a partisan struggle between two forces: one good, the other bad. In the specific case of black representation, Harris demonstrates that the story has been one-sided because the noises of "whiteness" have largely drowned the voices of "blackness."

While focusing on the interpretation of commemorative black figurines and other stereotypical black representations in this book, Harris describes a situation that transcends the discussion of race, a condition that permeates international political and aesthetic culture in its entirety. Contemporary political culture and critical thinking operate on that partisan form of history, based on representation, with the representatives and their laws, regulations, and ordinances. The effect is what the postmodernism scholar Thomas Docherty describes as the tyranny of the majority, where decisions are based not really on justice or merit but on numbers.[1] In other words, wherever the majority carries the vote, merit is a numerical scapegoat, so that as long as the majority is right, the minority will be wrong. In the democratic laws of representation, you cannot belong to both parties simultaneously. You belong to either the majority or the minority. In the British parliamentary system, the majority forms the ruling party, and the minority forms the opposition. In the American presidential system, the members of the conservative party are ideologically opposed by the liberals, and the representatives of the parties present their views from the ideological right or the left. The risk is that the color *looks* different from each side, as Tola and Tolu discovered.

In arguing for a different interpretation of the images of blackness that he analyzes in this book, Harris convincingly states the problem of an asymmetrical dimension. He realizes that the one-sided perspective, advocating the views of the laws of representation, may utterly jeopardize the sense of justice, in the process of "representing" or "representin'" and of "signifying" or "signifyin'."[2] One view projects and protects the understanding of what may be regarded as the majority, white, privileged culture — versus the interests and dreams of the

1. See Thomas Docherty, "Postmodernism: An Introduction," in *Postmodernism, A Reader,* ed. Thomas Docherty (New York: Columbia University Press, 1993), 26.

2. Rap artists who are "true" to their music, and who "say it like it is," are said to represen'. It is a form of signifyin' that Michael Harris discusses in this book.

minority, colored, underclass culture. One culture is essentially suburban, while the other is predominantly inner-city; one hails the Queen's English, and the other, Ebonic English. One is rich and the other poor. They are divided by the color line, traditionally symbolized in America by the train track. Whenever one side sees white, the other side sees black, just as Tola and Tolu did. W. E. B. Du Bois, the black philosopher, called it the dividing veil. Du Bois therefore spoke of the double-consciousness caused by the color line, which he described as the line dividing black from white America. That dividing line he described as the Berlin wall of U.S. history and culture in the twentieth century, a curse to be carried as part of the heritage of African slavery into our present American reality.

As Harris eloquently demonstrates in this volume, art grows on both sides of the color line, even under the watchful eyes of the signifyin' critics within the black community. On the one side of the wall are the works of artists such as Jeff Donaldson, Wadsworth Jarrell, and other members of the AfriCobra group of artists. These are artists with specific manifestos proclaiming an Afrocentric aesthetics and a commitment to the radical interpretation and practice of culture from a black perspective. On the other side of the wall are artists whose works do not espouse what may be regarded as a black aesthetics. To Jeff Donaldson, the struggles may be formulated as a we/they equation. According to him,

> We know them very well. But they know nothing, [at best] very little, about us. And they don't know how well we know them. But they think they know everything about us. . . . You must realize that we live in two different universes. If I remember clearly, not until say 1967 did you see black people featured in positive images, on billboards, magazines, in newspapers, movies, or in any visual medium. We [African American artists] painted and sculpted figures because we could not afford the luxury of losing the opportunity of showing our people at the height of their glory.[3]

The responsibility of a black artist is clear to Donaldson: to develop a rigorous black aesthetics emanating from the intensity of the black experience, and to articulate that distinctive aesthetic experience in the form of spectacular images that extol the place of black people in the nexus of the emergent American culture.

But there are African American artists, notably Sam Gilliam and Mildred Thompson, whose works are less readily reduced to a monolithic black experience, and whom many others have regarded as some sort of ethnic sell-outs or

---

3. Interview conducted with Jeff Donaldson in 1999 by me. It was partly reproduced in Moyo Okediji, "Returnee Recollection: Transatlantic Transformations," in Michael D. Harris, *Transatlantic Dialogue: Contemporary Art In and Out of Africa*, (Chapel Hill: Ackland Art Museum, 1999), 36.

cross-overs. According to Thompson, "[T]hey told me, 'Hey, Mills, up on campus they say you are not a Black artist.' I laughed thinking it was some kind of a joke, but their seriousness and concerned faces told me otherwise. 'It's because you have lived with "whitey" and there is no trace of Africa in your work.' I became furious and ready to attack."[4] Having crossed over, the works of such artists are often regarded as prospering on the terrains of the other side of the wall, no longer actively engaged with depicting the peculiarities, challenges, and rewards of the "black" experience. Such artists are perceived as having an easy access to shows in the white mainstream galleries because their works share the aesthetics of the conventional Eurocentric side. The works of these artists are often labeled abstract, and they do not reference race or sexuality either directly or indirectly; they refer to a universality of creativity that represents art as an apolitical activity.

What complicates the challenge that Harris faces in writing this book is that, with the emergence of the twenty-first century, the color wall is beginning to fall apart. This disintegration is not a new reality because it also interested Harlem Renaissance poet Langston Hughes, who, pondering his protagonist's hybrid background ("My old man's a white man / And my old mother's black"), asked in his remarkable rhetorical voice, "I wonder where I'm gonna die, / Being neither white nor black?" Since the beginning of the Second World War, the revolution in Cuba, and the rise and fall of Communism, particularly in Asia, the insidious Du Boisian color line is gradually being fractured by the urgency of other minorities and interests, such as Jews, Hispanics, and Native Americans, in addition to Asian Americans and immigrant Africans who are perceived and treated differently from African Americans. Further fracturing that color line are nonracial factors such as class, sexuality, and (dis)ability. These issues complicate the perception and interpretations of reality within and beyond the convolutions of a racial perspective. Given the complexity of contemporary situation, according to Adrian Piper, it is possible to look "black," be regarded as "black" by society, and still not possess what is stereotypically regarded as a black experience.[5] Thus, she describes her personal experience as the gray experience. It is a case of being both black and white because you are a cultural hybrid, neither fully white nor fully black. It is not a case of being either black or white. Nevertheless, as Harris constantly reminds the reader, the fact of looking black and being classified as black automatically nullifies the individual or group from fully enjoying the privileges of white culture.

4. See "Mildred Thompson," in *Gumbo Ya Ya: An Anthology of Contemporary African-American Women Artists* (New York: Midmarch Arts Press, 1995), 296.

5. See Adrian Piper, *Out of Order, Out of Sight*, (Cambridge, Mass.: MIT Press, 1997).

But Harris concedes that art does not germinate *only* on each side of the color line. As the line gets fractured, art sprouts in the virgin pores of the interstices too. These noontide arts betray the vulnerability of the artists to the constant pressures from both sides of the wall, and they reveal the extent to which the artists yield to these pressures, as well as the intensity of their struggles against the gravity of the pressures. The very bipolarity of these artists' visions as they bestride the color line—the left leg on one side and the right leg on the other side—resembles a distortion to viewers from either side of the great divide. One side of the wall will see white, and the other will see black, and both sides will be right and wrong at the same time.

Harris is grappling with the challenge of deciphering the writing on the wall that acts as the dividing line between the races. He urgently realizes that as the color line becomes increasingly fractured, an increasing body of artists has grown in the interstices of the racial divide, generating intense controversy about the meaning of their works when viewed from either side of the line. This book explores controversial images that are bred in the interstices of the color line. They must be examined with lenses that are not based on the laws of representation; otherwise only a partisan view that represents the panorama from one side of the color line will emerge. The challenge facing the author is how to fashion a view that balances the perspectives of both sides, based on symmetry and equity and justice.

The fall of the twin towers of the World Trade Center on September 11 subtly signifies the metaphoric collapse of the historical binary system of asymmetry, of inequalities and injustices, found in the duality within the theory of representation. There has emerged a new paradigm beyond representation, beyond the indeterminacy and practical playfulness of postmodernism. That paradigm, based on equation and *not* representation, balances the views on both sides of the color line and presents an algebra of healing, particularly along the fractures of the color line. That algebraic theoreticality reconnects with its origin in Arabic *al-jabara*, and produces a cultural orthopedics, the genesis of which this book embodies, as it engages those very images that struggle along the cutting edge of the shattered color line. Beyond the Afrocentric trope, this book is not about representin' and signifyin'. And beyond the Eurocentric model, it is not about representing and signifying. Rather it plots an equation that reveals the biases on both sides, using a cultural scale that demonstrates a symmetrically balanced concept of humanity—which values the practice and theories of equity beyond the bold black lines, and the bleached white lies of Western representation, and postmodern reconstruction.

Moyo Okediji

# ACKNOWLEDGMENTS

This book was completed with generous research support from the University of North Carolina at Chapel Hill through a series of grants and funded leaves of absence provided by the University Research Council, the Humanities Center (West House), the Frye Fund for American Art, and the Department of Art. Many of my colleagues in the department and at the university offered invaluable help and advice, and I wish to thank them all.

In many ways the work of, and a talk given by, Kenneth Goings was the inspiration for this project, and I want to thank him for all his help and support. I would also like to thank Louise Stone for her patient support and encouragement. Her editorial skills and the information she shared with me were invaluable as I worked to complete this book; her friendship and enthusiasm have been inspirational and sustaining. Also, the dissertation research and conversations of Amy Mooney, now at Washington State University of Washington, were fundamentally helpful to my research on Archibald Motley.

The artists who offered their images and shared information with me must be acknowledged. I thank Jeff Donaldson, Jon Lockard, Joe Overstreet, Charnelle Holloway, María Magdalena Campos-Pons, Michael Ray Charles, David Levinthal, Camille Billops, Juan Logan, Alison Saar, and Frieda High for sharing their work.

Thanks to Selma Stewart of Newport News, Virginia, for sharing information from her research. Sholomo Levy has been most gracious with support and information. Thanks to my colleagues and friends Helen Hills, C. T. Woods-Powell and Richard J. Powell, Kellie Jones, Janine Harris, Edgar Sorrells-Adewale, Moyo Okediji, Maghan Keita, Lester Bentley, Tosha Grantham, Tuliza Fleming, and Howardina Pindell for taking time to read various chapters of this work while it was in progress and for offering helpful feedback and insight. A special thanks to Murry DePillars—my brother, friend, and mentor—for all his patient support and for the fabulous information and thought-provoking dialogues he provided. I had marvelous graduate research assistants: Natacha Dockery, Dana Gibbons Bice, Shawnya Harris, Adera Scheinker, and Marcella Stockstill.

Of course there have been many others who have shared information, encouragement, anecdotes, and the like with me, and I am grateful to all of you.

In certain ways, conversations with my dear professor Sylvia Arden Boone set the foundation for this work, and it is in her memory that I offer this text to you.

# INTRODUCTION
## BLACK: THE DISCREDITED SIGNIFIER/SIGNIFIED

*"Act your age, not your color." I turned only slightly; but just enough to make certain I had not imagined these words—that they had actually been spoken by someone and had not slipped away from a distant childhood memory.*

—Karla Holloway, Codes of Conduct *(1995)*

When I quoted this mother's rebuke to her disruptive child at a symposium at UCLA, an audible murmur went through the crowd of diverse people. As I first read the passage, I had been stunned because the admonition exploded from storage in my own childhood memories. How many times had I heard it used when growing up?: "Act your age, not your color." Even in black communities, black was a negative signifier; an indicator of discredited conduct, ethics, and appearance. We were inscribed and circumscribed by our color—by how we looked! There simply was no way out because blackness, unlike Jewishness or Irishness, is primarily visual (though certain speech is thought to symbolize blackness as well).

Even the Bible, if read literally, occasionally treats black skin with disdain. It is evidence of extreme misery and disease in Lamentations 5:10: "Our skin was black like an oven because of the terrible famine"; and in Job 30:30: "My skin is black upon me, and my bones are burned with heat." In Solomon's song (Song of Songs 1:5), the statement is "I am black, but comely," a statement that indicates a beauty that conflicts with being black; I am beautiful *despite* being black. The original Hebrew and Greek passages translate to "I am black *and* comely," and the substitution of *but* in the English version speaks to a biased translation of the Bible by people who saw black beauty as a contradictory exception.[1] When Africans encountered this interpretation in a racist/slave context, it gave divine legitimacy to all the derogatory associations of race attached to black skin, transforming it into a trope. These and other racial readings of the Bible had deep and harmful effects on many African Americans.

Race is pandemic in the history, structure, institutions, assumptions, values, politics, language, and thinking of the United States. It is so deeply embedded

in the American consciousness that much of our language and imagery operates from racial assumptions that seem natural and therefore resist critical inquiry. Many conservative whites (and a few blacks) at the end of the twentieth century argue for a nonracial discourse, for level-playing-field politics, without examining or acknowledging how dependent the formation of the language and the playing field itself have been on race. Race complicates gender and other human rights issues in the United States. It informs and often distorts African American self-perception and identity formation. Race is important because it codifies power. This book will examine how race has been codified visually and verbally, discuss some of the effects of racial constructions on African Americans, and look at some of the visual responses that have evolved as an effort to counter harmful racial characterizations.

## DARKNESS/INVISIBILITY: LOOKING AT RACE

Race is a complicated, fluid, and unreliable subject, and its definitions have shifted over time. Racial discourses, though they are discourses of power, ultimately rely on the visual in the sense that the visible body must be used by those in power to represent nonvisual realities that differentiate insiders from outsiders. As Nicholas Mirzoeff argues, "The definition of the Other as wholly different from the Self was, of course, haunted by anxiety that difference was more apparent than real. It was therefore crucial that difference should not only be known but visible. In the modern period (1750–1945), the pseudo-science of 'race' dominated such efforts to visualize difference."[2] The mother's statement quoted at the beginning supports the fact that this effort to define Otherness visually was terribly successful. Blackness was defined as a demeaned state of being that was indicated visually by skin or physiognomic traits or conceptually by blood and genetics. To be black was to be demeaned by birth and, unlike original sin in the Bible, it could not be completely redeemed: no absolution through sacrifice or prayer was available. Blackness was a stain beyond sin. It was an essential and divine reality, and, though behavior and character could not overcome it in the eyes of whites, we still seemed to believe that we could, as Solomon's song suggests, become "comely" in God's eyes.

Modern racial definitions have their roots in eighteenth- and nineteenth-century Enlightenment efforts to categorize and rank human groups as a part of the project of cataloging the natural world. These projects typically placed whites at the top and blacks at the bottom of hierarchies, and people with vested interests built on such ideas to support and justify European imperialist objectives. The individual physical body eventually symbolized in various ways

one's membership in a particular social body or body politic. All the terms devised to designate and denigrate the dark peoples of African descent (such as black, noir, Negro, darkie, Sambo, nigger, mammy, coon, colored, and so on) became signifiers of discredited characteristics and objectified individuals behind a wall of essentialism within categorical ghettos. The physical characteristics of people of African descent and the objectifying terms given them became equivalent markers in racial discourse; certain derogatory images evoked the same concepts as words like "darkie." The point is that definitions and visual indicators of race were used to form a black-white hierarchical dialectic and that each was dependent on the other to support the whole; but in racial discourse *black* is the discredited signifier.

Visual signs were reinforced by representations of black dialectical language as an aspect of the complex visual/verbal representation of race. Black vernacular speech has been approximated and exaggerated in print media as a means of identifying the speaker as black and indicating certain social characteristics that ensure the speaker's status as an outsider who does not fit. Though blacks were seldom pictured or mentioned in the nineteenth-century magazine *Scribner's Monthly*, which began publication in 1870, the November 1871 issue contained an image (figure 1) accompanying a poem, "Momma Phoebe," describing a plantation mother's loss of her husband to fever and of her son to wounds in the Civil War fighting alongside his young slave master, whom she had been given to raise as a son. In many ways the image casts Phoebe as a mammy, complete with a bandana, who has raised both white and black "sons." The poem, through dialect, attempts to tell the story in her vernacular voice.

> Eff my hah is de colo' o' silbah,
>     I aint mo' d'n fifty yea' ole;
> It tuck all dat whiteness f'om mo'nin',
>     An weepin', an' tawtah o' soul.
> Faw I los' bofe my dahlin' men-child'en—
>     De two hev done gone to deh res'—
> My Jim, an' my mist'ess' Mahs' William,
>     De pah dat hev nussed at my breas'.[3]

The final stanza of the poem recalls Phoebe's burial of her two sons back on the plantation and her looking toward the end of her own days.

> Den on to de ole plantation
>     We toted de cawpses dat night,
> An' we guv um a beautiful beryum,
>     De colo'd as well as de white.

FIGURE 1.

*Image accom-*
*panying the poem*
*"Momma Phoebe"*
*in* Scribner's
Monthly,
*November 1871,*
*62.*

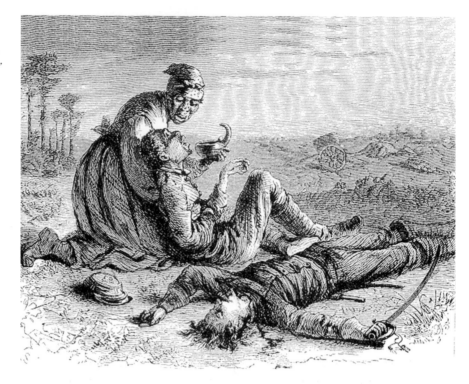

An' I shall be jined to dem child'en,
    When de jedgmen'-day comes on;
    Faw God'll be good to Mom' Phoebe
      When Ga'el is blowin' his ho'n."[4]

The dialect of this poem is made more jarring by the poem, "Out of the Depths," that immediately precedes it on the preceding page of *Scribner's Monthly*.

Arise, come forth, O heart thou art not dead!
    'Twas but the jeering falsehood of Despair,—
     Earth bourgeons bright for thee,—the skies are fair,
And Hope to greet thee lifts her shining head.[5]

The language of "Momma Phoebe" located her within blackness and its associated meanings. The poem reinforced plantation realities by contextualizing the woman within that setting, and nowhere in the long poem does the speaker acknowledge an understanding of the Civil War as a means to emancipation. In the fifth stanza of the poem, the speaker says, "Mahs' William, he run de plantation, / But de niggahs could easy fool him; / An' de place would hev all come to nuffin', / Ef 'twant faw ole momma an' Jim."[6] The word "niggah" clearly separated blacks from whites, and its use here suggested a certain level of black acceptance of the prevailing racial and plantation oppositions and realities as

natural. After all, the categorical "niggah" only existed within a racial context in which white prevailed. All of this became part of a racial discourse that redefined peoples of African descent as beings in line with European perceptions and expediency.

Cultural studies scholar and innovator Stuart Hall wrote about the role discourses play in creating perception:

> Discourses are ways of referring to our constructing knowledge about a particular topic of practice: a cluster (or formation) of ideas, images and practices, which provide ways of talking about, forms of knowledge and conduct associated with, a particular topic, social activity or institutional site in society. These discursive formations, as they are known, define what is and is not appropriate in our formulation of, and our practices in relation to, a particular subject or site of social activity; what knowledge is considered useful, relevant and "true" in that context; and what sorts of persons or "subjects" embody its characteristics.[7]

The discursive formation about race in American society constructed definitions of race, valuations of the groups involved, and devised a series of verbal and visual representations to reinforce the "truth" of the constructs. According to Hall, there are two systems of representation involved. One system, the discursive formation, correlates events and people with a set of concepts or mental representations. Meaning "depends on the system of concepts and images formed in our thoughts which can stand for or 'represent' the world, enabling us to refer to things both inside and outside our heads."[8] Language is the second system of representation involved in the construction of meaning. The shared conceptual map "must be translated into a common language" so that we can "correlate our concepts and ideas with certain written words, spoken sounds or visual images." Words, sounds, or images that carry meaning are called *signs*, and signs are organized into languages to express meaning and to communicate one's thoughts with others. "The relation between 'things,' concepts and signs lies at the heart of the production of meaning in language. The process which links these three elements together is what we call 'representation.'"[9]

Significantly, Hall warns that "meaning is *not* in the object or person or things, nor is it *in* the world. It is we who fix the meaning so firmly that, after a while, it comes to seem natural and inevitable."[10] Images devised to construct a concept of blacks in the nineteenth century in support of racist ideology were commonly accompanied by correlative language, whether to describe blacks or to represent them through dialogue. Because meaning cannot be completely fixed, blacks have worked to resist and undermine those verbal representations in a variety of ways.

Several strategies have been used to unfix verbal representations. Many blacks worked at using proper speech, particularly in public. As I was growing up, my Aunt Ezell, an elementary school teacher with a master's degree, insisted that I enunciate words properly. Every syllable was to be pronounced, especially the consonant at the end of a word. Many of us were given cues and codes like this to represent ourselves as living resistance to racial stereotypes. Historically, debates about how to verbally represent the group have repeatedly come and gone, as folks have sought dignified alternatives to demeaning characterizations: should we be "colored Americans," "colored," "Africans," "Negroes," "blacks," "African Americans," or be known by some other designation? Finally, there have been efforts to transform derogatory terms in order to disarm them, appropriate them, and redefine them. In recent decades, the terms *black* and *nigger* have undergone this effort at transformation.

This is not to say that we have been overwhelmed at every turn by the discreditation of our black identity. Of course, it is never that simple. Our opinions have fluctuated between self-deprecation and disregard for white folk's opinions because of their madness (for surely the illogic of racism indicates madness). We played with their racism to "play" them. There can be a play and double play evoking white notions of blackness in a sort of double signification. We grew up with an appreciation of the trickster figure, a poseur surviving by his wits and verbal adroitness. Many African American folktales told of Br'er Rabbit and the sassy Signifyin' Monkey, who were New World incarnations of African tricksters like *Ananse*, the spider, and, among the Yoruba, *Eshu*, the deity associated with the crossroads, confusion, and communication. Tricking and signifyin' the master, the white man, was a folk institution for which we had been culturally prepared. Often the humor and irony of signifyin' depended on the fact that terms can be unstable and that the double entendre could slip humor or absurdity into a statement.

Verbal games practiced turning circumstances inside out through linguistic exaggeration and inversion, or else they just entertained. Growing up, we would play the "dozens" (also known as "capping" or "snapping") by saying, "Ain't jo mama on a pancake box?" The dozens are testing, teasing insults, making for a contest of wit and coolness under fire. As Robin Kelley points out, "it was an effort to master the absurd metaphor, an art form intended to entertain rather than to damage."[11] To use Aunt Jemima as an insult was to know that she was not real; instead, she functioned as a fixed negative, a double signifier: a white fantasy about blacks and an insult based on the unreal. Her smile was just a hated darkie mask that we once wore, and anyone acting or appearing in a manner resembling black stereotypes like this one was disdained because that time was over. Insinuating that someone's mother was the pancake mammy was an

insult. The insult was an exaggeration and an acknowledgment of the falsehood of white definitions of blackness, but it was also an acceptance that there were black people who still unintentionally acted out those compromising stereotypes. It carried the insinuation that a person was acting out a grinning, servile stereotype rather than resisting it. As the P. H. Polk photograph *The Boss* (figure 2) suggests, there were black women who had physical characteristics resembling conceptions of the mammy, but there were personal qualities that separated them from the grinning, subservient caricature.

On another level, color consciousness among blacks replicated white definitions, and class/color conflicts were alluded to by any insults or admonitions with darkie characters (like Sambo or Aunt Jemima) or references to dark-skin coloration. African American color consciousness took another spin with the use of the word "colored." This term acknowledged the diversity of skin coloration to be found among African Americans: it began to be used in the late eighteenth century as an attempt to undermine the monolithic concept of blackness, so those of mixed heritage with fairer skin would not be lumped in with their darker neighbors.[12] The move toward conceptual diversity came to be, in the end, another way of identifying African Americans as a monolithic group, as can be seen in the signs of segregation designating "White" and "Colored" public facilities.

Some slippage in language can occur because, as Hall indicated, the meaning of verbal signs cannot be totally fixed. Over time, usage alters the concepts evoked by a sign, and in time African Americans began to renovate denigrating terms to resist their implications. For example, in the first decades of the twentieth century there was an effort to devise a "New Negro"—an effort to redefine and re-present Negroness—and this effort was the foundation of the Harlem Renaissance.[13]

But why did so many of us consciously or subconsciously ever believe that blackness was a signifier of all the stereotypical associations to which it was linked? Why and for whom did we need a New Negro? Why in our middle-class aspirations were so many African Americans acutely aware of how white American society viewed us? Probably because we were bombarded with visual, verbal, and experiential confirmations of that view in both direct and subtle forms. They were to be found in art, print media, books, product trademarks, collectible kitsch, films, radio programs, plays, and, eventually, television. By the nineteenth century the worldview that blacks inhabited had been racialized, and, as historian Mechal Sobel suggests, "the world view does more than provide 'unthinking routine'; its structuring of significance provides a taxonomy, models, and goals in relation to which the individual must evaluate reality and choose action."[14] James Baldwin, in an essay constructed as a letter to his nephew, ar-

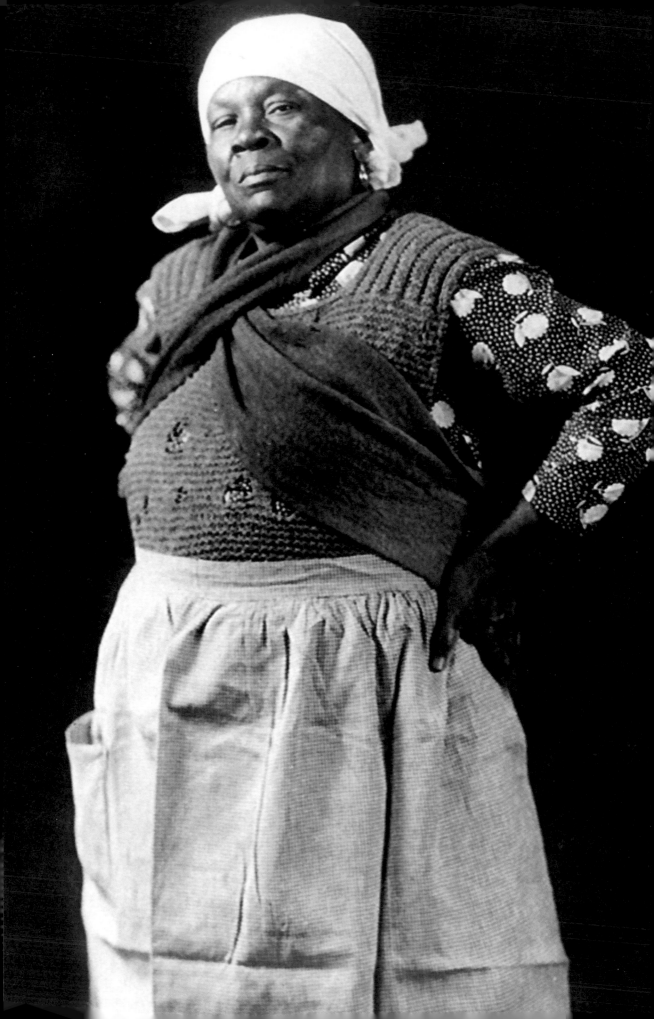

ticulated the forces and worldview molding Negro self-consciousness: "You were born into a society which spelled out with brutal clarity, and in as many ways as possible, that you were a worthless human being. . . . The details and symbols of your life have been deliberately constructed to make you believe what white people say about you."[15]

The momentum of over 150 years of derogatory images and characterizations flowed down on our heads with real consequences because white power enforced and depended on black racial identity. We reinvented ourselves repeatedly to resist and frustrate the oppressive systems and representations that circumscribed us collectively, acting on the belief that we either became coproducers or might change the worldview by our action. We re-presented ourselves to counter the other form of representation—the substitute or stand-in—that amounted to a misrepresentation rather than a proxy.

The African/Negro/black body did not change visibly, and the meanings it used to evoke as a visual sign in this racialized society are still produced in varying degrees by its appearance despite the verbal transformations of its name. The word *black* was somewhat transformed because of the ideas behind the "Black is beautiful" slogan popularized in the 1960s, when the Black Arts movement took form. To have that body even today, at the beginning of the twenty-first century, can have dire consequences, and the awareness of that reality evokes a deep self-consciousness among many African Americans.

In his *Souls of Black Folk* (1903), W. E. B. Du Bois explored the impact of the racial worldview on African Americans through his discussion of "double consciousness," that preeminent awareness of how we were perceived by others. He argued that "the Negro is sort of a seventh son born with a veil, and gifted with a second sight in this American world—a world which yields him no true self-consciousness, but only lets him see himself through the revelation of the other world."[16] Du Bois wrote of "two warring souls within one black body" trying to reconcile Negroness with an Americaness that had been naturalized to exclude Negroes. A veil of color—a terribly apt metaphor—separated whites and blacks, and each group was aware that blacks stood on the outside socially because American identity did not have dark skin anywhere in its definition. Du Bois was educated in an Hegelian tradition at Harvard and again during his studies in Berlin, and he employed Hegel's thesis-antithesis-synthesis model of progress when he devised his ideas about double consciousness.[17] According to Joel Williamson: "Du Bois neatly pressed the Negro American into the Hegelian model. Hegel traced the World Spirit as having moved forward toward a realization of itself through the successive histories of six world historical peoples: Chinese, Indians, Persians (culminating with the Egyptians), Greeks, Romans, and Germans."[18]

opposite:
FIGURE 2.
*P. H. Polk,*
The Boss, *1932.*
*Collection of*
*Paul Jones.*

Therefore, when Du Bois wrote that the Negro was "a sort of seventh son, born with a veil, and gifted with second sight into this American world," he linked black people to this history as the latest collective incarnation to advance human history. Williamson points out that in hoodoo belief "the seventh son is the fortunate one and to be born with a veil is to have the gift of prophecy."[19] This allusion to black folk beliefs follows the Hegelian idea of *Freiheit*, true freedom, which comes from knowing the self through one's people and "governing one's self in accordance with the folk spirit."[20] Du Bois also presented the possibility that the black experience in America offered a cultural bilingualism providing unique insights into both white and black realities and the potential for contributions to a progressive future for both.

What were the conditions that challenged Du Bois to map a strategy, to devise an analysis, for the progression of African Americans as an entity when they were not a nation and the most common element of their identity was the shared experience of being black? What did it mean to be black? Why and how was black or Negro identity seen as distinct from American identity? What did blackness look like?

The next chapter will present my answers to these questions; it will examine some of the ideas and images that formed the view of black folk underlying Du Bois's analysis at the end of the nineteenth century and that set the stage for

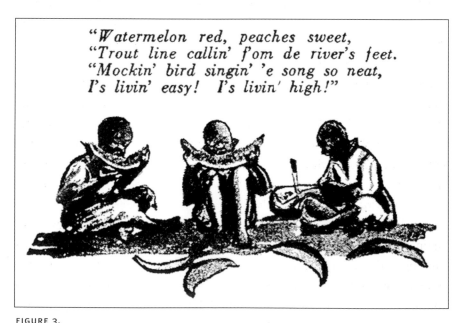

FIGURE 3.

*This image was one of a number of stereotypical plantation images accompanied by dialect in a 1939 cookbook. The appearance of such imagery in popular media contributed to the normalization of this type of black misperception. Lillie S. Lustig, S. Claire Sondheim, and Sarah Rensel,* The Southern Cook Book of Fine Old Recipes *(Reading, Pa.: Culinary Arts Press, 1939), 28.*

the movement to create a New Negro in the twentieth century. Also to be examined are concepts of race and ethnicity, some historical developments affecting the invention of racial identities, and the relevance of black identity to the construction of white identity. The point is to set the historical and theoretical context for a discussion of issues in black representation, self-perception, and self-representation that follow in subsequent chapters. This will begin the process of looking at the images of blackness as conceived and expressed on both sides of the veil of color.

Chapter 2 will document some of the artistic and popular media representations of blacks by whites that partly inspired Du Bois to devise his notion of double consciousness and helped create the need for unified organizational and visual responses within the black community. Henry O. Tanner painted one of the first counterhegemonic images at the end of the nineteenth century, *The Banjo Lesson*, and it was a harbinger of what was to come during the next several decades. Chapters 3 and 4 will discuss the conceptual and visual representation of black women as mammies and Jezebels and present additional artistic responses to these mischaracterizations. Additional chapters will discuss issues and debates among African Americans about class and color consciousness, the recycling of derogatory imagery and terminology, and the creation of art that attempts to provide a double vision rather than a double consciousness. Art imbued with that double vision locates itself in the center of an African American epistemology rather than on the periphery where definitions and contentions of race are found.

The fluidity between European and American ideas and iconography assumed throughout this book might best be encapsulated by Barbara Groseclose in her examination of nineteenth-century American art: "If I recognize the embeddedness of things American within their predominant European heritage, I also reconfigure the prevailing dichotomous reading of the European-American cultural interchange with one in which that interchange is understood to be a dialogue, continuous and salutary, rather than an intermittently valuable but inherently crippling obstacle to the formation of a national art."[21]

In addition, there is a fluidity between popular culture and fine art that gains momentum in the mid-nineteenth century and is taken for granted at the beginning of the twenty-first century. This book will not take on popular culture in recent decades in a significant way because of the overwhelming mass of information and material already available. Rather, I will use pertinent references and examples to illustrate or support the issues being examined.

As this book seeks to demonstrate, societies articulate their values and social hierarchies *visually* in many grand and subtle ways. In the modern world, images containing nonwhites have become associated with racial ideas, the visual

articulation of which has had a profound impact on how people see themselves and see others. I will look at some of those images, explore some of the ideas to be found behind them, and consider some of the effects that racial ideas and representations have had on both blacks and whites. And throughout I will raise questions about the nexus of race and representation.

# CONSTRUCTING AND VISUALIZING RACE

*You can only be destroyed by believing that you really are what the white world calls a nigger. I tell you this because I love you, and please don' t you ever forget*

—*James Baldwin,* The Fire Next Time *(1962)*

Akua McDaniel, an art historian at Spelman College in Atlanta, told me recently that her mother refused to wear red dresses or smile broadly in photographs.[1] The red dress would have suggested that she was a loose woman, a "hoochie mama" as another friend would say, and to bare one's teeth was just not done. A mask of decorum was to be maintained. Akua's mother, visiting Atlanta from Chicago just a few years ago, encountered an African American artist's book in her daughter's home that dealt critically with the Ku Klux Klan by using triangular forms and commentary. The elder McDaniel admonished her daughter to remove that work from public display. It should be "put away" very quickly. How could she display such a thing in her house?

My mother-in-law recalled how she and her siblings in New Haven, Connecticut, were not allowed to eat watermelon on the steps of their home. It would be too easy for whites to see these dark children eating fruit as something else, something from their own imaginations. Corrine Jennings, director of the Kenkeleba House Gallery in New York, said that her mother used to visit the racetrack in Providence, Rhode Island, until one day a white man rubbed her mother's head for good luck. That day was her mother's last at the racetrack.[2]

So many African Americans over the age of forty have such stories of resistance to their dehumanization and caricature in the small acts of life, stories that indicate a consciousness of being seen as racial beings rather than as individuals. Many African American psychologists like Na'im Akbar and the late Bobby Wright have written and spoken about the psychological implications of negative imagery on self-perception. Wright called acts such as the creation of derogatory images and the concepts at their root "mentacide," the act of mental genocide.[3] Akbar proposes that

> a great deal of what constitutes self-concept grows out of the social images that are projected about people. . . . One of the consequences of oppression is the loss of control over the projection of those images. As you begin to lose control of those images, then usually the oppressor, or the power holder, creates images consistent with their objectives. And their objective, of course, is usually one to keep the powerless powerless, and to keep themselves powerful.[4]

The gist of it is that images are laden with political and psychological potential and potency. They help ideological constructions like race take form in the physical world. They construct, confirm, and affirm identity. When associated with power, images can impose and reiterate social and conceptual models on others. (Imagine the potential lifelong impact on a child of derogatory characterization by a parent.) Images can affect people in realms just beyond language

and below rational consciousness—harmful images imposed from power are more difficult to subvert than language. Language, after all, is available to common folk and often is enlivened with new twists, spins, and value-added meanings in vernacular culture, but images are produced by the few to be consumed but seldom manipulated by the masses.[5]

Akbar states that "what comes through the perceptual medium [has], in fact, the most direct impact on our thinking. So what you see has much more meaning to what you come to 'understand.' The label that gets attached to what you see is a second step." With words, "you either create, or associate with it, an image and the image then becomes the mechanism by which you internalize the idea." With the image, "you only have a one-step process of where the image impacts on your psychology directly, and that, then, becomes what you internalize."[6] When it comes to visual representation, clearly a lot is at stake.

Despite the real-world impact of the construction of a black racial identity and its derogatory imagery, it is important to recognize it as what it is: a construction, an invention. All identities are constructed. When Europeans first came into contact with Africans, there were no blacks or whites, just people from various cultural and linguistic groups living in Africa and people from various linguistic polities in Europe. In colonial Virginia, according to Mechal Sobel, when the slave trade began in earnest, the English peasants serving indenture and the African captives had more in common than is usually assumed. They shared a sense of "spirit power, its nature and its possible control; of human beings and their purpose; and of time and its relation to space." Both groups marked time as being cyclical and tied to events rather than rationalizing it into regular segments.[7] She indicates that "blacks and whites worked out symbiotic relationships: blacks widely took plantation produce and exchanged it with poor whites for drink and hard goods. Poor whites were often dependent upon this cheap source of provender."[8]

White slave owners sought to separate dangerous free whites and dangerous slave blacks by creating racial contempt. This became more critical after Bacon's Rebellion of 1676 revealed the potential for joint activity by white and black malcontents. The upper class enacted harsh slave codes in 1705, 1723, and 1748 that were intended to "dishonor the blacks and thereby elevate the poor whites without actually having to give them anything." In addition, laws prohibiting intermarriage and miscegenation were passed in 1691 and 1705 respectively.[9]

The effort to separate blacks and lower-class whites was made more effective by certain social assumptions already present in English society. Elizabeth O'Leary indicates that white servants were seen as part of a discredited class because, "[i]n both England and in the colonies, service was traditionally consid-

ered a demeaning occupation that carried the stigma of menial labor and economic and physical bondage." Whites sought to escape this stigmatization, so Africans became the servants of choice, and gradually the legal system was altered to keep them in perpetual servitude. The foundations for black stereotypes were already in place because lower servile classes "were often perceived as ignorant, immoral, or lazy persons incapable of succeeding in an honorable livelihood,"[10] resulting in an ideology that helped justify their servitude, and the discourse on black skin could be easily grafted onto these notions. Such attitudes toward labor undoubtedly stemmed from medieval views of work and from the fact that manual labor was "never considered choice labor"; only in the eighteenth and nineteenth centuries did the Puritan upper-class ethic of work having an association with service to God prevail. Neither English nor African agricultural peasants had worked constantly or valued work for its own sake.[11] The separation of social classes in European society by convention and definition rehearsed racial separation, and many racial definitions and practices would be used in the future to contain the white lower classes.

In racial discourse, the European social body had to be defined in contradistinction to the foreign body; at the same time, it had to be protected from the contamination and dis-ease signified by that alien body. Many laws and codes were devised to institutionalize slavery and simultaneously maintain the social order by regulating sexual conduct. John Hope Franklin notes that in Virginia the statutory recognition of slavery came in 1661 and that the following year "Virginia took another step toward slavery by indicating in its laws that children born in the colony would be held bond or free according to the condition of the mother."[12] The legal codification of race was inspired, in part, by the complications that developed in the colony as whites and blacks had children, people of mixed heritage had children with whites or others with mixed backgrounds, and people with these diverse backgrounds began to move fluidly back and forth across the color line.

The Virginia slave codes, which borrowed heavily from Caribbean practices and became the model for other American colonies, protected white male sexual access to slave women by remanding the children of such unions to slavery. The codes implicitly demanded, however, the physical and social separation of white women and black men lest a black child be born to a free white mother. The statutory controls were part of an attempt to alleviate the confusion caused by miscegenation and to define legally the children of mixed racial heritage. Here was legal sanction for the racial convention in the eventual United States, which dictated that even a drop of "black" blood contaminated any body and therefore all having a drop were defined as black. It also was necessary to enforce racial distinctions while separating blacks from lower-class whites because

familial ties would complicate that task and aid in the formation of class alliances that would work against the control of the elite.

The codification of bodies into black and white categories required the construction of a white identity into which various European peoples could be conscripted. Whiteness contains an assumption of privilege over nonwhites, and this advantage has been particularly seductive for working- and lower-class whites. Although they did not enjoy the privileges of wealthy slave owners, they no longer occupied the bottom rung of the social and economic hierarchy. Fluidity in the definition of whiteness allowed competing groups of whites to unite in support of the slave system and, subsequently, postbellum segregation, or, in Europe, in support of overseas colonial adventures. Here it may be useful to invoke Karla Holloway's distinction between race and ethnicity:

> Race is a simplistic, political distinction that can support stereotype and prejudice. Ethnicity, on the other hand, evolved through a complex association of linguistic, national, cultural, and historical identities that affirm all of the shifting forces and hierarchies of modern life but that are also continuously affirmed, created, and embraced by those who are ethnic. It is an issue of agency. Ethnicity is a self-determined and defined construction. Race is a politically conferred and simplistic abstraction that is easily co-opted into systems of abuse and domination.[13]

Historian Maghan Keita has said in conversation with me that race is an abstraction for the way people access power. Put more concretely for the purposes of the present discussion, white is an ethnicity centered in power that confers racial designations on nonwhite Others in order to limit their access to that power. In fact, the power in question elevates opinions and fables about blacks to a discourse deeply affecting us. K. Sue Jewell extends the scope of this notion by arguing that race, ethnicity, gender, and class are used to explain the differential access to societal resources that people experience. "These same qualities have also become systems of division and domination which protect the interests of those who mediate societal resources and institutions."[14]

If we emphasize the role of imposed power in racial discourse and contrast it with the empowerment implied by the self-construction of ethnicity, then what is at stake becomes more apparent. Ethnic groups have and maintain antagonistic or hostile relations with other ethnic groups, but racial characterizations dehumanize and objectify their subjects; so the assertion of ethnicity is part of a process of humanization in many cases. Although Michael Gomez argues that "ethnicity's purpose is to dissociate rather than to associate,"[15] ethnicity is self-defined and its antagonisms are not *inherently* based on unequal power relations.

As a reaction to racism and racial characterizations, African Americans have constructed a *black* ethnicity that is built on assumptions present in the racial hierarchy but operates differently from black racial identity in its visual representations. Compare, for example, the watermelon-eating Sambo of racial stereotype with the positive ethnic appeal that dining on "soul food" such as candied yams and collard greens holds for many African Americans. The construction of ethnicity for African Americans is a process of affirmation and agency based in lived experience as well as in an act of resistance to the imposition of white power. It is also the catalyst for the formation of a distinct, complicated, hybrid African American culture. Unlike other ethnic groups, however, blacks were physically marked and therefore could not choose to remain within their cultural enclaves or move into the community at large, as their Jewish, Polish, Italian, or Irish counterparts might.

Black ethnicity is rooted in vernacular cultural expression, and the indicators of cultural authenticity often are found there. These indicators might be blues, gospel, rhythm and blues, or rap music—ska, reggae, and Calypso, among others, in the Caribbean—and the vernacular speech and slang sayings of the day. Black style in dress and hair, familiarity with folkloric characters such as the Signifying Monkey or Stagger Lee, and the practices of signifyin' and playing the dozens—all of these might indicate that a person has insider knowledge.

Despite their conceptual opposition, white and black identities share a mutual dependency. The construction of white ethnicity has been dependent on an opposition to blackness, while black ethnicity has been dependent on the threat of white racism. White is more describable by its contours and what it is not than by what it is, and its normalization also standardizes the opposition to, and devaluation of, nonwhiteness. White ethnicity is masked behind a racial description and enjoys the political and economic privileges of racial advantage, but it functions as a "self-defined" construction. Whiteness and blackness are inextricably linked, mutually dependent, and always mediated by power.[16]

Regardless of its status as a race or an ethnicity, whiteness functions within a racial discourse. Racism is an ideology, and the idea of race cannot be defined in scientific terms.[17] White identity collapses into smaller, often conflictual, ethnicities or national identities if not supported by racial oppositions, and the peoples grouped under any racial construct do not have natural, historical affiliations. Effort is required to maintain racial identities because they are ideological and not necessarily historical, biological, or cultural. Barbara Fields tells us that ideologies "do not have lives of their own. . . . An ideology must be constantly created and verified in social life; if it is not it dies."[18] Therefore, to validate the beneficial ideology of race, popular culture imagery has been enlisted

to verify racial constructions and normalize them by helping to re-edify black racial identity and white ethnicity.

The normalization of white identity has been reinforced continually in a number of ways, many of them disarmingly subtle. For example, in the summer of 1997, the U.S. Postal Service issued a set of fifteen stamps called "Classic American Dolls." The American Child doll in figure 4 appeared on the cover of the April 3, 1939, edition of *Life* magazine. The designer, Dwees Cochran, based the head of the doll on four faces that she saw as being typical of American children: blond hair and northern European features were to her the standardized American visage.[19] Dolls are significant in popular culture because they carry subtle messages to young children. In recent decades many African American mothers have made it a priority that their daughters receive only black dolls as Christmas or Kwanza gifts. Also, the important studies by Kenneth Clark and Mamie Clark (1939, 1947), which became a building block for the legal challenge to segregated schools leading to the *Brown v. Board of Education* Supreme Court ruling in 1954, demonstrated the overwhelming preference by black children for white dolls over black ones; the children's identification of good with white and bad with black were shown to be indicators of poor self-esteem and self-image. The white doll/image was in thousands of homes, seen by millions through the distribution of *Life* magazine, and now has been reproduced seven million times as a stamp. The message is very clear—white is the American standard— and this message is reiterated again and again in American popular media and culture to inscribe and reinscribe it.

What is not clear is what white is—what it looks like. It can include blue, brown, gray, or green eyes and blonde, brown, red, or brunette hair color. It is usually not fragmented or undermined by national or ethnic subidentities such as French, Italian, German, Anglo Saxon, or Irish—especially with the presence of black—though class distinctions do exert pressure against white racial solidarity. As Richard Dyer tells us, "Trying to think about the representation of whiteness as an ethnic category in mainstream film is difficult partly because white power secures its dominance by seeming not to be anything in particular."[20] This standardization, hiding in plain sight, is part of the process of the consolidation of power.

Now, it must be reiterated that blacks did not passively agree to, or accept, racial designations. Due to the disparities in access to power, black agency often took complex strategies to undermine or neutralize the imposed identities as much as possible. "Black" or "Negro" or "African" became useful terms for the organization of resistance to white or European control or domination, and the process of inverting or reformulating white racial characterizations became a

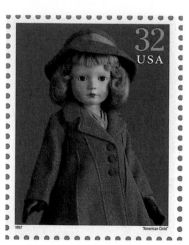

FIGURE 4.
*Stamp of "American Child" doll designed by Dwees Cochran, Classic American Doll stamp series, U.S. Postal Service, issued July 29, 1997, pane of 15, 4424840.*

strategy for subverting racial objectification. There is a commonality in the experience of being black, and this common experience helped African captives overcome their ethnic diversity and language differences to form slave communities and to collaborate in order to resist their captivity. Also, vernacular and folkloric expression winked at racial characterizations through signifying, verbal allusion, and occasional outright parody, such as the cakewalk dance that nineteenth-century slaves devised to satirize the way white folk paraded and strolled.

In addition, local American considerations ought to be seen in the context of global concerns because they were and are, to my mind, linked. As Jan Pieterse suggests, "America has all along been the arena of European racism: for it was the slaves of Europe who were put to work in the West Indies and America, in European colonies and on plantations."[21] Many characteristics associated with black identity in America had congruency with ideas at work in Europe, particularly in nations with slave colonies in the New World and interests in colonial expansion in Africa. European notions about Africans were translated almost intact into the Americas to describe blacks. As Pieterse points out, "the 'black brute' of the American South is the 'primitive savage' of Europe's Africa,"[22] and Hammond and Jablow argue that the term "nigger," first used by the British to denigrate people in India, gained currency in Africa before being used in America.[23] India also was where the Black Sambo stories began.

Doubly ironic is the possibility that blacks formed the first postmodern population at the beginning of modernism. Postmodernism consists of a fragmentation and irony that opposes the monolithic assumptions and metanarratives of modernism. Clearly the African cultural body was fragmented and reassembled in new combinations in the New World, incorporating old African, old European, and completely new hybrid elements. As Stuart Hall suggests, postmodernism "represents an important shifting of the terrain of culture toward the popular—toward popular practices, toward everyday practices, toward local narratives, toward the decentering of old hierarchies and the grand narratives."[24] Both in black cultural resistance to modern social and global racial hierarchies and in the irony and signification found in vernacular black humor, songs, and fables, the seeds of postmodernism were present.

Because African American ethnicity was developed within the terrain of racial identity, many intellectuals like Wilmot Blyden and W. E. B. Du Bois began to equate black/Negro identity with the qualities assigned to nations as a foundation for a racial nationalism. This was a strategy to devise a community

of resistance that would challenge white racial descriptions. Kobena Mercer points out that "[i]t was the formation of black *communities of resistance* that transformed the experience of oppression into a field of antagonism."[25] In the United States black solidarity was emphasized not to engender a separate black nation but to develop an effective political bloc for resisting racism and working into the fabric of the nation.

## IMPERATIVES OF SLAVERY AND RACIAL DIFFERENCE: A HISTORICAL CONTEXT

*Are we MEN!!—I ask you, O my brethren! Are we MEN? Did our Creator make us to be slaves to dust and ashes like ourselves? Are they not dying worms as well as we?*
—David Walker, Appeal to the Coloured Citizens of the World *(1829)*

The construction of racist ideology generated a momentum long outlasting the original circumstances that it served because it bestowed real world privileges on those accepting the ethnic/racial definition of being white. Initially the prodigious financial gains offered by trade along the African coast was the driving motive for Europeans in Africa, and there were few grand schemes beyond economic objectives. West African gold was an important source of trade and wealth beginning in the fifteenth century, but few of the European goods imported into African societies were not already produced within African economies. Trade was between equal partners with no dependency on either side.[26] However, the wealth Europeans found in the raw materials and cultivated products of New World colonies prompted the Atlantic slave trade, and its profits soon superseded the trade with African states.

The growth of New World colonial enterprise and expansion and its growing dependence on African slave labor engendered an organized effort to define white over black in order to stabilize and institutionalize that labor. It should be remembered that the slave trade was managed primarily by profitable international corporations in competition with one another and supported and taxed by their governments; in the seventeenth and eighteenth centuries many Europeans either made or sustained their fortunes at home through the absentee management of colonial plantations.[27] Also, the widespread poverty of preindustrial England motivated many lower-class citizens to seek land and a better life in colonial settlements.

Eventually in the United States, the law defined black slaves as property, and many offenses against slaves were defined as violations or trespass against the property of the slave owner.[28] Herbert Aptheker wrote that slaveholders in the first half of the nineteenth century were "the most closely knit and most im-

portant single economic unit in the nation" and that their slaves and land comprised "an investment of billions of dollars."[29] In other words, economics and the profit motive prevailed before and throughout the time of slavery (despite the evangelical rhetoric), and the legal and rhetorical descriptions of slaves very often were rooted in the language of commerce.[30]

In addition, the wealth and status many plantation owners acquired provided a social motive for the preservation of the slave economy. John Vlach points out that the architecture and layout of the plantation served to reinforce visually its hierarchies and values: "The tangible glory of manorial estates served as the most persuasive propaganda for the celebration of the plantation ideal. Implicit in the structured layout of Georgian houses, formal gardens, and extensive stretches of fenced and cultivated fields was a strong sense of the planter's dominance over both nature and society."[31]

A wealthy planter's house often was situated on a hill so that it looked down over its domain, but also so that white visitors of lesser social or economic status had to approach from below, thus emphasizing the social hierarchy. The slave quarters generally were set behind or to the side of the planter's residence, where they would not compete with it visually. Even those quarters which were visible were obviously smaller, subordinate buildings.[32] Roger Abrahams writes that "the mansion served as an embodiment of the integrity and the power of the family residing within."[33] The landscape and the house itself presented a series of physical and social barriers to create a symbolic landscape including "rows of trees, terraces, dependencies, the kitchen. Finally, the house itself confronted the white visitor with more barriers: portico, doorway, grand stair hall, chambers for waiting, chambers for formal talking, chambers for formal dining." This social space was "a carefully orchestrated exercise in the definition of status; every barrier passed was a mark of preference."[34] Power and privilege were visually encoded in the landscape and architecture.

There were financial benefits even for slave owners with smaller holdings. In mid-nineteenth-century Callaway County, Missouri, slaveholders held on average just over three hundred acres, and nonslaveholders held slightly more than one hundred acres. The average slaveholder's farm was valued at $1,720, and the nonslaveholder's property was valued at $500.[35] It is easy to see that, as slavery developed, much was at stake for slave owners and for those wishing to attain similar wealth and status, prompting, in turn, a vigorous defense of slavery.[36]

The financial benefits of slavery were great and were not confined to southerners. A partner in a New York mercantile house in 1835 asserted to Rev. Samuel J. May, a leading abolitionist that "[t]here are millions upon millions of dollars due from the Southerners to the merchants and mechanics of this city alone, the payment of which would be jeopardized by a rupture between the

North and the South. We cannot afford, sir, to let you and your associates succeed in your endeavor to overthrow slavery. It is not a matter of principle with us. It is a matter of business necessity. We cannot afford to let you succeed."[37]

A decade later South Carolina planter James Henry Hammond, a leading spokesman for slave owners, addressed abolitionists reiterating this same theme: "Nay, supposing that we were all convinced, and thought of slavery precisely as you do, at what era of 'moral suasion' do you imagine you could prevail on us to give up a thousand millions of dollars in the value of our slaves, and a thousand millions of dollars more in depreciation of our lands, in consequence of the want of laborers to cultivate them?"[38]

The point is that the derogatory representation of blacks upheld an ideology devised in support of an economy reliant on slavery. Slavery of some sort had been a continual part of human history for thousands of years, and it was only in the face of organized opposition that slave owners constructed a series of formal arguments to justify it. The fact that "slaves" and "blacks" became synonymous, and that blacks seemed very different than whites physically and culturally, helped generate justifications rooted in the perceived difference of black people.

Not everyone participated materially in slavery, and a small number of people worked actively against the institution. Antislavery pressure by Quakers in the eighteenth century gained support after the War for Independence, and it forced slaveholders to defend their enterprise with increased vigor and logic during the Constitutional Convention of 1787. Slavery no longer could be defined as a British enterprise—slave owners had to accept responsibility and justify the institution. Abigail Adams wrote to her husband, John Adams, in September 1774, while he was leading the war effort in Philadelphia, to suggest that "it always appeared a most iniquitous scheme to me to fight ourselves for what we are daily robbing and plundering from those who have as good a right to freedom as we have."[39] The dependency of many northern businesses on products from and trade with southerners caused their resistance to the moral suasion of abolitionist arguments.

Many free blacks worked for the abolition of slavery. Men like Prince Hall, Benjamin Banneker, and Richard Allen published pamphlets containing most of the arguments developed later in the abolition movement while also arguing against the concept of racial inferiority.[40] Black abolitionist David Walker's inflammatory 1829 pamphlet, *Appeal to the Coloured Citizens of the World*, aroused the ire of southern planters, and the state legislatures of North Carolina and Georgia met secretly by request of the governors on several occasions from 1829 to 1831 to discuss how to deal with the effects of Walker's publication.[41]

Abolitionist sentiment grew steadily among whites, particularly after the

1820 Missouri Compromise. For example, the following antislavery comments appeared in the *African Repository*, a New York journal, in 1825:

> In defiance of all our records of antiquity, both sacred and profane—they [Negroes] are contemptuously spoken of as a distinct order of beings; the connecting link between men and monkies.
>
> Those who talk this way, do not recollect, or perhaps do not know that the people whom they traduce, were for more than a thousand years . . . the most enlightened on the globe.
>
> They were called "Ethiopians," from two Greek words denoting the colour of their skin; and the spirit of adventure by which they were distinguished together with the superiority which they every where manifested over the nations among whom they dwelt.[42]

Abolitionist sentiment and activism testified to the fact that slavery was not universally accepted in the white community and that it presented a moral dilemma for a free society. William Lloyd Garrison's denunciation of slavery in *The Liberator* in 1831 helped spur the formal development of an American proslavery discourse, and an abolitionist mail campaign of 1835 began the open battle over slavery.[43] Southerners united to call on the region's finest minds for defenses of slavery, to discuss with one another the appropriate contents and goals for their writings, and to arrange wide distribution of those writings in newspapers, pamphlets, and book-sized collections of previously printed favorites.[44] Perhaps this is when the value of popular media conscripted in the service of ideology came to be appreciated fully. The ideology took on new forms rooted in existing racial arguments that had been part of proslavery thought since early in the colonial period.[45]

During the first half of the nineteenth century, biblical arguments in support of the enslavement or colonization of African people began to be replaced by pseudoscientific inquiry conducted on both sides of the Atlantic. The so-called sciences of craniology, physiognomy, and phrenology grew as people searched for visual and physical characteristics that would separate whites from nonwhites and establish a code for the clear delineation of a hierarchy of racial types.[46] According to this system of valuation, those higher in the hierarchy would naturally dominate those below them, thus justifying the enslavement or colonial exploitation of blacks. Drew Gilpin Faust contends that the "scientific validation of Negro inferiority offered an alluring and seemingly irrefutable argument to those favoring the social subordination of blacks in slavery,"[47] an argument that supplemented with science what was seen as biblically ordained.

Petrus Camper, a professor of anatomy at Groningen in the Netherlands, produced an evolutionist model of facial angles (figure 5) to explore human dif-

ference based on cranial structure, and he used Greek classical sculpture as the anatomical norm against which those lower on the evolutionary scale were to be measured. Ideologues adopted Camper's model to justify racial and social stratification. Anthea Callen reveals that by 1845 Camper's facial angle was being invoked to criticize artists whose ignorance of scientific anatomy resulted in "unrealistic" depictions of blacks who were given Caucasian heads with dark skin. The use of art in anatomical texts caused artistic imagery to be "taken to encode *scientific* signs of anatomical difference—whether racial, class or gender." After the spread of Darwin's ideas, Camper's hierarchy could be a means of enabling a spectator to decipher images in order to signify the subject's relative placement on an evolutionary grid.[48]

Camper's model apparently became standardized across Europe, as evidenced by the chart in figure 6 that appeared in a late-nineteenth-century Portuguese dictionary under the definition for "face." The text states that "in the savage races the face angle is a little open," and the chart's categorical facial angles descend from the ideal classical Greek profile to a negroid type, the lowest human form, to a monkey ("*macaco*") snout.[49] Unlike Camper's chart, even with its Eurocentric assumption of a Greek ideal, the one used in the Portuguese dictionary, a popular reference book, obviously carried a racial message.

There were other attempts to historicize the racial hierarchy. In his 1844 volume, *Crania Aegyptiaca*, Dr. Samuel George Morton, using cranial measurements, suggested that "Egyptians were not Negroes" and that blacks had had the same servile status in ancient Egypt as they now had in America.[50] Ancient Egypt itself was depreciated in the Enlightenment idea of progress because it was an earlier civilization and therefore must have been more primitive than subsequent Greek, Roman, and European civilizations. Still, Egyptians had more status than black Africans, from whom they were categorically separated. Martin Bernal, in *Black Athena*, contends that the use of a classical Greek ideal to chart a human evolutionary scale was dependent on the concurrent development of a new historical view of Greek culture: separating it from its Egyptian (African) and Mediterranean foundations—a historical model accepted for two millennia—scholars concocted an Aryan model of Greek culture based on northern Dorian contributions.[51]

These ideas of human categorization and the philosophical, intellectual, and scientific inquiry into racial differences may have had their roots in the racial ideas of British thinkers David Hume and John Locke, the interpretations of Greek culture by Johann Winckelmann (the father of art history), and the development of professional academics at the University of Göttingen in eighteenth-century Germany, where the Aryan model of Greek origins was developed. In his worship of Greek art and culture, Winckelmann held the view, according

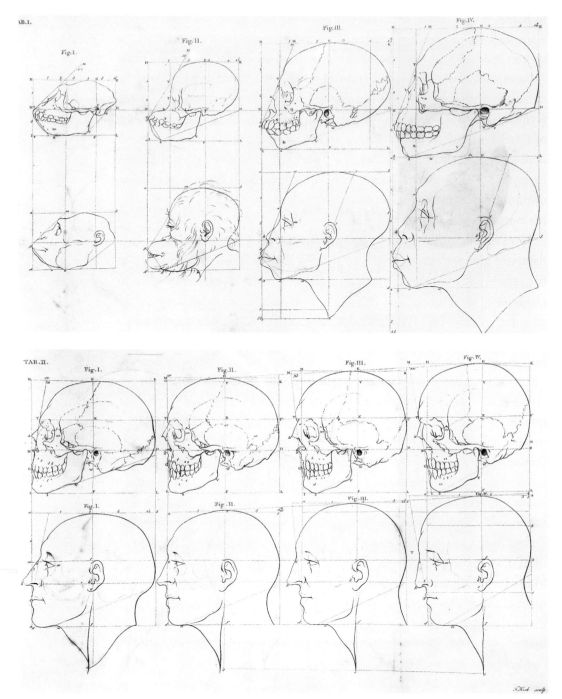

**FIGURE 5.**
*Petrus Camper, "The Evolution of Man," in* Works . . . on the Connexion
between the Science of Anatomy and the Arts of Drawing, Painting, and
Statuary *(London, 1821), tabs. 1, 2. Photograph courtesy of the Wellcome Trust.*

to Bernal, that "Greece epitomized freedom, while Egyptian culture had been stunted by its monarchism and conservatism and was the symbol of rigid authority and stagnation—which also happened to be non-European."[52] Bernal argues that "central to [Winckelmann's] love of Greece was his appreciation of Greek homosexuality" because of his own sexual preference.[53] Winckelmann's work had an enduring impact on German intellectualism and the development of a canon of Western art history still devoted to Greece as the soul of classical antiquity.

Most significantly, it was at Göttingen in 1775 that naturalist and anatomist Johann Friedrich Blumenbach presented to the medical faculty his dissertation, *De generis humani varietate nativa* (On the Natural Variety of Mankind), an investigation of the division of human groups into racial classifications. In the third edition of this work, published in 1795, Blumanbach originated the name Caucasian for whites. Having devised a five-race scheme of human classification, he initiated a shift from a geographic to a hierarchical ordering of human diversity that would prove disastrous for blacks.[54] Blumenbach was more a scientist than an overt racist, but his ideas were very useful to others with political, economic, and social agendas.

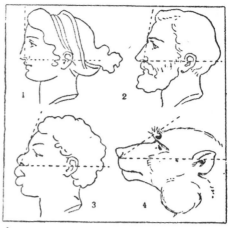

ÂNGULO FACIAL : 1, do antigo; 2, de raça branca; 3, de negro; 4, de macaco.

FIGURE 6.
*Apparently influenced by Camper and others, this diagram of facial angles appeared in a two-volume Portuguese dictionary published in the nineteenth century.*

This period also saw ethnology emerge as a social science dedicated to studying racial differences. Given the transparency and naturalization of whiteness, it seemed consistent to have the social sciences function in ways that were compliant with the aims of scientific inquiry into human differences. By implication, "we" used these social sciences to study "them," whether they were of a different race, ethnic group, or class. The use of scientific physical and social indicators of racial and cultural differences to delineate which groups belonged inside or outside of an American or European body politic was deemed appropriate in the modern Age of Reason. Early anthropology was more telling about the anthropologist than about the nonwhite subject, but this epistemological bias was hidden under the guise of scientific objectivity.[55]

Many early proslavery rationales had been constructed around biblical arguments and interpretations of natural law. Some went so far as to devise theories of polygenesis, suggesting that there were two Creations, that whites and blacks were created at different times and therefore were not of the same species. The usual argument relied on the notion of blacks being the descendants of Noah's cursed and discredited son Ham, any descendant of whom, according to Genesis 9:25, "a servant of servants shall he be unto his brethren." These arguments probably were devised to refute the early abolitionist writing of John Woolman

THE SPIRITUALIST.          THE MATERIALIST.

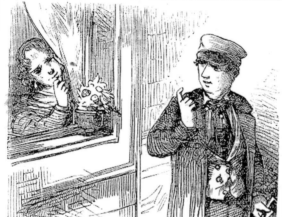

THE TELEGRAPHIST.          THE NATURALIST.

FIGURE 7.
*This chart lampooning several types of people presents the African as a crude cannibal roasting white flesh. Published in* Harper's Weekly *on April 25, 1857 (272), this was only the second image of a person of color to appear in the magazine in its first year of publication.*

(1720–72) who published a small, widely read book in 1754, *Some Considerations on the Keeping of Negroes*, that asked, "Did not He that made us make them?"[56]

In combination, religion, science, and ideology justified the subordination and harsh treatment of blacks and their containment at the margins of society. Expressing these views in relation to social policy, Richard Colfax published in 1833 a proslavery tract arguing that "the physical and mental differences between negroes and white men, are sufficient to warrant us in affirming that they have descended from distinct origins, and that no alteration of the social condition of the negro can be expected to create any change in his *nature*."[57] The "nature" of the Negro was that of a savage brute, and the docility formed through slavery was considered to be a limited level of civilization that had been imposed artificially by captivity. Because of the association of Negro nature with brute animals, it was thought not to be possible to overwork or overly abuse a

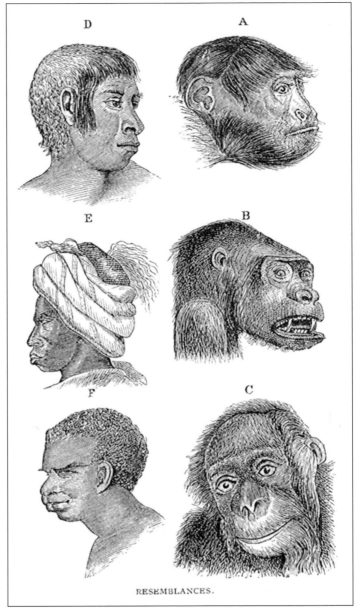

RESEMBLANCES.

FIGURE 8.
*This chart,
"Resemblances,"
appeared in*
Scribner's
Monthly, *July
1872, 335.*

slave except in the manner one might treat a horse. These theories and scientific treatises may have reached the height of absurdity in the work of a Dr. Samuel Cartwright, who in 1852 published a medical essay describing Negro "diseases" resulting from mismanagement of slaves, among them drapetomia (running away) and rascality.[58]

Among the visual signifiers of discredited blackness were the obvious physical traits defined as racial: dark skin, woolly hair texture, full lips, and broad noses. Also, such features as slanting foreheads and prognathism of the jaw

were seen as indicators of degenerate mental and moral qualities — as discerned by the "science" of physiognomy. Because blood was a prime carrier of these and other racial characteristics, the presence of even a bit of black blood posed a latent threat. It was important to associate natural or inherent characteristics with blacks so as to suggest that certain social traits were distributed through blood; thus one could justify a prohibition against miscegenation, a theoretical position that did little to deter many white males from instigating illicit sexual liaisons with black women. Blackness was envisioned ideologically as a threat to the white social body and genetically as a threat to the white racial body. The black brute was the embodiment of this threat, and the foolish Coon or Uncle Tom was its subjugation through emasculation.

Discredited visual signs assigned to blacks (and other primitives) proved useful for the maintenance of social divides between ruling-class whites and other whites. In Europe, gender and class distinctions within white ethnic or national communities were justified by linking the visual traits associated with primitive human groups, especially blacks, to the lower classes of their own societies. Callen writes that this came from "the growing need of the male European bourgeoisie to establish for itself a separate and higher state of evolution, both biological and cultural, to help legitimise its position as a ruling patriarchy at home and abroad."[59] Visual indicators of "degenerate" types were produced, including a skull type, an acute facial angle, a jutting jaw, and prominent cheek bones, and these signifiers were used as a template for judging women as inferior to men and as a means of identifying "criminal types" and primitivized (and sexualized) women. Since it was believed at the time that blood and visual signifiers carried or indicated social, intellectual, moral, and behavioral traits, it followed that the sons of criminals were predisposed toward criminal behavior because it "ran in the family."

Callen produced a feminist analysis of a famed sculpture by Degas, *Little Dancer of Fourteen Years* (figure 9), and its implications regarding the relationship of lower-class women and upper-class men of the period. The young dancer was depicted with an exaggerated slant to her forehead as a codification of her sexual availability and lower social status. Callen argues that Degas deliberately "transformed his model, the Belgian dancer Marie Van Goethem, to give his sculpture an emphatically primitive cranium," and studies for the sculpture stand as evidence of this change.[60] Sexually available white women from the lower classes were interpreted into the same primitivist discourse used to describe blacks — primitives lacked sexual morals and social discipline — and this played out in images, especially in France. The conceptual linkage of sexualized white women and black women will be explored in depth in chapter 5.

So where does all of this lead us? The black African body, long a fascination

*Edgar Degas,* Little Dancer of Fourteen Years, *ca. 1880–81, wax, silk, satin, ribbon, and hair, h. 990 mm. National Gallery of Art, Washington, D.C.*

for Europeans because of its difference, served as a marker facilitating the redefinition of that body as an indicator of a lesser humanity, a humanity most suitable for domination and servitude. These ideas were actualized into a black racial identity that was constructed and reinforced by convention, religion, ideology, legal institutions, and (fallacious) science. The alien black identity increased the commonalities for Europeans under a white identity, and blackness was defined as the antonym of whiteness. As the distinctions between Africans and Europeans, between whites and blacks, were more clearly drawn, visualized, and codified, concerns grew among whites about the pollution of the white social body with the staining potential of all forms of blackness, whether actual or simulated. These ideas were formulated among the elite to help the consolidation and maintenance of their power by pushing a racial wedge between lower-class whites and blacks to prevent coalitions that might threaten that authority and power. In Europe especially, whites perceived to have the physical or behavioral traits attributed to blacks and other so-called primitives were also seen as threats to the main white social body, and this became a rationale for controlling their social status and mobility as well. Because the discourse of difference was centered on the visual, visual representation came to be important in the reinforcement of these ideas of social hierarchy, or at least as evidence of how thoroughly they permeated society.

## INVERSIONS AND TRANSFERALS: THE WHITE STAKE IN BLACKNESS

*White people believed that whatever the manners, under every dark skin was a jungle. Swift unnavigable waters, swinging screaming baboons, sleeping snakes, red gums ready for their sweet white blood.*
*—Toni Morrison,* Beloved *(1987)*

Toni Morrison, in her book of essays *Playing in the Dark*, suggests that the fabrication of an "Africanist" persona in the United States should be studied for its implications regarding the fabricator: "As a writer reading, I came to realize the obvious: the subject of the dream is the dreamer. The fabrication of an Africanist persona is reflexive; an extraordinary meditation on the self; a powerful exploration of the fears and desires that reside in the writerly conscious."[61]

Morrison argues successfully that blackness is at the center of American identity (always assumed to be white) and gives meaning to whiteness. This may explain the persistent fascination and repulsion whites have expressed toward black people, an attitude vividly expressed in the journal of a Russian diplomat, Pavel Svinin, documenting his travels across North America from 1812 through

1813. Svinin wrote in his diary that in a black church "the piercing outcries and howls resembling a chorus of Furies horrify you and make you shudder, whereas the harmony of the singing in a Greek church fills the heart with a sweet emotion."[62] An entry describing his visit to a black church in Philadelphia illustrates Morrison's argument and reveals more about Svinin's consciousness than it does about the black churchgoers: "We entered a large hall or temple, very poorly lit with torches. . . . The hall was full of Negroes; the men were gathered on the right side and the women on the left. The dim light of the fire and the frightening faces of the Africans whose eyes, fixed on us, flickered like so many tiny sparks — all this aroused in us a sense of horror, which was further intensified when they began to howl in wild and shrill voices. It seemed to me that I had fallen into the realm of Pluto among all the frights of hell."[63]

Morrison questions whether the characteristics of American literature are, in fact, responses to the black or "Africanist" presence.[64] In the first half of the nineteenth century, one or two blacks often appeared in American genre paintings "to denote the scene as specifically American."[65] Certainly, it is impossible to understand American society, as Svinin realized, without considering the African body around which its history pivots and which is a source for many of its cultural elements. So many of the political and moral debates of the past two centuries have revolved around the presence of African Americans. The contradiction of a democratic ideal of freedom with the ultimate nonfree status, slavery, at its center, inspired, as we have seen, many bizarre rhetorical and logical strategies to reconcile this conflict and has contributed mightily to the history, literature, and culture of this society.

Pieterse, in an argument that is easily linked to Morrison's, writes that internal tensions within European and American societies were projected onto nonwhites, especially sexual ambivalence. He argues that in the United States "([r]epressed) sexuality, white male domination and violence are so closely interwoven here that they merge with one another."[66] Morrison concurs, suggesting that the white male, by projecting fantasies of savagery on blacks, tried to absolve himself of his own indefensible savagery by "persuading himself that slavery is 'out there.' The lashes ordered . . . are not one's own savagery; repeated and dangerous breaks for freedom are 'puzzling' confirmations of black irrationality."[67] Slave revolts or escapes, then, were not the result of savage treatment but indications of some endemic flaw within the slave, and the persistent, widespread sexual abuse of slave women was the consequence of their own libidinous nature. This logic obfuscated the sexual and autobiographical aspects of racial relations that Morrison and Pieterse have explicated.

One of the more celebrated breaks for freedom (from the savagery of slavery) occurred in 1839 when the Spanish slaver *La Amistad* was taking captured

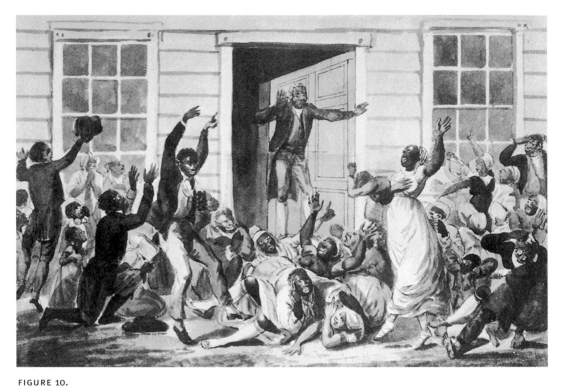

FIGURE 10.

*Pavel Svinin,* A Negro Group in Front of the Bank of Pennsylvania, Philadelphia, *ca. 1812, 6¾" × 9¼". This image reportedly represents a Methodist Negro open-air meeting and reveals the emotionalism associated with Negro worship that Svinin disdained in his writing.* Traveling across North America, 1812–1813: Watercolors by the Russian Diplomat, Pavel Svinin *(New York: Harry N. Abrams, 1992), 31.*

Africans from Cuba for resale in Puerto Rico; after four days at sea Cinqué, a Mende, led a revolt to force the ship back to Africa. The surviving crew sailed the ship north and west at night instead of east, and the ship ended up at Long Island. Authorities brought the captives ashore in New London, Connecticut, and abolitionists, including former president John Quincy Adams, who eventually defended the captives as their lawyer, sued for their freedom in the court system. The *Amistad* rebellion ended successfully when the Supreme Court agreed with arguments in favor of the acquittal of the mutineers. They toured the Northeast as heroes at antislavery meetings and returned to Sierra Leone in 1841.

Robert Purvis, a black abolitionist from Philadelphia commissioned Nathaniel Jocelyn, an abolitionist sympathizer, in 1840 to paint a portrait of Cinqué (figure 11). One of the more remarkable aspects of this work is the fact that the central figure is black and not a servant or an entertainer, the common pictorial roles of blacks in the art of the period. Yet Jocelyn's *Cinqué* and the entire *Amistad* affair reflected the concerns and imaginations of whites about blacks much more than they revealed about the African at the center of it all. McElroy wrote that "Jocelyn's depiction, with its high brow and dramatically shaped cranium, may have . . . conformed to the claims of phrenologists, whose careful analysis of Cinqué's head led to extravagant explanations for his exceptionally courageous behavior." Accounts from the period celebrated Cinqué's personal quali-

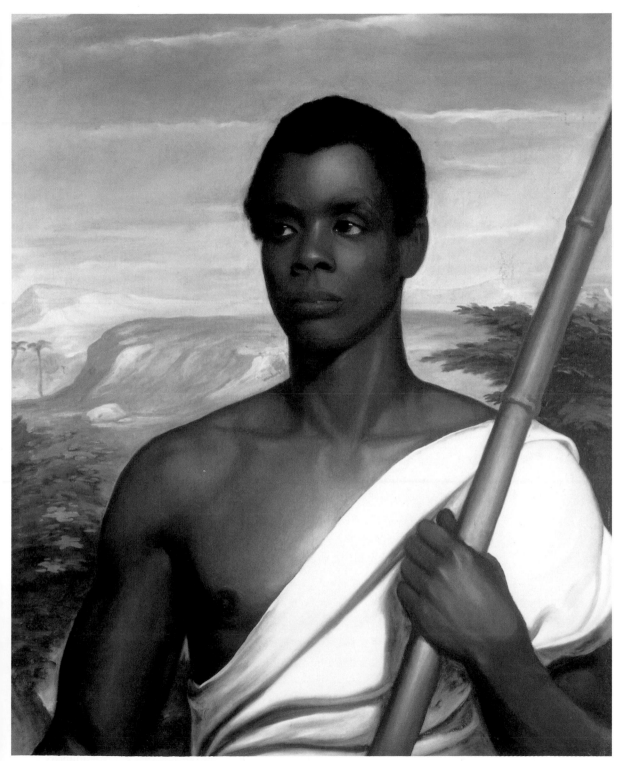

**FIGURE 11.**
*Nathaniel Jocelyn, Cinqué, 1840, oil on canvas, 30¼" × 25½".*
*The New Haven Colony Historical Society.*

ties in ways linking him to admirable white behavior, praising his "commanding presence, forceful manners, and commanding oratory."[68] Richard J. Powell reports that "[w]ithin a week of their incarceration, Cinqué and his fellow Africans became the subjects of a phrenologist, who took measurements of their heads and, in the typical fashion of phrenologists of the day, gave detailed interpretations of each of the captives' respective characters and personalities."[69] The explanations by phrenologists made Cinqué the exception that proved the rule, though the painting would have been vulnerable to the European critiques mentioned above for not adhering to Camper's chart in the depiction of Cinqué's head.

Jocelyn's studio portrait has an idealized landscape as its background, and Cinqué is dressed in a toga, suggesting a link to Greek and Roman ideas of freedom; those ideas might be awkwardly displayed if he were represented in his native Mende clothing, but in the 1840s they were metaphorically significant for the self-perception of the nation as a free democracy. His bare shoulder links him to primitivist discourse because nudity was associated with "primitive" native populations. Also, nudity and classical references suggest that he is in a premodern state, as all primitive peoples and earlier cultures were seen to be; so he remains a misfit in an industrializing modern world. Any role he or his African brethren might have in that world would be limited to the physical labor for which they are suited. Cinqué is an outsider, but an acceptable one.

With Cinqué's features seemingly somewhat anglicized and his dress linking him to the perceived Greco-Roman foundations of Western civilization, the portrait was created with an anticipatory glance at the critique it risked in the minds of slavery's apologists. His visual connection to classical ideas emphasized the contradiction between American ideals and the reality of slavery. Powell argues that this work's role in antislavery publicity efforts is confirmed by its having been reproduced as a mezzotint in an edition of at least 200 by John Sartain in 1840–41.[70] Cinqué was to be seen as the classic noble savage whose character embodied many traits valued by whites and whose body confirmed this by its appearance. Therefore, his body could become the field on which the moral dilemma of slavery could be played out by whites. The work became less a portrait of Cinqué than a black-body-as-Rorschach-test revealing the white psyche.

According to Powell, Purvis was a leading abolitionist of his day, who "helped launch Garrison's *Liberator*[,] served as a charter member of the first national antislavery organization, the American Anti-Slavery Society," and was involved in several other antislavery societies and reform organizations.[71] His activism, and later that of Frederick Douglass, was black participation in what essentially was a white discourse about the fate of blacks in the United States. Conducted mainly between whites, the discourse was about how they were to

feel, think about, and treat blacks. It is therefore possible to suggest that the black subject in art, literature, politics, and social theory can be construed as circumstantial and reflective evidence for envisioning the elusive white identity that has been naturalized out of description.

It must be stressed that this elusive white identity is complex and incomplete because white ethnicity allows a diversity and flexibility not granted to black racial identity. The point is that blackness is a fabrication that has been re-fabricated by African Americans. Both black and white identities are fictions, but fictions do exist. African Americans have resisted racial discourses and the oppression they produce since their forebears arrived in the Americas. That resistance has taken physical, semantic, social, and visual forms. Images of blacks by whites reveal far more about whites than about blacks, but the realities of power cause them to affect blacks harmfully when they are derogatory, which necessitates subversive strategies to resist them. That is why Mrs. McDaniel resisted wearing red—and why for so long, even for African Americans, black was a discredited signifier.

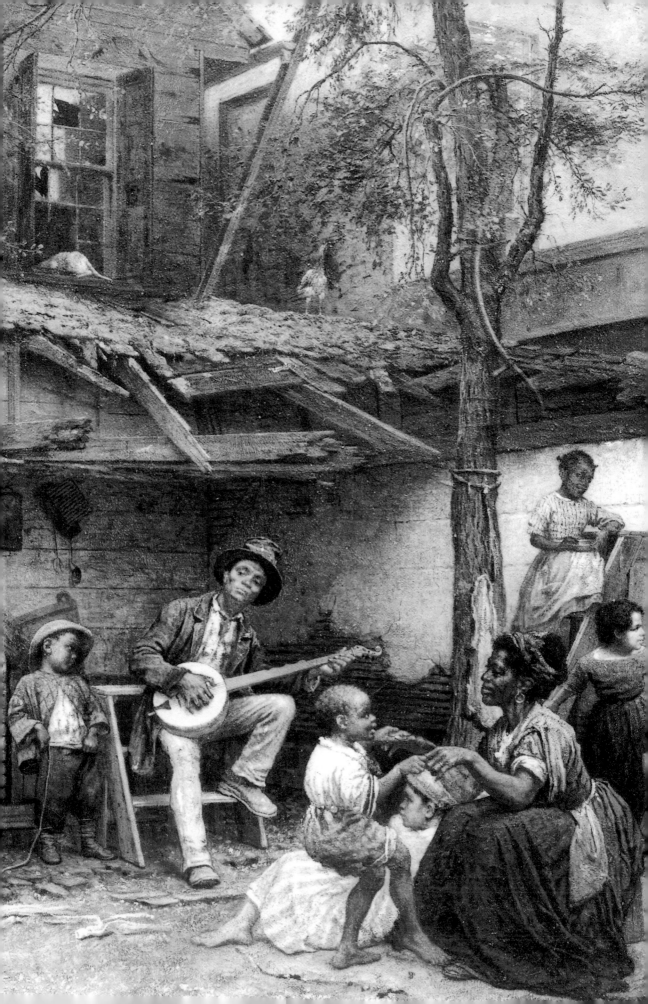

# 2

## THE NINETEENTH CENTURY IMAGED IDEOLOGY

*Oh, Liberty, thou golden prize*

   *So often sought by blood—*

*We crave thy sacred sun to rise,*

   *The gift of Nature's God!*

*Bid slavery hide her haggard face,*

   *And the barbarism fly:*

*I scorn to see the sad disgrace*

   *In which enslaved I lie.*

   *—George Moses Horton, "The Hope of Liberty" (1829)*

*Art represents and sanctifies what is valued in a society. . . . Definitions of art are*

*therefore highly political. They are major battlegrounds on which the struggle for*

*human and social recognition is waged.*

   *—Eugene W. Metcalf, "Black Art, Folk Art, and Social Control" (1983)*

Despite the centrality of Africa and Africans in the economic development of Europe from the sixteenth century forward, and the significance of the Africanist presence in the formation of New World cultures, rarely are people of African descent represented in Western art and literature. What representations we do find of them prior to the twentieth century usually are done by non-Africans; so they can serve as barometers for tracking the changing attitudes toward these outsiders. Different types of images appeared in different idioms—such as art, popular print media, and, eventually, product advertisements and brand logos—and often reached different audiences, but rarely did any of the images reflect the perspective of their black subjects.

During the nineteenth century, art and popular culture imagery served to both reflect and establish racist ideas and to reiterate the social order even when the intentions behind the images were not sinister. Blacks were not imagined visually as full participants in society so even in sympathetic renderings they were relegated to marginal social roles consistent with racial readings of social order. For example, the masthead of William Lloyd Garrison's radical abolitionist journal, *The Liberator*, evolved from its initial version showing an auction block and the selling of slaves to one showing the auction block paired with an image of liberation depicting blacks still doing the same menial agricultural labor on the plantation but without a white boss (figure 12).

Images of blacks in artworks most often iterated limited or derogatory perceptions held by most whites and helped create a visual iconography for black representation. Usually they naturalized a social order with black subjects on the periphery doing menial tasks or exhibiting stereotypical behavior so as to emphasize their social and political inferiority. Images from popular culture became more important and widespread in the second half of the nineteenth century; they exaggerated simplistic or stereotypical ideas about blacks to large audiences and often used demeaning humor. These images of blacks by whites affected black self-perceptions and must have contributed to the development of W. E. B. Du Bois's theory of double consciousness at the beginning of the twentieth century.

This chapter will focus more closely on nineteenth-century representations of blacks by whites in the United States and the (mis)perceptions they helped create. We will take an extended look at the 1893 World's Columbian Exposition in Chicago, when America attempted to articulate a vision of itself in and for the world, and examine where blacks fit in that vision. We also will touch on the gathering strength of political and aesthetic resistance of blacks to the way whites envisioned them.

In American, English, and European paintings, blacks often appeared as servants. Usually they were in the margins of a scene, and black servants often oc-

FREEDOM S.
EMANCIPATION
SLAVES HORSES & OTHER CATTLE TO BE SOLD

# THE LIBERATOR

OUR COUNTRY IS THE WORLD---OUR COUNTRYMEN ARE ALL MANKIND.

BOSTON, FRIDAY, SEPTEMBER 29, 1843.

cupied the same level on the picture plane in portraits as the subject's pets. David Dabydeen describes this as revealing a hierarchy of British power relationships. The "superior white (superior in social and human terms) is surrounded by inferior creatures, the black and the dog, who share more or less the same status."[1] It was not uncommon in British art to have a dog and a servant sitting at the feet of the master or mistress with both gazing upward respectfully.

A frequent scenario in early American paintings, when blacks appeared at all, was one showing them playing music to entertain a gathering of whites (which amounted to another kind of service), or, less frequently, to entertain each other. The latter type tended to be the voyeuristic fascination with black culture that became institutionalized through minstrelsy. An 1830 genre image by William Sidney Mount, *Rustic Dance after a Sleigh Ride* (figure 13), includes a black fiddler playing for white dancers and onlookers, and two black servants—a bellowsman by the fireplace and a driver peering in the door—are also in the scene. The fiddler is depicted in a manner consistent with the black representation to come in minstrel performances, complete with exaggerated red lips, dark skin, and a wide-eyed expression. All three blacks are on the outer edges of the social circle as well as physically on the edges of the composition. Only the fiddler interacts with the gathered whites, and he does this through his labor—his music making—rather than verbally or socially. As Elizabeth Johns has pointed out, they "do not assume equality in the merriment; instead, they make it possible."[2] The driver brought them to the gathering; the bellowsman keeps them warm; and the fiddler provides the music. Mount was an anti-abolitionist, so this work presents what he saw as an acceptable social order with black servitude.

*Rustic Dance after a Sleigh Ride* has frequently appeared in publications and articles dealing with American genre painting and is featured in nearly every publication detailing how whites represented blacks in art. It is important because it was Mount's first attempt at genre painting and was so well received

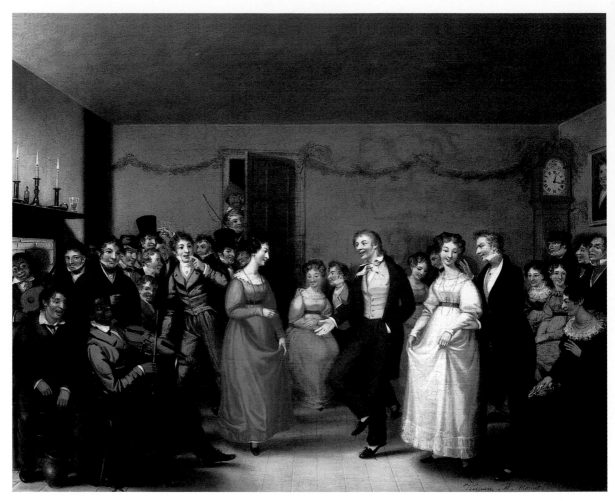

FIGURE 13.
*William Sidney Mount,* Rustic Dance after a Sleigh Ride, *1830, oil on canvas, 22⅛" × 27⅛". Bequest of Martha C. Karolik for the M. and M. Karolik Collection of American Paintings, 1815–1865, 48.458, Museum of Fine Arts, Boston.*

that it earned him associate status at the National Academy in 1831 and full membership status the next year. The work was a part of the early growth of American genre painting and may have contributed to the acceptable formulae for the form, especially those prescribing the representation of marginal black subjects.

Though black musicians depicted in art represented particular social expectations, there were some nuances to be found in the actual social reality. Whites on the plantation became dependent on black celebration and performance for their entertainment. Roger Abrahams has detailed how the annual corn-shucking ceremonies came to be remembered fondly by both slaves and masters, albeit for different reasons.[3] After the corn shucking was complete, there was a feast, and "[a]fter the feast, the tables were cleared, the fiddler was sent for, and dancing began."[4] A slave musician obtained a bit of stature and extra compensation from his role, and his reputation often extended well beyond his

home plantation. A runaway slave, Solomon Northup, gave testimony about the benefits he experienced from serving as a musician. In his autobiography he wrote, "It introduced me to the great houses—relieved me of many days' labor in the field—supplied me with conveniences for my cabin—with pipes and tobacco, and extra pairs of shoes."[5] He also developed a level of regard for his skills in the plantation community, among both slaves and masters.

A slave owned by Micah Hawkins, the uncle in Manhattan with whom Mount lived after his father died, may have been the inspiration for the fiddler in *Rustic Dance after a Sleigh Ride*. Mount remarked as an adult, "I have sat by Anthony when I was a child—to hear him play his jigs and Hornpipes. He was a master in that way and acted well his part."[6] The slave musician, Anthony Hannibal Clapp (1744–1816), was given a headstone after his death with a fiddle carved in it and an inscription suggesting his high esteem within the social space he occupied: "Anthony, though indigent, was most content, Though of a race despis'd, deserv'd he much respect: in his deportment modest and polite. Forever faithfully performing in life's drama the eccentrick part assign'd him by his Maker. . . . Upon the Violin, few play'd as Toney play'd, His artless music was a language universal, and in its Effect—most Irrestible!"[7]

Several years after Mount's painting was completed, German-born Christian Mayr's work *Kitchen Ball at White Sulphur Springs* (figure 14) also presented black musicians in the margins, but his painting is novel because it is one of a very few of the time centered on Negro subjects, as well as one of the first to have a scene located in the South. Mayr's painting shows a group of blacks having a celebration at a well-known Virginia resort (which became a part of West Virginia after the Civil War). These are slaves gathering in their free time. The kitchen typically was not attached to the main house in plantation architecture, and that probably is the case here. The gathering takes place in a separate space where the blacks work, but it is not an independent space. Johns points out that antebellum images of blacks that placed African Americans "in the American social world conspicuously made that place one of relationship." Her interesting argument is that placing black subjects in their own world made them sovereigns in the same sense that peasants became sovereigns in the work of European artists like Brueghel. Sovereigns of a lower order could arouse sympathy because of glimpses into their "softer emotions" through scenes showing family responsibilities, or they could achieve near heroic status through their honest labor. Blacks, on the other hand, were always placed in some relationship with whites and never in their own autonomous, self-defined space.[8] They were not depicted doing honest work; nor was the cruelty of slavery depicted unless the setting was somewhere else, such as the West Indies or Brazil.

*Kitchen Ball at White Sulphur Springs* is unique for the time in that women are

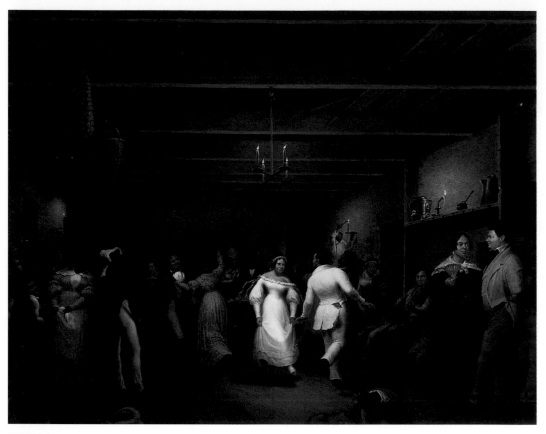

well represented in the work—black or white, they almost never appeared in an-
tebellum paintings—and they are shown with varied skin tones, though the
fair-skinned couple of mixed heritage is the central focus of the work. An En-
glish guest at the resort, Frederick Marryat, observed that in his painting Mayr
"had introduced all the well-known coloured people in the place,"[9] a fact that
shows the work's value in documenting plantation miscegenation. The musi-
cians occupy an inconspicuous space to the right of the work, and they are a
part of the crowd rather than outsiders on the edges. Although the work did not
articulate the prevailing notions about African Americans the way Mount's
work did, it is implied that the blacks are under the supervision of unseen
whites because they are slaves. This image offered to Mayr's contemporaries a
glimpse into the private lives of slaves and showed them to have similar tastes
and aspirations as whites.

In 1859 Eastman Johnson completed a work, *Negro Life at the South* (figure 15),
that is also centered on a black musician entertaining a group of blacks. The
work became one of the most prominent paintings of its day and often has been
misinterpreted as a plantation scene; it was in fact a commentary about slavery
in Washington, D.C. John Davis writes that the painting depicts "some of the

black inhabitants of [Johnson's] father's block on F Street [in Washington]." The work joined a controversial discourse about slavery in the District of Columbia that had gone on for nearly thirty years. Some people felt that slavery in the nation's capital was an embarrassment and should be abolished, but there were southerners who felt that the abolition of slavery in the district would constitute a dangerous "entering wedge"—and that giving way on the issue would mean the loss of their cause in the end. The issue was further inflamed by a practice in Washington of capturing free blacks and selling them into bondage in the South. Slaves were held in areas hidden from view in interior alley spaces, where their cries and moans were muffled. Johnson's painting depicts one of these spaces.[10]

In the work, only the white woman emerging from the house next door to the right and the small boy immediately behind him actually look at the musician. No one is dancing to his music, nor is he laboring for anyone. Johnson provides an unusual range of visual roles for his subjects in this work, including those as parents and lovers. Still, Johns argues that the work supported many of the arguments of the time for the paternal control of African Americans: "While seeming to exculpate Southerners from horrid treatment of their slaves, however, the image also indicts blacks for all the faults that whites had been ascribing to them for decades. Johnson scattered his blacks across a space that impresses the viewer with its barrenness, clutter, and lack of function. This backyard is a mess. . . . The world of the black is one of decay, disorder, and moment-by-moment activity. Left to themselves, blacks pass the time rather than use the time."[11]

Johnson's figures did not approach the minstrel caricature that can be seen in Mount's early work, but their social status was virtually the same.[12] Critics of the day commended the work for the characteristic *types* of blacks it identified; according to Davis, "To identify these types, critics resorted to the language of minstrelsy and popular literature, particularly Harriet Beecher Stowe's *Uncle Tom's Cabin* (1851). Thus, Uncle Neds, Topsys, and Cuffys were confidently picked out in the scene, and much was made of the stereotypical banjo playing and dancing."[13]

They were happy, childlike figures in need of the guidance provided by the supervising whites next door to the right. The black subjects in these works were "Negroes" rather than individuals. The visual vocabulary for the representation of black subjects was so limited, and increasingly affected by images produced in minstrelsy, that viewers during the time easily missed or overlooked the more sympathetic sentiments Johnson may have incorporated in the painting. Davis advances the argument that slave musical culture is now seen as a means of maintaining an African identity. He argues that "[r]eligious spirituals,

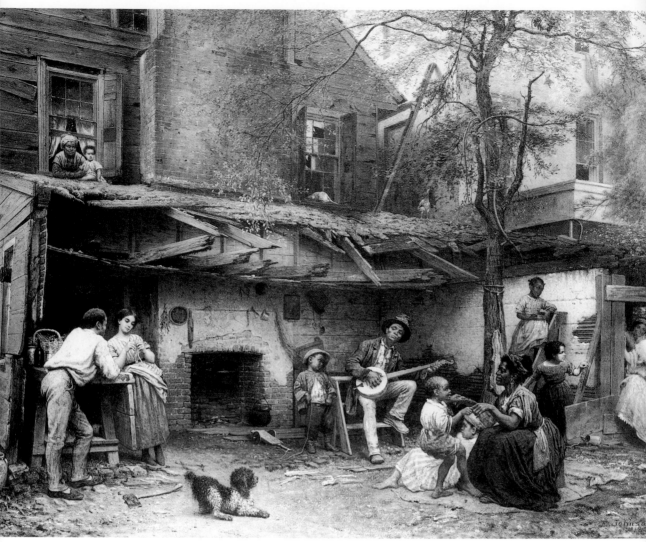

communal 'shouts,' celebratory dances, and secular songs (sometimes com-
posed as veiled mockeries of white owners) were used to preserve African pat-
terns of movement and speech" as well as to take some control of those mo-
ments when slaves had time to themselves. The banjo player suggests the
generational transfer of knowledge from the old player to the watching child to
his right in an image that may anticipate *The Banjo Lesson* (1893), a work by
Henry O. Tanner completed thirty-four years later.[14] The white woman observer
on the right, rather than overseeing the black gathering, represented a "self-
conscious reminder of [the white audience's] alterity in this slave space and an
embodiment of the shared vicarious titillation of peering into a forbidden
area." Davis contends that her relegation to the periphery of the composition
overturns what had become a prevalent compositional convention in American

genre painting, "that of the black interloper who must be excluded from the central field of action reserved for whites." Yet Davis admits that this painting generated contradictory readings by abolitionists and proslavery advocates sympathetic to each of their positions because it "largely operates within the broad realm of stereotype."[15] Stereotypical readings led to the work mistakenly being identified with Stephen Foster's minstrel song, "My Old Kentucky Home."[16]

Johnson produced another work featuring a black musician in 1866, *Fiddling His Way* (figure 16), showing an itinerant fiddler entertaining an agrarian family. He is an outsider in this family circle, but the family is fascinated and entertained by his talent. Each figure gazes at him (except the elderly woman to the right), and in this work the black musician is central to the scene. Perhaps this work, completed just after the Civil War, anticipated a renegotiation of the social contract governing race relations in the wake of slavery's final dissolution. The artist metaphorically illustrated the centrality of African Americans in the American consciousness as the nation debated how millions of freed slaves would be folded into the society. The fiddler is earning his own way through his labor rather than exhibiting dependency. He is not isolated within a slave community but has joined the community at large in the nation.

It is possible that this work melded with the nineteenth-century discourse on artistic self-invention, what Barbara Groseclose describes as "a gift for dynamic invention, an omnivorous untamed curiosity, a proclivity for adventure and mobility" that also constituted qualities of American masculinity. The close tie between "self-making and masculinity" presented "nearly insurmountable obstacles to the professional recognition of black men," who were quarantined from the masculine realm that had been reserved for whites.[17] Johnson's statement may have suggested subtly that the itinerant musician, though appearing in a role generally accepted for black males, was a metaphor for African American postemancipation reinvention and participation in American society.

Still, the fiddler is surrounded by women and children and occupies the same social and physical space as they do. The tools and utensils on the doorway wall to the right are from the prescribed woman's domain of the time, and this is reinforced by the items on the shelves in the background, which are associated with cooking and food storage. The adult women engage in domestic labor or pause from it to enjoy the fiddler's entertainment. The male of the house sits on the other side of the image and observes the fiddler philosophically but is unconnected physically and emotionally. He is the only figure unconnected to labor inside the house. Clearly blacks and women were differentiated from supervisory white males. Neither of these paintings by Johnson gives insight into how blacks felt about themselves or their circumstances. Their narratives *about* blacks are conducted from the space of white privilege.

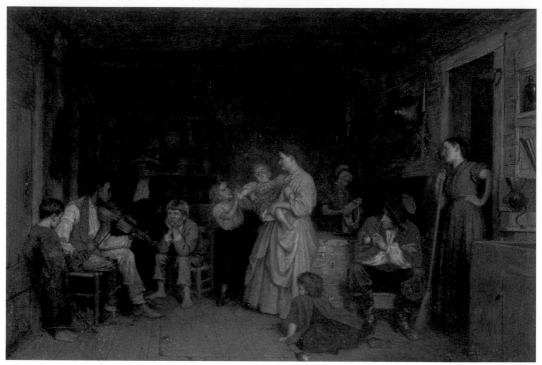

A lithograph from Winslow Homer's Civil War *Campaign Sketches* series, *Our Jolly Cook* (figure 17), reiterates the theme of blacks, particularly males, as entertainers for whites. Homer also has made the black cook the central figure in the composition instead of his having a role peripheral to and supportive of the activities of whites. His buffoonery is the subject, and it links Homer's work to the way blacks were depicted in eighteenth- and early-nineteenth-century American painting and in minstrelsy. As Johns has argued, before the 1830s "blacks were often depicted as monkeylike presences in a crowd or, at best, as servants on the margins," or they were made "clowns in the middle of a group, at other times laborers at the edge of social gatherings."[18]

Homer separated the awkward, flailing buffoonery of the uncontrolled black body from the controlled dignity of the white soldiers who observe the cook's awkward jig. He is the center of attention, but he is dancing to the tune of the white piper on the right edge of the image.[19] With eyes and mouth gaping wide, the black man is completely outside the standards of restraint and decorum shown by the whites, and in the minds of white viewers this image humorously demeaned any social pretensions the freed slaves might have had because, after all, art functioned as proof.

The cook's performance argued against his ability to do more than amuse or serve whites. Though this particular image was created as part of a series of commercial lithographs for the Boston publisher Louis Prang, lithographs and

FIGURE 17.

*Winslow Homer,* Our Jolly Cook, *from* Campaign Sketches, *1863, lithograph, 14″ × 10⅞″.*
*Courtesy of the American Antiquarian Society, Worcester, Mass.*

engravings that illustrated newspapers and magazines of the day added the function of visual reportage to induce their perception as fact, which emphasized the messages they conveyed. It is important to note that the shift in idioms from art to popular print media is accompanied in this case by a shift toward exaggeration, a shift linking the image to minstrel performance, which by the 1860s had become wildly popular.

Another important implication articulated by this image concerned the manhood of black males. The uncontrolled buffoonery of Homer's subject served to separate him from the masculine ideals exemplified by the white soldiers. Michael Hatt has argued that "control" is the defining word of the nineteenth-century masculine ideal. "Whatever else manliness might have been, it always connoted a man's power over himself, his appetites and emotions, and over his environment, both geographical and social." The lack of control exhibited by the cook showed a lack of manhood. This served to affirm why the Negro was thought to be "inherently incapable of achieving the masculine qualities of courage, morality, conscience, and civility."[20]

Until the second half of the century, most representations of blacks were of males. Many of these representations constructed the social marginalization of African Americans, defined them as objectified beings ("blacks," "Negroes," and worse), but also worked to emasculate them. Hatt suggests that the regulation of space is important in gender history and that certain social spaces are open only to men while others are heterosexual spaces. Masculinity is a product of homosocial relations: it is "in all-male arenas that masculinity can be displayed, learnt, transmitted and controlled."[21]

*Our Jolly Cook* takes place in a homosocial space, and many African American men sought access to that space during the Civil War in order to participate in the destruction of the slave system and to warrant their access to American society as full participants. Homer's work undermines that aspiration by relegating the black subject in this narrative to the customary role of entertainers for whites, not that of a soldier who might fight alongside other men. The emotional expressiveness of the cook linked him to what were interpreted to be feminine characteristics, or at best antonyms to white manhood, and his awkward dance at the very least affirmed him to be outside the boundaries of manhood, as a boy might be. Immature, uncontrolled black males still needed the paternalistic regulation of white manhood. The title of the work is possessive and emphasizes that this buffoon is safely under white supervision.

The images discussed here sweep across a period of roughly fifty years, and in each case, despite the sympathy or lack of it in the image, the black subject is pictured in a marginal or menial circumstance. Each is an outsider to the setting in which he appears, but his labor amuses whites or helps produce white

ease and luxury. Even in the *Liberator* masthead image, the social interaction of blacks and whites as equals or nonracial beings is not represented. Because blacks were most often presented visually as outsiders, menials, and entertainers, it was difficult for most whites to imagine them in any other social capacity.

## JUMP JIM CROW

Through blackface minstrelsy, black entertainment had become a staple in American society by the 1860s, when Homer completed *Our Jolly Cook*. According to legend, Thomas Rice in 1831 (the same year William Lloyd Garrison launched *The Liberator*) imitated the shuffle of a black man he had seen on the Cincinnati levee and called it "Jump Jim Crow" in one of the founding minstrel performances. W. T. Lhamon in *Raising Cain* argues brilliantly that the foundations of minstrelsy were older and more complicated than this myth and that minstrelsy may have had its beginnings elsewhere than along the Ohio River. He writes that blackface may have begun in 1815 in Albany, New York, and that it may have begun with the function of "slashing back at the pretensions and politesse of authority more than at blackness."[22] Thomas Rice was a backup actor at the Chatham theater in New York and observed top-billed George Washington Dixon "working out some of the earliest blackface material" in the summer of 1828."[23]

Lhamon suggests that the black figure became a metaphor for the outsider, a means for working-class whites to resist the downtown Knickerbockers and stiff necks: "Abstracting themselves as blacks allowed the heterogeneous parts of the newly moiling young workers access to the same identity tags. Irish, German, French, Welsh, and English recent immigrants as well as American rustics, could all together identify in the 1830s with Jim Crow, Bone Squash, and Jumbo Jim, then in the forties with Tambo and Bones. . . . Precisely because middle-class aspirants disdained the black jitterbug in every region, the black figure appealed all across the Atlantic as an organizational emblem for workers and the unemployed. Hated everywhere, he could be championed everywhere alike."[24]

Though Lhamon presents a convincing argument for cross-racial identification and empathy in early minstrelsy, my interpretation of the material is centered on the fact that the black subject in minstrelsy was "hated everywhere" and then could become an emblem for society's marginal figures and outsiders. That was possible only because of deep-rooted assumptions about the meaning of the black figure, and these assumptions, despite the more benign character of

early minstrelsy, were a source of great discomfort for African Americans. The black face became a symbol of resistance to the power structure because blackness was emblematic of exclusion. Blackness was the mark of Cain, a discredited signifier.[25]

Abrahams introduces another factor for consideration in the discussion of minstrelsy. He suggests that a long history of white fascination with black celebration and performance, particularly that associated with corn-shucking events, contributed significantly to the development of minstrelsy. He writes that the isolation of whites from each other in plantation communities, and their proximity to blacks, caused planter families to "rely on slave singing and dancing displays regularly for their entertainments,"[26] and they began to amuse themselves by imitating blacks. Abrahams argues that "the phenomenon of white Southerners imitating blacks in performance predates even the earliest development of blackface entertainments. The earliest reports of whites dancing in slave style, in fact, come from the period of the American Revolution."[27] The slaves regularly imitated and mimicked the whites as well, devising dances such as the cakewalk. Abrahams contextualizes the growth of minstrel performance as a combination of earlier comedic traditions such as Harlequin and commedia dell'arte, the nineteenth-century American era of touring performers and traveling variety shows, and the imitations of slave styles.[28] Minstrelsy was theater for the masses, Ethiopian operas for the unwashed.

Abrahams's description bends toward Lhamon's argument with his suggestion that blackface performance was an observation of slave expression and a celebration of black creative and entertainment abilities. "In this system African Americans have remained cast as the strangers in our midst, the exotics," and minstrel performance was the appropriation and commodification of the exotic. Importantly, "the role of playing black" enabled the singer or dancer "and the hipsters in his audience to experience a sense of cultural liberation."[29] As Abrahams explains, "Often Irish, and therefore subject to marginal status themselves in mid-nineteenth-century American life, these entertainers found in black culture an abundance of stylized ways of acting, signing, and dancing by which they could establish themselves as performers."[30] The blacked-up performers played against Mr. Interlocutor, described by Mark Twain as a figure "clothed in the faultless evening costume of the white society gentleman [who] used a stilted, courtly, artificial and painfully grammatical form of speech."[31] The hypercorrect upper-class white trying to keep order was laughed at as much as was the speech and wild dances of the end men in blackface. Not only could white performers escape their own social locus, but they were also able to lampoon the upper classes that disdained them. The voyeuristic fascination with black behavior and expressive culture, along with the lampooning of upper-

class whites, would seem to confirm the idea that the one who looks holds power over the one who is looked at.

The arguments of Lhamon and Abrahams appear to coordinate nicely with those of Mechal Sobel, mentioned earlier, which indicate that antebellum lower-class whites and black slaves had relationships that were not nearly as antagonistic as they became in the nineteenth century and their collaborations were seen as threatening to the status quo for the wealthy.[32] Additionally, Sobel points out that many blacks were sailors or riverboatmen working with whites; runaway slave advertisements "often expressed the fear that white sailors might have provided berths for escaping black slaves."[33] Lhamon argues that it was among transient workers and roughnecks that blackface performance found its early groundings. Minstrel performance forcibly established a popular theater responding to the codes, parlance, and sensibilities of working-class whites. The fact that it lampooned the wealthy bluenoses and identified with blacks as disdained outsiders may have alerted the wealthy to the need for popular media expression of their ideologies and politics.

In the later years of minstrelsy, the black figure increasingly became a vehicle through which various factions in society argued political and philosophical positions. This was particularly true during the decade preceding the Civil War. Robert Toll argues that "[i]t was no accident that the incredible popularity of minstrelsy coincided with the public concern about slavery and the proper position of Negroes in America."[34] Abrahams writes that, while articulating and codifying racial and cultural difference, blackface made "black-style expression into a vocabulary of social commentary."[35] Minstrel shows reflected and created popular ideals and exposed northern whites to black performance in safe and satisfactory ways. It provided a forum for the expression of class conflict, sectional debates about slavery, and discomforts with northern free blacks, while it also affirmed white superiority through the black absurdity on stage. Alexander Saxton suggests that from the beginning minstrelsy had the "dual task of exploiting and suppressing African elements" in expressive slave culture.[36] Blackness was both a danger and a fascination; it needed control, and yet it inspired voyeuristic consumption lasting nearly a century.

Before the 1850s a variety of black characters were presented on stage, but the struggle over slavery that threatened the Union, along with the threat of black competition with whites for land, jobs, and status in the North, caused minstrelsy to take a more strictly proslavery turn. Toll says that after that time "black character types virtually disappeared, leaving only contrasting caricatures of contented slaves and unhappy free Negroes,"[37] and Lhamon concludes that "[w]hat had begun as a way of registering cross-racial charisma and union then became also a way of registering racial separation and disdain."[38]

Minstrels became associated with the values of the Democratic Party, and minstrel performance became a venue for the expression of plantation myths venerating an interracial "family" of benevolent whites guiding and caring for childlike blacks. Democratic proslavery ideals were articulated and propagated through exaggeration, dialect, and deprecating humor that functioned to create an image of the Negro in line with southern white interests. Toll says that repeatedly "minstrel blacks recounted how their kind masters took care of them, gave them all they wanted to eat, indulgently let them play and frolic," and helped them establish households in the extended family of the plantation.[39] Both plantation blacks (Jim Crow, Sambo) and urban dandies (Zip Coon) were caricatured on the stage to indicate that both were best served by being on the plantation.[40] Northern blacks were shown in uncomplimentary ways, signaling that their efforts to emulate whites were unsuccessful because of their nature, not because of discriminatory practices. According to Toll, they were pictured as "lazy, pretentious, frivolous, improvident, irresponsible, and immature—the very antithesis of what white men liked to believe about themselves," and this confirmed that blacks could not play a constructive role in free society.[41]

Most purveyors of minstrelsy and minstrel shows tended to be northerners who performed in northern and western urban centers despite their use of slave expression, plantation subject matter, and southern nostalgia.[42] The popularity and impact of minstrelsy can be deduced from the fact that Stephen Foster's song, "Old Folks at Home," sold over 130,000 copies in three years, and one of Dan Emmett's compositions, "Dixie's Land," was so popular in the South that it became "the de facto Confederate national anthem" during the Civil War.[43] *Frank Leslie's Illustrated Newspaper* reported in 1856 that the Christy and Woods minstrels performed in a New York theater seating 2,500 "in spite of the crinoline."[44] The *Saturday Evening Gazette* told its readers in 1858 that two "groups of sable performers warble nightly to appreciative audiences" in Boston, and most larger cities had resident troupes.[45]

The city of New York played an important role in the development of minstrelsy and in the types of images of blacks that developed in art and popular media. Then, as now, New York was the center of the American art, publishing, and theater worlds. New York, the major entry point for immigrant populations, had the largest free black population in the country—13,815 in 1850. The images discussed here represented many southern notions about African Americans, but they were produced largely by artists, performers, or publishers based in the North. Northern attitudes about African Americans were not much more egalitarian than those of southerners. In 1859 a reviewer for the *Cosmopolitan Art Journal* described the scene portrayed in Johnson's *Negro Life at the*

ANOTHER CASE FOR THE COURTS.

FIGURE 18.

*In the first appearance of blacks in* Harper's Weekly *(April 11, 1857, 240), these urban dandies are dressed elegantly, but their speech gives them away. The conversation that appeared beneath the cartoon read in part:*

*First Gentleman of Color. "Mr. Jonsing, did you obsarve dat Angel at de table, in de superb blue taffeta, wid lace bouillonnées, an de coiffure à la Imperatrice?"*

*Second Gentleman of Color. "Dat Young Lady attracted my partic'lar an 'specful observation. She is de Belle ob de Season."*

*South* as including a "knotty-limbed wench and one or two dancing 'pickaninnies'."[46] The clinching argument is that blackface minstrelsy developed and established itself in New York, not in the South.

Several images and ideas about blacks were established and spread by minstrelsy that set the standard for generations to come. Paintings had an interest for middle- and upper-class patrons, but they were not seen as widely as minstrel performances were by working-class people. Minstrelsy reinforced stereotypes about urban blacks by lampooning their dress, their bumbling attempts to emulate whites, and their failed efforts to use proper language. In virtually every minstrel show for nearly a century, minstrel troupes caricatured southern blacks as childlike with a love of entertaining whites, firmly establishing that image in American popular culture.[47] Many of the derogatory depictions of blacks institutionalized in minstrelsy became the foundation for visual imagery in popular culture and contributed to whites' taking misperceptions of African Americans as facts.

Curiously, it was acknowledged that white minstrels in blackface were engaged in imitations, and audiences displayed a hunger for "authentic" black performance. In the 1840s a Negro performer named Juba was advertised as giving imitation dances of "all the principal Ethiopian Dancers in the United States," after which he would demonstrate, acting as himself, the proper dance forms.[48] After the Civil War, many troupes of black performers in blackface advertised themselves as authentic plantation figures — "genuine slave bands" or "formerly slaves" promising to appear in full plantation costumes and to bring practices from those lost days to the stage.[49] During this same period, derogatory visual images of blacks began to appear regularly in popular print media, reinforcing the derisive image popularized by minstrelsy and simplifying or exaggerating some of the imagery found in antebellum art. Currier and Ives lithographs and *Harper's Weekly*, two New York–area enterprises, were important sources for these images.

In the nineteenth century, virtually every image of an African American pivoted around the concept of race in some way, and race, as I posited in the introduction, was a construction devised to institutionalize white over black. African Americans' blackness, not their humanity or individual qualities, was the subject. Their exotic difference was a fascination and an entertainment, but they were types and categories and rarely seen as individuals. In most cases, the black subject was a reflexive signifier of whiteness functioning like a photographic negative and reversing the prescribed norm for whites.

## POPULAR BLACKNESS

*Harper's Weekly*, an illustrated magazine modeled after the *Illustrated London News*, was published in New York beginning in 1857 and often took a liberal (for the time), egalitarian stance toward race relations. The magazine was identified with the Republican Party until 1884—despite claims of nonpartisanship—and a number of its readers shared moderate Republican sentiments. Yet in 1861 and 1862 an average of sixteen comic images of blacks per year appeared in the newspaper along with general images of blacks. In 1874, as Reconstruction was crumbling and racial violence was escalating in the South, certain images and text reflected the prevailing beliefs of the day toward African Americans. The maliciousness to come in Currier and Ives's Darktown Comics was not present in *Harper's Weekly*, but on January 3, 1874, the American public was introduced to a caricatured black family, the Smallbreeds, living in the fictional community of Blackville, whose surname alluded to earlier discourses about the genetic inferiority of blacks.

The first image in this series (figure 19) reveals the family trying to prepare for a holiday meal. The father has won a pathetic little turkey in a raffle and exclaims, "De Breed am Small, but de Flavor am Delicious." The setting is rustic and spare, and five children gather eagerly around the table, the oldest appearing to be no more than six or seven years old. The mother's face and those of several of the children have the appearance of being less than fully aware, each displaying the bliss of ignorance, mouths wide open; this is especially true of the little girl immediately to the mother's right. The boy in the chair facing the viewer has a simian quality, and a baby hangs on the mother's neck in the manner of a monkey. All these visual clues suggest that their modest conditions are the result of their biological shortcomings rather than the outcome of discrimination. This image exemplifies patterns that persisted in the caricature or lampooning of blacks. They included the use of dialect as a demeaning sign and the depiction of blacks attempting middle-class pursuits by mimicking whites with disastrous or comic results. In addition, as mentioned above, the humble living circumstances of the family are consistent with the expected location of blacks in the economic and social hierarchy of society.

Two years later, a story about some of the images appearing in *Harper's Weekly* had this to say about Sol Eytinge, the artist of the Blackville series: "This artist has made negro character a special study, and although he naturally inclines to the delineation of the humorous side of that character, he never falls into unkindly caricature nor unjustifiable exaggeration. In the whole series of his inimitable negro pictures which have appeared in the pages of *Harper's*

*Weekly* there is not a single stroke of the coarse satire in which some caricaturists have indulged in treating of the peculiarities of the race."[50]

The supportive tone of this story may have been inspired by Eytinge's breaking of several conventions in the visual representation of blacks. According to Johns, in the nineteenth century blacks were never shown at labor, seldom as servants in white homes, and never as chattel or undergoing the cruelties of slavery; black men were not depicted as heads of, or even as members of, families.[51] In the cartoon described above we see the male head of a black family attempting to provide for his loved ones, though he has won rather than earned the goods. A black woman is shown, and they are the parents of several children. Perhaps it can be said that the image is evidence of the progress whites were making, but, like Eastman Johnson's *Negro Life at the South*, the image was a catalog of racial stereotypes about African Americans.

It is very doubtful that many African Americans would have agreed that Eytinge's Smallbreed cartoons were not "coarse satire," but not every image of blacks appearing in *Harper's Weekly* was demeaning. Many were actually supportive of Negro concerns. During the remainder of 1874, several of the magazine's stories defended the civil rights of Negroes and condemned violence against them, and a number of dignified images of notable individuals were shown. In the October 3 edition, a sensitive image of Julie Hayden (figure 20) was printed with a story detailing her murder in Louisiana by the White Man's League. Hayden was a "colored school-teacher" from Tennessee who had recently moved to Hartsville, Louisiana. She was hunted because she intended to educate black people: "Three days after her arrival at Hartsville, at night, two

FIGURE 19.
*Sol Eytinge Jr.,*
*"Christmas*
*Time—Won at a*
*Turkey Raffle: 'De*
*Breed am Small,*
*but de Flavor*
*am Delicious.'"*
Harper's Weekly,
*January 3, 1874, 8.*

white men, armed with guns, appeared at the house where she was staying and demanded the school-teacher. She fled, alarmed, to the room of the mistress of the house. The White Leaguers pursued. They fired their guns through the door of the room, and the young girl fell dead within. Her murderers escaped, nor is it likely that the death of JULIE HAYDEN will ever be avenged, unless the nation insists upon the extermination of the White Man's League."[52]

One significance to be found in the Hayden case and the discourse in *Harper's Weekly* about blacks is that both pivot around notions of reading. The invention of the steam-driven press in 1830 and the expansion of the postal system's circuit helped increase the production and circulation of newspapers while reducing the price. Groseclose indicates that newspapers (and, by extension, illustrated magazines) provided an instrument of connection that helped reinforce a sense of community because a readership "not only sees itself mirrored in the reading of others but also learns about the events, opinion, plans, and conditions of those like and unlike itself, all members being incorporated in the newspaper as subjects and objects."[53] The content of antebellum newspapers was directed at white male readers, and genre paintings of the time represented readers who were able to vote—a group excluding blacks and women. Because reading was a demonstration of economic and social power, slaves were pro-

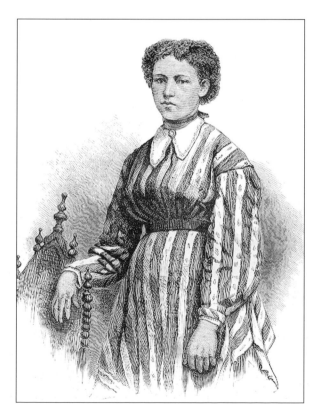

FIGURE 20.
*Miss Julie Hayden (from a photograph).* Harper's Weekly, *October 3, 1874, 813.*

hibited from reading, and the power of print to cultivate ideas and tastes was reflected in fears among many slave owners that abolitionist publications would cause black rebellion.

Julie Hayden represented black agency in her seeking to teach literacy to blacks, an act in the South that was interpreted as a challenge to white control. *Harper's Weekly* reported her murder at a time when the growth of literacy in America was unique in the world and included more of society's classes within the sense of community it engendered, but the irony is that the attack on Hayden, and the recurring caricatures of blacks, reinforced black exclusion from the broadening democracy.

What is noticeable in *Harper's Weekly*'s various cartoons and engravings is that blacks were consistently denigrated as a group, and this was done through dialect (something not done to Native Americans or immigrants) and the distortion of physical features. The fact that mention is made of certain artists whose depictions of blacks *did not* demean or caricature them testifies to the oppressive, pervasive normalcy of demeaning images of blacks in the nineteenth century, even though the details of many of these sympathetic works revealed the assumptions and social hierarchies of the day.

One of the more demeaning images from 1874 in *Harper's* was a cartoon by Thomas Nast in the March 14 issue (figure 21) that illustrated a report from a Charleston newspaper ridiculing the conduct of several black legislators. Imagery such as this later became a powerful disfranchisement argument in D. W. Griffith's 1915 film, *Birth of a Nation*, which showed blacks putting their feet up on desks, falling asleep, arguing, and eating chicken during a legislative session. Nast's image appeared on the front page of the magazine. The accompanying story inside described the black farce: "This, says the Charleston News, 'is the usual style in which the business of law-making and money-grabbing is conducted in the South Carolina Legislature.' . . . The moral to be drawn from Mr. Nast's cartoon on our front page. These ignorant and incompetent legislators must give place to those who will more faithfully represent the worth and intelligence of the people of the State, both white and colored. But it must be confessed that the colored members of the South Carolina Legislature could point to very unsavory precedents as to manner and language among white legislators of Southern and Northern States.[54]

Nast's legislative cartoon relied on physical exaggeration to extend the satirical effect, and the presence of two white legislators provided standardized normalcy for comparison. The two central combatants took on the appearance of a minstrel spoof: the rotund man on the right has bulging eyes, and his lips extend unnaturally in much the same way as blackface minstrels exaggerated their lips with makeup. The sloping forehead of the figure to the left recalled the

FIGURE 21.
*Thomas Nast,
"Colored Rule in
a Reconstructed(?)
State (The
Members Call
Each Other
Thieves, Liars,
Rascals, and
Cowards)."*
Harper's Weekly,
March 14, 1874,
229.

COLORED RULE IN A RECONSTRUCTED(?) STATE.—[SEE PAGE 242.]
(THE MEMBERS CALL EACH OTHER THIEVES, LIARS, RASCALS, AND COWARDS.)
COLUMBIA. "You are Aping the lowest Whites. If you disgrace your Race in this way you had better take Back Seats."

phrenology discussions of the first half of the century. The gaping of his mouth suggested a lack of control or decorum (in a reprise of *Our Jolly Cook*).

*Harper's Weekly* and the images of Thomas Nast had a wide and significant impact. Their campaign against the notorious Tweed Ring, led by William Magear Tweed, within the Tammany Society in New York helped undermine the powerful Tweed and contributed to his being jailed. After Tweed escaped from an American jail, he was captured in Spain by a Spanish official who "identified him by means of a Nast cartoon in the *Weekly*, and who, though he had no idea of the real nature of the man's offense, could see by the picture that he was

an undesirable."[55] *Harper's Weekly* had a circulation of about 50,000 six months after its inception and by 1861 had a circulation of 120,000. The Tweed campaign tripled circulation for a period, but by 1880 the circulation again was around 120,000. Nast's influence was such that Frank Mott claimed that "[i]t was Nast who invented the Republican elephant as a symbol of the Republican Party, and who popularized the donkey as the emblem of the Democrats."[56] The elephant first appeared on November 11, 1874, as a symbol of the Republican vote, which had grown notably large.

The spirit of the Blackville series and Nast's legislative satire was taken up with a vengeance six years later by Currier and Ives when the company introduced the Darktown Comics in 1880. The popular lithographs violently misrepresented African Americans and re-imagined the black body with distorted lips, bulging eyes, and awkwardly flailing limbs. These images ranged far more into demeaning caricature than even the Blackville series and replaced exaggeration with absurdity. One image from 1888, *Grand Football Match* (figure 22), had players from Darktown in competition with a team from Blackville in a scene overcome by chaos.

The Darktown series was developed by Thomas Worth in the 1880s and drew heavily on the Blackville series by Eytinge. In 1915 Worth recollected that John Logan, the head of sales at Currier and Ives, asked him to produce more of the series by telling him that one of his first Darktown Comics sold 73,000 copies.[57] Currier and Ives prints had international distribution and, presumably, affected tastes and perceptions widely. Worth recalled how members of English royalty had collected his Darktown Comics: "The Duke of Newcastle, who accompanied the Prince of Wales when he visited this country, strolled through Nassau Street one day, stopped to look at the Darktown show in Currier and Ives, and was immensely delighted with the coons. He entered the store and after a pleasant visit bought one hundred (a full set) of the Darktowns, and ordered them sent to the Clarendon Hotel on Fourth Avenue. The Duke thought the 'comic coons were very clever' and showed them to his friends at the hotel."[58]

Obviously, comic images of blacks did not originate with the Currier and Ives Darktown lithographs. Karen Dalton indicates that this tradition dates back to the late 1820s (to Edward Clay's *Life in Philadelphia* series lampooning middle-class free blacks), but their popularity became one of the main staples keeping the lithographic firm afloat.[59] Dalton reports that, "[b]eginning with a modest four in 1880, the year of Nathaniel Currier's retirement, Currier and Ives increased the output to ten in 1881, seventeen in 1882, eighteen in 1883, until the Darktown Comics peaked in 1884 with thirty prints. In that year Currier and Ives issued a total of eighty-three lithographs, which means that in 1884 Darktown Comics accounted for more than one-third of the firm's output."[60]

FIGURE 22.
*Currier and Ives
print,* Grand
Football Match —
Darktown against
Blackville, a Kick
Off, *1888.*

GRAND FOOTBALL MATCH - DARKTOWN AGAINST BLACKVILLE.
A Kick off

More than two hundred Darktown lithographs were produced, and most of them were issued in pairs showing black attempts at middle-class activities, with absurd outcomes or failures. Figures 23 and 24 illustrate a typical sequence. In the first, a robust black woman attempts to step into a small boat with the gentlemanly assistance of a black sailor. She is dressed in colorful clothing, as is another woman descending stairs to the dock in the background. The "yacht" is a small rowboat and the lady is much larger physically than the sailor helping her enter the boat. In the second scene her excessive weight has overwhelmed the five sailors already in the boat and capsized it. Not only does this image ridicule black middle-class aspirations, but it tosses a few barbs at African American women. The idea that these women typically were overweight is consistent with the imagined mammy figure that took shape after the Civil War and became ubiquitous at the end of the nineteenth century and during the first decades of the 1900s through the growing popularity of Aunt Jemima.

After the Civil War, demeaning images of blacks had a wide distribution through popular media; along with minstrel shows, they effectively spread stereotypical ideas about blacks across the country. It is probable that the popularity of minstrelsy was the inspiration for the growth of comic scenarios involving blacks in print media. The absurdity and cruel satire of minstrel performance was rooted in the imitation of black performance style and a fascination/horror with blackness. Minstrel stereotypes functioned to affirm black inferiority by giving visual emphasis to physical and cultural differences. Stuart Hall has argued that popular culture "is an arena that is *profoundly* mythic. It is

**DARKTOWN YACHT CLUB—LADIES' DAY.**
You'll just ballast de boat, Miss Tiny.

PUBLISHED BY CURRIER & IVES NEW YORK

FIGURE 23.
*Currier and Ives
print,* Darktown
Yacht Club—
Ladies' Day:
"You'll just
ballast de boat,
Miss Tiny,"
*1896.*

a theater of popular desires, a theater of popular fantasies."[61] Popular prints and publications continued this practice, this construction of imagined black people, that had begun in minstrelsy.

It is a particularly revealing irony that in the later years of minstrelsy African American performers applied blackface and performed in minstrel shows, having no other venue in which to work on stage. The variety of hues found in African American skin tones needed to be standardized to a deeply discredited "black" tone for the stage, but the performers, having regained *some* control of black representation, were able to add subtle shifts and nuances to minstrel performance, making it more comic and less demeaning. Toll notes that by the mid-1870s it was clear that the freedmen had not "emerged from slavery to invade Northern job markets and bedrooms as some demagogues had predicted." Also, Reconstruction was ending with "at least a tacit agreement that blacks would be kept in their place—in the South as subordinates to whites."[62] This allowed a renewal of northern interest in slave and plantation life, and black minstrels capitalized on the interest.

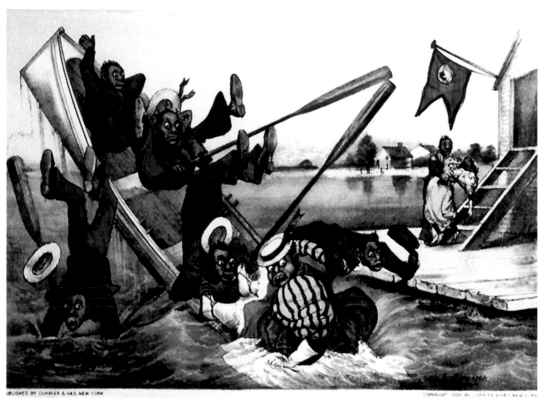

**DARKTOWN YACHT CLUB—LADIES' DAY.**
In cose I will, Honey.

FIGURE 24.
*Currier and Ives
print,* Darktown
Yacht Club—
Ladies' Day:
"In cose I will,
Honey," *1896.*

In some of the subtleties of black performance we can find resistance to the prevailing order. White minstrels often had skits concluding with reunion scenes: an Old Darkie character, feeling lost and alone among the ruins of the old plantation, is reunited with a child he once held on his knee who informs him that, to his great joy, his mistress or master is still alive and will take care of him for the rest of his life. In contrast, nostalgic songs written by black minstrels rarely mentioned their masters or mistresses and, instead, focused their affection on lost relatives and friends and the memories of youth, and some expressed strong antislavery feelings.[63] In engravings and lithographs, the potential for the introduction of subtle complications, as was the case with black blackface minstrel performance, was subverted because blacks did not have artistic access.

This account is not meant to suggest that all whites were virulent racists and actively suppressing African Americans, nor should we assume that whites today constantly think about blacks. Actually, the opposite is true, and blackness more often comes to mind in its *disruption* of whiteness. So often white colleagues, when it is pointed out that a certain policy or practice is insensitive to blacks, retreat by saying, "Oh, I hadn't thought of that." In addition, the sup-

port, activism, and humanity of many whites were indispensable in the African American struggle toward freedom. But it was also true that most whites were complicit by toleration in the growth of vicious racial oppression and the system of segregation after Reconstruction. As C. Vann Woodward wrote, "The South's adoption of extreme racism was due not so much to a conversion as it was to a relaxation of the opposition. . . . What enabled them to rise to dominance was not so much cleverness or ingenuity as it was a general weakening and discrediting of the numerous forces that had hitherto kept them in check."[64] Perhaps regional antagonism between the North and the old slaveholding South separated northern whites from close identification with the behavior of the southern terrorist groups in the last quarter of the nineteenth century. Certainly the Civil War had exhausted the nation's appetite for sectional conflict and activist interest in the plight of Negroes. Slavery finally proved unacceptable to many whites, but the black as an inferior antonym to white did not reflect anything that was too unpalatable.

Blacks did provide a fascination for the nation, as the continual popularity of minstrelsy showed, and several important artists made them sympathetic subjects in their artwork in the second half of the nineteenth century. One of the most prominent was Winslow Homer. His representations of blacks continued to soften after the Civil War, and his portrayals were quite sensitive for the time. One of his important works from 1876 is *A Visit from the Old Mistress* (figure 25). Although Homer's Civil War work made use of black stock characters, his later work relied more on his own observations and in some ways conflicted with or complicated prevailing images of blacks. Unlike several *Harper's Weekly* images from the period, Homer does not show the former slaves smiling and bowing at the presence of white former masters.[65] Wood and Dalton observe that "[a]ll eyes and heads are turned to acknowledge [the mistress's] arrival, but there is no bowing and scraping, no gesture of welcome"; the work "crystallizes into a single moment the staggering realization faced by all Southerners after the Civil War—both black and white—that things will never again be the same" since slavery has been abolished.[66] The work captured the tensions that developed with the shifts in social status and power relations during Reconstruction. The three black women and the child stand on the left facing right toward the mistress, who is on the right facing left. The colorful clothing of the former slaves contrasts with the simple black and white dress of the mistress, and the body language of all the women indicates that we are witnessing an awkward moment, not a joyous one.

Homer often has been cited as an artist whose sensitive, complicated portrayals of African Americans were unusual for the nineteenth century. Richard Powell points out that Homer had little to say about these paintings "beyond af-

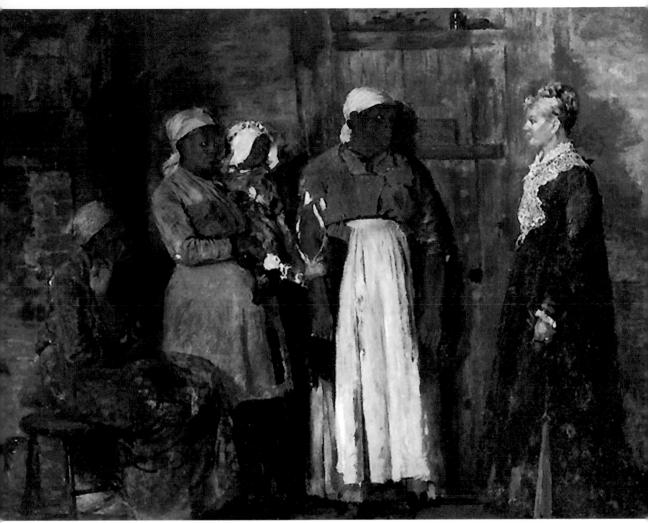

FIGURE 25.
*Winslow Homer,*
*A Visit from the*
*Old Mistress,*
*1876, oil,*
*18" × 24½".*
*Smithsonian*
*American Art*
*Museum, Gift*
*of William T.*
*Evans.*

fectionately calling them his 'darkey pictures,'" but "the fact that he entered several of them into some of his more celebrated exhibitions suggests that he too believed that these Afro-American images were significant."[67] Of particular note about Homer's paintings of blacks during this period is that a great number placed his subjects in plantation settings in much the same way *The Liberator* masthead had done. In *A Visit from the Old Mistress*, the black women are living in a cabin in close enough proximity to their former mistress that she is able to drop in. The image undoubtedly was a construction with metaphorical implications, but other notable works such as *The Cotton Pickers* (1876) and *Dressing for the Carnival* (1877) put Homer's subjects in similar settings. He undeniably brought new sensitivity to the representation of black subjects by whites and he successfully moved beyond stereotypical or stock imagery in his work, an accomplishment that was rare for the time.

## PICTURING NATIONS

The last decade of the nineteenth century set up a great deal of the racial antagonism to be felt in the twentieth century. The imagined black of minstrel shows and popular media began to appear regularly in product advertisements and one of the stars of this medium took form in the persona of Aunt Jemima. Nancy Green, the woman who had been selected to personify Aunt Jemima, made her first appearance in 1893 at the World's Columbian Exposition in Chicago. Green worked in front of a flour barrel that was twenty-four feet high and sixteen feet in diameter with an interior outfitted as a reception parlor to entertain visitors. There, as Aunt Jemima, she "sang songs, and told stories of the Old South while greeting fair visitors." She also cooked thousands of pancakes.[68]

The World's Columbian Exposition was an important event because the organizers used it as an opportunity to define visually the United States and its relation to the world. It took place, one year late, to commemorate the 400th anniversary of Columbus's landfall in the New World. Over 27 million people visited the fair during its six-month duration—14 million from outside the United States—and it reached millions more through publicity releases and souvenir sales. According to Reid Badger, a World's Fair presented "the opportunity for a nation to show its most progressive and representative achievements," and "it required that culture to define itself and thus forced upon it a certain kind of self-consciousness."[69] Robert Rydell concurs, writing, "By all accounts, the fair was an instrumental force in defining American culture."[70] This was the first major American showcase for the world. It also was a triumph for the city of Chicago, which had revived and rejuvenated itself after the disastrous fire of 1871 that destroyed the entire core of the city, killed 300, and left over 90,000 homeless.

One of many ironies of the exposition that emerge in retrospect is the fact that Columbus encountered American Indians in the Caribbean when he first landed in the New World, but at this celebration their presence was minimal and their status was not unlike that of their black fellow citizens. Frederick Putnam organized exhibits to showcase American Indian life and handicrafts on the Midway, but a member of his staff, Emma Sickles, was fired when she publicly protested that the exhibits were used to "work up sentiment against the Indian by showing that he is either savage or can be educated only by Government agencies." She said that "[e]very means was used to keep the self-civilized Indians out of the Fair."[71] A volume from the day, *Some Artists at the Fair*, had this to say about American Indians:

If the native Indian were of a reflective turn of mind, all this might awaken unpleasant thoughts. Judging from outside appearance, however, he has no thoughts whatever. He stalks solemnly about the grounds with a face as impassive as his wooden counterparts on Sixth Avenue. And yet he is the American. . . . As he stalks about among the dazzling structures of the Fair, and tries, or more likely, does not try, to grasp the innumerable wonders of art and science that only annoy and confuse him, it may require a too exhausting mental effort to recall the fact that his grandfather very likely pursued the bounding buffalo over the waste of prairie now covered by the city of Chicago.[72]

In the image accompanying this passage (figure 26), a man on a horse looks curiously at the distant towers of the city in a statement graphically separating him from the civilization being celebrated at the exposition. This image was consistent with the ideology expressed by the Midway Plaisance, which was organized to present graphically various villages that introduced fair visitors to the lower groups of humanity. As one commentator of the day remarked, "Beginning with the Dahomey village, immediately on the right as one enters the Plaisance, all the barbarous, semi-barbarous, and partially civilized stages of development are strikingly illustrated on the broad avenue, a mile in length, lined on either side with communities and villages from the South Sea Islands, Central Africa, and many parts of the Orient. It is, as an acute observer pointed out, a walk through the past history of the race, preparing and conducting one to the highest development which it has attained."[73] The Midway, organized by showman Sol Bloom, had so-called living ethnological villages of nonwhites, including the Dahomey Village (figure 27), a Chinese Village, an Indian Village, an American Indian Village, a Chinese Tea House, Morocco Exhibits, Algeria and Tunis, a Street in Cairo, a Moorish Palace, and a Turkish Village. Also included were villages representing life in Germany, Holland, and Austria. The villages were located between food and amusement concessions and seemed to be organized in a "social Darwinian ladder" from the savagery of Africans and Native Americans to the edge of civilization at the Women's Building just inside the grounds of the White City, as the main area of the fair was called, where cultural and industrial displays were mounted.[74]

Just like the hierarchical order structured visually by the organization of antebellum plantation buildings, the Columbian Exposition reinforced ideas about human hierarchies through visual structures as well as with living images. Rydell notes that "the fair set the standard for measuring civilized accomplishment and strengthening popular perceptions of underdevelopment in much of the Third World."[75] *Harper's Weekly* quoted Julian Ralph's book *Chicago and the*

FIGURE 26.
*American
Indian outside
civilization.
Frank D. Millet,
J. A. Mitchell,
Will H. Low, W.
Hamilton Gibson,
and F. Hopkinson
Smith,* Some
Artists at the
Fair *(New York:
Charles Scribner's
Sons, 1893), 43.*

*World's Fair,* which characterized the Midway Plaisance as the "Church Fair" annex of the Columbian Exposition and suggested that "the primary purpose of the features in the Midway Plaisance is not educational, but rather to amuse."[76]

The eminent painter of the American West Frederic Remington wrote a brief article for *Harper's Weekly* that reflected the spirit of the time: "Strange and fierce-looking negroes who have evidently not felt the elevating influence of South Carolina pass you, and Bedouins who are over-conditioned for folks who eat only barley and figs. . . . We did all the savages in turn, as every one must do who goes there [to the World's Fair], and Buffalo Bill's besides, where I renewed my first love."[77] Remington's remarks were consistent with his racial views, but his respect for and admiration of soldiers in the American West caused him to document in some of his paintings soldiers from the four African American cavalry regiments stationed west of the Mississippi.

African Americans complained during the planning of the fair about the lack of Negro involvement. A club of Negro women, the Woman's Columbia Auxiliary Association, "drew up resolutions requesting that 'the Negro be given some consideration in the World's Fair exhibits.' A copy of these resolutions was sent to Judge Albion W. Tourgee [*sic*], . . . a prominent friend of the colored people." Tourgée promised to use whatever influence he might have toward this end.[78] All-white male boards ran the fair, and no African American women were included on the Board of Lady Managers, though, ironically, their interests were represented by a white woman from Nancy Green's home state of Kentucky. Ethnologists from the Smithsonian Institution represented Native American women with a display called "The Arts of Women in Savagery."[79] August 25 was set aside at the fair to be Negro Day, generally known as Colored American Day,

FIGURE 27.
*Dahomey Village,
Midway Plaisance,
World's Columbian
Exposition,
Chicago, 1893.
Carolyn Kinder
Carr and George
Gurney,* Revisiting
the White City:
American Art at
the 1893 World's
Fair *(Washington,
D.C.: Smithsonian
National Museum
of American Art,
1993).*

and antilynching activist Ida B. Wells advocated a boycott of it. Frederick Douglass disagreed with her, feeling that the day offered the opportunity for African Americans to highlight their contributions and accomplishments since the end of slavery.

Although more than "10,000 Negro visitors were expected from Tennessee, Kentucky, and Ohio alone," a number of Negroes were concerned that the day not be seen as a "'watermelon festival' or cakewalk jubilee, but a 'refined and dignified' assembly of 'cultured Afro-Americans.'"[80] Their concerns may have seemed justified when an image called "Darkies Day at the Fair (A Tale of Poetic Retribution)" (figure 29) was published on August 21, 1893, ridiculing the prospects of that day, and 2,500 watermelons were sent to the fair for the crowd. The first two stanzas of the poem accompanying the image indicate its dependence on black stereotypes, biblical associations with Ham, derogatory misnomers, and a bit of exaggerated dialect:

PART I
The Events of the Great World's Fair Impressive went their way.
Time rolled around; at last it was The Colored People's Day!
The Sons of Ham from far Soudan

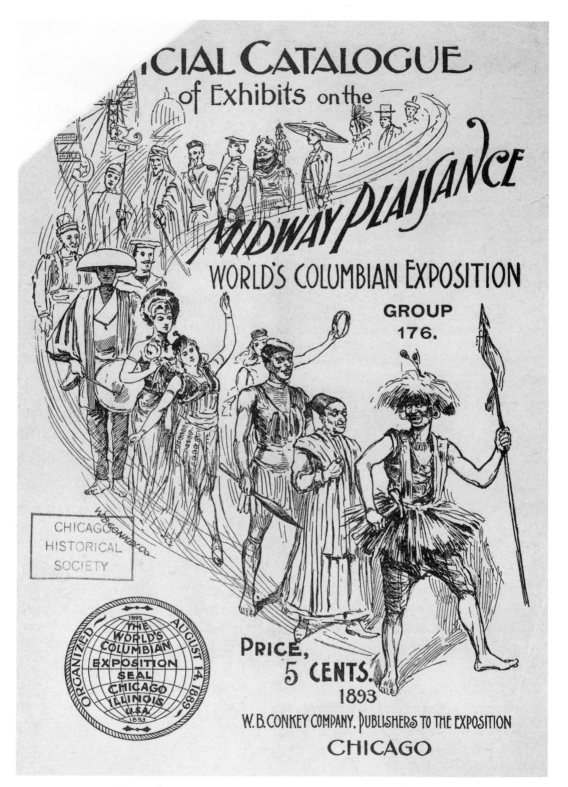

FIGURE 28.
*Official catalog of exhibits on the Midway Plaisance, 1893. Courtesy of the Chicago Historical Society.*

And Congo's Sable Kings Came to the Fair with all the hosts,

Their wives, their plumes, their rings.

From distant Nubia's torrid sands,

From far-famed Zanguebar,

Together with their Yankee Friends, The Darkies all were dar!

PART II

But a Georgia coon, named Major Moon,

Resolved to mar the day

Because to lead the whole affair

He had not had his way.

Five hundred water-melon ripe,

(The darkey's theme and dream,)

He laid on ice so cold and nice

To aid him in his scheme.[81]

Despite the belittling images and some people's misgivings, the day drew together an impressive slate of speakers and participants. The poet Paul Laurence Dunbar was there as an assistant to seventy-five-year-old Frederick Douglass, who was in charge of the Haitian Pavilion at the fair and who gave an address at the urging of composer Will Marion Cook. It was reported that Douglass began a dispirited speech; but the jeers of several white men in the gallery aroused his old fire, and "he threw his manuscript to the floor" and "discoursed scathingly on the treatment accorded 'free' Negroes in a free land." During the speech, "the scoffers were won over by his surging, passionate eloquence," and the large audience responded at the end with applause that "rocked the building, echoed and re-echoed even over the lake."[82] Ida B. Wells, who had boycotted the day, read about the speech in the morning papers and rushed to the Haitian Pavilion to beg Douglass's forgiveness. She later said that he had done more to bring the concerns of black people to the attention of white Americans than "anything else that happened during the fair."[83]

Dunbar read some of his poems; Douglass's nephew Joseph played the violin; and Harry T. Burleigh sang a solo that brought him several encores. Robert S. Abbott, a member of the Hampton Quartet singers, heard Douglass's speech, and another by Ida B. Wells telling of the destruction of her Memphis newspaper by a mob. In 1897 Abbott returned to Chicago to take up residence and work as an attorney. He did not meet much success as an attorney, having been told by Edward H. Morris, Chicago's most successful Negro attorney at the time, that he was "a little too dark to make any impressions on the court in Chicago" and that he might try a smaller town. Abbott tried to practice in nearby Gary, Indiana, but met with little success there. As a result, he returned to Chicago

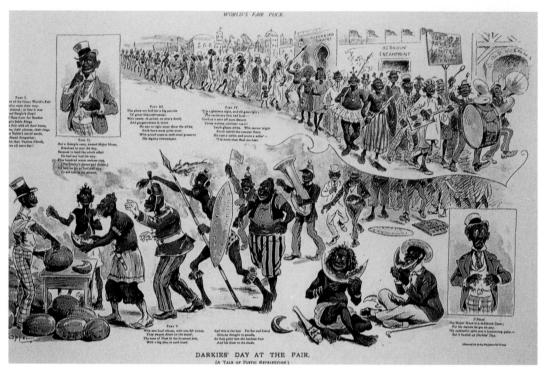

**FIGURE 29.**

*"Darkies Day at the Fair (A Tale of Poetic Retribution)."* World's Fair Puck, *no. 16 (August 21, 1893):
186–87. Robert W. Rydell, "Rediscovering the 1893 Chicago World's Columbian Exposition," in Carolyn
Kinder Carr and George Gurney,* Revisiting the White City: American Art at the 1893 World's Fair
*(Washington, D.C.: Smithsonian National Museum of American Art, 1993), 84.*

and in 1905 launched the *Chicago Defender*, the most important and influential
African American newspaper in the nation.

Besides a number of images belittling people of African descent, images ar-
ticulating various racial and national hierarchies appeared in connection with
the fair. *Harper's Weekly* (which covered the Columbian Exposition from various
angles with many images during the fair's entire six-month duration) ran a story
about a procession of "Foreign Peoples," saying that the Chinese "are a meek
people" but that the serpent from the Mongolian Theatre "evidently did much
to raise the standing of the Midway Chinese among the more savage but not
half so ingenious races."[84]

A series of cartoons in *Harper's* about the black Johnson family visiting the
fair may have contributed to the trepidation some felt about Colored American
Day. Their tone and content caricatured blacks in much the same way that the
Blackville series had done nearly two decades earlier. As they emulated white
middle-class visitors to the fair, this family often seemed woefully out of place,
and the wife physically was linked to the mammy stereotype of black women by
her exceptional weight. An image from August 5, 1893, (figure 30) is consistent

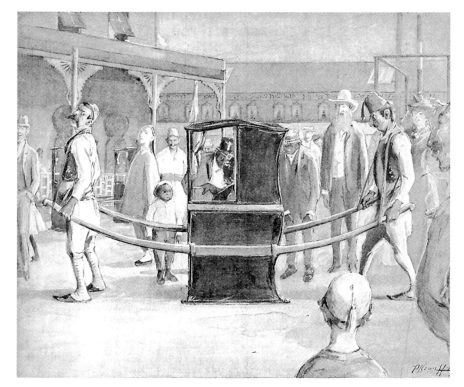

FIGURE 30.
*"The Johnson
Family on
the Midway
Plaisance."*
Harper's Weekly,
*August 5, 1893,*
743.

THE JOHNSON FAMILY ON THE MIDWAY PLAISANCE.

MRS. JOHNSON *(who has with difficulty crowded her ponderous self into a Salon chair).* "WOT'S DE MATTAH DEY DON'T GO, EZ?"
MR. JOHNSON *(with great delicacy).* "DE POLES SEEM LIMBAH, SOZE DE MACHINE DON'T MISS DE GROUN'."

with the *Darktown Yacht Club* pair that followed in 1896. Mrs. Johnson is seated
in a hand-ported cab, and her weight has supposedly caused the wooden poles
carried by the porters to sag, making the whole thing impossible to lift. So that
certain readers got the point, the caption says that Mrs. Johnson "with difficulty
crowded her ponderous self into a Salon chair."

The first image of the series, from July 15, 1893, showed the Johnsons' arrival
at the Great White City, and, despite their well-dressed appearance, the heavy
dialect revealed their social "place." The father exclaimed, "Great Lan' Gloriah!
I'd giben dat spotted mule ob mine for de contrac' on whitewashin' dis yer
place!"[85] A month later another image in the series (figure 31) showed the family
visiting the Dahomey village, and genetic and social links between Africans and
African Americans were implied when Mrs. Johnson admonished the husband,
Exwell, not to shake hands with the Dahomean by asking if he wanted "de hull
Fair ter t'ink you's found a poo' relation?" Still another in the series showed Mr.
Johnson encountering a Samoan, whom he asked, "Does you speak English?"
The Samoan, called "The Native," replied, "Yes; Does you?"[86] Again, dialect was
used to demean the intelligence of blacks, but at the same time both images
linked blacks with so-called primitives elsewhere in the world.

It seemed that the Johnsons spent a great deal of their time on the Midway, an insinuation in line with the *Harper's Weekly's* wrap-up of the exposition, which said that many people "found the Midway exactly on the level of their intelligence, and went no further" into the fair.[87] An American identity was being visualized and placed in a global context in 1893. The only significant black element of that identity demonstrated at the fair was Aunt Jemima. The Johnson family graphically articulated the inappropriateness of full black participation in American society through a revision of themes and imaginings from minstrelsy, the Smallbreeds of Blackville, and the Darktown Comics. Subsequent fairs using this one as a model were in San Francisco in 1894 (with some of the ethnological villages having been sent directly from Chicago), Atlanta in 1895 (the site of Booker T. Washington's "Atlanta Compromise" speech), Nashville in 1897, Omaha in 1898, Buffalo in 1901, St. Louis in 1904, and five more fairs of this kind were held around the nation through 1916.[88]

The Chicago fair ideologically, according to Curtis Hinsley, "commodified the exotic" by having the ethnological villages organized by a showman and placed in the midst of food and amusement concessions. Aunt Jemima, the embodiment of the mammy, was there as a product shill, a plantation stereotype packaged to entertain and to sell pancakes. American racial ideology and ethnic hierarchy were sold in an unprecedented manner as entertainment. The show

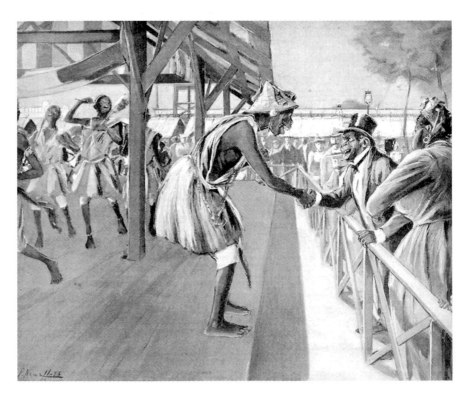

FIGURE 31.
*"The Johnson Family Visit the Dahomean Village."* Harper's Weekly, *August 19, 1893, 797. The caption read: "Mrs. Johnson. 'Exwell, stop shakin' han's wid dat heathen! You want de hull Fair ter t'ink you's found a poo' relation?'"*

traveled the country for twenty-two years, deeply installing and instilling ideology and imagery into the American consciousness.

Among the lasting things to come out of the Columbian Exposition in Chicago, beyond racial and ethnic categorizations, was the ritual devised by Francis Bellamy, editor of the *Youth's Companion*. Feeling that American children needed a dramatic way to reaffirm their loyalty to a nation recently torn by the Civil War and post-Reconstruction racial strife in the South, Bellamy formulated the wording that became the Pledge of Allegiance. The Federal Bureau of Education started a nationwide campaign to have schools "include the salute to the flag as part of their Columbian celebrations."[89] The World's Columbian Exposition clearly produced complicated messages and affected the twentieth century in a variety of ways, institutionalizing hierarchies of race, ethnicity, and gender and formalizing definitions and images of the nation.

Another irony was that at this same time an important event took place elsewhere in Chicago, the Chicago Congress on Africa. It opened on August 14, 1893, and lasted a week. Olisanwuche Esedebe contends that this event "may be taken as the beginning of Pan-Africanism as a movement," and among those in attendance were Alexander Crummell, Bishop Henry Turner (who was "an ardent advocate of the back-to-Africa movement and founder of the African Methodist Episcopal churches in Sierra Leone and Liberia"), a representative of the American Colonization Society, and "European scientists, explorers, and missionaries, most of whom had come to Chicago primarily for the World Columbian exhibition held there that summer."[90]

Just over seventy years earlier, in 1822, Denmark Vesey attempted to organize a slave revolt in South Carolina based on what amounted to a concept of Pan-African identity. As Michael Gomez has written, Vesey called for "the deemphasis of African ethnic ties while fording the free-slave divide. In their stead, Vesey sought to elevate a single status, a lone condition, that of blackness, of descent from Africa." This "theme of unity based solely upon common African ancestry became a refrain in Vesey's message."[91] Though Vesey's plan for a violent insurrection failed—and the deemphasis of ethnic, class, and social status was not embraced by most Negroes—the strength of the concept of Pan-Africanism allowed it to be a useful organizational principle in fin de siècle Chicago.

Henry Ossawa Tanner[92] spoke at the Conference on Africa, discussing "The Negro in American Art," and around this time produced two of the few genre paintings of his career featuring African Americans, *The Banjo Lesson* (1893; figure 32) and *The Thankful Poor* (1894). Judith Wilson has provided an interesting reading of these two works as resisting the prevailing negative characterizations of blacks through articulate visual statements. *The Banjo Lesson* "debunks a widespread myth of innate Black musicality by showing the deliberate care with

which a Black elder instructs a Black child" on the banjo.[93] Also, the concentration and control found in the faces in *The Banjo Lesson* counter the common misperceptions seen in Homer's *Our Jolly Cook. The Thankful Poor* undermined the "prevalent contemporary perception of Black religiosity as overwhelmingly emotional—and thus, presumably inferior to an allegedly more tranquil, stable and introspective White brand of piety."[94] The fact that the banjo is an instrument believed to have been imported from Africa gives even more significance to genre paintings showing black musicians playing the instrument. It entered the Americas through the West Indies in the early seventeenth century and has been called *banja, bangil, bangie*, and, in Brazilian Portuguese, *banza*. The name most likely was derived from the Kimbundu *mbanza*: a plucked string instrument. It was constructed from gourds, wood, and tanned skins and had hemp or gut strings. Early versions of the instrument used varying numbers of strings, but the five-string version became popular in minstrelsy and appears to be what the subjects in Tanner's painting are using. As was mentioned earlier, this sort of music making has been interpreted recently as a subtle form of resistance by serving as a cultural refuge for the expression of African practices and the performance of unique identity.

Tanner developed *The Banjo Lesson* from sketches and photographs made during his visits to rural Georgia and North Carolina in the summer of 1889 while he was residing in Atlanta. Tanner had come to the South from a family of middle-class free blacks in urban Philadelphia, but the common experience of racial oppression overcame such personal experiential, class, and regional differences. He was terribly aware of racial issues and characterizations, and they violently upset him throughout his life. About a year after his speech in Chicago, Tanner wrote about himself in the third person to explain his aims in having painted Negro subjects: "To his mind many of the artists who have represented Negro life have only seen the comic, the ludicrous side of it, and have lacked sympathy with and appreciation for the warm big heart that dwells within such a rough exterior."[95]

Tanner was one of the first African American artists to resist the caricatures and stereotypes through imagery, though the burden of race proved too much for him. He chose physical expatriation in Paris for most of his adult life and, apparently, aesthetic expatriation as well: he primarily painted biblical subjects with implications about the human condition and spiritual transformation rather than genre paintings or works with racialized subjects.[96] Tanner, like most Western artists, sought to find himself as an artist in the history of art, and racial practices were impediments to this ambition. *The Banjo Lesson* was a renovation of a theme found in a Thomas Eakins painting, *Negro Boy Dancing* (1878). Eakins had been Tanner's instructor at the Philadelphia Academy of Art

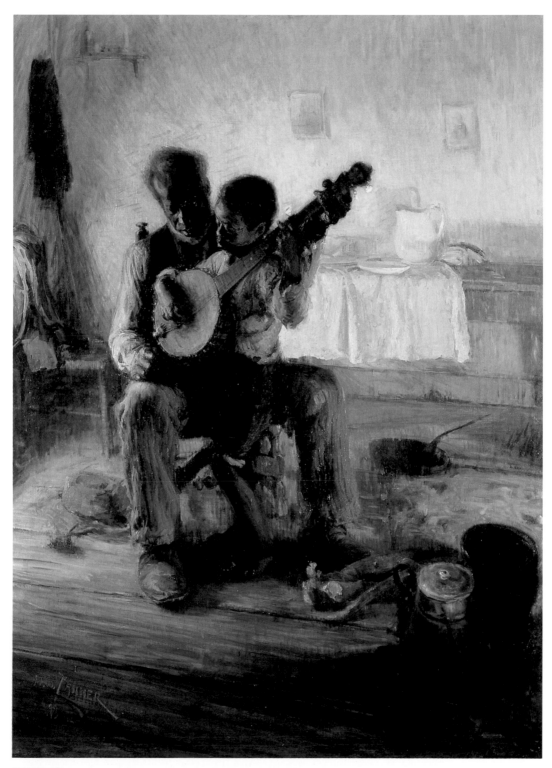

FIGURE 32.

*Henry Ossawa Tanner,* The Banjo Lesson, *1893, oil on canvas, 49″ × 35½″.*
*Collection of Hampton University Museum, Hampton, Va.*

and had encouraged his student to paint black subjects. His painting from 1878 shows a black youth dancing to music by a banjo player while an older man watches as if he were tutoring the youth. *The Banjo Lesson* was linked to the genre of images depicting black musicians that included derogatory caricatures of minstrels playing banjos, the fiddlers in the paintings by William Sidney Mount (who also did studies of a black banjo player, a fiddler, and a bones player in the 1850s), and the musicians portrayed by Eastman Johnson. John Lewis Krimmel produced one of the earliest works in this genre with his *Quilting Frolic* from 1813, a painting showing a black fiddler and a young black woman serving tea for whites. Krimmel's painting revised precedents found in English genre painting, but the English musicians were white. Tanner, in his painting, accomplished the delicate and complicated task of expanding on a genre, shifting the perspective of the image to that of the black subject, and he transcended a racial stereotype to reveal the humanity of his subjects.

Tanner transformed the silent, objectified "Negro" by giving him (or her) a voice and a particularized humanity. For Mount, Eakins, and even Eastman Johnson, black music making offered a voyeuristic entrée into an exotic, black world, a fascination that offered the metaphoric possibilities of minstrelsy. Tanner undoubtedly discovered during his excursions into rural Georgia and North Carolina that music was a sanctuary behind the veil for black folk fighting to maintain a sense of self against the deluge of derogatory characterizations and the intense oppression that animated those grotesque misrepresentations.

In 1893, while Nancy Green masqueraded as Aunt Jemima, an act and a persona in complicity with the inscription and reinscription of white identity and the maintenance of white power, elsewhere in Chicago people of African descent were reformulating their identity. Wilmot Blyden's ideas of racial nationalism were being further developed, and the coalition of people of African descent from all around the Atlantic basin was a response to the challenges of European power and domination. The aim of uniting under the concept of an "African," was, perhaps, a renovation of David Walker's 1829 *Appeal to the Coloured Citizens of the World*, which implied a common cause rooted in color. Sterling Stuckey suggests that, ironically, the foundations for black nationalism and Pan-Africanism in the United States were laid by slave owners, particularly in the nineteenth century, because they did not pay close attention to African ethnicities, choosing instead to see all Africans as virtually the same.[97] By the 1960s the Pan-African identity that initially took organizational form in Chicago would fully overtake the mythology presented in minstrelsy and visualized in the derogatory images found in popular media.

Chicago's fair came three years before the Supreme Court's decision in *Plessy*

*v. Ferguson* (1896), which officially sanctioned segregation and completed the total re-oppression of African Americans in the South. In 1900 W. E. B. Du Bois would be one of the organizers of a Pan-African conference in London, and in 1903 he correctly predicted in *The Souls of Black Folk* that the key issue of the twentieth century would be the problem of the color line. The Spanish-American War of 1898 would mark America's entry into imperialist colonial adventure with the conquest of Cuba and the Philippines. The United States was becoming a global power industrially and militarily, and the 1893 fair in Chicago marked the assertion of that position on the world stage. It also marked the point when blacks began organized resistance to white oppression on a global level. Soon this political resistance would be replicated by artists attempting to counter the deleterious effects of the Blackville, Darktown, and Aunt Jemima imagery.

> To suggest that the problem of the twenty-first century will be the problem of the color line is not to ignore the changes that have occurred in this as well as in other centuries. It is merely to take notice of the obvious fact that the changes have not been sufficient to eliminate the color line as a problem, arguably the most tragic and persistent social problem in the nation's history.
> —John Hope Franklin, The Color Line *(1993)*

A friend and I visited a Barnes and Noble bookstore in Durham, North Carolina, recently and while we were standing in front of the African American Studies section she remarked on how much pain was there. Very little written by black authors seems able to evade the pain found in the experience of being black. So many cultural messages have indicated that black is the discredited signifier for so long that Du Bois's idea of double consciousness, that persistent awareness of how we are seen collectively by those in power in this nation, shows itself in our reactions to oppression and the pathologies that oppression creates in its victims. For a Welsh person in England to disdain a Scot is a matter of antagonism but is not *inherently* more than that. The force of power and its economic privilege make racism a far more serious matter. It is still more complicated by the violence that has been employed to enforce the racial hierarchy in the United States over the past three centuries—enslavement, lynchings, beatings, rapes—and the use of the official institutions of society to further enforce and legitimize white control. For African Americans (a term that is more ethnic than racial), the pain of this circumstance and resistance to it can be found persistently in our slave testimony, literature, music, and poetry—and in our twentieth-century art expression.

Richard Dyer, in his discussion of the visual and conceptual construction of

whiteness, has written, "[H]ow anything is represented is the means by which we think and feel about that thing, by which we apprehend it."[98] Images of African Americans in the nineteenth century helped construct a perceptive apprehension of them for whites and worked in the service of apprehending them for containment or conceptual incarceration. The derogatory and stereotypical imagery found in nineteenth-century minstrel performance, artwork with black subjects, popular lithographs, advertising products, and popular media combined with political, social, and economic oppression and the official and renegade enforcement of racial ideology to control and trap the black individual within his or her community and ultimately within his or her body.

To be unaware of racial practices, Black Codes, and the harsh unwritten codes of conduct was to risk lethal harm, so the development of a double consciousness not only was a psychological development but also a mode of survival. A body awareness was terribly necessary because gesture, expression, eye contact, posture, and position within a social space could all have consequences if you got any of them wrong. One was discredited for being. The only salvation was to resist the misrepresentation by avoiding any posture resembling the images, to escape racial classification, and to form coalitions within the grouping in which we found ourselves. To be African, colored, black, or Negro was inescapable because of the state of power relations in the world, but those designations could become the flags under which we organized, the nations for which we fought the oppression, and the first places to exercise agency by rehabilitating the demeaning, derogatory images. Resistance was a means for reinventing blackness and devising a New Negro. Perhaps the New Negro could escape the racial prison.

# AUNT JEMIMA, THE FANTASY
# BLACK MAMMY/SERVANT

*We wear the mask that grins and lies,*
*It hides our cheeks and shades our eyes, —*
*This debt we pay to human guile;*
*With torn and bleeding hearts we smile,*
*And mouth with myriad subtleties.*

*Why should all the world be overwise,*
*In counting all our tears and sighs?*
*Nay, let them only see us, while*
   *We wear the mask.*

*We smile, but O great Christ, our cries*
*To thee from tortured souls arise.*
*We sing, but oh the clay is vile*
*Beneath our feet, and long the mile;*
*But let the world dream otherwise,*
   *We wear the mask!*

*— Paul Lawrence Dunbar, "We Wear the Mask" (1895)*

Aunt Jemima has become the ultimate symbol and personification of the black cook, servant, and mammy. She began her public career as a minstrel show character, but she entered into a new career as a product trademark in 1889 because blacks were widely imagined to be exemplary servants and cooks and because the endorsement of a product like self-rising pancake mix by a black cook was an asset if the black image was humorous or derogatory.[1] The idea of making Aunt Jemima a living product trademark emerged from a visit to a minstrel show in St. Joseph, Missouri, in the fall of 1889 by Charles L. Rutt, one of the owners of the Pearl Milling Company, developers of a ready-mix pancake flour. He saw a renowned performance of a cakewalk to the song "Old Aunt Jemima" written by Billy Kersands, a Negro blackface minstrel who was one of the most prominent minstrels of his day. Many white minstrels performed the popular song and modified the lyrics, as was true of the performer Rutt saw in blackface and in drag. Pretending to be a black cook, the minstrel wore an apron and a bandanna around his head.[2] According to Arthur Marquette's history of the Quaker Oats Company, which now owns the Aunt Jemima brand name, "Here was the image Rutt sought! Here was southern hospitality personified."[3]

Billy Kersands was born in New York in 1842. He improvised on "Old Aunt Jemima" during his many performances, and one set of lyrics suggested that the song had been derived from a slave lament.

My old missus promise me
Old Aunt Jemima, oh, oh, oh
When she died she'd set me free
Old Aunt Jemima, oh, oh, oh
She lived so long her head got bald
Old Aunt Jemima, oh, oh, oh
She swore she would not die at all
Old Aunt Jemima, oh, oh, oh[4]

The lyrics of "Old Aunt Jemima" reveal a glimpse of the real desire for self-control and freedom behind the mammy mask. Robert Toll speculates that the song's "lack of even a face-saving comic 'victory' for the black character" and its protest message differ from the black tradition in minstrelsy, which most often used "symbolic indirection" and some sort of victory, however small, for the black characters.[5] In minstrel performance, blacks frequently expressed their resistance and displeasure with the social order, often with allusions or coded references that white audiences usually missed. Toll writes that black culture sensitized people "to hear and enjoy . . . surreptitious barbs, while most whites

FIGURE 33.
*Billy Kersands,
Callender's
(Georgia)
Minstrels,
ca. early 1870s.
Billy Rose Theater
Collection,
New York Public
Library for the
Performing Arts,
Astor, Lenox
and Tilden
Foundations.*

# BILLY KERSANDS.
## CALLENDER'S (GEORGIA) MINSTRELS.

might not even notice them."[6] Direct protest and confrontation by blacks was not common and could be dangerous to the protester.

The song's popularity with black audiences suggests that something else may have been going on in this particular case; the displeasure with the social order may have been layered within the song. Sterling Stuckey confirms this by revealing a slave song that apparently was the source for the minstrel version:

My ole missus promise me
W'en she died, sh'd set me free,
She lived so long dat 'er head got bal'
An' she give out'n de notion a-dying' at all.[7]

The fact that "Old Aunt Jemima" was performed to a cakewalk complicates things while providing the key for decoding the performance. The cakewalk was a dance devised by African Americans to spoof the formal promenades of whites through exaggerated gestures. The dance and the lyrics suggest that Kersands had modified the song and layered it with messages that did provide a small victory for blacks. It seems that there was a level of *signifyin'* going on—spoofing white folks's ways. The old "missus" was so mean, so committed to keeping black folks in captivity, that she would not die, even after her *hair* fell out! Hair is a woman's crown, the source of great energy and vanity, and this woman kept on despite losing it. Also, whites consistently broke their promises to blacks. These lyrics floated atop the signifying dance—the cakewalk. A black audience would get it. Beneath the physical and cultural transvestism that Rutt saw as authentic was the kernel of African American authenticity and sentiment that he did not see.

Another minstrel song, "Jemima Susianna Lee" by Geo. L. Rousseau, presents a younger Jemima who is desirable and has interracial coupling in her lineage:

Twas on de ribber, o de old Tennessee
Dat I first met Jemima Susianna Lee
Black eyed yeller gal, lubly as de moon
Golly I did lub her, dat same Octaroon
    (chorus)
Oh Jemima Susianna Lee
Sweet as de sugar cane
Busy as de bee
Lublier dan any on the Mississip to see
de Rappaban, de Potomac, or de Tennessee . . .

One night in her cabin on de ribber side
I asked de lubly Jemima would she be my bride
Dat she would, case she lub'd no oder
So I took de yeller belle and happy we libed togedder[8]

This Jemima was young enough to be a bride, a "yellow-skinned" octoroon, and was not called "Aunt" as were many older black women. This Jemima would not serve the purposes of the mammy Jemima.

The use of the term "Aunt" or "Uncle," according to Mechal Sobel, was part

of a process of "ageing" slaves. This was a way "the owner reduced the social distance between them and could allow himself to treat the black differently." The term was a testimony to their (perceived) loyalty and the fact that such long-term servants often helped the owner by being "held responsible for order and stability in the slave community." Therefore, giving a modicum of respect to them was not seen as dangerous to the slave system hierarchy.[9]

Where did the name Jemima come from? It could have roots in African languages because it is not a common English name. In the Yoruba language the name *Jémílá* appears in an Ijebu song about the complaint of a man who paid a dowry to Jémílá's parents only to be denied her hand. There also is the name *Yémàmá*, a term used to address one's maternal grandmother. There are Wolof words such as *gëmma* (to close one's eyes), *gëmmi* (to open one's eyes), *jamma* (peace), *jëmma* (prestige, presence, appearance), and the name *Maama*.[10] While these and possibly other names or terms from West African languages hold some promise, it seems most probable that the name comes from an obscure Bible verse naming the daughters of Job after his restoration by God:

12. So the LORD blessed the latter end of Job more than his beginning: for he had fourteen thousand sheep, and six thousand camels, and a thousand yoke of oxen, and a thousand she asses.
13. He had also seven sons and three daughters.
14. And he called the name of the first, Jemima; and the name of the second, Kezia; and the name of the third, Kerenhappuch. (Job 42:12–14)

Jemima, a variant spelling of Yemima, is a name possibly related to an Arabic term meaning "dove." Finally, according to the Targum (an ancient translation of Hebrew scripture into Aramaic that often included commentary), "Job named his daughters in accordance with their attractiveness: Jemimah means 'day,' for her beauty shone forth like the sunlight."[11] Because slaves often identified with the plight of biblical Hebrews enslaved in Egypt, and many folk learned to read by studying the Bible (notably Frederick Douglass), it is possible that the name Jemima came to someone's attention, and so it was bestowed on a daughter.

The Free Negro Register of Sussex County, Virginia lists a freed slave woman, Jamima, a dark woman, 5'6¾" tall, who was manumitted on July 6, 1797.[12] A will filed in the Fayette County, Virginia, Clerk's Office on December 14, 1807, records that Toliver Craig gave his daughter, Joyce Falkner, "a negro girl by the name of Gemima otherwise called Mima."[13] There was a Jemima Cook Vaughan (wife of John Vaughan) who was born in South Carolina in 1801. Jemima Marie Johnson was born in Fairfield County, South Carolina in 1832. The 1847 *Baltimore Directory* compiled by R. J. Matchett lists among the free Negroes a washer,

Jemima Loadfield, residing at 59 Chestnut Street.[14] Other Jemimas have been documented across the antebellum South. The likelihood that these names were biblical references is given more weight by the fact that white Kentucky slave owner Adam Broyles's will from April 19, 1782, lists among his children a daughter, Mima, whose full name was Jemima and who married Joseph Brown Jr. Jemima Robinson (1761–1847), a white Quaker and the wife of Thomas Robinson (1761–1851), was a member of the Vermont and Ferrisburg, Vermont, antislavery societies. William Harris (born circa 1669) and Temperance Overton Harris (born circa 1678) of colonial Virginia had five children, one of whom was a daughter named Jemima. Jemima Shayler (or Saylor) was born in 1701 or 1702 in Bolton, Tolland County, Connecticut, and Jemima Weed, a New York resident, was born in Ireland in 1821. It also is possible that the Hebrew "Jemima" sonically resembled certain African language forms enough to be comfortable to some slaves.[15] Unfortunately, whatever the origins of the name Jemima and the protest sentiments at the root of the original song, its ubiquitous presence in association with the pancake mammy has suppressed its usage in African American communities in the twentieth century.

Whites intimately identified black cooks with southern cooking in 1889 when Charles Rutt was searching for a symbol for his self-rising pancake flour. The product was introduced to the public at the New Era Exposition in St. Joseph in the fall of 1889. Undercapitalized, Rutt and his partner, Charles Underwood, registered the trademark and sold the company to R. T. Davis in 1890. An account written by Charles Rutt states that "Charles G. Underwood went to work for the R. T. Davis Milling Company in St. Joseph," and at his suggestion "the Davis Company purchased the Aunt Jemima formula and business and the registered label."[16] After Davis purchased the company from Rutt, he initiated a search for a black woman to fulfill his perception of Aunt Jemima as "a Negro woman who might exemplify southern hospitality."[17] That woman, Nancy Green, was found working as a domestic for a Judge Walker in Chicago, and she was hired to personify Aunt Jemima. Subsequently, a mythical plantation past was invented for Aunt Jemima, a narrative showing her loyalty to the South and to her master, and Green traveled the United States promoting the product as the fictional character.

Nancy Green was born in Kentucky in 1834. As Aunt Jemima she masqueraded as a former slave with a love for the Old South and devotion to the whites she served. As a human trademark, she became an advertising icon and the latest twist in the complex history of blacks and commerce in the Americas; from advertisements announcing the arrival of slave ships to ads for runaway slaves, to an entertainment industry of minstrel performance based on the appropriated representation of black culture, to product icons. All of these forms

FIGURE 34.
*One of the earliest representations of Aunt Jemima, this image appeared on the cover of the booklet from the 1893 Chicago World's Columbian Exposition naming her "The most famous Colored Woman in the world."*

silenced the black voice and controlled the black body by the invention of an economic system and a white ethnicity built around a central blackness that benefited and helped define whites. Blackness was prescribed in ways comfortable to whites, and it required that black people act out those prescriptions. That black women worked as cooks and domestics is unquestioned—in 1900 over 80 percent of the Negro women in Chicago worked as domestics and personal servants[18]—but it is unlikely that many of them were happy that such jobs were the primary employment/career alternatives for themselves or their daughters.

Aunt Jemima was not a real black woman but rather an invented persona

FIGURE 35.
*Nancy Green,
ca. 1895. In this
image Green
does not wear a
bandanna, nor
does she resemble
the images of
Aunt Jemima
found on boxes
of the product
bearing that
name.*

based on the way whites wished to perceive their black servants and on a misinterpretation of a character devised by blacks to critique their treatment by whites. Using the appellation "Aunt" instead of "Mrs." or "Ma'am" suggests that the minstrel song was composed for a white audience. In her commercial incarnation, Aunt Jemima lost the critical commentary found in minstrel performances of the role and instead was projected entirely the way whites perceived a black cook—as the servile, devoted mammy, which was itself a fantasy. The coincidence of an innovative marketing strategy using a live trademark to advertise a revolutionary new product helped to embed Aunt Jemima deeply in the American consciousness.

The mammy construction was useful for the maintenance of white patriarchal authority over both white and black women while allowing sexual access to and domination over them. A good deal of miscegenation did occur in the American South (as it did everywhere that whites dominated black populations), and a sexual mythology was attached to notions about black women; this mythology was used to define all women labeled as primitive—including sexually available white women. The sexual desire and dalliances of white men for and with black women were not openly represented in visual media in the United States, and they seem to have been hidden further behind the myth of the asexual mammy.

Jo-Ann Morgan argues convincingly that the mammy also aided a larger strategy to reconcile the South with the North in the post-Reconstruction era. "The North needed southern agriculture; the South needed manufactured goods from the North. Both depended on an integrated system of transportation and a steady, reliable work force." The mammy's voluntary residence with her old "Missus" and "Massa" suggested, in this revisionist view of antebellum life, that the "slave-holding planter had not been so villainous after all," and it put "a benevolent face on domestic relations between planter and slave." The old plantation life began to capture the imagination of the North aided by a collaboration between writers from the South and publishers and artists in the North. Starting in 1870s, popular northern periodicals such as *Harper's Weekly*, *Cosmopolitan*, *Munsey's*, *McClure's*, and *Lippincott's* published conventional southern themes for a wide audience.[19]

The mammy had a peculiar place in the lore of the American South, a place that seemed nostalgic yet strangely oblivious to the objectification and fantasy on which it depended. Albert Bagby opened his 1904 novel, *Mammie Rosie*, by describing the search by a southern aristocrat, Reginald Thornton, for a suitable black woman to serve him:

"Well! If I could get a right good nigger to keep house for me—I don't mean a coloured person, but a right good nigger—I think I'd take it."

"Excuse me, sir, I'm only a janitor; but I'd like to shake your hand. No one but a southerner could pronounce 'nigger' like that."

"Certainly," said Thornton, acquiescing, "we've a way of recognising each other, haven't we?"

A fortnight later Reginald Thornton found himself installed in his new apartment with all the appurtenances of luxury and comfort save the much desired "nigger."[20]

In the passage that follows, the janitor shows "his gratification at being of service to a gentleman of Southern grace and breeding" by bringing Thornton his choice of two black women to work for him.[21] Within one page in this novel, the reader encountered a clear expectation of the place of the black as servant, the affirmation of Thornton's social superiority by the janitor, and the total objectification of blacks into the term "nigger." This objectified being then was desired as the completion of "luxury and comfort" and seemed to be both a luxury possession and a comforting presence in service affirming the status (and racial supremacy) of the racist Thornton.

The idea of a black servant as an indicator of luxury and status was linked to British precedents. Elizabeth O'Leary writes that new prosperity and a growing cosmopolitan outlook in the latter part of the nineteenth century "inspired many Gilded Age Americans to look to Europe for standards in manners and tastes."[22] Wealthy eighteenth-century Europeans had been especially interested in the services of African children, to the point where possessing them became a fashion, and advertisements for their sale in London, Liverpool, and elsewhere were printed in newspapers.[23] According to O'Leary, "As it became fashionable in the eighteenth century for aristocratic British families to own black servants, particularly houseboys, the number of Africans brought to England from the West Indies steadily increased. . . . Bought and sold at inns and coffeehouses, boys and girls were trained as house servants and groomed as domestic pets."[24] Therefore, O'Leary argues, "[t]he portrayal of black servants in American art was built on British traditions of representing slaves as docile attendants, figures who functioned primarily to elevate the importance of white subjects."[25] By the end of the nineteenth century, these notions were firmly in place in the United States, especially in the South. It was this context that generated Bagby's novel.

The mammy construction persisted into the second half of the twentieth century. George Carroll in 1958 opened a memoir praising his mammy and presenting some of her stories in her "own inimitable voice" (in other words, her

dialect): "In an effort to keep alive in the memory of all who claim the South as home, this essay is dedicated to that greatest of home institutions throughout the South; the old black Mammy. . . . Mammy was an institution on the farm or in plantation homes throughout the southern part of the United States. She occupied a position in the family that was peculiarly her own, disputed by no one and shared by none. In this position, recognized and respected by all, she reigned supreme."[26]

The love of the mammy stated so emphatically by Carroll was a nostalgia for an imagined past, for a carefree period of childhood when this surrogate mother/grandmother figure would have cared for him and bestowed an overarching humanity on white children. Carroll wrote that her "loyalty to her 'white folks' was a thing of beauty. She never spoke disparagingly nor would she permit any one to 'knock' any member of her 'family'" at any time. She considered the whites her family but was quite content to live in a cabin behind their big house.[27] Such a fantasy of black devotion was strangely similar to the love ascribed to a pet, but it is not found in African American expression, as the texts of black minstrel songs, poetry, and literature confirm. Carroll's narrative fits an old pattern. Even Harriet Beecher Stowe's 1852 abolitionist novel, *Uncle Tom's Cabin*, features a cook named Aunt Chloe and a nursemaid called Mammy. Aunt Chloe proves herself to be so loyal as to sleep on the floor near her mistress. Suggesting that the Aunt and the mammy eventually coalesced into one figure, Morgan indicates that having been nurtured by an "old black Mammy" became a "requisite fantasy for any southerner seeking to establish his or her pedigree."[28]

Black mammies were revered in the South to the point that a movement developed after the turn of the century to establish monuments to old black mammies. In Athens, Georgia, a Black Mammy Memorial Association was formed in 1910 to charter a Black Mammy Memorial Institute, which would train young blacks in domestic skills and "moral attitudes that were generally associated with 'old black mammy' in the south."[29] In 1923 the Daughters of the Confederacy raised money and asked Congress to set aside a site in the Capitol for the erection of a bronze monument in recognition of the black mammy.[30]

Blacks as workers contributing to the comfort of whites had become the standard social assumption, and the black dialect one found whenever black people were given a voice on stage, in literature, or in popular culture was a confirming signifier of inferiority that justified their lesser social status. The mammy was the ultimate servant; the most common image of a mammy was the opposite of idealized white womanhood, which itself was a male fantasy. She was large, dark-skinned, usually smiling, and covered from neck to ankle with clothing. She wore a bandanna and an apron, both of which signified that

FIGURE 36.
*The blackface minstrel mammy was still an important figure in American entertainment in the 1920s. Sheet music for "Carolina Mammy," Al Jolson's hit song from "Bombo," by Billy James, 1922. Music Division, New York Public Library for the Performing Arts, Astor, Lenox and Tilden Foundations.*

she was a worker doing cleaning, laundry, or cooking. And she was a myth. On plantations a mammy was a wet nurse, a black woman who suckled white infants. Black women worked as cooks, maids, chambermaids, and nurses, but one woman did not perform all these tasks.

Many African American women were dark-skinned, large, and worked as domestic servants. Many wore headscarfs to keep dust and dirt out of their hair, but these characteristics were iconic in visualizations of the mammy figure, meant to affirm her status as a servant and differentiate her from the white mistress. To have seen these women at their best in church or on a special occa-

sion would have rendered the mammy unrecognizable because black women often wore elaborate hats and lovely dresses on such occasions, as can be seen in the photograph of Nancy Green (figure 35). They had their hair done and probably wore make-up and perfume (particularly in twentieth-century urban settings), and their interactions with family and friends were quite different than with white employers. When Hattie McDaniel accepted her Oscar in 1940 for playing a mammy in *Gone With the Wind*, she hardly resembled that character as she gave a thoughtful, articulate acceptance speech in an outfit suitable for the occasion.

The headscarf worn by the typical mammy may have been the ultimate denouement of African American ethnicity in the contrived caricature. Hair has been a significant item of concern and beautification for African and African American women for centuries. The scarf negated any beauty potential to be found in an elaborate coiffure and its decoration with combs, beads, or ribbons. Also, black women shared beauty rites in grooming each other's hair. The headscarf/bandanna literally covered up these potentials and soon became a signifier of demeaned racial and social status. In nineteenth-century New Orleans, for example, mulatto women had to wrap their hair to distinguish them from white women.[31]

Hairstyles can be a means for women to express their individuality and assert their location within a social class. Hair itself was associated with meaning and metaphysical potentials. Black folklore suggests that hair can carry a person's essence. Hair cut from men in barbershops was to be swept up and burned, so no one could pick up a sample and work "roots" on the man. One admonition women might hear would be not to let hair cuttings get out of one's control because a bird finding them and using the hair to make a nest might cause madness.

Some of these ideas may be a carryover from African discourses about the significance of the head. The head is the source of wisdom, knowledge, and personality. It is where the spark of divinity resides within humans, where the eternal aspects of being remain until the end of a particular life, when that transcendent element returns to the spirit realm. When a devotee is possessed by the spirit in Yoruba religious ceremonies, an equestrian metaphor describes the spirit (*òrìṣà*) as mounting the head of the believer. This explains why the head is outsized in proportion to the body in much West African sculpture.

Judith Wilson argues that, along with "a preference for *abundance*, . . . both African and African American hairstyles frequently exhibit a high degree of *artifice*."[32] Wilson also points out that the curly texture of the hair of many black women required strategies to manage and enhance it, and in the New World, separated from the resources and practices developed in African settings,

**FIGURE 37.**
*McCoy cookie jar modeled after Hattie McDaniel's mammy character
in* Gone With the Wind, *ca. 1940s. Collection of Kenneth W. Goings.*

women devised new methods and materials for their hair care. Madam C. J. Walker developed a new method of relaxing and promoting healthier hair and then formed a company to sell hair care products to African American women. Madam Walker invented the hotcombing method in 1905 and subsequently a formula for hair pomade, thereby creating the essentials of the "Walker method" of hair care.[33] In its first decade of selling hair products, Walker's company rapidly grew in the United States, the Caribbean, and Panama, which indicates how much attention black women gave to their hair at this time.

The headscarf worn by Aunt Jemima, and seen in so many mammy images, suppressed her individuality and effectively separated her from the African American ethnic discourse about hair. How many women represent themselves publicly or in photos by wearing the clothing or the hair covering they might use when cleaning the house? My mother-in-law recounted that when she and her sisters were growing up in Connecticut, they were not allowed to be seen outside in a headscarf or with their hair uncombed because this would link them visually to these mammy stereotypes. In addition, their hair could not be done in a style with a great number of small braids because that would too closely resemble the pickaninny image. A person's character could be discerned from how her or his head was represented visually.

Stereotypes clearly affected the self-perceptions of African Americans in complicated and persistent ways, posing threats to their dignity. Hair and treatment of the head with hats or scarves signified a variety of meanings or presented social codes. Representing black women as mammies wearing bandannas contained the whole cultural discourse about hair within a stereotypical image. Aunt Jemima was the best-known and most stereotypical incarnation of the mammy. To understand her stereotype, perhaps it is useful to take a cursory look at the idealized white woman for whom she was an antonym while keeping in mind the statement from Toni Morrison cited in chapter 1: "the subject of the dream is the dreamer."

David Lubin, in his interesting book *Picturing a Nation*, argues that in nineteenth-century America a system of values was in place in which "a female's worth (typified synecdochically by her breasts) is calibrated by her proximity to or distance from an ideal age, which is to say, the age of being marriageable." The

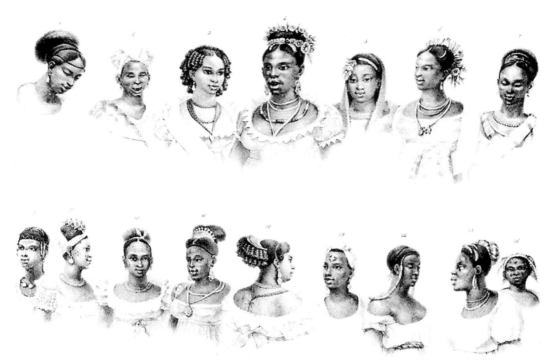

**FIGURE 39.**

*This illustration showing the hairstyles of slave women in nineteenth-century Bahia, Brazil, documents the attention and artifice black women gave their hair. There is no reason to believe this to have been different anywhere in the African diaspora. Jean-Baptiste Debret,* Escravas Negras de Diferentes Naçoes *(n.d.), from Boris Kossoy and Maria Luiza Tucci Carneiro,* O Olhar Europeu: O Negro Na Iconografia Brasileira Do Século XIX *(São Paulo: Editora da Universidade de São Paulo, 1994).*

decorous value of a woman aestheticizes her, something that "makes her seem less a person than an abstraction: a symbol of beauty, innocence, spirituality, narcissism, danger or whatever, but a symbol nevertheless. And this is a necessary precondition to her social and political subjugation."[34] Lubin points out that during the Victorian era in England the age of marriage was *raised* to fourteen, and ideas about childhood, innocence, pubescence, and female adulthood began to be entwined in complicated ways. Puberty formed a fine line of distinction between childhood and womanhood, but Lubin also suggests that cultural spokesmen of the day such as John Ruskin, the mass media, and men in general urged women "to be like children" while at the same time condemning them for being childish.[35]

A woman functioned as an object of desire, a decorous adornment in the home of a man of means, and as the mother to the children. Elizabeth Johns notes that women were "the moral center of the nation, with special gifts and responsibilities" and meant to "exercise their gifts and responsibilities exclusively in a home-centered life."[36] During the nineteenth century, white women could

not vote, enter universities, or serve on juries, and a married woman's wages usually were given directly to her husband. Among the few professions open to women were domestic work, factory work, teaching, and prostitution; an exceptional few were writers. Philosophy and political activity were male spheres, and most art of the nineteenth century placed women in domestic settings—their prescribed social space—or had them function as symbols.

The Woman's Building at the 1893 World's Columbian Exposition was designed by a woman architect, Sophia G. Hayden, but the exhibits on display in the building emphasized the woman's role as "educator, housekeeper, and minister of the afflicted."[37] Maud Elliott, in the official publication about the Woman's Building, suggested that the architecture was consistent with perceptions of the nature of women: "Our building is essentially feminine in character; it has the qualities of reserve, delicacy, and refinement. Its strength is veiled in grace; its beauty is gently impressive; it does not take away the breath with a sudden passion of admiration, like some of its neighbors, but it grows upon us day after day, like a beloved face whose beauty, often forgotten because the face is loved for itself, now and again breaks upon us with all the charm of novelty."[38]

Numerous paintings and architectural panels at the fair by American artists presented women as admirable middle- and upper-class figures, pious women exhibiting their devotion or exemplary morality, or as allegorical figures signifying national or moral ideals. One panel representing a contribution from New England for the decoration of the Woman's Building used imagery of Pilgrim women (figure 40) to articulate the place of women in American society. The women are young, slender, modestly dressed, and engaged in activities connected to child care and the home. Elliott described the significance of the work: "... the dress and bearing of the women [are] reserved, simple, and full of character. The thought behind the picture needs no criticism, it is an assertion of the prime duties of women, the home-maker and care-taker; it is a hint full of significance to our day and generation, reminding us that unless the higher education now open to our sex makes women better and wiser wives and mothers, it is a failure."[39]

Many of the paintings by American artists at the fair depicted women in domestic settings or caring for children, emphasizing their role as moral anchors for the family and society, but a number of artworks adorning buildings presented women as symbols of male domains. Two images from the Manufactures Building exemplify the way that popular illustrations "commonly made use of healthy, robust, Anglo-featured young maidens to symbolize the nation and its interests or needs."[40] J. Carroll Beckwith's image *The Telephone* (figure 41) was in the Manufactures Building dome of the North Portal and shows a woman using the newly invented telephone. She is wearing a garment to cover

FIGURE 40.

*Lucia Fairchild, study for* The Women of Plymouth, *decorative panel, the Woman's Building, World's Columbian Exposition, Chicago, 1893, oil, 23″ × 20″. Courtesy of the Pocumtuck Valley Memorial Association, Memorial Hall, Museum, Deerfield, Mass.*

**FIGURE 41.**
*J. Carroll Beckwith,*
The Telephone,
*from a dome of*
*the north portal,*
*Manufactures*
*Building, World's*
*Columbian*
*Exposition,*
*Chicago, 1893.*
*Frank D. Millet,*
*J. A. Mitchell,*
*Will H. Low,*
*W. Hamilton*
*Gibson, and*
*F. Hopkinson*
*Smith,* Some
Artists at the
Fair *(New York:*
*Charles Scribner's*
*Sons, 1893), 23.*

her torso, but it is so sheer and tight fitting that we can see her navel. Nonetheless, she is symbolizing and decorating the telephone rather than functioning in a real way. The billowing skirt falling from her hips seems more suggestive of sexual or voyeuristic promise than reflecting the dress of a woman who might visit the fair. It is only in this type of allegorical image, or in romantic imagery of distant places or times, that we find nudity or sensual imagery at the fair.

Another female image, *Pearl* (figure 42) by Walter Shirlaw, was in the dome of the North Portal. This woman was merely decorous and had no association with a product of American industry or invention. She is draped in gossamer fabric that floats behind her in a fortunate breeze. The cloth accentuates rather than conceals every sensuous curve of the woman's body, revealing her navel, the contour of her hips, and even the outlines of her tumescent nipples. Pearl is a female nude who has been draped just enough to maintain a level of modesty acceptable for the public occasion.

Both images presented an idealized Anglo-featured white womanhood. The small breasts on the telephone image woman suggested that she may be just reaching puberty, but neither woman was reclining nor primitivized in ways to make them sexually available or expressive of wanton sexual behavior. Both were idealized symbols of the burgeoning promise of America at the end of the nineteenth century. They were catalogs of the physical characteristics of idealized white women, and their function was primarily to adorn or support the work of men. It is possible to speculate that this idealized womanhood as pubescent youth may have been a result of male nostalgia for an adolescence of missed opportunities and unappreciated beauty (in addition to the obvious features of control and domination made easier by submissive, innocent women in need of instruction and protection). The puritanical influences in American society, like the Victorian history of England, served to make frank sexuality forbidden; so the more blatant artistic representations of sexually desirable women tended to appear in the art of continental Europe, especially that of France. This does not mean that the same issues and desires were not present, but they tended to play out in ciphers and subterranean formats in the United States. The idealized female was therefore white, slender, young, girlish, innocent, decorous, domestic, and submissive. As an allegorical symbol she was scantily clad, or wore revealing clothing, and her hair was long and flowing. The ideal-

ized domestic woman was dressed in modest cloth-
ing, was most often depicted as engaged in domestic
or child care activities, and emblematized the nation's
moral integrity. She was neither nude nor depicted in
sexual situations.

The mammy and the Aunt became synonymous.
She was black, older, usually overweight, worldly wise,
and a bit aggressive (aggression being a masculine
characteristic). She dressed for service in long dresses
and an apron, covered her hair with a bandanna, and
did difficult labor. Carroll, speaking of his mammy,
recalled that, "[e]arly each morning, she could be
seen waddling up to the big house from her cabin.
She would be freshly dressed in clean raiment, a
freshly ironed and starched white apron completed
her attire."[41] She was perceived as asexual and able to
roam freely throughout the home because she was

undesirable to white males, and a comfort rather than a threat to the white
woman. Her loyalty extended to a leadership role in bringing together other
blacks to cooperate with the interests and work objectives of the white master.
The mammy was presented as the ideal of black womanhood, and this con-
cealed her sexualized counterpart, the Jezebel (to be discussed in chapter 4),
who was hidden for renegade consumption by the white male so inclined and
who represented the immoral antonym of the chaste female ideal.

Racial and gender roles were organized in part by concerns about sexual and so-
cial interactions. Thus black men were severely restricted in their access to
white women, and white women were protectively restricted in order to limit
their availability to black men. Black women were represented by mammy
figures and this masked white renegade desire for young black women by white
men, who also retained exclusive sexual access to white women.

Nancy Green in the persona of Aunt Jemima at the 1893 World's Columbian
Exposition should be seen as a cipher, an antonym to idealized white woman-
hood, and a producer of white wealth and comfort. Morgan argues that Aunt
Jemima was "a supporting player in affirming the stereotype of the Euro-
American woman" because her role as a pancake mix trademark symbolically
placed her in kitchen service for white women, aiding their domestic roles while
confirming their status.[42] Also, as a survivor from the Old South, "her continued
service to a white mistress, now her northern employer, was a reunifying gesture
toward North-South reconciliation." She was an easy solution to the problem of

FIGURE 42.
*Walter Shirlaw,*
Pearl, *from a*
*dome of the*
*north portal,*
*Manufactures*
*Building, World's*
*Columbian*
*Exposition,*
*Chicago, 1893.*
*Frank D. Millet,*
*J. A. Mitchell,*
*Will H. Low,*
*W. Hamilton*
*Gibson, and*
*F. Hopkinson*
*Smith,* Some
Artists at the
Fair *(New York:*
*Charles Scribner's*
*Sons, 1893), 19.*

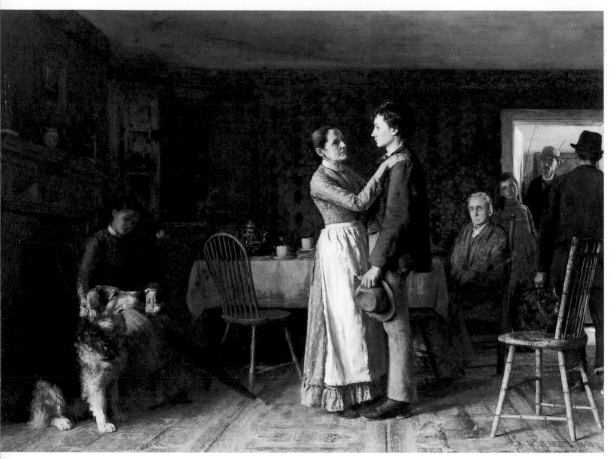

FIGURE 43.

*Thomas Hovenden,* Breaking the Home Ties, *1890, oil, 52¼" × 72¼", Philadelphia Museum of Art, Gift of Ellen Harrison McMichael in memory of C. Emory McMichael, 1942. This was the single most popular painting at the Chicago World's Fair, despite being dismissed as too anecdotal by critics. The men are either heading out the door or have come in from outside, while the women populate the interior space and engage in domestic labor.*

assimilating the former slave population into society without presenting new competition for jobs, and she kept middle-class white women in their ladylike roles as home administrators.[43]

In addition, it is appropriate to suggest that Aunt Jemima was white male minstrel transvestism in the guise of the mammy and that Nancy Green was playing that character. The transvestism was literal, and complex, because the original performance of Aunt Jemima was done by Billy Kersands, a black performer in blackface, acting out a white male performance form and imitating a lamenting mammy doing a cakewalk.[44] Morgan points out that as early as 1844 "George Christy of Christy's Minstrels was renowned for his impersonations of African-American women."[45] The Aunt Jemima routine was comic and pan-

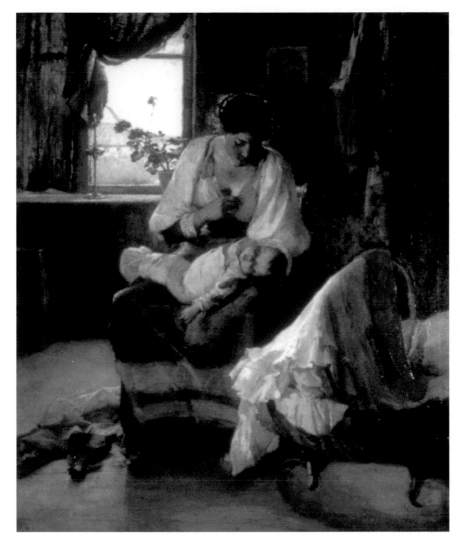

FIGURE 44.
*Alice D. Kellogg,*
The Mother,
*1889, oil,*
*38½″ × 32½″.*
*This work*
*appeared as*
*a frontispiece*
*in* Century
Illustrated
Magazine *in*
*January 1893*
*prior to its*
*inclusion in the*
*World's Fair*
*exhibition. Jane*
*Addams Hull-*
*House Museum,*
*University of*
*Illinois at*
*Chicago.*

dered to white audiences, while broadcasting underground sentiments to black audiences. With this genealogy, Nancy Green's performance seems to be a fourth cousin to actual black reality—related but distantly so.

Nonetheless, Green's appearance at the fair firmly established Aunt Jemima in the public mind. People gathered at her display for pancakes, folklore, and conversation in a script drawn in part from the minstrel song, memories of her own plantation days, and her imagination. Purd Wright, the original advertising manager for Aunt Jemima products, devised a souvenir lapel button to pass out to the visitors jamming the aisles; on it was a likeness of her and the caption he had invented, "I'se in town, honey." According to Marquette: "Her audience took up the phrase and it became the catchline of the fair. Special police had to be recruited to monitor the exhibit. Davis claimed later that more than 50,000

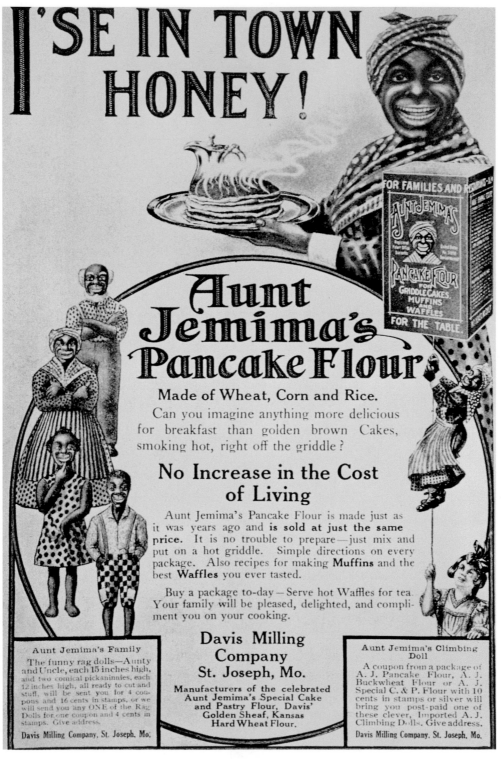

orders for his pancake flour were placed at the fair by merchants from all over the world."[46]

Soon thereafter, Davis and Wright published a souvenir booklet, *The Life of Aunt Jemima, the Most Famous Colored Woman in the World*. The company prepared a narrative about her plantation life in the Old South along with factual material about her triumph at the fair—she was named Pancake Queen—and the medals and certificates she received.[47] Among the plantation myths wrapped around Aunt Jemima was one showing her devotion to her plantation "employer," Colonel Higbee. When the Union soldiers arrived at his plantation on the banks of the Mississippi, they were about to tear Higbee's mustache out by the roots. Aunt Jemima saved him, though, by offering the troops her pancakes, and in their excitement the Colonel was able to escape. An important myth was that Aunt Jemima shared her secret recipe with her beloved white family, and now they were making it available to everyone.

One of the more successful marketing ploys promoting Aunt Jemima Pancake Mix was used in 1905: customers could send in a box top from a carton and twenty-five cents to receive an Aunt Jemima rag doll. This expanded on the 1895 gimmick of printing cutout paper dolls of Aunt Jemima on the new packaging cartons that were replacing the old one-pound sacks of the mix. The rag doll offer was so successful that it was claimed that "almost every city child owned one." Eventually, a whole family was created, with Uncle Mose as the father and two "moppets," Diana and Wade, as the children.[48]

An advertising series describing the legend of Aunt Jemima was launched in the October 1918 issue of *Ladies' Home Journal*, with images drawn by N. C. Wyeth.[49] This same ad estimated that over 120 million Aunt Jemima breakfasts were served annually. Just before the Quaker Oats Company acquired Aunt Jemima in 1926, the rag doll was again offered in a national magazine. The sponsor was swamped with requests from women who said they grew up with Aunt Jemima dolls and now wanted them for their daughters.[50] Marquette tells of other promotions that distributed the name and myth of Aunt Jemima as widely as possible: "Latter-day promotions have distributed four million sets of Aunt Jemima–Uncle Mose salt and pepper shakers in polystyrene, and 200,000 dolls in vinyl plastic. A cookie-jar premium shaped like Aunt Jemima sold 150,000. Another premium sought by more than a million housewives was a plastic syrup pitcher."[51]

The mammy as personified by Aunt Jemima was so widely dispersed into the American consciousness that she continued to make popular culture appearances in the 1990s. When the U.S. Post Office issued its Classic American Dolls stamps in 1997, only two of the fifteen stamps on the sheet depicted black dolls. One of these appears to be a mammy doll and is named "Babyland Rag" from

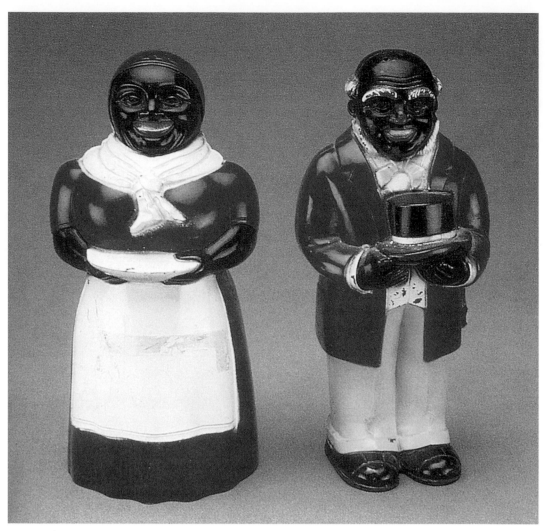

1893 (figure 47). She is the only *servant* doll depicted, clad in an apron and head-scarf, and it is far too easy to see this as a mammy doll related to the Aunt Jemima rag doll promotion of about twelve years later. Goings has written that, "after slavery, the headkerchief came to symbolize the 'happy darkie' (particularly the mammy) of Old South mythology."[52] How many young girls play in headscarfs and aprons? This is a doll depicting an adult.

The mammy has been a symbolic site of contention about the representation of black womanhood for so long that even today anything resembling a mammy can be offensive to African Americans. The deluge of Aunt Jemima images, myths, and advertising objects, including rag dolls, has saturated American society to the point where it is impossible to miss any allusion to the ubiquitous trademark mammy. With the Babyland Rag doll stamp, 7 million more entered service.

## REPRESENTING THE SELF

*What then did you expect when you unbound the gag that had
muted those black mouths? That they would chant your praises?
Did you think that when those heads that our fathers had forcibly
bowed down to the ground were raised again, you would find
adoration in their eyes?*

—*Jean-Paul Sartre, "Orphée Noir" (1948)*

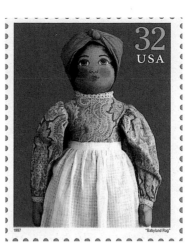

FIGURE 47.
*Stamp of
"Babyland Rag"
doll, manufactured
ca. 1893–1928,
Classic American
Doll stamp series,
U.S. Postal
Service, issued
July 29, 1997,
pane of 15,
4424840.*

During the late 1960s and early 1970s, artists like Jeff Don-
aldson, Joe Overstreet, Murry DePillars, Betye Saar, and Jon
Lockard transformed Aunt Jemima images in ways that made
distinct political statements about them, but they did not re-
produce the original images as pop culture icons like Warhol's Marilyn Monroe.
Instead, they interceded to manipulate them for effect, deconstructing the vi-
sual sign, questioning Aunt Jemima's role as a popular trademark, and giving
voice and humanity to all the black women aggrieved by the stereotypical rep-
resentation of Aunt Jemima and the mammy image. Still, because Aunt Jemima
had become an image found in graphic media and product advertising, most of
the images used to repudiate the fantasy were more graphic in character than
painterly.

One of the first Aunt Jemima transformations was done by Jeff Donaldson
(figure 48) in 1963. Donaldson was in Chicago watching on television the March
on Washington and Martin Luther King Jr.'s famous speech. Donaldson was not
enamored with nonviolent tactics, and he felt disappointed that King gave no
marching orders; he gave no charge to African Americans for specific actions
after the march. So two years before the 1965 Watts uprising in Los Angeles,
Donaldson visually predicted that the struggle for rights would move to the
streets with the "minions" of the black community in confrontation with the
representatives of white oppression. Moreover, he reasoned, what figure em-
bodied the working people of the community more than Aunt Jemima did?[53]
Donaldson visualized black resistance as being centered in vernacular culture,
the historical locus of refuge and much resistance to slavery and oppression. It
was here that we found the signifyin' dance, the cakewalk, and the trickster
tales, in which the mighty were overcome by guile and wit. Aunt Jemima be-
came a sign of black vernacular resistance in Donaldson's painting. It was what
Moyo Okediji describes as a counterhegemonic effort.[54]

Donaldson took the American flag and abstracted the stripes into a chevron
pattern that might make it seem at first as if the flag is furled in the wind. This
rhythmic pattern would become quite prominent in the art of AfriCobra, the
important artists's group that Donaldson helped found in 1968, and it has

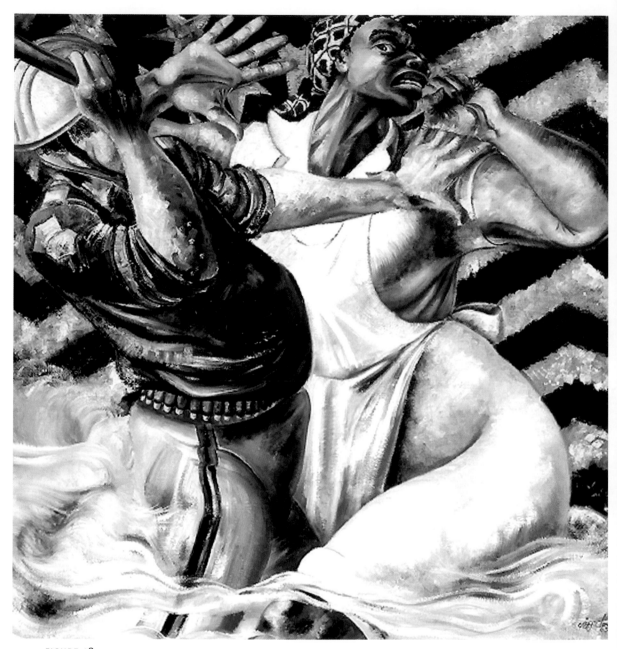

FIGURE 48.
*Jeff Donaldson,*
Aunt Jemima
and the Pillsbury
Doughboy, *1963,*
*oil on canvas,*
*48″ × 48″.*
*Collection of*
*the artist.*

antecedents in Kuba cloth and other African decorative traditions. The two combatants are reinterpreted product icons, and as such they allude to the economic basis for a great deal of race conflict and openly comment on the corporate/big business complicity in slavery and black oppression. Many of the best-known mythical black characters in the twentieth century—including Aunt Jemima, Uncle Ben, the Gold Dust Twins, and Rastus—were put forth to the public as product trademarks to produce white wealth. They were double ser-

vants: Negroes at work as servants but also at work in the service of free enter-
prise. The Pillsbury Doughboy transformed into a truncheon-wielding police-
man represents a corporate front man, thus suggesting that the struggle in the
street will be between the working folk and the agents of corporate interests.

Donaldson's Aunt Jemima is a large, powerful woman, but her size suggests
strength and vigor; she is not overweight or elderly. (Nancy Green was fifty-nine
when she appeared at the Chicago fair.) The work is executed in Donaldson's
early style, an outgrowth of Hale Woodruff's Atlanta University "Outhaus"
school of painting, which improvised on American social realist painting and
employed "broodingly rich color, heightened muscularity and dynamic lineal
effects."[55] Jemima's apron and scarf locate her in the working world of domes-
tic or food service, but she has been humanized and cannot be beaten back into
myth and fantasy. Here it is the policeman who is faceless, frozen in anonymity.
Donaldson's Aunt Jemima is no smiling servant, nor is she a long-suffering
victim. From the vantage point of the 1960s, she was to be seen as rooted in
confident self-awareness and as the first wave of resistance and protests to come.

Joe Overstreet, who worked in New York, began a series of protest paintings
and collages in the late 1950s and early 1960s that assaulted stereotypical im-
ages. Throughout his career, Overstreet has combined an interest in social or
cultural content with an exploration of form and technique. In 1964 Overstreet
constructed a life-sized box to create an image of Aunt Jemima that can be
linked thematically to the pop art movement, but he transformed the advertis-
ing icon into a political statement that moved in far different directions than
Andy Warhol's pop icons.[56] The initial version of the painting was smaller, but,
at the encouragement of artist Larry Rivers, he created a larger version for an
exhibition in Houston.

In Overstreet's *New Jemima* (figure 49), the pancake icon has a machine gun
and seems to have tossed a hand grenade among the flying pancakes. Mary
Schmidt Campbell wrote that "[u]nlike the images of [Charles] White, [Jacob]
Lawrence, [Romare] Bearden, or [Mel] Edwards that interpreted experience,
Overstreet's *New Jemima* sought to destroy a tradition, the 'colonized' tradition
of a docile nurturing Black people."[57] His narrative is a political and symbolic
one predicting or prescribing action rather than recalling experience, though it
had its roots in his childhood experiences in Conehatta, Mississippi, where he
lived until he was eight years old.

Overstreet recalled playing Sambo in a school play and "running around and
around a tree" until he melted into butter, which his sister scooped up with a
spoon.[58] He says that *New Jemima* came out of his "sheer frustration" with white
oppression and his reaction to the 1963 bombing of the 16th Street Baptist
Church in Birmingham that killed four young black girls attending Sunday

school. He linked his work to the civil rights movement and to his desire to "break the idea of black servitude and stereotyping." He also did a work protesting the lynching of black men, *Strange Fruit*, that visualized the protest in the song of that name by Lewis Allen, made famous by Billie Holiday's rendition of it.

Overstreet was angry and frustrated by the derogatory depictions of black women and wanted to express the black community's sense of resistance to and revolt against stereotypes, misrepresentations, and oppression. He also expressed an acute awareness of the frightening and harmful effect of stereotypes on black children. He said that Uncle Remus sitting with a white girl on his knee talking of throwing Br'er Rabbit into a briar patch was a frightening vision for him when he was very young. For these reasons, he strongly dissociates himself from black artists who revive derogatory black stereotypes in their work.

FIGURE 49.
*Joe Overstreet,*
New Jemima,
*1964, acrylic on
fabric over ply-
wood construction,
102⅜" × 61" × 17".
The Menil
Collection,
Houston.*

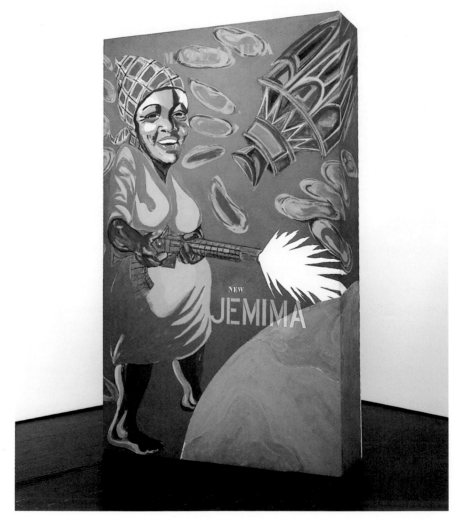

Overstreet, unlike Donaldson, used a face based on the Aunt Jemima seen on pancake boxes, but he transformed her smile from that of a comforting servant into a sarcastic one that insinuates the danger she presents to the status quo once she has removed her "happy darkie" mask. In many ways this image revives the critical undercurrent at the heart of the original minstrel performance. Overstreet replaced Jemima's long dress and apron with a shorter, light dress that carried no occupational implications. He undermined the mammy stereotype of the black woman by recontextualizing her and giving her agency. He turned her around to be an indictment of her inventors; she was evidence proving their commission of racial crimes.

During the 1960s Murry DePillars lived in Chicago and was inspired and influenced by Donaldson and Charles White, but he clearly had his own vision. While growing up on Chicago's West Side, DePillars did not encounter any whites other than "the mailman, milkman, and the insurance man."[59] He would get up early in the morning as a child and walk with his mother to the bus stop as she went to work. At the bus stop, he heard the conversations of black women, many of whom were on their way to work as domestics in the homes of whites. Their conversations centered on subjects like family, children, and working in white homes. They talked about the illusions that later were aired on the *Ozzie and Harriet* and *Father Knows Best* television shows and discussed the realities they saw that were quite different.

By 1968 DePillars had returned from a stint in the military and was attending undergraduate school at Roosevelt University. He had nearly enough credits to get a degree in political science or sociology, so his understanding of black social realities was well developed. He recognized that "women, period, were treated as property," and he linked the plights of white and black women, having read about "tobacco brides" in colonial America—women who could be mail-ordered from poorer regions of Great Britain for a certain weight of tobacco because the shortage of white women in the colonies made companionship scarce. He also realized that black imagery "was suspect in the classroom environment," so he learned to produce one kind of work in class and another kind at home. *Aunt Jemima* (figure 50) was done at home as part of a series of three works dealing with the subject.

The woman in the work was, in DePillars's mind, an archetype for women in general, but also she emerged from his memories of those women his mother sat with at the bus stop. DePillars remembered the contradictions between their realities and the media constructions of black women like Aunt Jemima and Beulah. It all gelled one evening after work in the latter part of 1968. He says, "It all began to make sense, and I could see the image."

DePillars wanted to capture the image, spirit, and value system of those

FIGURE 50.
*Murry DePillars,*
Aunt Jemima,
*1968, pen, ink,*
*and pencil,*
*37" × 31¼".*
*Collection of*
*the artist.*

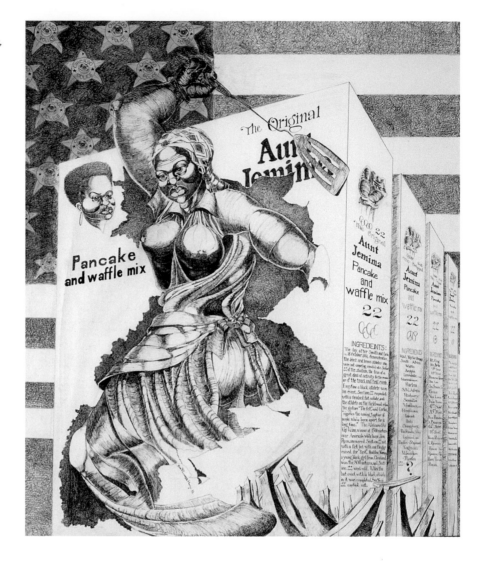

black working women of his childhood. He thought about the certainty he saw
in Fannie Lou Hamer's eyes and the power he heard in Bernice Reagan's voice.
The muscular arms of the central figure are a metaphor for the power he saw
in those working women and the powerful voices of Hamer and Reagan. The
muscularity of the figure and the linear qualities of the image link it to the style
of Donaldson's earlier image and show the influence of Charles White, who
made robust, hard-working women into heroic, almost mythic figures in his
work. The full breasts have a quality to them that echoes the naked breasts
found in African art, particularly Yoruba carving, a fullness and firmness sug-
gesting the ephebism and fecundity of child-bearing women. DePillars says that
women are "keepers of the water," the life-giving characters in the communal
drama, and the breasts imply this role. The firm breasts undermine the meno-
pausal nature projected for the stereotypical Aunt Jemima, but they do not fully

sexualize her. Many black men do not aestheticize breasts with the emphasis common in some other communities, instead preferring to focus on the derriere. Deciphering *Aunt Jemima* with this in mind does not completely subvert the masculinist character of the image, but it tempers a sexist and sexual reading of the work.

DePillars's drawing depicts Aunt Jemima exploding from the conceptual imprisonment of caricature. Here she is a symbol of aggressive resistance to white containment, both containment imposed by caricature and, as implied by the police badges that make up the stars on the American flag contextualizing the scene, containment by the agents of white political authority. The four boxes in the image indicate the constructed reality and ideas that have contained Aunt Jemima, black women, and African American people. Freedom would involve more than changing laws of segregation. It would require tearing free from the box that had normalized and naturalized assumptions about blacks, which blacks had adopted in everyday living: the box of double consciousness and self-deprecation.

The second box compares the Robert Taylor Homes housing project in Chicago with conditions for blacks in South Africa and Angola. Believing any colony to be the same as another colony and blacks to be colonized in America, DePillars uses the question mark at the bottom to ask where the next colony will be. The third box lists people DePillars considered inspirational: friends from his West Chicago neighborhood, such as Montez Reynolds "who could solve a [math] problem faster than anyone."

DePillars, like Donaldson, used the American flag to signify the racially oppressive structures of the United States—a strategy used by many African American artists during this era. Though whiteness was still transparent, African American artists had found an image that could embody and metonymically represent all the oppressive white structures, acts, and ideas that had done such violence to their community for so long. The violent attacks by the Chicago police on protesters at the 1968 Democratic Convention inspired him to transform the stars of the flag into badges with blue eyes in the upper left corner of the image to signify that America, in the artist's eyes, was a police state. Unfortunately, for the flag to succeed as a symbol of racial oppression, American identity had to be assumed and naturalized as white. That schism rearticulated the dilemma presented by Du Bois's 1903 description of double consciousness as a struggle within the black body: "One ever feels his two-ness,—an American, a Negro; two souls, two thoughts, two unreconciled strivings; two warring ideals in one dark body, whose dogged strength alone keeps it from being torn asunder."[60] Over sixty-five years later, blackness remained unreconciled with Americaness.

Jon Lockard worked in Detroit in the late 1950s painting billboards and advertising signs. During one assignment, he met Colonel Harland Sanders, who was there to open the first Kentucky Fried Chicken franchise in the area. Lockard did sketches that were used to create the billboard, and during the process Sanders told Lockard a story about a slave woman who was a cook on a plantation and made great fried chicken. No one knew her recipe, but she told the secret to Sanders's relatives on her deathbed. She used certain herbs and spices, mixing the coating for the chicken with a "pinch of dis and a dash of dat," as Sanders put it. Of course, this myth is very close to the fiction about Aunt Jemima's secret recipe, and it operates with many of the same stereotypical assumptions. For over a century, going back to minstrelsy, whites had given themselves the sanction of authenticity in their appropriations of African American culture and performance by constructing tales of chance encounters with certain individuals who shared with them secrets of dance, song, or recipes.

Lockard says, "Aunt Jemima was *every*where" at that time. What are now called collectibles were sold in Kresges and other five and dime stores.[61] Lockard felt that Aunt Jemima, and the mammy generally, was intended to represent a doting, giving enslaved mother figure who raised the master's children. To him, this reflected a negative attitude toward African American women and "made a large portion of the American population comfortable, which made me uncomfortable." By the late 1960s Lockard had moved to Ann Arbor and recognized the value of the artist as a social critic. It was there in 1972 that he created *No More* (figure 51), his homage to black women and his aesthetic response to Colonel Sanders and Aunt Jemima.

Lockard's intention with this work was to present the opposite of what the original image propagated. Aunt Jemima is scowling rather than smiling. A black power fist thrusts up through the box tearing apart the word "Aunt," thus symbolically destroying the term of address used by whites for older black women to suggest familiarity but to withhold the more respectful terms of address given to elderly white women like "Ma'am" or "Mrs." The side of the box where the lid typically is punched open contains the phrase, "Open at Your Own Risk." This referred to her mind because the personal thoughts and feelings of mature black women were ignored, but Lockard felt they had significant things to say. So many people responded strongly to this image that Lockard had it reproduced as a poster about four years later.

Interestingly, all four male artists transformed Aunt Jemima into a strong, resistant woman, but her resistance tended to take an aggressive, masculine form, with weapons and physical confrontations in several instances. All the works suggest the prominent role women played in black liberation struggles, which is consistent with the history of such women as Harriet Tubman, Sojourner

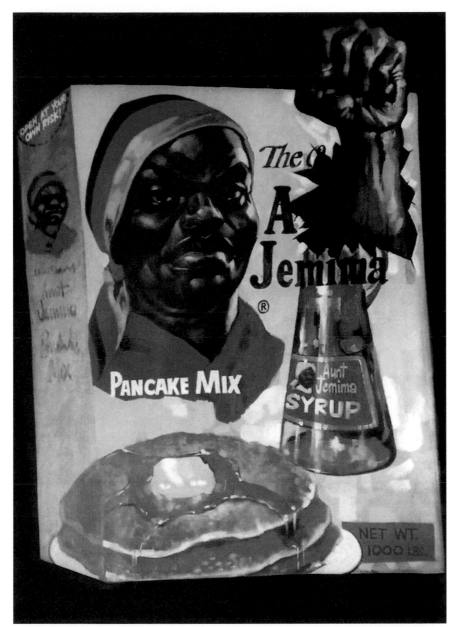

FIGURE 51.
*Jon Onye Lockard,*
No More, *1972,*
*acrylic, 40" × 30".*
*Collection of the*
*artist.*

Truth, Ida B. Wells, Rosa Parks, Kathleen Cleaver, Elaine Brown, and Fannie Lou
Hamer. The late 1960s and early 1970s were a period when African American
men attempted to assert their own manhood in ways that were subject to femi-
nist critiques in the 1980s and 1990s. Often the images of women by black male
artists in this era used different strategies than would be taken by women artists
in the coming decades. Many focused on physical transformations more than
on emotional insights.

Perhaps a too literal reading of these Aunt Jemima images confuses narrative

with allusion. It is possible to read these works as a shift into *signifyin'* and the reconfiguration of the pancake mammy as a trickster. Literary critic Henry Louis Gates Jr. suggests that signifyin' is "a mode of formal revision," "a trope in which are subsumed several other rhetorical tropes including metaphor, metonymy, synecdoche, and irony (the master tropes)," and it can function as a trope-reversing trope.[62] It was a way of troping the master's tropes. Gates uses the Signifying Monkey trickster from vernacular lore as the focus of his theory, emphasizing the possibility that this character represents the "ironic reversal of a received racist image of the black as simianlike," a character capable of "repeating and reversing simultaneously as he does in one deft discursive act."[63] Generally the trickster figure from West Africa, whether *Ananse* the spider from Ghana or the Yoruba *òrìṣà* Eṣu Elegba, is a character who outwits and humbles the mighty, the arrogant, or the powerful. In the case of Eṣu, we have a figure who is an instigator of transformation and metaphoric and metaphysical communication. He is the principle of indeterminacy because, unlike the *Ifá* corpus with which he is indelibly associated, he is the personification of unexpected, transformational potential. Perhaps because Eṣu is able to inject his will or whim, he might also be associated with improvisation, the cultural principle that informs black expressive culture and music.

These Aunt Jemima images at once signify with ironic reversal, signal the humbling of oppressors, and herald the anticipation of racial transformation. The visual representation of Aunt Jemima, once the obsequious, jolly, subservient, loyal mammy but now an angry revolutionary, suggests someone who has cleverly bided her time, masking her real sentiments, all the while tricking the master into complacency as a means of survival. How much more ironic can it be to take the icon of black stereotypical misrepresentation and to reverse it? This ironic reversal is doubled by the possibility that Aunt Jemima was a reversal of sorts for Jemima Susanna Lee, the octoroon girl in the minstrel song mentioned earlier who signifies the outcome of transgressive desire as a product of miscegenation, as well as serving as the inverse of the white woman. The masculine character of the images makes them trope-reversing tropes by unmasking the minstrel transvestism of Aunt Jemima to reveal the original male behind her. Aunt Jemima as a sign functions in a male discourse as the materialization of a male agenda.

What makes these signifyin' images effective is that they are reversed with a difference that exceeds mere mirroring. Here we encounter a complex visual rhetoric that induces aporia and effectively undermines a visual icon on its own terms. The artists are destabilizing a visual sign visually, making it a double entendre and a punch line. Even the fantasy constructions of blackness are not safe for continual consumption by whites. Gates cites Kimberly Benston as call-

ing this a "tropes-a-dope" strategy. This is not the verbal play of "Ain't jo mama on a pancake box?" This is the in-your-face retort of Langston Hughes:

> And they asked me right at Christmas
> If my blackness, would it rub off?
> I said, ask your mama.[64]

Betye Saar was one of the few women artists to take on Aunt Jemima during the early 1970s with her 1972 work, *The Liberation of Aunt Jemima* (figure 52). Saar's strategy involved using a background in a 2¾" deep shadow box with repeated images of the transformed, modernized Aunt Jemima of the Quaker Oats Company. The box format showed the influence of the work of Joseph Cornell, an artist known for constructing allegorical medicine cabinets in the late 1940s and early 1950s, and whose work Saar admired. Here in Saar's cabinet we find powerful antidotes and remedies for the mammy headache.

Updated Aunt Jemima images of varied sizes form a sort of wallpaper behind a stereotypical Aunt Jemima that originally was a notepad for a kitchen. Her eyes bulge, her lips are extremely red, and she is wearing a red-and-white checkered bandanna, a yellow polka-dot scarf around her neck, and a red flowered dress. The bright colors, clash of patterns, prominence of red in her clothing, and her exceptionally black skin, large bosom, wide-open eyes, and large full lips combine to play out some of the derogatory stereotypes commonly used against black women in the past. Saar said that "the black woman could *only* be seen as an Aunt Jemima or else she was seen as a hooker, a piece of property."[65]

In the center of the image, the notepad has been transformed into an image of a black woman caring for, as a mammy, what appears to be a white baby, but a black power fist thrusts upward interrupting the image and the concept. Saar says that the baby is a mulatto and serves as a testimony about how black women were "sexually abused or misused" in the household.[66] Aunt Jemima is carrying an automatic handgun on her right hip next to the broom (with a pencil attached to it) and has a military carbine on her left side. Looks are deceiving here, and the obsequious smile of Aunt Jemima proves to be a mask hiding what can be interpreted as Black Nationalist or militant black feminist sentiment lurking beneath the surface.

Saar's intention in this work was to take a figure "that classifies all black women and make her into one of the leaders of the revolution—although she is a pretty strong character anyway."[67] Like the other artists addressing the Aunt Jemima image, Saar identified with the plight of domestics and others forced into subservient roles, whose lives and character the stereotypes distorted. Like the other artists discussed above, Saar saw Aunt Jemima stepping out from behind the imagined persona and aggressively joining the liberation struggles

FIGURE 52.
*Betye Saar,* The
Liberation of
Aunt Jemima,
*1972, mixed
media, 11¾" × 8"
× 2¾". Courtesy of
the artist and the
University Art
Museum,
University of
California at
Berkeley.*

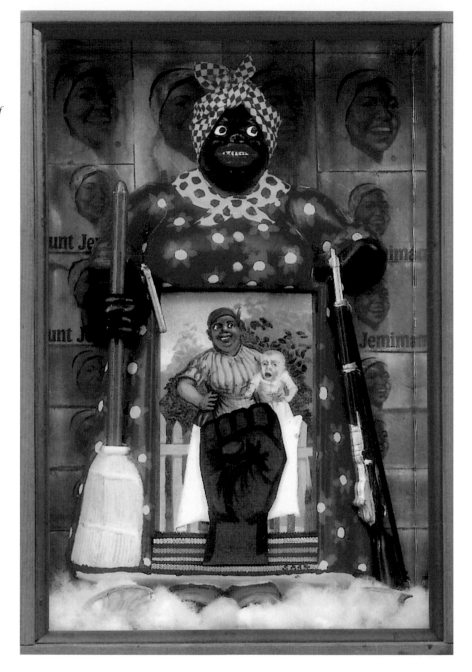

engaged by African Americans during 1960s and 1970s. Saar's strategy differed
from that of the male artists because she tried to defuse the stereotypical
mammy/Jemima image by recontextualizing it rather than visually transform-
ing it. She suggested that the harmless objects, now given the misnomer of
black memorabilia, were in fact very dangerous.

The persistence of Aunt Jemima, racial stereotypes, and the emergence of

young black artists who do art dependent on stereotypical imagery inspired Saar to revisit Aunt Jemima, mammies, and racist kitsch in a new series of works completed in 1997 and 1998. Saar writes that the work is about "the endurance and dignity of memory." She feels that the use of negative stereotypes is the "surfacing of the subconscious plantation mentality and a form of controlling black art." The works reflect her concerns about "the struggle of memory against the attraction of forgetting." Therefore, she concludes, "Aunt Jemima is back with a vengeance and her message: *America, clean up your act!*"[68]

The series of works is made from vintage washboards adorned with memorabilia objects, lettered statements, and, in some cases, painted or photographic imagery. In *Dubl—Duty—I's Back Wid a Vengeance* (figure 53), the mammy object balances the broom in her right hand with an automatic weapon in the left. In much the same fashion as was done in *The Liberation of Aunt Jemima*, household kitsch with demeaning imagery is transformed into an item containing militant danger. The central notepad contains an angry message assailing the racist history endured by many African descendants. On the bottom horizontal strip of wood can be found the slogan "Extreme Times Call for Extreme Heroines."

Again Saar has attempted to turn the Aunt Jemima/mammy construction on its head to make it an image of discomfort rather than one of comfort and service, but her dependency on language to do the subversion and inversion of the mammy icon may have undermined the effort. Saar has highlighted the problem, but her protest may not overcome the fact of her using the language of derision to protest its use. Recycling the original objects may be a too literal response and prevent slippage into a signifyin' discourse. If we use Gates's configuration of signifyin', we find that it depends on troping and difference. It repeats, reverses, layers, and doubles using the rhetorical devices of repetition, revision, chiasmus, metaphor, metalepsis, and hyperbole.[69] There is a turn of a phrase to twist the original out of shape; hence, troping a trope. There are limitations to translating rhetorical strategies into the visual because visual comprehension does not replicate aural perception, a fact attested to by the literary theories differentiating between the written sign and speech.

When images are contradicted by text, images win. The visual information in *Dubl—Duty* is not different enough from that in the original mammy memo holders for it visually to match Saar's written fury. Perhaps a picture can only be replaced with another picture, rather than undergoing the rehabilitation of modification.[70] *The Liberation of Aunt Jemima* was pulled into the region of protest by the clenched fist and the painted image just behind it. Images conflicted with images to create tension and commentary. The context of the time made the work appropriate. Still, the layering of irony and commentary atop the orig-

FIGURE 53.
*Betye Saar,* Dubl-Duty—I's Back Wid a Vengeance, *front view (right),* back view *(opposite)* *1997, mixed media on vintage washboard,* *18″ × 8½″ × 3″.* ©Betye Saar. *Private collection, courtesy of Michael Rosenfeld Gallery, New York, N.Y.*

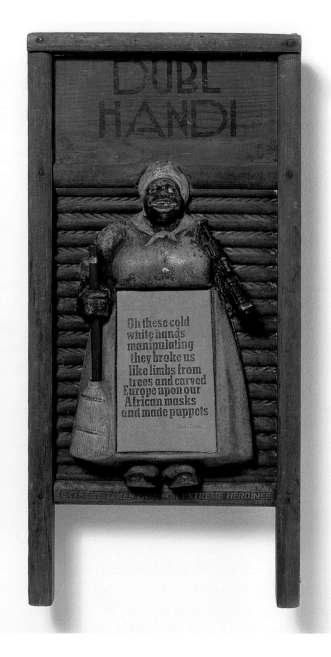

inal derogatory pastiche was risky. In fact, the subtlety of the work may be understood by women in ways men might not. In one woman's reading of the image, the placement of the figure atop a washboard implied that she had undergone the kind of hard, almost violent thrashing produced by washing clothes on such a harsh surface.

In the 1990s, twenty-five years after Jon Lockard's *No More, Dubl—Duty* has a different effect, though it does point to the fact that these stereotypes have not yet gone away. The work was motivated in part by the irony that African Amer-

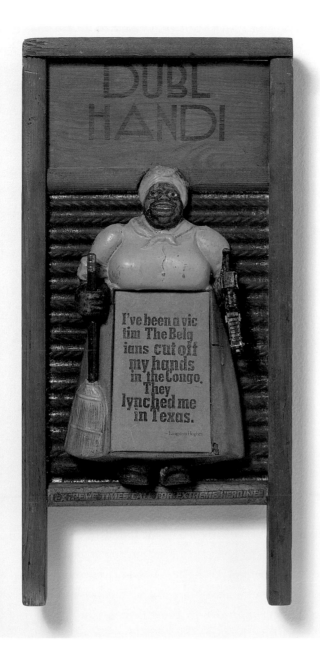

ican artists and collectors have significantly contributed to their continued presence in American society through reinterpreting them in art and preserving them as memorabilia.

Jon Lockard and Murry DePillars attempted to give voice, and perhaps humanity and ethnicity, to the black women working as domestics and cooks for whites as a way of exploding the mammy fantasy/myth. Jeff Donaldson, Joe Overstreet, and Betye Saar forcefully expressed the political consciousness behind

their images. Several attempted to reveal a woman behind the stereotype. All of them used Aunt Jemima as a site for symbolic and visual resistance against misrepresentation and social containment, with a keen recognition of the role such images as the mammy played in the subjugation of African Americans. Their intentions were counterhegemonic. Their various works have social realist roots and graphic characteristics or are based in the aesthetics and objects of advertising that reflect the popular culture context of Aunt Jemima. They adopted the lexicon and syntax of graphic media and popular culture to make statements in a more expressive realm. They gave visual form to the resistance felt by so many people to all those stereotypical images and imaginings. Those who placed the nexus of their resistance within the refuge of vernacular through levels of signification and the transformation of the mammy into a trickster stepped into a black cultural stream of protest and symbolic triumph. The trickster is the symbol of the powerless who must triumph through guile because they lack force. All of the artists emphasized that the Aunt Jemima/mammy construction was erroneous. She did not represent what African Americans thought, felt, or believed black women to be.

The fact that so many African American artists have chosen to repudiate the Aunt Jemima image indicates how terribly the stereotype, and others like it, affected African Americans. In addition to examples discussed above, Freida High's *Aunt Jemima's Matrilineage* (1982; figure 54), Faith Ringgold's *Who's Afraid of Aunt Jemima* (1983), and Renée Cox's *The Liberation of Lady J and U. B.* [Uncle Ben] (1998) are notable works subverting the pancake mammy. Saar's need to revisit the subject to repudiate the mammy twenty-five years after her initial protest is a testimony to the persistence of racist stereotypes. If we accept black caricatures to be products of white imagination, if we know that the minstrel song about Aunt Jemima concerned a fictional character embodying the invented concept of a mammy, then she is not a black woman. She is white fantasy in blackface, an embodiment of certain white needs and projections that have more to do with white identity construction than African American personalities. The fact that the source of inspiration for Aunt Jemima was a minstrel performance is telling. Minstrelsy itself was a fabrication, with whites pretending to be blacks acting out caricatures on stage in front of whites, who were spared the threatening experience of facing actual blacks, for they might step out from behind the safety and control of racial expectations.

Aunt Jemima and the sexualized black woman were signs in racial discourse. Stuart Hall notes that discourses are "ways of referring to or constructing knowledge about a particular topic of practice," and a cluster of related "ideas, images and practices" helps define "what knowledge is considered useful, relevant and 'true' in that context; what sorts of persons or 'subjects' embody its

FIGURE 54.

*Frieda High,* Aunt Jemima's Matrilineage, *1983, pastel on paper, 32″ × 45″. Collection of the artist. High says that women like actress Hattie McDaniel had stereotypical masks laid on them; "beneath this mask of performance and a look were human beings, human characters, who had histories and lives that they knew were beyond the gaze of these people who could only see the masks" (Frieda High Tesfagiorgis, interview with the author, tape recording, Madison, Wisc., May 6, 2000).*

characteristics."[71] Hall's statement is especially apt for discussions about racial discourses and how they worked to construct their truths and characters. To reiterate Morrison's point, "the subject of the dream is the dreamer." The construction of the mammy, like that of the Sambo, was a means of ordering white society and edifying white identity. As sociologist Steven Dubin suggests, "[A] superior position may only be confirmed if it is acknowledged in comparison to an inferior position in either real or symbolic ways."[72] Images of these characters, then, were signs in the racial discourse defining an epistemological reality dependent on blackness as oppositional and inferior to whiteness and reinforcing the "truth" of the whole discourse.

Clearly, the social struggles around race and gender were mapped and fought on visual terrain. Men like Donaldson, Overstreet, Lockard, and DePillars came to the fore initially to defend black women against the violence of caricature, but they also were fighting to establish a collective black masculinity by step-

ping up to protect the women of their families and communities. African American women like Saar took to the studio and began to represent themselves in complex and sensitive ways, paving the way for younger artists to articulate their concerns about race *and* gender issues. All these artists were aggressively forcing their way into the racial discourse and representing their own interests. No longer would the discourse be between men about women, just as the discourse about race no longer would take place only among white men.

# JEZEBEL, *OLYMPIA*, AND THE SEXUALIZED WOMAN

*The ethics my grandmother encouraged in her grandgirls followed her well-considered reflection*

*on the history of the gendered stereotype. When she warned us away from red, she reinforced the*

*persistent historical reality that black women's bodies are a site of public negotiation and private loss.*

—*Karla Holloway,* Codes of Conduct *(1995)*

During the nineteenth century, the black female body in art had become a signifier of sexuality, among other things, as myths of black lasciviousness became entwined with other sexist ideas. The female nude, long a classical subject in Western art, can be interpreted as evidence of patriarchal structures, an assumption of the universality of white male perspectives, and the appropriation of female bodies for male prerogatives. Exotic reclining nudes from harems, like Jean Ingres's *Grand Odalisque* (1814) and *Odalisque with a Slave* (1840; figure 57), were signifiers of colonial and imperial expansion out into exotic regions where such harems were thought to exist. These images in France evolved into blatant unabashed brothel women like the one in Manet's *Olympia* (figure 55) and took on the invasive voyeurism found in Degas's images of naked bathers in their private spaces.

In *Olympia* the African woman's presence is a signifier for sexuality and disease, an association that had been a part of the essentialist stereotyping of non-white women. In the nineteenth century, women of color were associated with nature, uncontrolled passion, and promiscuity. Often they were appropriated in colonial adventure along with the land, the culture, and the natural resources of colonized areas.[1] Hammond and Jablow tell us that in British literature black women "are stereotyped as creatures that are all body, without mind or soul."[2] The bold nude prostitute on the bed stares directly at the viewer, assumed to be an upper-class male in midcentury Paris, who has given her flowers. The African attendant heightens the sexual suggestion of the scene by her mere presence because of the implications assigned to her. Even dressed, she would be perceived by many Europeans as naked. As German critic Ivan Goll wrote about Josephine Baker in 1926, "They never dance naked: and yet, how naked is the dance! They have put on clothes only to show that clothes do not exist for them."[3] Sander Gilman writes that "one of the black servant's central functions in the visual arts of the eighteenth and nineteenth centuries was to sexualize the society in which he or she is found."[4] Here within the privileged space of the white male gaze is a layered black subject who is at once socially inferior to a naked prostitute, for whom she is a servant, and yet a sexual signifier and cipher; her mere presence is the equivalence of Olympia's nakedness. She is linked to the white woman because both are sexualized females. The black servant is socially invisible and therefore can be present in this most intimate encounter. Both female bodies are contained and controlled within male power, but the black woman as an object of sexual desire is codified and correctly deciphered only within male-dominated contexts.

Hammond and Jablow write that in English literature about Africa "the image of the African woman is never that of a whole woman. Whether drudge or sex-object, the literature reduces her to physical organs."[5] Similarly, Gilman

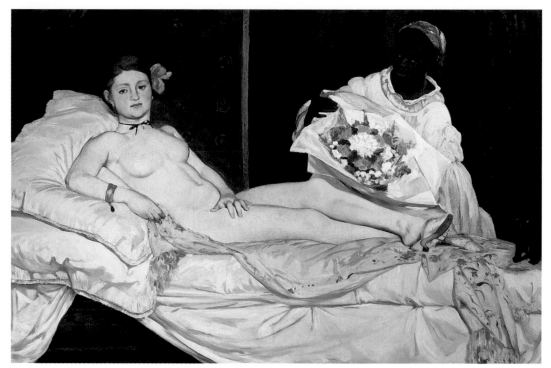

FIGURE 55.
*Edouard Manet,*
Olympia, *1863,*
*oil, 51⅜″ × 74¾″.*
*Musée d'Orsay,*
*Paris. Erich*
*Lessing / Art*
*Resource, New*
*York.*

observes that in the nineteenth century "the black female was widely perceived as possessing not only a 'primitive' sexual appetite but also the external signs of this temperament—'primitive' genitalia." Gilman discusses the plight of an African woman, Saartjie Baartman, who was displayed publicly like an exotic animal for whites to observe her buttocks and genitalia. After her death in 1815, her autopsy was published so that she could be compared physically as an example of the "lowest" human species with the highest ape, the orangutan, and to show her physical anomalies.[6]

The fascination with Baartman undoubtedly grew from medieval ideas about the wild forests being populated with mythic creatures like the satyr and the centaur. According to Jan Pieterse, these creatures suggested a "transitional zone between human and animal, and hence began a search for the missing link between humans and animals."[7] By the late eighteenth century, the Hottentots of southern Africa were thought to be that missing link. These notions affected the ideas of David Hume (1711–76) who produced a theory of biblical polygenesis. He wrote in the mid-eighteenth century a passage speculating that all other men were inferior to whites and the differences were so fundamental that they must have been formed by separate Creations: "There never was a civilized nation of any other complexion than white, nor even any individual eminent in action or speculation. No ingenious manufactures amongst them, no arts, no sciences. . . . Such a uniform and constant difference could not happen in so many

countries and ages, if nature had not made an original distinction betwixt these breeds of men."[8]

Twenty years later, former plantation owner Edward Long published his racist *History of Jamaica*, in which he divided humans into three categories: Europeans and other humans, blacks, and orangutans. His publication presented some of the more extreme attitudes about black sexuality and may have contributed to the fascination with Baartman, who has been called the "Hottentot Venus." According to Long, "[The Negro's] faculties of smell are truly bestial, nor less their commerce with other sexes; in these acts they are libidinous and shameless as monkeys, or baboons. The equally hot temperament of their women has given probability to the change of their admitting these animals frequently to their embrace. . . . Ludicrous as it may seem I do not think that an oran-outang husband would be any dishonor to an Hottentot female."[9]

Linking Baartman to Venus was a well-rehearsed sexual ploy, not a redemptive one, but it did serve to connect the sexual primitive to the sexual discourse already present in art. Titian's *Venus of Urbino* (figure 56), painted in 1538, was one of the first reclining nudes in Western art and served as the foundation on which Manet improvised in his *Olympia*. Titian's Venus is a courtesan, and her dog is replaced in *Olympia* by a cat. Such small dogs could be carried by the woman while in public and allowed a gentleman to approach her under the guise of asking about the pet.[10] If a woman was carrying the dog in her arms, the man's hand could slide from petting it to touching her face or shoulder to initiate familiarity.

The work was purchased by Guidobaldo II, the son of the duke of Urbino for his private viewing, and he called it *la donna nuda*—the naked woman—in his correspondence with his agents handling the purchase.[11] The new title linking the work to classical mythology came thirty years later. This new title linked the work's sexual content and implication allegorically to a goddess who was deemed to be the divine embodiment of carnal love.

Mary Pardo argues that the work was part of a carnal discourse that considered whether a painting could be as arousing as a sculpture because of the tactile offerings of three-dimensional work. Pardo writes that the gesture of self-touching in the painting "reproduces, within the fictive space of the painting, the tactile verification craved by the viewer"; this is "like the ecstatic doubling and displacement of self made palpable in the sexual act."[12] Various bedclothes, wall drapes, and the fruit in her hand accentuate the tactile qualities of the work, making the flesh more "palpable" by its juxtaposition with different textured materials. This is accomplished in *Olympia* with similar materials and flowers replacing the fruit.

The pictorial composition in *Venus of Urbino* is replicated in *Olympia* with

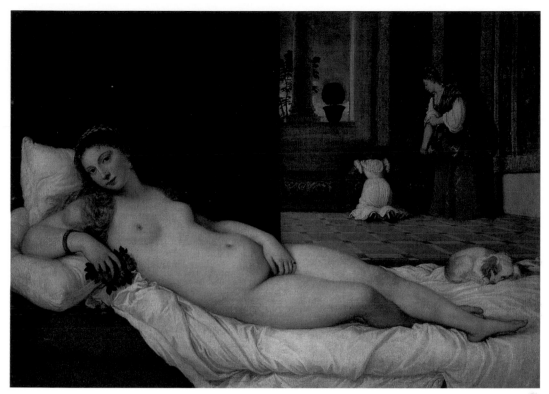

FIGURE 56.
*Titian*, Venus
of Urbino, *1538,
oil, 46⅞″ × 56″.
Galleria degli
Uffizi, Florence.
Scala / Art
Resource, New
York.*

each having the background divided by a vertical line thrusting down into the vaginal area, which is protected from visual intrusion by Olympia and caressed seductively by Titian's courtesan. In each case, the vertical line highlights the genital area of the nude woman. Tactile references act as visual artifice, making the voyeurism of the viewer the equivalence of sexual action; he is able to give the nude woman an ocular caress. Manet, in his mid-nineteenth-century work, eliminated all classical and exotic veneers and showed a French prostitute greeting her caller. He removed any possibility for an allegorical interpretation of this woman that would link her to Venus; he stripped away all the pretensions of the genre. He also flattened the forms in his painting, flattened the spatial depth of the room, and flattened the emotional implications of the work by giving a matter-of-fact gaze to the prostitute. The fact that each woman meets the viewer's gaze suggests that both women are complicit and compliant in the sexual arrangements, though the nude in Titian's work seems to indicate some desire, whereas the nude in Manet's painting appears to be moved only by commerce.

Although the nude woman in Ingres's *Grand Odalisque* has her back to the viewer, she looks over her shoulder to meet the viewer's gaze. She is a member of a harem, which is an added complication, and that fact introduces implica-

tions about colonial enterprise and the exotic, primitive sexuality to be found outside Europe. *Odalisque with a Slave* continued this theme, but a nonwhite male, presumably a eunuch, is depicted, and the nude harem woman has turned her head away from the viewer. In both works the European male viewer possesses the nude woman through voyeurism and fantasy because the paintings present an intrusive scenario: only the male possessor of the harem, eunuchs, and female servants legitimately could have visual access to the woman. All the painted harem nudes are available for visual consumption by the viewer—who is implicitly a European male. The painting presents the private vision of the harem master, and the European viewer has been cast in that role by the artist. All the nudes as paintings were available as artifacts for ownership and private consumption by male patrons, a fact that rehearsed or reiterated colonial and imperial adventure and its appropriation of land, resources, and people.

In the 1890s Paul Gauguin articulated a European male fantasy of primitive sexuality by brazenly presenting a world full of languid, sensuous brown women

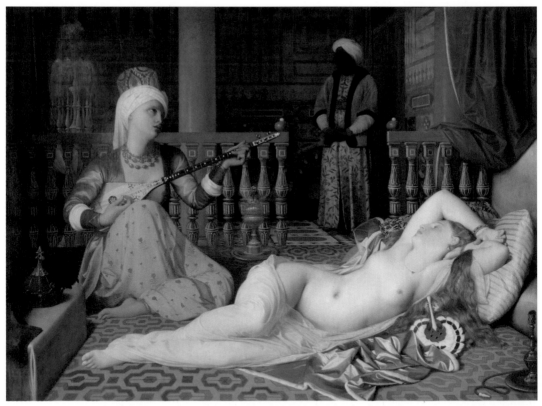

FIGURE 57.
*Jean Ingres,* Odalisque with a Slave, *1840, oil, 72″ × 100″.*
*Courtesy of the Fogg Art Museum, Harvard University Art Museums, Bequest of Grenvill L. Winthrop.*
*Photograph by Katya Kallsen, © President and Fellows of Harvard College.*

from the colonized South Sea islands (a world that was nearly devoid of native men). Two decades earlier, in 1872, a French sailor named Julien Viaud, whose nom de plume was Pierre Loti, spent time in Tahiti. His popular novel, *Rarahu*, later retitled *Le Mariage de Loti*, seems to have influenced Gauguin because the latter's own novel, *Noa Noa*, reveals many similarities in events, descriptions, and expectations regarding the people of Oceania; Gauguin also mentions Loti's book in his own writings. In *Le Mariage de Loti*, the narrator speaks of an affair he has with a Tahitian girl, Rarahu, who "had just completed her four-teenth year. She was a remarkably attractive young girl whose striking and sav-age charm defied all the conventional European standards of beauty."[13] Only the islanders recognized Loti's "marriage" as valid, but the use of the term in the revised title of the book served to legitimize, somewhat, his relationship with the young girl. Gauguin, almost mimicking Loti, at the age of forty-four became involved with a thirteen-year-old girl after rejecting another young *vahine* be-cause she was half-white and had been too involved with the French colonists and visitors on the island. Of the rejected one, he wrote: "In spite of traces of profoundly native and truly Maori characteristics, the many contacts had caused her to lose many of her distinctive racial 'differences.' I felt that she could not teach me any of the things I wished to know, that she had nothing to give of that special happiness which I sought."[14]

Gauguin's notable painting, *Spirit of the Dead Watching* (1892; figure 58), de-picts his young *vahine* as an inverted *Olympia*, but the black attendant and the reclining woman have become one.[15] Picasso articulated this same symbolic equation in *Les Demoiselles d'Avignon* (figure 59) in 1907 by placing African masklike faces on several prostitutes, thereby merging the primitivized white fe-male and the imagined libidinous black woman into one body. Black invisibility became complete and total in Picasso's work: the mask forms insinuated a black presence yet subordinated it to the white females whose sexual consumption was linked to the colonial physical consumption of Africa.[16] The convergence of European sexuality and African masks also was an act of disdain because it blas-phemed works that had functioned in religious contexts by placing references to them in the most discredited and profane of secular circumstances.

In *Spirit of the Dead Watching*, the spectatorship of the viewer as male caller in *Olympia* is shifted slightly to the viewer as artist/lover who is privy to Gau-guin's private vision, a position quite different from the voyeuristic perspective created by Degas's series of bathers. Gauguin's young subject has turned over onto her stomach, and Olympia's brazen gaze is replaced by a more demure, sidelong glance, one more befitting a submissive, pubescent girl. Yet, again, the subject gazes into the eyes of the viewer/lover. The darkness of her skin is heightened by its contrast with the white bedclothes—perhaps repeating the

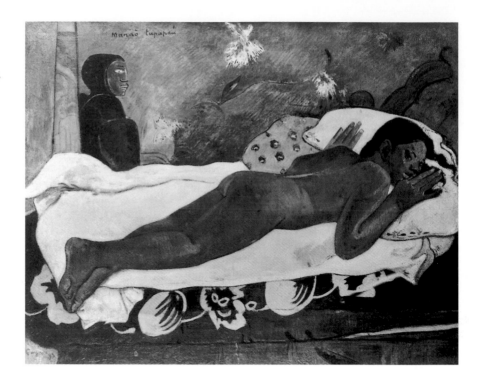

tactile artifice used in Titian's work—and the details of the setting strengthen the sense of the exotic. The flattened space of *Olympia* has become complicated by a sense of mythic and metaphoric space behind the bed. Phosphorescent sparks flash in front of a native god figure, and the whole area is energized by color modulations and brush strokes.

In 1894, two years after Gauguin painted *Spirit of the Dead Watching*, the Midwinter International Exposition in San Francisco had on display a photo of a South Seas woman (figure 60), which joined the tradition of reclining nudes. The San Francisco Exposition was something of a revival of the Chicago World's Columbian Exposition from the previous year and part of a sequence of fairs where the United States began to visually define its place in the twentieth century. The photo shows the woman in a pose from a male-dominated discourse, but she gives no evidence of willing compliance. Her gaze does not meet that of the viewer, and nothing in her expression or posture suggests any involvement beyond following instructions. The photo itself, however, suggests a willingness by the photographer to contribute to the existing tradition of artistic nudes. Though this tradition was largely absent from American art, the nudity of a primitive nonwhite woman was more acceptable than that of a white woman.

As Gilman has indicated, black or exotic primitives became signs of uncontrolled sexuality, and sexually available white women were linked to these characteristics in ways that both heightened their sexual connotations and sepa-

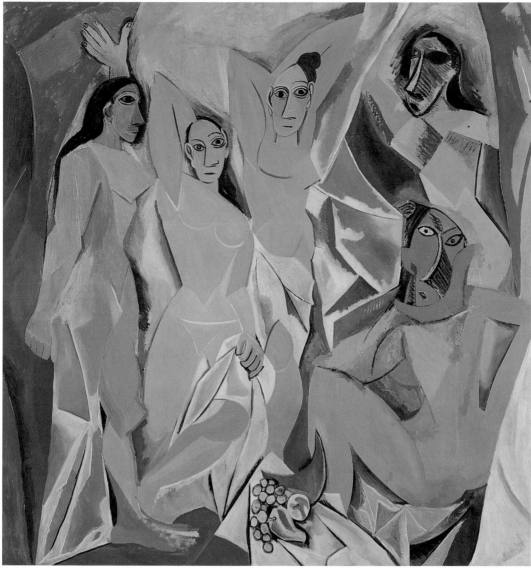

**FIGURE 59.**
*Pablo Picasso,* Les Demoiselles d'Avignon, *1907, oil on canvas, 8' × 7'8".*
*Museum of Modern Art, New York. Acquired through the Lillie P. Bliss Bequest;*
*photograph © 2002 Museum of Modern Art, New York. Scala/Art Resource, New York.*

rated them from the body of middle- and upper-class society. Men protected women of their own class from the dangers to be found in primitive sexual energy, yet many of these men were able to indulge their own fantasies by sampling forbidden sexual experience, as Gauguin was able to do in French colonial enclaves or as others were able to do voyeuristically through the images that privileged them.

Voyeurism in regard to a pubescent girl, such as Gauguin's subject, speaks to

**FIGURE 60.**
*"A South Sea Siesta in a Midwinter Concession,"* The Official History of the California Midwinter International Exposition *(San Francisco: H. S. Crocker Company, 1894), 164.*

a certain nostalgia for male youth and its vitality. David Lubin argues that "gazing at women voyeuristically is a means by which men may experience, reexperience or experience in fantasy their virility and all the potency and social worth that implies. Voyeurism by any definition, suggests detachment, estrangement, viewing from a distance."[17]

Voyeuristic engagement with the black/primitive woman safely separates the viewer from her dangers and reinforces his position within acceptable boundaries. He is white and gazes at the spectacle and danger of nonwhiteness, and he has the option of making real but disaffected forays into this realm as an exercise of his male prerogatives and power. Using the nonwhite female body as a spectacle, as was the case with Baartman, offers a stage to play out white moral superiority because the exotic woman is a sign of the wanton sexual danger that white society has mastered. Nudity, which was a sign of primitive status when "natives" were encountered in colonial regions, offered safe sexual action through fantasy and displacement: ocular consumption transferred the sexual encounter into the private mental realm of the viewer and allowed the requisite physical and social distance from the savage woman.

Victorian attitudes about women and sex informed English fantasies about black women in ways that made them similar, but not identical to, French and American sexual fantasies, which included mythic notions of "some ultimate sexual experience to be found only in Africa"[18] or, presumably, with Africans. Perhaps this is related to the "special happiness" that Gauguin was seeking in the Pacific South Seas. The complexity and social implications of this confluence of sexuality, objectified African femaleness, male conquest, and control of nonmale bodies with white womanhood informed opinions and social action. Hammond and Jablow write that "According to the literature, sexuality is a disruptive force, one which must be either repressed or else safely channeled into inconsequential affairs, or even more safely into marriage. Marriage, of

course, provides the socially sanctioned outlet. Ideally, it should be a union between members of the same class who share the same values."[19]

Sexuality as a disruptive force would have particularly problematic potential if it were applied to white women of the middle or upper classes. The sexualized black male body and its mythic penis potentially represented the "ultimate sexual experience" for white women, and, consequently, the black male image had to be eviscerated of its vitality and potency.

Enter Aunt Jemima and Uncle Mose, the masculinized black female and the emasculated black male, who were invented to facilitate the control of the black female and male bodies; they supposedly were harmless, witless, menopausal or impotent beings not to be taken seriously. They were servants and represented ideals to circumscribe the latent threat posed by black primitive sexuality. The contradiction between the representations of black males as childlike Sambos or impotent uncles with representations asserting them to be brutish sexual beings with huge penises remains unresolved. Both images could not have been accurate. The phallic mythology seems to have evolved from medieval mythology about satyrs and centaurs; a new face was grafted onto an old terror.

As idealized blacks, mammies and uncles were not marriage material by age or social status, and this removed the need for any sanction against sexual engagement with them; they were seen as the antonyms of what attracted the opposite sex. On the other hand, because the sexualized black woman was out of bounds—beyond the pale—she could not be found easily or consistently in art or popular imagery; she had been ciphered and hidden behind the mammy.

## DANGEROUS LIAISONS

In the United States, the sexual primitive embodied by Baartman was conceived as a wanton Jezebel. Manring argues that "the chief image of black women was the lustful Jezebel," who supposedly lured white men into interracial sex. She represented the "nightmarish consequences of lascivious black women free to tempt white men" and therefore justified the legal and social strategies to contain her.[20] The laws did not restrain or punish white males in their aggressive liaisons with black women, but they helped suppress categorical escapes by mixed-race children seeking to end the hardships produced by the experience of being black.

Many slave narratives speak about the sexual impositions made by white men on black women. These sexual liaisons most often were violent abuses of power. Darlene Clark Hine writes that "virtually every known nineteenth-century female slave narrative contains a reference to, at some juncture, the ever

present threat and reality of rape."[21] Melton McLaurin documents a case in Missouri where Robert Newsome purchased a female named Celia in 1850 when she was approximately fourteen years old. "On his return to Callaway County, Newsom raped Celia, and by that act at once established and defined the nature of the relationship between the master and his newly acquired slave."[22]

Former slave James Green recalled: "One slave had four chillun right after de other, with a white moster. Deir chillun was brown, but one of 'em was white as you is."[23] Another former slave, Mary Peters, told about her mother's harrowing experience: "Mother always worked in the house; she didn't work on the farm, in Missouri. While she was alone, the [mistress' sons] came in and threw her down on the floor and tied her down so she couldn't struggle, and one after the other used her as long as they wanted, for the whole afternoon. Mother was sick when her mistress came home. When Old Mistress wanted to know what was the matter with her, she told her what the boys had done. She whipped them, and that's the way I came to be here."[24]

Sexual aggression between white males and black females was so widespread that W. E. B. Du Bois was compelled to comment about it in *The Souls of Black Folk* in 1903: "The red stain of bastardy, which two centuries of systematic legal defilement of Negro women had stamped upon [the Negro's] race, meant not only the loss of ancient African chastity, but also the hereditary weight of a mass of corruption from white adulterers, threatening almost the obliteration of the Negro home."[25]

It would be unfair to suggest that all the sexual liaisons between white men and women of African descent were brutal, though most did reflect the prerogatives of power. G. W. Featherstonhaugh, an Englishman, traveled through the South in the early 1840s and detailed some of the intricacies of the sexual arrangements. He wrote of the liaisons at the Bal de Société in New Orleans between quadroons — women who were one-quarter black — and white men: "[I]f it can be proved that she has one drop of negro blood in her veins, the laws do not permit her to contract a marriage with a white man; and as her children would be illegitimate, the men do not contract marriages with them. Such a woman being over-educated for the males of her own caste, is therefore destined from her birth to be a mistress, and great pains are lavished upon her education, not to enable her to aspire to be a wife, but to give her those attractions which a keeper requires."[26] At these social affairs, if one of the women "attracts the attention of an admirer, and he is desirous of forming a liaison with her," the man then makes an agreement with the mother and pays her a sum of money "in proportion to [the daughter's] merits."[27] Such arrangements had resonances of the auction block and were consummated at the instigation of the

white male. This event was also known as the Quadroon Ball, but the practice ended in the 1840s under the growing pressure of a "more puritanical Anglo-Saxon element of the population" in New Orleans, who suggested that it was not far removed from common prostitution.[28]

Even Thomas Jefferson had a long relationship with a slave in his charge, Sally Hemings, who was twenty-eight years his junior. Hemings and Jefferson represent the most notorious story of black-white coupling, and it may be more similar to the New Orleans arrangements than the violent abuse described above. Madison Hemings, son of Sally Hemings and Thomas Jefferson, during an 1873 interview spoke of his African great grandmother who was the mistress of a Captain Hemings, the white sea captain of an English trading vessel. She was the property of John Wayles, who refused to sell her and her child Elizabeth to Hemings. Eventually, Elizabeth became Wayles's mistress after the death of his third wife, and he fathered six children by her, one of whom was Sally. Wayles also was the father of Martha, Thomas Jefferson's wife. When Wayles died, Martha brought Elizabeth Hemings and her children to Monticello, where Sally encountered Jefferson. After Martha died, Jefferson is alleged to have impregnated Sally in France when she was around sixteen years of age; she had gone there in 1787 to be the body servant of Jefferson's youngest daughter, Maria.[29] Sally lost that child, but after her return to the United States she had four other children whom Jefferson fathered. Annette Gordon-Reed convincingly supports Madison Hemings's claim that Jefferson induced Sally to return from Paris to Monticello with the promise that he would free all of her children when they reached the age of twenty-one, which, in fact, he did.

In this case we have an African woman who was given a child by a white man, and that daughter, Elizabeth, was given six more children by her slavemaster. One of those children, Sally, was given four children by her slavemaster, the third president of the United States. Sally's half sister was Jefferson's wife. In Paris, Sally was the servant protector of Maria, the daughter of her half sister whose father would also father her children. No wonder the Jefferson-Hemings affair has generated so much interest and controversy during the past 190 years.

With this history of sexual exploitation by both the high and the obscure showing the raw exercise of power, the notion of the sexualized black woman had no place in polite society, especially as symbolized in visual expression. The renegade sexual liaisons of white males with slave women presented moral, ethical, and legal conundrums and contradictions for a social order dependent on the exploitation of black social inferiority and the containment of sex within marriage. These conflicts were unresolvable though well understood by all.

A brief scan of statistical information can provide a perspective on the situa-

tion. In 1850 New Orleans had a population of 116,375 as reported by the U.S. Census. Of that number, 9,961 free blacks were recorded. Of those, 8,058 were designated mulattoes—a category that presumably incorporated quadroons and octoroons but did not include those who had escaped categorization by "passing" for white. Of the mulattoes counted, 98 were born in nonslaveholding states, 496 had been born in the West Indies, 95 were born in foreign nations, and 6,820 had been born in Louisiana. During the same census, New York City reported a free black population of 13,815, of whom 3,066 were mulattoes. Of these mulattoes, 1,183 were born in the South, and 1,887 were born in New York State. From 1850 to 1870 a mulatto population of 178,298 was documented in the United States, 154,966 of whom lived in the South. Despite legal and social prohibitions, interracial liaisons occurred in the South in greater numbers than in the North, and the mulatto population was 16.96 percent of the black population in the South, as compared with 14.59 percent in the North. In addition, the New York City figures suggest that it is safe to assume that a substantial portion of the northern mulatto population was born in the South.[30]

White wives knew about the affairs of many masters with their black slave women. The presence of half-caste children on a plantation or in northern cities made it obvious that much philandering was occurring. The plantation diary of one, Mary Boykin Chesnut (1823–86), may indicate how many felt about it: "A magnate who runs a hideous black harem with its consequences under the same roof with his lovely white wife, and his beautiful and accomplished daughters? He holds his head as high and poses as the model of all human virtues to these poor women who God and the laws have given him."[31]

Chesnut articulated the conceptual linkage between the viewer/voyeur in Paris and the plantation owner in the United States: the harem. Harems were populated by exotic, nonwhite women—sexual primitives. Ingres's paintings visualized for European men the fantasy of harem mastery. In the antebellum South, white males actually were able to have sexual access to a number of women who were not their wives. Such arrangements were not visualized and, in fact, required moral and conceptual masking. Perhaps the mammy image, grafted atop that of the Jezebel, would mask the harsh realities of interracial sexuality and provide a protected space for the white woman. It also is possible that the visualization of the dark-skinned mammy masked the reality of half-caste, fair-skinned women, the products of miscegenation who were working in the big house, for they seldom were relegated to the fields. At the very least, the pretense provided a face-saving charade for the white woman to use as a protective covering.

## HOOCHIE MAMAS AND REDEMPTIVE SISTERS

One of the most notable images of the black woman as sexual primitive was that of Josephine Baker who, in the late 1920s in Paris, opened her career as a modern sexual spectacle causing a voyeurism and fascination not unlike that surrounding Saartjie Baartman. Andrea Barnwell, in an essay emphasizing Baker's agency and transformation, opens with a description of her acting out the ultimate colonial fantasy in her most notorious stage role: "Fatou, a native girl, bare-breasted and clad in a skirt of rubber bananas, slithers down the limb of a jungle tree and encounters a white explorer who lies asleep and dreaming under his mosquito net. Scantily dressed black men provide the ambience for this setting by singing softly and beating drums. As Fatou shimmies, the bananas jiggle, as if imitating the erect phallus of the explorer, who is awoken by her call to the wild."[32]

Baker in time was able to reclaim control of her image and escape the cage of primitivist fantasy, but she rose to stardom on the strength of the sexual fantasies she manipulated. The "call" of the pristine wild state of humankind that awakens the explorer in this scene was a part of the lure of Tahiti to Gauguin. The black men residing in the margins as "ambience" also symbolize the dominance of the white explorer who has access to the native woman while the native men provide the theme music rather than protective resistance for the woman. The explorer has sexual prerogatives with regard to any woman he chooses and the power to subvert any challenges that might arise when his desires are transgressive. Baker as Fatou enables and makes visual this fantasy of potency and liberated libido. Like the Negro minstrels such as Billy Kersands who donned blackface to play with white perceptions of blackness, Baker became the Jezebel, the hoochie mama onstage, because it was one of the very few options open to her.

Nearly fifty years later Grace Jones decided to take a variety of sexual attitudes and histories and toss them back into the faces of the public. She played the sexual primitive with ferocity to undermine the concept, to confront it and its unquestioning believers. She also played with the boundaries between genders and between heterosexuality and homosexuality. Her former husband, French photographer Jean-Paul Goude, described a performance by Grace that he witnessed at a place called Les Mouches in Paris.

> That night she was singing her hit song, "I Need a Man" to a room full of shrieking gay bobby-soxers. The ambiguity of her act was that she herself looked like a man, a man singing "I Need a Man" to a bunch of men. . . .
> Anyway, she was performing wearing just a prom skirt and nothing else.

Her tits were bare. The strength of her image, then as now, is that it swings constantly from the near grotesque—from the organ grinder's monkey—to the great African beauty. You are constantly looking at her and wondering if she's beautiful or grotesque, or both, and how can she be one if she's the other?[33]

Jones had inverted the male gaze with gender-bending, undermined it with double entendre, and, in the process, deconstructed Josephine Baker's topless Fatou. She took it further with a 1978 Halloween performance at Roseland, a gay club in New York City.[34] In that performance in front of 6,000 fans, Jones had a tiger in a cage rolled out to the end of a runway. Jones was dressed as a tiger, and she sang, hissed, and snarled at the live tiger. "The music stops. It is pitch black! Then this loud tape comes on of two tigers roaring as though in a fight to the death. Ten scary seconds go by." The lights and music come on, and "the tiger has disappeared and in its place, Grace is singing and chewing on a big piece of meat."[35]

She was performing an outrageous camp routine devised to upstage a madcap audience on its most outrageous night, but Jones had taken Baker two steps further, though Baker has a tradition of cross-dressing that Jones was continuing.[36] In her performance, Jones may a have exceeded many of the primitive notions of nineteenth-century racists with defiance and a wink. She also may have added a new twist on minstrel gender transvestitism by masquerading as a man in playing with white primitivist fantasies about nonwhite women. There is little to suggest that Jones had a social or political agenda behind her outrageousness, and a good deal of it appears to have been constructed, ironically, through Goude, who seems to have been captivated more by his own fantasies and conceptions of Grace Jones as a tall, unique black woman than by the person she actually was. He described his first thoughts about her that night at Les Mouches, saying that "[s]he was exactly what I had been looking for all these years—not just a pretty model, but a fresh image, a demi-goddess, black, shiny, her face something more than just pretty. It was more like an African mask."[37] At the end of their relationship, after having a child together, he reflected: "My masterpiece was a vision entirely my own of what was essentially a simple, naive person, holding back to what she had always been. Trouble. By the time 'One Man Show' reached the U.S., I knew I had lost her. The "party nigger" had gone back to what she knew best, and I would have to find a new vehicle."[38]

Both Josephine Baker and Grace Jones played to or against white male fantasies of the black sexual primitive. This fantasy is the kernel at the heart of the Jezebel concept in the United States. Though the promiscuous black woman was not an image fully formed and widely disseminated like the mammy in the

United States, some black women artists have felt the need to address issues of gender that might be tied to the Jezebel construct and her link to the sexualized/ primitivized white woman. The growth of feminist thought and the emergence of African American women artists as a force in the second half of the twentieth century have enabled women to make artistic statements addressing their unique difficulties as black women. The work of artists like Elizabeth Catlett and Loïs Mailou Jones, among many others, tended to address racial orthodoxies and their constraints and oppressions. Lorna Simpson, an artist from the younger generation, has chosen instead to deal with the point where issues of gender, race, and the male gaze intersect.

Simpson's work *You're Fine* (figure 61; 1988) challenges the male gaze and its privileged assumptions from the perspective of the black woman who has been objectified through a focus on her physicality and sexual potential. By turning the subject's back to the viewer, Simpson has resisted the accessibility associated with the reclining nudes of the past. Gone is the returned gaze, the openly available body, and any hint of dominated compliance. Simpson's work confronts the viewer with an active female subjectivity that subverts male control. She is, in essence, "talking back" to male authority. As bell hooks describes the term, talking back "meant speaking as an equal to an authority figure." For hooks, becoming a woman unafraid to talk back became a feminist act "affirming my link to female ancestors who were bold and daring in their speech."[39] According to Dana Gibbons, talking back might be seen as a force in African American female resistance since Maria W. Stewart of Boston in 1831 challenged black women to reject negative images of black womanhood and "to forge self-definitions." This was followed in 1851 by a more renowned act of talking back, Sojourner Truth's "Ain't I a Woman" speech at a Women's Rights Convention in Akron, Ohio.[40]

Like Goude, Simpson has chosen to use photography as her primary medium, but she is not collaborating with the performer/subject as he did with Jones. Simpson is, in effect, playing both roles. The woman in this work has on clothing, and, by being made anonymous because her face is hidden, she becomes a signifier for women more than an individual personality. The work fits into a radical political art that Ernest Larsen describes as having an "interest in producing its own accompanying text as context, less to preempt meaning than to frame the terms of reception."[41] The text around the image suggests that the subject is being assessed for her physicality rather than her skills or internal qualities. On the right is the text, "Secretarial Position," which indicates that the examination is for a clerical job, but also implied is the sexual harassment that frequently comes with such jobs—the *position* is one of lying down. The emphasis on the body has echoes of the slave auction block and the humiliating

FIGURE 61.
*Lorna Simpson,*
*You're Fine,*
*four-color*
*Polaroid prints,*
*fifteen engraved*
*plastic plaques,*
*ceramic letters,*
*40" × 103".*
*Courtesy of the*
*Sean Kelly*
*Gallery, New York.*

physical examinations Africans endured there. The sexual implication of the work is heightened by the woman's pose replicating all the reclining, sexually available women found in art over the centuries. However, the fragmentation of the image into panels begins to deconstruct the sexual iconography, and the vertical parts of the frame form a barrier.

By having a black woman at the center of this work, Simpson directly has addressed the issues around *Olympia* and *Spirit of the Dead Watching*, and she has made the woman a voice; she is Simpson's voice, the sign for her subversive intentions, her talking-back sass. Through this image, the objectified black woman, and even perhaps Saartjie Baartman, here expresses her disdain for the male viewer/voyeur. No longer will she be compliant or complicit in such display. The consuming male gaze has been subverted. The work engages both the history of reclining nudes and the implications of sexual exploitation it signifies, as well as the sexual exploitation of black women by both white and black men. Simpson does not speak for all black women, but she has visually articulated the sentiments of many in the same way that Ingres may have captured a widespread sentiment in the art of his time.

Some African American men have in recent decades developed abusive relationships with their women, and the art and writing of many African American women address this troubling reality (for example, Alice Walker's *The Color Purple*). Racial oppression and the destructive images that reinforce it have caused what might be called the pathology of oppression to afflict many African Americans. This pathology might in part explain the dysfunctional families, antisocial behavior, domestic violence, and acts of self-hatred occurring in contemporary African American communities. The misrepresentation of black women has had an effect on both black men and women. The mammy and the Jezebel

constructs bear little resemblance to the ways women were represented in many African cultures, ways that affirmed them and helped construct their social value. The Yoruba, for example, iconographically codify the metaphysical potential of women through the image of a bird. This bird resides atop the beaded crown worn by kings (ọbas) and serves to visualize the female sanction of male authority (figure 62). The power of women is dramatized through gèlèdè masquerades—performances designed to appeal to the benevolent side of women and witnessed by the entire community. These ideas and their representations contrast starkly with the way women of African descent have been represented visually in the United States, and, as I have argued in previous chapters, visual representation affects human perceptions of the self and others. While this does not justify or excuse the abuse African American women have endured from both white and black males, it does partially explain the development of the attitudes of disrespect that contribute to such abuse.

FIGURE 62.
*This spectacular example of a beaded crown worn by a Yoruba ọba, William Adétónà, Oràngún Ilá, shows the bird at the summit and three registers of birds on the conical structure of the crown. Photograph courtesy of John Pemberton III.*

Atlanta artist Charnelle Holloway has addressed black male-female relationships from two interesting perspectives in her art, one of which deals directly with domestic violence within the community. Both works resist the sexualization of black women by men by calling for respectful, committed relationships. Holloway was trained as an artist to create jewelry and metal objects such as teapots, bowls, and silverware. Around 1990 she decided to make something that was less functional and more of a social statement, so she produced *Family Jewels (Male Chastity Belt)* (figure 63), a metal work designed as if to fit over the male genitalia. The work, she says, "was actually a statement on the protection of the black male and the family. Because the AIDS epidemic was sweeping, it still is, but it was really bad back in the early '90s." She says that the work made a statement for monogamy to argue against the notion "that guys are not at fault for what they do. They're just *guys.*"[42] Holloway indicated that the work looked functional to make certain viewers think twice. She believes that making the object was an advantage because "there's a difference between looking at a painting of a chastity belt and seeing one that might actually function." Inadvertently, she may have engaged the centuries-old debate about the potential for viewer arousal to be found in a sculpture versus that in a painting that existed during the period when Titian painted his *Venus of Urbino.* In *Family Jewels (Male Chastity Belt),* emotional arousal and identification replace the notions of

FIGURE 63.
*Charnelle*
*Holloway,*
Family Jewels
(Male Chastity
Belt), *1991,*
*mixed media.*
*Collection of*
*the artist.*

sensual arousal in the early debate. The tactile quali-
ties of the work, as the artist intended, take it from
the realm of artifice into the realm of possibility.

Charnelle Holloway's most aggressive and memo-
rable work may be the *Altar for Abused Women* (figure
64) from 1998. This installation sanctifies the self-
defense and retributive threats of women who are
physically and sexually threatened or abused by men.
Perhaps this work most emphatically reflects Karla
Holloway's statement, cited at the start of this chap-
ter, that "black women's bodies are a site of public
negotiation and private loss."[43] It was inspired by two
women on the staff of Spelman College known to the
artist who were abused in their relationships. Both
women were shot to death after a period of harm and
fear.

One of the women had been physically attacked in
her office on campus, but the security men guarding the gated campus contin-
ued to let the attacker on the grounds. Her brother was a police officer in an-
other state and did not intervene, and the justice system failed to protect her
after she moved to another county to escape the man. Because the assaults had
not been committed in the new county, they said they could do nothing to pro-
tect her. Holloway says, "After a while, I heard that she was just waiting to die.
She knew she was going to die; she just didn't know when." This failure of the
males around the woman to protect her, and the revelations of Holloway's re-
search on the subject, led Holloway to a feeling that women needed to protect
themselves. Also, too many abusive men go unpunished because of legal loop-
holes, and the fear and embarrassment many women suffer causes them not to
report incidents or press charges. Holloway's fanciful altar is an enactment of
her desire "to think of something that an abusive male would consider, maybe,
something to slow them down in attacking these women." In making the altar,
she asked, "Suppose women had laws? Suppose there was an underground ven-
geance patrol?" She says that her sentiments did not spring from a militant fem-
inist ideology but from a sense of compassion and fairness. She attempted to
adjudicate what the male justice system did not address adequately or urgently.
She resorted to what might be an Islamic or an Old Testament logic where the
punishment fits the crime—for example, a thief would lose a hand, or a rapist
might be castrated.

Rather than interrupting the male gaze as Simpson has, Holloway encour-
ages it with the understanding that each gender will have terribly different emo-

FIGURE 64.
*Charnelle
Holloway,*
Altar for Abused
Women, *1998,
mixed media.
Collection of
the artist.*

tional responses to the content. *Altar for Abused Women* is adorned with the language and evidence of abuse to give the terms the impact of sacred language in an attempt to sensitize viewers to the words that are warning signs for potentially lethal acts. In various places on the box around the jeweled butcher knife (figure 65) she has inscribed, "Why do you make me hurt you?," along with a list of some of the injuries women suffer, such as bruises, black eyes, detached retinas, loss of vision, pulled joints, and miscarriages. Several loose teeth lay on the

FIGURE 65.
*Charnelle
Holloway,* Altar
for Abused
Women, *detail
showing the
butcher knife.*

altar as well. She felt that the term "abused women" was too vague, so she wanted more specificity. She uses even more chilling language to embellish several containers on the altar. One box is "for the hand and foot that hit and kicked me." Another is a container for "[t]he phallus that raped me." She says, "I made it small on purpose." Finally, there is a money box with the lettering "For the Hit Man to avenge my death." Holloway's retributive zeal takes over because, she says, "just because you've killed somebody doesn't mean it's over. I mean, they're going to have to be looking over their shoulders." The primary utensil on the altar is a butcher knife covered with gold leaf and adorned with a jewel. Holloway selected this type of knife because she "wanted to make it a common object that was commonly used for stabbing—not that that's good—but I just thought the butcher knife was more symbolic of the home." Also, she felt it was the knife most black women pick up to defend themselves in domestic disputes.

The phenomenal craftsmanship and elegant beauty of the objects on Holloway's altar belie the brutal, violent nature of the issue it addresses and the solutions it offers. Her focus is on the violence that takes place in marriage or close relationships, but the work might be read as the kind of response that may have lain unarticulated in the minds of those slave women who endured sexual abuse and degradation. Talking back on behalf of the abused women, the artist suggests that talking back might be escalated to fighting back. Holloway does not

express the acute sensitivity to the way sexual domination has played out visually in the tradition of the reclining nude in the fashion that Lorna Simpson does, but both artists stand in defense of their gender against sexual depredation through visual means. Simpson directly addresses the representation of the black female body and its control, while Holloway suggests its invisibility beyond its facade because so many people will not see the evidence of abuse in the struggle for self-control versus a pathology of domination.

The struggle women have joined to secure control of their bodies extends into the public sphere with the struggle over representation. Reclining nude courtesans visualized male sexual fantasies that were actualized through patriarchal power. As these images became more available to a wider public, they worked in support of the expansion of that power through the appropriation and control of nonwhite females. The public display of Saartjie Baartman helped turn the black/African female body into a synecdoche for primitive sexuality, and that sexuality became a trope to explain and define all sexually available women.

The relegation of black women into a category of sexual availability helped justify their sexual exploitation by white males in the eighteenth and nineteenth centuries and made them vulnerable to abuse. At some point many black males began to twist under the weight of their oppression and turn on black women physically. These women then were left to defend themselves, often unsuccessfully. Artists such as Lorna Simpson and Charnelle Holloway have channeled their resistance into the realm of images. There Simpson challenges and critiques the voyeuristic male gaze and resists its structures and assumptions about the female body. Holloway finds in the visual realm a means to materialize her umbrage, her outrage, at the physical and sexual abuse of women, and she constructs retaliatory imagery as a warning to potential transgressors. The sexualized black woman has been deconstructed visually in their work and in the work of other black women artists. Perhaps the spirits of the Saartjie Bartmanns and the sexually exploited slave women can rest now.

# COLOR LINES MAPPING COLOR CONSCIOUSNESS IN THE ART OF ARCHIBALD J. MOTLEY JR.

*Artwork is judged according to its capacity to elucidate and contain shared histories, but also in its ability to determine, enact and formulate histories—pasts, presents and futures.*

—*Allen deSouza, "The Flight of/from the Primitive" (1997)*

"*Òyìnbó*." The name, which most often was applied to whites, was tossed at me casually by a young boy in the market in Ile-Ife, Nigeria, in 1991. I took umbrage and responded firmly in an appropriate slang, "*Mi kì í ṣe òyìnbó!*" ("Don't call me *òyìnbó!*") The young man looked at me with surprise and asked, "What are you?" I told him that I was a black person ("*Èmi ni ènìyàn dúdú*"). In this brief exchange, which took place entirely in the Yoruba language, a number of issues relative to race became tangled. Despite over a century of Pan-African thought and organization, most Africans and African Americans still did not identify closely with each other. Though my experience since early childhood reinforced my blackness (or Negroness or Otherness), that identity construct was relative and contextual. What did it mean to be black in Nigeria? *Òyìnbó*, though it referred to whites (literally, the term refers to something that is peeled),[1] also suggested that one was a foreigner from a distant land living within the culture of whites. It was applied to Difference. Because of my mixed ancestry — African, a little Irish somewhere, some Cherokee on both sides — my physical appearance would seem closer to that of Ethiopians than to Yoruba men due to my reddish brown skin and black hair that is soft and wavy. Therefore, I was physically identifiable as an outsider. My cultural experience in the United States, my first language being English, and my double consciousness in the Du Boisian sense, all separated me from the Yoruba. My social instincts were more American than African. I moved from being a part of the oppressed black minority in America to being perceived as part of the privileged white minority in Nigeria merely by taking a couple of airplane flights. This experience pointed up the mutability and the impermanence of racial identity. Physically, I had not changed, but the meaning of my physical body had shifted because of the new context in which I found myself.

Sometimes shifts in the perception of race took different kinds of twists. A young man in my Cleveland neighborhood, Lamar Parker, had a father who took a German bride while in the military. Lamar and his sisters were very fair-skinned with brown, wavy hair. By the time we went to high school, for some reason Lamar and I were not as close as we had been, but we were friendly. He went into the navy at the age of seventeen and returned home in 1968. In November 1969, Lamar and some friends went to Big Bill's, a club in the heart of a rough black neighborhood in Cleveland, in part because he was enamored of a woman who danced there. The woman, Sue, was behind the bar, and Julius Collins, one of Lamar's friends, was talking with her with his back to Lamar when he heard someone yell, "What the [expletive] are you looking at, honky?" Then there was a gunshot.[2] The story I heard at the time was that someone believed that Lamar was white and took exception to his coming into that neighborhood to be with a black woman. Lamar had taken a gun with him and was

shot in the stomach as he tried to defend himself with it. When he fell to the floor, he was shot a second time in the head. The assailant walked away from the bar, and the murder remained a mystery for thirty years until a suspect was arrested in June 1999.

Apparently Big Bill's was a hangout for militant black nationalists who had warned Lamar to stay away from the bar because they thought he was white. Parker was fearless. He had just done a stint in the service during the Vietnam War, and he refused to back down. I remember his fiery temper so this was characteristic of him. The terrible irony of Parker's death is that his fair skin, light-colored eyes, and "good" hair were thought to be an advantage at the time, though he did not separate himself from the rest of the black community with an elitist attitude. Perhaps this was because Lamar, whose father was black, was in the same economic strata as we were. He would have derived his sense of identity from a brown-skinned African American father and a white mother for whom race was not an overwhelming issue.

In both cases, we were misperceived by others and, in their minds, pushed into racial or cultural categories that did not fit with our self-perceptions. Color lines mapped territories of consequence—charting lines between races and also lines between strata within the black category—but those boundaries, like concepts of race, proved to be somewhat arbitrary and unreliable. Unfortunately, a great deal could be at stake for people as they negotiated these shifting boundaries, a fact that was sadly apparent with the death of Lamar Parker. The cold reality was that in Nigeria in 1991 and in Cleveland in 1969 being categorized as white or near-white had advantages if one chose to use them. This has been the case in Ohio for two centuries and in West Africa for at least a century and a quarter. In the United States tangible social and economic benefits developed for people of mixed heritage and encouraged a de facto separation of African Americans into the equivalent of the South African categories of "black" and "colored."

According to E. Franklin Frazier, in 1850 "mulattoes or mixed-bloods constituted 37 percent of the slave population,"[3] and mulattoes alone accounted for almost 37 percent of the free black population for the nation. In the South, 43 percent of the free black population was of mixed ancestry, and in New Orleans (as cited in chapter 4) almost 81 percent of the free black population was of mixed ancestry.[4] These figures reflect the fact that there was a great deal of miscegenation occurring within slave society and the children of interracial liaisons were much more likely to be freed from slavery. On large plantations, a social hierarchy developed, with blacks who worked close to the master's family in the house or close to the house having more status and privileges than those who labored in the fields. As Frazier reported, enslaved women had incentives to sub-

mit to the white master's sexual advances, "such as freedom from the drudgery of field work, better food and clothing, and the prospect that their half-white children would enjoy certain privileges and perhaps be emancipated,"[5] which was the case with Thomas Jefferson and Sally Hemings. Therefore, people of mixed race often became a part of the free black population. This population became the foundation for the black bourgeoisie at the beginning of the twentieth century.

Frazier argued that a small upper class emerged and that "[t]he members' light skin-color was indicative not only of their white ancestry, but of their descent from Negroes who were free before the Civil War, or those who had enjoyed the advantages of having served in the houses of their masters."[6] According to Frazier, the "free Negroes constituted, in fact, the element in the Negro population that had made the greatest progress in acquiring European culture."[7] It is in this population that we can find the roots of the color consciousness plaguing the African American community for the past century. The institutionalization of economic and social benefits by skin color and racial category ensured that a schism would form. The intragroup conflict has had cultural aspects because, often, the mixed heritage group chose to identify culturally with whites, while the African and vernacular folk cultural and expressive aspects of African American life were disdained. Some of the nuances of this conflict might be discerned in a particular reading of the early work of Archibald J. Motley Jr., whose life also reflected how complicated identity issues were for Negroes in the first half of the twentieth century.

## MAPPING COLOR LINES

Chicago artist Archibald J. Motley Jr. (figure 66) was born in New Orleans in 1891 to a family of mixed heritage. Motley lived in Louisiana for only two years before his family moved and in 1894 settled in the predominantly white Englewood neighborhood on Chicago's South Side. They were a part of a constant, though small, migration of Negroes to the North. Chicago attracted a large portion of those leaving the South between 1890 and 1910 in what historian Carter G. Woodson called "The Migration of the Talented Tenth."[8] This refers to W. E. B. Du Bois's ideas about a talented, elite group of Negroes who would provide leadership for the rest of the group.

Motley's mother was a schoolteacher until she married his father, who was a Pullman porter. They lived in a community largely populated by people of German, Irish, Swedish, British, and Dutch ancestry.[9] Motley said that they "were the only colored family living within a radius of about three miles."[10] The com-

munity protected the Motley family from harm during the deadly Chicago race riots of 1919 when a white mob threatened them, "as Motley's father listened behind the door, shotgun in hand."[11] During the six days of rioting, white and black mobs terrorized Chicago, fighting on street corners, murdering passersby, and destroying property. "Thirty-eight died, 537 were injured, and over one thousand were rendered homeless" before order was restored.[12]

One factor in the rioting was the insistence by whites that Chicago's black population, swollen by the flood of migrants from the South after 1915, remain confined within a black neighborhood on the city's South Side. Before 1900, most Negroes lived in mixed neighborhoods, though they were concentrated in certain sections of the city. Between 1890 and 1910, the Negro population had grown from under 15,000 to 44,000, and by 1920 it was over 109,000. Whites felt threatened by this growing population and responded violently to prevent Negroes from moving into their neighborhoods.[13]

FIGURE 66.
*Archibald J. Motley Jr. Courtesy of the Chicago Historical Society, ICHi-16136.*

Additionally, the Great Chicago Fire of 1871 had destroyed a great portion of the central business area and the infamous red-light district, which was not rebuilt. Vice and prostitution moved to the edges of the Negro community, and by 1909 the Chicago Vice Commission reported that the growing Negro population had not been able to keep even one jump ahead of the continuously expanding red-light district. "Inevitably the Black Belt became associated in the popular mind with 'vice,' and reformers exhorted the Negro community to clean house."[14] Historian Allan Spear reports that Chicago authorities tried to confine vice and prostitution to certain well-defined areas — away from commercial and white residential areas — where it could be closely monitored. Invariably they located it in or near the Black Belt.[15]

When the Motleys arrived in Chicago in 1894, their mixed racial heritage must have made them a comfortable fit for the old-line Negro elite. Spear reports that before 1900 "the community was dominated by a small group of upper-class Negroes, usually descendants of free Negroes and often of mixed stock, who had direct links with the abolitionist movement."[16] In 1924 Motley married Edith Granzo, a woman of German descent from the neighborhood with whom he had maintained a relationship for the previous fourteen years. Her family was so upset by the marriage that they disowned her, and only one of her brothers continued contact with her.[17] By the time of their marriage, Chicago had virtually become a racially divided city, but interracial marriages were

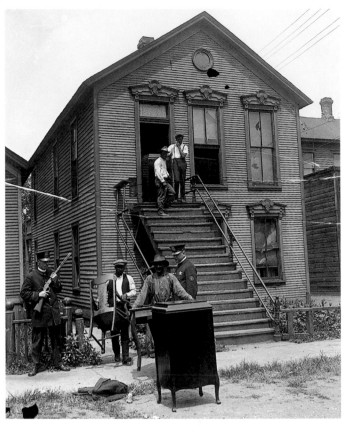

FIGURE 67.

*Photograph from
the 1919 Chicago
race riots by Jun
Fujita. Courtesy
of the Chicago
Historical Society,
ICHi-23870.*

not uncommon among Chicago's black elite before the First World War. The Manasseh Society, a social club for Negro men with white wives, had over five hundred members in 1892 and was still active in 1912.[18] The earliest genre scene that Motley painted, *Black and Tan Cabaret* (ca. 1920–22), had as its subject one of Chicago's interracial nightclubs.

During his days as a student at the School of the Art Institute of Chicago (1914–18) and in the years immediately following, Motley executed a series of portraits, many of which explored the variety of skin tones to be found among African Americans. One of his most acclaimed early works, *Mending Socks* (1924; figure 68), was a portrait of his paternal grandmother, Emily Motley, a former slave born in British East Africa who was then eighty-two years old. Motley was very aware of Western art traditions, and this composition must have been inspired by James McNeil Whistler's notable *Arrangement in Grey and Black, No. 1: Portrait of the Artist's Mother* (1871), often called *Whistler's Mother* in popular culture, and possibly by Henry O. Tanner's similar painting from 1897, *Portrait of the Artist's Mother* (figure 69). All three present the subject seated in profile looking to the left of the image from the right. Motley's painting was voted the most popular painting in an exhibition at the Newark Museum of Art

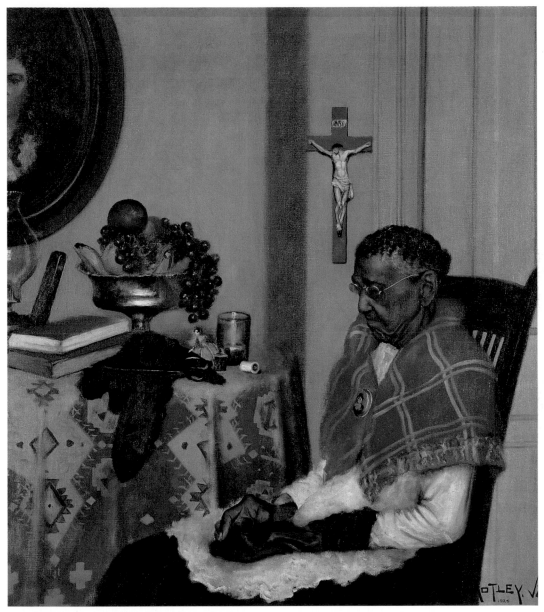

FIGURE 68.

*Archibald J. Motley Jr.,* Mending Socks, *1924, oil on canvas, 43⅞" × 40". Ackland Museum of Art, University of North Carolina at Chapel Hill, Burton Emmett Collection.*

in 1927. His great affection for his grandmother led him to include in the painting "those things she loved best."[19]

The domestic scene can be read as a catalog of her life and of Motley's background. She was a religious woman, as indicated by the large Catholic cross near her head and a Bible on the table. This was consistent with the family's roots in Catholic French Creole Louisiana. The cloth on the table suggests a Native

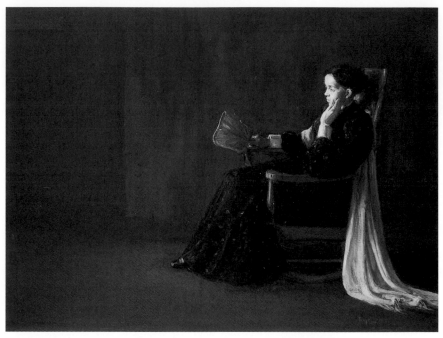

**FIGURE 69.**

*Henry O. Tanner,* Portrait of the Artist's Mother, *oil on canvas, 29¼" × 39½", 1897.*
*Philadelphia Museum of Art, Partial gift of Dr. Rae Alexander-Minter and purchased with*
*the W. P. Wilstach Fund, the George W. Elkins Fund, the Edward and Althea Budd Fund,*
*and with funds contributed by the Dietrich Foundation, 1993.*

American pattern and may be a reference to or remembrance of her husband, who was an American Indian.[20] The pile of socks on the table, in what appears to be a sly reference to her African birth, approximates the form of the African continent. Holding her shawl in place is a hand-painted brooch, which has the picture of her only daughter on it. The bowl of fruit represents her fondness for fruit. The setting indicates that this is a middle-class home, and the portrait in the upper left corner of the painting is a portrait of her slave mistress.

In a 1978 interview Motley indicated that his grandmother had worked as a domestic in slavery, and she had told him that "[t]hey treated her just lovely, she got nice clothes, nice shoes, they made them take good care of themselves, they made them bathe. They had good food to eat, they had the same kind of food as the master and the family had. So she said it wasn't difficult at all. She said she liked it, she loved her master and mistress."[21]

When Motley's grandmother was emancipated, she was given the picture of her young mistress, and she kept it throughout her life. One must consider the psychological impact of slavery to contextualize her attitude toward her experience. During an interview around 1916, a Negro preacher in Mississippi spoke of his father who had been enslaved: "My father was born and brought up as a

slave. He never knew anything else until after I was born. He was taught his place and was content to keep it."[22] Spear argues that the plantation tradition was strong in the immediate aftermath of slavery: "Negroes were still loyal to those 'Southern gentlemen of the old school' who took a paternalistic interest in them."[23] For some, this was true.

During the early portion of his career, many of the portraits Motley painted depicted his family members, but he also did a series of works documenting categories of women of mixed racial heritage. One of the earliest of these was *Mulatress with Figurine and Dutch Seascape* (1920; figure 70). The woman in the painting has been placed in a comfortable middle-class setting. On the table sits a small figurine, which likely was drawn from a plaster model that Motley used in his anatomical studies at the School of the Art Institute. A Dutch painting hangs near the woman's head—Motley was particularly enamored of Dutch artists like Frans Hals. Nothing in the painting beyond the title suggests that the subject of this work has African ancestry. The title points to Motley's interest in the social space where racial identity becomes unstable—the place where physical features become unreliable markers and ideas of genetics or "blood" prevail. Possibly he was investigating the "one drop" rule pictorially, but more likely the work reveals Motley's fascination with fair-skinned women.

In his early portrait work, Motley painted at least four octoroons, a quadroon, and two mulattoes. Without the titles of these works, the racial identities of the women in them become totally ambiguous which in fact could have been the point. Yet Motley seems to have accepted racial categories and tried to document the physiognomic character of women of mixed race. He wrote about his fascination with the woman of mixed heritage in an essay explaining his art.

> In this painting [*Aline, An Octoroon*, ca. 1927] I was sincerely interested in the pigmentation of the skin in regard to the supposedly lightest type of colored person. . . . The head is normal and well constructed and symmetrically balanced. The construction of the body such as an elongation of the arms, a tendency toward a weak bone construction found in many of the dark purer Negroes and large fat heels are nonexistent. In fact a very light octoroon could be compared favorably with a Swedish or Norwegian person. In this painting I have tried to show that delicate one-eighth strain of Negro blood. Therefore, I would say that this painting was not only an artistic venture but also a scientific problem.[24]

In 1922 Motley painted *Octoroon* (figure 71), showing an attractive, well-dressed woman against a simple dark-red cloth background. The woman has her hair up in a formal style, and she is adorned with a jeweled hair clip, dan-

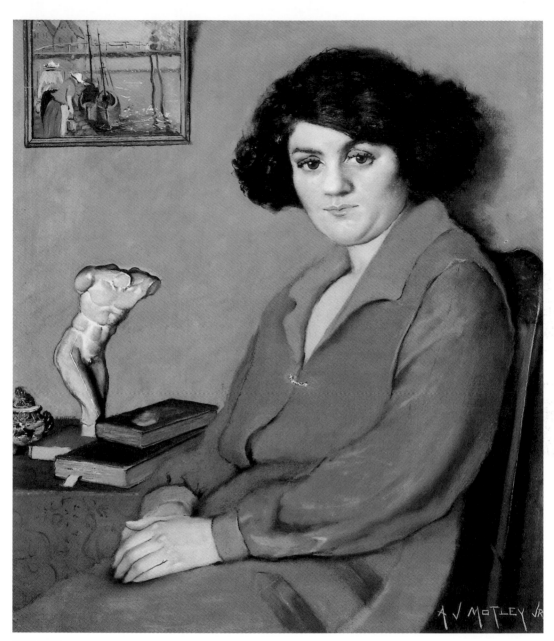

gling earrings with what appear to be pearls, and a simple string of pearls around
her neck. The black dress with a low neckline seems to be made from velvet, and
the red background is made from heavy cloth. The woman's hands bear no
rings, but they are delicate with slender fingers and long, well-manicured nails.
Her eyes and expression seem gentle and relaxed, and the pose and placement
of the hands suggests that she is a mannerly, cultured young woman. And she is
available. Her expression and the tilt of her head indicate an informality, and
the slightly parted lips and the low neckline of her dress seem to say that she is

relaxed because the artist/viewer is a part of her familiar inner circle. The title and the setting suggest that she is a part of the Negro elite, Frazier's fair-skinned black bourgeoisie, but without the title of the painting it would not be apparent that she was a Negro.

The ambiguity of the woman's race, in American terms, and the impersonal title of the work open up issues of "passing." There were incentives for a black to pass as white because such a person could escape the harsh oppression experienced by blacks in the South and in the North, and being seen as white provided access to jobs, housing, and schools that were otherwise unavailable even to fair-skinned Negroes. When their physical features might seem a bit swarthy and Mediterranean, some folk passed as Jewish. There were risks and punishments for trying to pass for white. Nella Larsen dramatized one of the humiliations in her 1929 novel, *Passing*. While entertaining two fair-skinned friends from her Chicago childhood, Clare Kendry, the woman passing, has a brief discussion with her husband, John, whom they have just met, about her deepening tan:

> Speaking with confidence as well as with amusement, she said: "My goodness, Jack! What difference would it make if, after all these years, you were to find out that I was one or two per cent coloured?"
>
> Bellew put out his hand in a repudiating fling, definite and final. "Oh, no, Nig," he declared, "nothing like that with me. I know you're no nigger, so it's all right. You can get as black as you please as far as I'm concerned since I know you're no nigger. I draw the line at that. No niggers in my family. Never have been and never will be."[25]

*Octoroon* was followed by another portrait in 1925 that Motley felt to be one of his best, *The Octoroon Girl* (figure 72), a painting that won a Harmon Foundation Prize in 1928. Motley met the subject in a grocery store and convinced her to pose for him. He said, "I happened to see a very beautiful lady in there; oh she was pretty, very beautiful. . . . I wasn't thinking about the groceries I wanted to buy, I was thinking about her in a painting. Not that I was in love with her; I was in love with what she'd look like on canvas; I could just imagine."[26]

This subject, like the one in *Mulatress*, is placed in a furnished interior setting. In a prelude to later work, the lighting is dramatic, but reds and dark colors dominate the setting, just as they do in *Octoroon*. The woman in *The Octoroon Girl* is dressed in a stylish outfit, and she carries a pair of gloves. There is a formality that is articulated by the rigidity of her pose and her unsmiling expression, unlike the softness suggested by the smile and slight tilt of the head in *Octoroon*. She wears an engagement ring on her left hand. The woman's personality seems strong, and she is guarded in her demeanor.

opposite:

**FIGURE 71.**

*Archibald J. Motley Jr.,* Octoroon (Portrait of an Octoroon)*, 1922,*
*oil on canvas, 37¾" × 29¾". Courtesy of the Chicago Historical Society.*

above:

**FIGURE 72.**

*Archibald J. Motley Jr.,* The Octoroon Girl, *1925,*
*oil on canvas, 38" × 30". Courtesy of the Chicago Historical Society.*

The prominence of red in the work, the effect of the woman's pale skin in strong contrast to the dark wall behind her, and the black of the dress she is wearing, when combined with the dramatic lighting used to illuminate the scene, charge it with emotion and a certain intensity. Red can suggest carnal qualities and passion, but the woman's wary, almost suspicious expression conflicts with notions of sexual availability. Her expression, and her ring, might have served to keep male desire at a safe distance, and their prominence in the painting may signal the practiced defense mechanisms often employed by an attractive woman.

Motley developed a logic for his approach to an image and wrote that he would begin by making abstract pencil sketches, "sometimes as many as forty or fifty," to resolve the relationship of figures and objects "to the various geometrical forms which compose the entire picture." He remarked that "every picture should tell a story, either in subject matter, a decorative arrangement or some technical expression." Every object within a painting should have a reason for being there, and the composition was built on the "geometrical forms which make up the human figure." He also indicated a fascination with the "arrangement of colors from two lights opposite one another, moonlight from a window or windows and artificial light in a room or rooms."[27]

Motley studied the effects of different kinds of light and showed a consistent interest in the variety of hues to be found in the skin of African Americans, particularly with women. He said in this regard, "I find in the black women such a marvelous range of color, all the way from very black to the typical Caucasian type."[28] In short, he was concerned with color and colored people. Both concerns surfaced in *The Octoroon Girl* and remained at the center of his work for the rest of his career. His attention to every detail of a painting justifies an equally detailed analysis of the contents of his images.

Richard Powell asks that we remember that Motley was a modern artist, that there were "signs of modernity fused with compositional fracturing and compositional freedom" to be found in his mature work, and that his focus on urban dynamism was similar to the work of white American artists of the time.[29] Motley organized his compositions with the geometric attention common among his contemporaries, and he indicated a formula that might be employed to organize the picture plane: "One very large space (at least twice the size of any other) two intermediate sizes. Six or more smaller sizes. With this wide range of sizes of space employ a wide range of values. Let the small class of sizes be very different in value from the intermediate and the intermediate sizes be of a different value from the largest space. But remember that the principal thing in the motif is a good variety of sizes of space."[30]

In his depictions of modern black life, Motley chose subjects who were

urban Negroes of the 1920s and 1930s. Though some of the middle- and upper-class socialites he painted undoubtedly were from families that had been in Chicago prior to the turn of the century, many of the characters in his notable Bronzeville paintings were migrants from the South. They may have been inspired to move north by the *Chicago Defender*, the most prominent Negro newspaper in the nation at the time. These folk, these modern Negroes, these New Negroes, were reinventing themselves as savvy urban dwellers. They were devising new styles of dress, new ways to wear hair, new lingo, and new social rituals. They developed new churches to accommodate their ways of worship, and in general their ways antagonized the old elite. The folk in *Black Belt* (figure 78) were not visually or verbally the same folk to be found in a Mississippi road-house, but neither were they the same folk who populated black Chicago before their arrival.

Motley stated that he "never cared about doing this modernistic art" and added that "[t]here are no modern painters, with the exception possibly of George Bellows—none of them have ever influenced me." He believed that Negro audiences did not purchase or appreciate much art, so he felt that "by putting them in the paintings themselves, making them a part of my own work," they would "see themselves as they are" and would begin to find reasons to gain in their appreciation of artistic work.[31] Still, the folk Motley painted were blacks living a modernist, urban life while grooming and dressing themselves in a modernist fashion. Motley deviated from past traditions in that he was one of the first African American artists to use African Americans as subjects, and few of his contemporaries or predecessors had chosen, as he did, to examine the outer edges of black identity, an act that complicated the perceived monolith of blackness. In his Bronzeville paintings of the 1920s and 1930s, he also was one of the first artists to explore urban black vernacular culture as a subject. In these paintings, Motley usually mixed Negroes of all shades and classes in Jazz Age Chicago social settings. Gone were the nineteenth-century landscapes and allegorical genre scenes. Missing was the middle-class artifice of James Van Der Zee's photographs. In a 1978 interview he stated that he "was trying to fill what they call the full gamut, or the race as a whole, not only, you know, being terribly black but those that were very light and those that were in between. You'll notice that in all my paintings where you see a group of people you'll notice that they're all a different color."[32]

One of Motley's more ambiguous works from his early period, *Reception* (also called *Afternoon Tea*; 1926; figure 73), has been interpreted as a gathering of white socialites being served by a black butler. The figures are stylized far more than in his earlier portraits, and their skin tones reflect the various types of light in the room. Powell, in conversation with me, suggested that this was a gather-

ing of fair-skinned black women, and he wondered how that reading would affect the interpretation of the painting. This would seem to be the most plausible reading of the work. Motley painted few whites in his career, and most of them appeared in Parisian scenes done during his year of study in France. Nothing in the body of his work or in his writing or interviews suggests an interest in white socialites. In an unpublished essay, "The Negro in Art," Motley stated his commitment to depicting Negro life in all its variations and prescribed the Negro subject for Negro artists.

> What a pity so many of our artists go in for pretty landscapes and pictures which have no bearing whatsoever on our group. The Negro poet portrays our group in poems, the Negro musician portrays our group in jazz, the Negro actor portrays our group generally with a touch of hilarity, comedy dancing and song. . . . All of these aforementioned portrayals are serious, original interpretations of the Negro. There is nothing borrowed, nothing

FIGURE 73.
*Archibald J. Motley Jr.,* Reception (Afternoon Tea)*, 1926,
oil, 29″ × 36¼″. Courtesy of the Chicago Historical Society.*

copied, just an unraveling of the Negro soul. So why should the Negro painter, the Negro sculptor mimic that which the white man is doing, when he has such an enormous colossal field practically all his own; portraying his people, historically, dramatically, hilariously, but honestly.[33]

Another painting completed in 1926, *Cocktails* (figure 74), seems to reinforce the idea that Motley depicted Negro women in *Reception*. *Cocktails* shows a group of women, obviously Negro, having late afternoon drinks and being served by a butler with dark skin. The compositional organization of the pictorial space of *Cocktails* is almost identical to that of *Reception*. The women sit near a similar floor-to-ceiling palladium window in front of a marble fireplace. A floor lamp with a red shade is at the right edge of the painting, and the coat of a guest lies draped across a cushioned chair at the left edge of the work. The oval mirror above the fireplace in *Reception* is replaced by an oval portrait. *Cocktails* seems to settle into the style Motley would use in most of his future work. The image is figurative, but the figures have been simplified and abstracted. The major difference between the two paintings is that the women in *Cocktails* have a range of skin tones from light to dark, and each is wearing a stylish hat.

In *Cocktails*, Motley has lowered the viewer's sight line and moved closer to the women, creating a more intimate presence for the viewer. The woman languidly resting in the chair to the left and seemingly unconnected to the women seated at the table, along with the fact that they are wearing hats, gives this scene the feel of a public setting—perhaps a hotel cafe or a fashionable restaurant. If so, the butler moving toward them with what appears to be roast chicken and tea would be a waiter rather than a servant.

Compelling issues of race, gender, and class can be read into Motley's work, though they may not have been a part of the artist's intent. If we accept that the women in *Reception* are well-to-do blacks, the presence of a darker-skinned Negro butler serving them presents a color/class tension. None of the women acknowledge the butler's presence. Their disregard would be common in such an upper-class circumstance and would supplant any racial solidarity, but his dark pigmentation separates him from the group in ways beyond a master-servant dichotomy. The implication is that the butler cannot join this social circle even if he acquires the financial means to do so.

The plausibility of this assumption is strengthened by the seldom discussed history of paper bag parties and comb parties, where the fair-skinned elite would limit the entry of anyone whose skin was darker than a paper bag or whose hair was too coarse to allow a fine-toothed comb to pass through. Such class/color tensions go all the way back to the antebellum South when mixed-race free blacks tried to disassociate themselves from darker enslaved blacks.

FIGURE 74.
*Archibald J. Motley*
*Jr.,* Cocktails,
*ca. 1926, oil on*
*canvas, 32" × 40".*
*Courtesy of the*
*Chicago Historical*
*Society.*

One of the most extreme examples of this may be found in the Brown Fellowship Society of Charleston. Founded in 1790 and lasting into the twentieth century, its membership was limited to fifty free men of color and good character. In 1904 on the anniversary of its founding, a leading member, J. H. Holloway, explained that their fathers had allied themselves with upper-class whites whose influence and protection they enjoyed, and therefore they "had to be in accord with them and stand for what they stood for." Though they had publicly supported the system of slavery, they had "sympathized with the oppressed" because they had endured oppression themselves.[34] Such tensions continued in late-nineteenth- and early-twentieth-century Chicago, and strong regional and class tensions grew as the large numbers of Negro migrants from the South generated some concern among the long-time residents of the city. In *Cocktails,* the presence of at least two women with the same skin tone as the waiter in the same circumstance as the fairer women limits the potential for overdetermination relative to Motley's psychology and values, and it adds caution to our reading color and class conflicts into his work.

Another possibility to consider is that this work begins the mature stage of

Motley's career when he commonly mixed fair-skinned and dark-skinned and upper-class and working-class Negroes in social settings. In reality, Negro identity functioned much like a caste in American society, and one's financial or professional status did not liberate one from it. This became increasingly true in Chicago after 1916. Class/color struggles amounted to conflict over the more privileged terrain within second-class citizenship. What seems most important to note is that racial identity is so fluid that a shift in the interpretation of the race of the women in *Reception* radically changes the meaning and tensions in the work. As it did for Lamar Parker, that sort of shift changes what is at stake in social transactions. Definitions of race are so imprecise that perception can cause slippage from one category to the next, and the status attached to various categorical identities can be quite arbitrary. Motley's own statements suggest that he did not question racial categorization but, instead, documented it.

The fact that most of the women depicted in Motley's paintings until 1926 are fair-skinned with mixed cultural backgrounds might suggest something about the form and color of Motley's desire. In contrast, two portraits he painted of brown-skinned women removed the artifice of class and subdued implications of desire. *Woman Peeling Apples* (1924; figure 75), was one of his earliest portraits. The work also has been called *Mammy* or *Nancy* and presents an older, weary, dark-skinned woman against a simple, whitewashed wall. (The second work, *The Snuff Dipper*, from 1928, will not be discussed here.) Was she a servant in a home similar to the butler in *Reception* from two years later? Unlike the fair-skinned women in Motley's work, this woman is shown doing domestic labor. She has tied a bandanna over her hair and wears a plain plaid dress. Her hands are large and strong, and the right one is balled up fistlike to hold the paring knife. Compare this with the graceful placement of the hands in *Octoroon* or the way the glove is held in *The Octoroon Girl*. This subject wears no makeup and is in a hard, spare setting. Although *Mending Socks* presents a woman doing domestic work, the setting there provides insight into the personality of the sitter and the comfort in which she lives.

Perhaps *Woman Peeling Apples* compares favorably in intent and composition to Motley's 1922 *Portrait of My Grandmother* (figure 76). Both subjects are posed straightforwardly against a wall: each sits with her hands in her lap, and each wears a wedding band. Motley rendered his grandmother's hands in a way similar to those of the octoroons, though they show signs of age, and the fingernails are not well manicured or polished. Her hair is uncovered and groomed. Her blouse seems to be made of a light, diaphanous material, and a decorative locket is worn at the base of the neck, all of which suggests that she is a woman living in comfort who has donned an apron to do light housework. In addition, the warm tones of this painting seem more emotionally inviting than the cooler

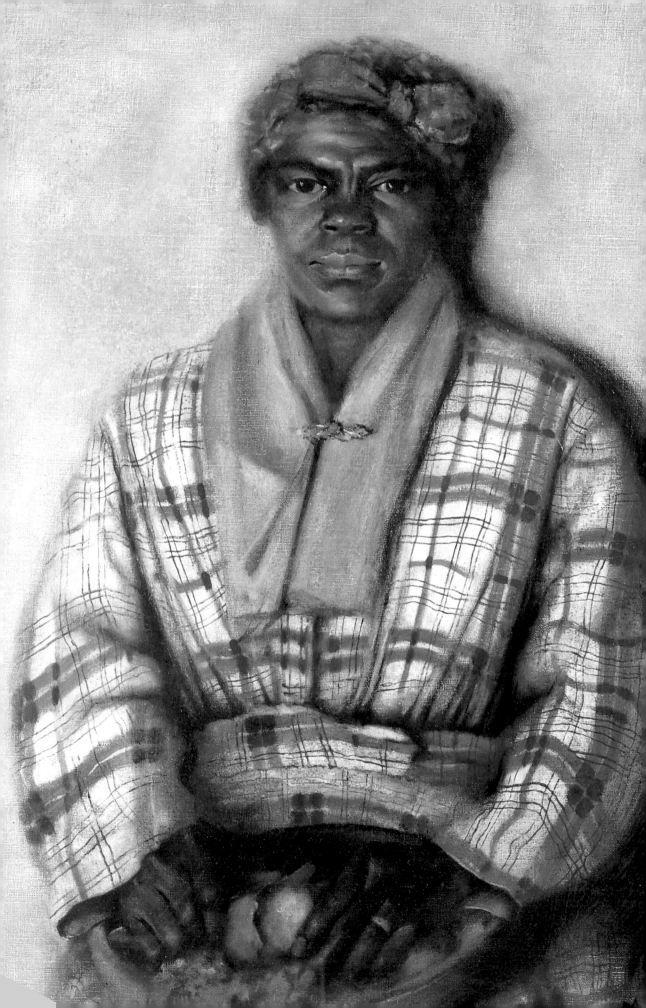

blues and purples of *Woman Peeling Apples*. The two works show older women in similar poses, but the emotional characters of the works are quite different.

What are we to make of *Mammy* as an alternative title for *Woman Peeling Apples*? Motley used this title when exhibiting the work in his successful 1928 one-man show at the New Gallery in New York. I have already discussed how the mammy was constructed to be an asexual being. Though the woman in *Mammy* is not overweight, she is wearing a bandanna covering her hair. Her large, balled-up right hand takes on a masculine character. Her removal from the realm of desire is completed by her unavailability because she is married, because she is middle-aged, and because her remote gaze prevents emotional contact with the viewer. Compare this figure with the woman in *Octoroon*, with her soft, direct gaze , her parted lips, her visible hair style showing attention and artifice, her hands placed gracefully in her lap, and her open neckline. Why were no *young* dark-skinned women painted in this fashion by Motley?

Was Motley "color struck," or was he merely documenting the life, people, and attitudes around him? His own words would seem to suggest both to be the case. When speaking about fair-skinned women, he remembered their names and found them to be attractive. He recalled bringing a colored girl to the Art Institute as a model. "Oh, she was a beautiful colored girl. Her name was Lisa. . . . She was what is called an octoroon, very light, very pretty, beautiful hair, nice color."[35] Another woman he painted was "the wife of a doctor. Her name was Cecile. She was a quadroon, very beautiful face, very chiseled features, small very strong sensitive mouth."[36] He described a dark-skinned schoolmate from Texas: "I don't remember her name now. She was real black, very black and very ugly too."[37] In more general terms, Motley wrote about his effort to honestly depict Negro life in his work in terms that seemed to separate him from his subjects: "The Negro is no more the lazy, happy go lucky, shiftless person he was shortly after the Civil War. Progress has changed all of this. In my paintings, I have tried to paint the Negro as I have seen him and as I feel him, in myself without adding or detracting, just being frankly honest."[38]

The most disturbing aspect of this statement is Motley's belief that blacks were "lazy, happy go lucky, shiftless" people at one time. Like many educated Negroes of his era, he had a perception that stereotypes had some basis in lower-class reality.[39] In fact, the majority of African Americans just after the Civil War were people who had recently emerged from generations of the cruelest form of slavery on record, who had been reduced legally to the status of property, who had worked without wages or tangible benefits, and who would hardly seem to have been lazy and happy go lucky. As historian Herbert Aptheker summarized slavery, "[I]f you did not work and work the way you were ordered to, then you would not eat."[40]

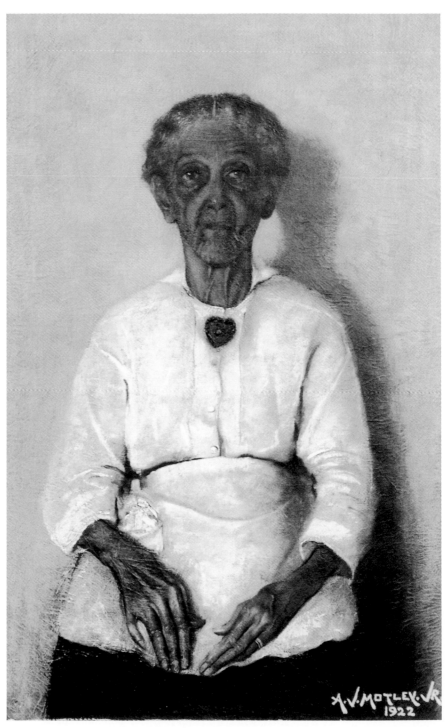

FIGURE 76.
*Archibald J. Motley Jr.*, Portrait of My Grandmother, *1922,
oil, 38¼" × 23⅞". Courtesy of the Chicago Historical Society.*

Motley was very aware of the negative images of Negroes that had prevailed for generations, and he felt deep pain and anger when encountering racist acts. He endured a racial incident on a trolley in Atlanta when he was young and avoided disaster when his father calmed his anger before trying to assault the offending white man. Once in Paris he was called "nigger" by two Americans whom he immediately threatened to beat with his fists if it happened again. He wrote about the racial stereotypes of the previous century: "For years many artists have depicted the Negro as the ignorant southern 'darky,' to be portrayed on canvas as something humorous; an old southern black Negro gulping a large piece of watermelon; one with a banjo on his knee; possibly a 'crap-shooter' or a cottonpicker or a chicken thief. This material is obsolete and I sincerely hope with the progress the Negro has made he is deserving to be represented in his true perspective, with dignity, honesty, integrity, intelligence and understanding."[41]

Motley's statement indicates a belief that blacks had progressed beyond the old plantation images, but it also suggests that he may have felt there to be a degree of accuracy in them previously. It is revealing of the psychological effect of captivity on people of African descent that blacks took on the idea of making "progress" relative to their acceptance by whites and their admittance to society. It might be more accurate, and healthier, to suggest that whites had made social and moral progress that was measured by their treatment of nonwhites. The fact that many African Americans accepted the onus of proving themselves worthy of inclusion in a society that was built and secured by black slave labor, and labeled that concept "black progress," suggests the internalization of some white racist perspectives by blacks. In the interpretation of double consciousness emphasized here, the two visions of self are in conflict and, because the outsiders (whites) have had almost absolute power and almost total disdain for the physical and cultural character of Africans, the dissonance has led to varying degrees of self-hatred among many African Americans. As a result, one of the lingering issues in the black community during the twentieth century was a color consciousness that approximated that of whites; the less European one looked, the less beautiful a person, especially a woman, might be considered.

It must be emphasized that the responses by blacks to oppression occupy a range of possibilities and that not everyone was affected the same way to the same degree. Many had a strong enough sense of self to be less affected by racist attitudes and images than others. Yet all people of African descent in the New World were affected because their access to power and their power to define themselves differed substantially from the self-definition their African forebears could command.

## MISE-EN-SCÈNE

Archibald Motley's early work is an indicator of his consciousness and provides evidence of how a number of middle-class blacks at the time may have felt, but these interpretations should not be taken as a judgment of the artist in retrospect. Motley's identity was complex and, at times, seemed to contain contradictory sensibilities. To his credit, he dealt with racism, to the end of his life, with a philosophical attitude rather than with bitterness. He was dedicated to depicting the various classes and colors of Negro society in Chicago in his paintings, and he showed an awareness of skin coloration in his work throughout most of his career. But he elevated folk and vernacular culture as subject matter, and he was committed to creating art for black folk.

In the twentieth century, the relationship of the middle- and upper-class African Americans to working-class folk presented a bit of a dilemma for many blacks. As sociologist Kenneth Clark explains, white America is basically a middle-class society, and the middle class sets the "mores and the manners to which the upper class must, when it wishes to influence, seek to conform, at least in appearances" and which the lower class attempts to conform to or defensively rejects. The attention politicians give to the middle class in their public rhetoric while their legislation and policies actually support and protect wealthy individuals and corporations, often at the expense of that same middle class, provides a perfect example.

Clark goes on to say that in "dark America" the lower class sets the "mores and manners to which, if the Negro upper class wishes to influence, it must appeal, and from which the Negro middle class struggles to escape."[42] The conundrum for aspiring artists of the Negro Renaissance was that folk or blues culture became a cultural reservoir and touchstone for authenticity in subject matter in art, but the middle-class aspirations of some artists separated them from the group of people constituting this group. Archibald Motley seemed to have been caught in this dilemma. Perhaps he might have been described as Henry McFarland of the *Philadelphia Record* in 1894 described various black leaders of his day. "They have little to do with the mass of colored citizens," he stated, "except in a business way or by making speeches or addresses to them."[43] Motley's art depicted Negroes and Negro life, but most of his sales were to white collectors, an irony still encountered by many African American artists in the twenty-first century. Additionally, his expressed perspectives more closely reflected those of Chicago's Negro elite than those of the working-class folk who enlivened his genre paintings.

Two works from the early 1930s give additional insight into Motley's interest in skin and affirm his color consciousness. The first, *Self-Portrait (Myself at*

*Work)* (1933; figure 77), presents the artist in his studio and comfortable with his artistic identity. He had won prizes in exhibitions at the Art Institute of Chicago in 1925, enjoyed a wonderfully successful 1928 exhibition at the New Gallery in New York, won a Harmon Foundation prize in 1928, and spent a year of study in Paris on a Guggenheim fellowship in 1929–30. The painting gives insight into the man by presenting him dressed in a smock and beret, affecting an artistic posture adopted from his stay in France. On the wall behind him is a Catholic cross similar to the one in *Mending Socks*. In the lower right corner of the image is a sculpture in a romantic European mode, and a plaster bust like one he would have drawn at the Art Institute hangs above his head. Motley shows himself at work painting a standing nude woman, and his signature on the painting within the painting also serves as the signature for *Self-Portrait*.

Nothing in this work can be linked visually to African American life, though the ceramic elephant just below his right hand offers a curious African reference. The painting-in-progress is most likely another one of Motley's mixed-race women. Her skin coloration is nearly identical to that of the artist. The fact that the subject is a classical female nude, along with his wearing a French beret and smock, connects the artist to Western artistic traditions. He was following his own admonition to Negro artists to paint Negro subject matter, but he also was inserting Negroes into the Western art tradition as artists and validating the Negro as subject matter. This effort was an important one and acknowledged the fact that contemporary American life has been heavily influenced by African American cultural and intellectual contributions. He felt that Negro artists should be able either to portray Negro subject matter or to pursue purely aesthetic concerns. This would "give the artist of the Race a chance to express himself in his own individual way, but let him abide by the principles of true art, as our [white] brethren do."[44]

Segregating African American accomplishment and artistic expression draws out differences and allows stigmatization because things outside the norm of a society tend to be imagined as inferior. Motley's attitude was correct in this instance. Yet the nude woman he appears to be painting is not discernibly African American. It would seem that, for Motley, desire was visualized by women who resided near the white color line and that he was unable to transpose the maid with Olympia. He was unable to make a dark-skinned black woman the object of either illegitimate or respectable desire.

Motley's color consciousness—which should not be overly criticized but utilized as a means of gaining insight into his era—does not undermine his courage as an artist. He explored Negro subject matter at a time when Tanner's *The Banjo Lesson* and *The Thankful Poor* were two of the few notable genre paintings by Negro artists with Negro subjects. Edmonia Lewis, with *Hagar* (1875)

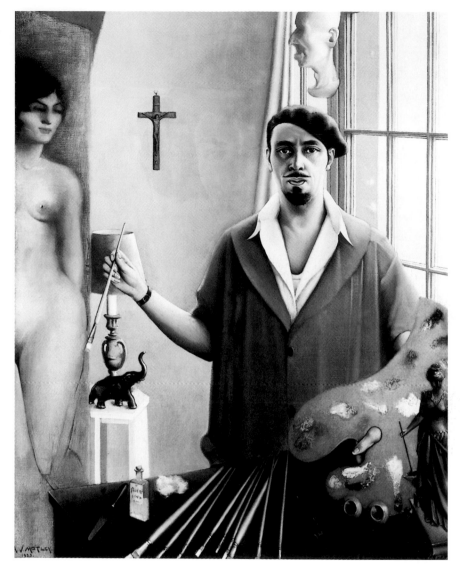

and *Forever Free* (1867) in the second half of the nineteenth century, and Meta Warrick Fuller, with *Ethiopia Awakening* (ca. 1920) in the second decade of the twentieth century, had explored themes and subjects related to Negro life in America, but they had done so allegorically. Motley entered one of his early paintings showing nightlife in Chicago's Black Belt, *Syncopation* (ca. 1924), in an exhibition at the Art Institute and met strong opposition from William Farrow, artist, critic, and president of the black Chicago Art League. Apparently he objected to the depiction of blacks engaged in "low life" amusements such as cabarets and dance halls, an objection that might have been rooted in an insecurity about the association of vice, nightlife, and prostitution with the Black Belt community mentioned earlier.[45] Motley persisted despite the objections;

yet he explored Negro life as an observer more than as a participant, and his work seldom directly expressed social commentary.[46]

The 1934 painting *Black Belt* was executed in the style for which Motley is most remembered, and it began in earnest his series recording the lively street life of the Bronzeville section of Chicago. The artist captured Negroes in a variety of shapes and sizes, both men and women, moving through a variety of light sources on a warm, clear evening. Motley wrote that he had "a sincere love for the play of light in painting and especially the combination of early moonlight and artificial light." This work came from his desire to explore such concerns and "to depict a street scene, wherein I could produce a great variety of Negro characters."[47] Motley did not live in the Black Belt and had to travel there to make his observations. The people in this work, and others in the series, are more ethnic *types* than individual personalities. This is consistent with his statement about his scientific approach toward painting and with his series of portraits documenting mulattoes, quadroons, octoroons, and a mammy.

Motley's 1935 painting *Between Acts* (figure 79) goes backstage at a Bronzeville burlesque theater but gives little insight into the personalities populating the image. It does, however, provide an interesting dialectic in the representation of the fair-skinned female performers and the darker male standing at their dressing room door. The two female performers are semi-nude and relaxing between performances, and they share an immodest disregard for the open door. Their faces are partially hidden, and each is lost in her own introspection. They do not talk with each other, nor do they acknowledge the dark-skinned male just outside the door, which has been left ajar. The open door allows the male voyeuristic access to the women should he choose to turn and gaze at them, but he is territorially remote. He is separated by physical space, by gender, and by his state of dress, and the artist has rendered his face almost as a caricature or stereotype, in contrast to the faces of the women, which, though lacking individuality, do not descend into caricature. He is composed mainly of straight lines and rectangles and is framed in a rectangular space, while the women are composed of organic lines and shapes and are contained within the ovate mirror.

The man, apparently a performer preparing to go onstage, carries a cane in white gloved hands and is wearing a top hat and a tuxedo with trousers that are too short for him. The pant legs are several inches above the tops of what appear to be brogan shoes. He has a cigar jutting upward from his large, red lips. He has the appearance of a coarse dandy, the zip coon of minstrelsy. In the future, he might be Kingfish from Amos 'n' Andy. The black clown is a foil for the pink-skinned women in a theater of the absurd. Though Motley stated his intention to replace the "obsolete" images and stereotypes of the previous century, this image almost catalogs old racial and color stereotypes by reprising the

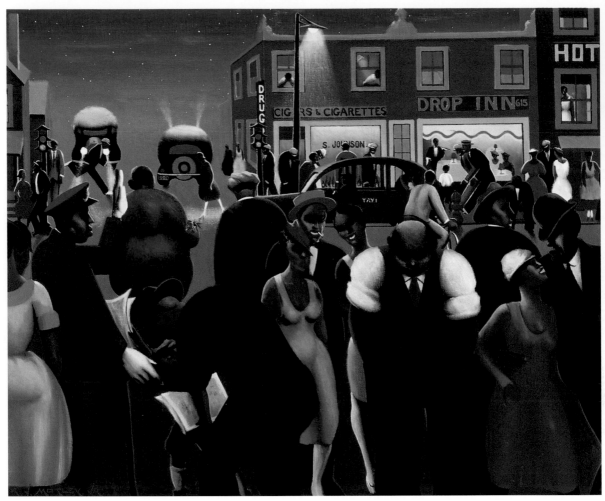

FIGURE 78.
*Archibald J. Motley Jr.,* Black Belt, *1934, oil, 37⅞" × 39¼". Collection of Hampton University Museum, Hampton, Va.*

minstrel buffoon and visualizing the sexualized black woman. By making that woman a mixed-race figure, Motley has intersected the discourses associated with miscegenation and with the black woman as a sexual primitive.

Perhaps this work serves to point up the theatricality of Motley's tableaux. Because he drew his compositions dozens of times before painting, his paintings are meticulously staged. Often their lighting has more in common with stage lighting than with natural lighting as we might experience it. Many scenes fade into backdrops of muted color, as can be seen in *Black Belt*, and this undermines a sense of deep space in an outdoor setting or, in an interior setting, the feeling of being inside a well-defined room. Finally, Motley expressed his interest in his subjects as characters, seldom naming them or participating in their lives. Did he mean that it was all a minstrel show?

Archibald Motley's images allow the construction of a framework for better understanding issues of color and color lines within African American urban

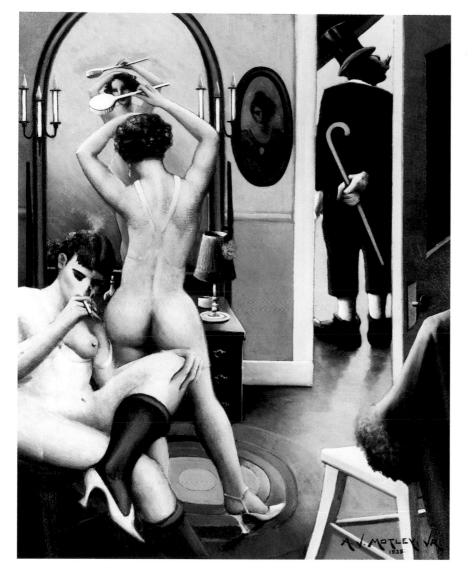

FIGURE 79.
*Archibald J. Motley
Jr.,* Between
Acts, *1935, oil,
39⅜″ × 32″.
Courtesy of the
Chicago Historical
Society.*

communities during the New Negro era and beyond. He presented a particular
male gaze, and he visually constructed black male desire for the black urban
middle-class. Motley looked at African American life, but he seemed to have
been glancing wistfully toward the restricted terrain across the white color line
while gazing across a colored line at black life. One is hard pressed to discover in
Motley's work the pathos of the blues or the sense of dislocation felt by mi-
grants from the South in the cacophony of urban Chicago. He seemed to have
an ambivalent relationship with the larger African American community and
felt little regard for Alain Locke's notable 1925 call for artists to look to their an-
cestral legacy. After his successful 1928 exhibition in New York, he declined to
attend a reception in his honor at the home of Bessye Bearden (Romare Bear-

den's mother),[48] a New York correspondent for the *Chicago Defender*, where he was to meet and mingle with many of the prominent African American artists in New York, and he believed for the remainder of his life that they were jealous of his success.[49] He married a white woman and lived in a predominantly white neighborhood all of his life. Motley documented color lines in his notable work, and he crossed them in his life, though he seemed most comfortable within the Negro territory adjacent to whiteness. He resided within a larger epistemological framework of assumptions and definitions privileging light-skin coloration and denigrating the physical and cultural elements of blackness—a framework he did little to resist. His work investigated black urban life but observed more than celebrated it. It was only when he painted women of mixed race that he worked from feeling and experience.

## SELF-ERASURE

*Were they not a superior class? Were they not a very high type of Negro, comparable to the persons of color groups in the West Indies? And were they not entitled, ipso facto, to more respect and opportunity and social acceptance than the more pure blooded Negroes? In their veins was some of the best blood of the South.*
—Wallace Thurman, The Blacker the Berry . . . *(1929)*

Issues of color appear to be a lingering problem wherever there was white domination over a black population along with fairly substantial mixed-race populations due to miscegenation. Some of the color issues of Motley's time have surfaced recently in Jamaica. A *Washington Post* story focused on Latoya Reid, a seventeen-year-old Jamaican girl who "was bothered by her dark skin." She felt that it was a hindrance to attracting boyfriends or finding a better life than what she endured in a poor section of Kingston. In order to become a "brownin'," a term referring to blacks with light skin, the young girl resorted to bleaching her skin using illegally imported skin creams containing steroids. The practice, which seems to have been fairly common in the first half of the twentieth century in many African American communities, has grown in Jamaica in the 1990s. According to the story, many of the island's poor feel that a lighter complexion "may be a ticket to upward mobility, socially and professionally, as well as to greater sex appeal." Reid is quoted as saying, "When I walk on the streets you can hear people say, 'Hey, check out the brownin'.'" She added, "When you are lighter, people pay more attention to you. It makes you more important."[50]

Many of the bleaching creams contain harmful chemicals, which is why they are illegal in Jamaica, and doctors there have reported an increase in patients

seeking treatment for skin disorders. The skin creams typically contain hydro-
quinone, a chemical used in the rubber industry that can lighten skin color, and
steroids that can suppress certain body functions. The two substances seem to
stop the formation of pigment in the skin. The use of high concentrations of
steroids for long periods can interfere with the growth of skin cells.[51] In some
ways this is a sad déjà vu of sixty-year-old events in the United States. Historian
Kathy Peiss reports that "[s]kin bleaches received particularly close scrutiny
from the American Medical Association in the 1920s and the Food and Drug
Administration in the 1930s. Nadinola bleach cream, it turned out, contained 10
percent ammoniated mercury, a concentration high enough to cause serious
skin irritation and damage. . . . Under pressure, the company decreased the am-
moniated mercury to 6 percent and finally reduced it to 1.5 percent in 1941."[52]

A twenty-two-year-old Jamaican woman who uses the creams despite their
potential for harm says, "I know they can do bad to your skin, but I have noth-
ing to lose in wanting to be a brownin'. I am poor and bored, and being whiter
would make me happier."[53] This legacy of colonialism, which institutionalized
advantages for whites and fair-skinned blacks, has inspired bleaching in other
Caribbean nations, such as the Bahamas, and in South Africa. Perhaps African
American women in Motley's era felt similar emotions. As blacks migrated to
northern cities in great numbers after the First World War, black newspapers
and social service agencies advised women on proper appearance and deport-
ment, "proscribing the rural customs of head rags, boudoir caps, aprons, and
house slippers in public."[54] Greater attention was paid to their appearance now
that they were moving and working in places that were more public. Peiss re-
veals that "[a] very dark complexion especially hampered women seeking work
as secretaries, waitresses, doctor's assistants, actresses, or other positions in-
volving face-to-face contact with the public. . . . Those with lighter skin were
viewed as more refined, while their darker sisters were considered better man-
ual laborers."[55]

Two novels two generations apart—*The Blacker the Berry* . . . (1929) by Wal-
lace Thurman and *The Bluest Eye* (1970) by Toni Morrison—engaged the per-
sistence of color consciousness within the African American community and its
effects on the psyche of people. In both stories, the protagonist grapples, just
like Latoya Reid in Jamaica, with her dissatisfaction with being black. Thur-
man's novel opens with this sentiment in the first two sentences: "More acutely
than ever before Emma Lou began to feel that her luscious black complexion
was somewhat of a liability, and that her marked color variation from other
people in her environment was a decided curse. Not that she minded being
black, being a Negro necessitated having a colored skin, but she did mind being
too black."[56] Emma Lou tried to address her skin coloring chemically:

Everything possible had been done to alleviate the unhappy condition, every suggested agent had been employed, but her skin, despite bleachings, scourgings, and powderings, had remained black—fast black—as nature had planned and effected.

She should have been a boy, then color of skin wouldn't have mattered so much, for wasn't her mother always saying that a black boy could get along, but that a black girl would never know anything but sorrow and disappointment?[57]

In the vernacular experience of many blacks, self-deprecating sayings played with this color issue. One sardonic saying I heard often was, "If you're white, you're all right. If you're yellow, you're mellow. If you're brown, stick around. If you're black, get back." Another expression that was not widely known, but one I heard several times, was the tag of "wasted yellow" applied to a fair-skinned black woman who was unattractive. The title of Thurman's novel is a fragment of "the blacker the berry, the sweeter the juice," a defense of dark-skinned women that dripped with sexual innuendo and was used at times to explain, with irony, the attraction many white males felt for black women. Still, for many black men, the ideal of female beauty was a woman with light skin, straight or wavy "good" hair, and light-colored eyes. This mulatto aesthetic played out visually in the art of Archibald Motley more obviously than in the work of any other prominent artist of the period.

Recently, issues of color and miscegenation surfaced in the 1992 work *La verdad no mata (The Truth Doesn't Kill You)* (figure 80) by black Cuban artist María Magdalena Campos-Pons. Three silhouettes of the artist's body appear: one in black, a cutout in a wooden plank, and the cutout area itself, which is presented in yellow. The yellow figure has a hatchet buried in her back, but a black heart bursts from her chest. Shifra Goldman wrote about this work suggesting that one reading of the work is that "the black and the white (or negative) have mixed and produced the mulatto (in this case, mulatta) whose ambiguity in society ranges from being ostracized by both black and white, to being glamorized as an exotic lover who combines a lighter skin with the erotic appeal of African sexuality."[58]

By presenting her body in a multicolored triplicate, Campos-Pons has unconsciously revived the Yoruba concept of *oríta méta*, a three-way crossroads. Crossroads are transformative thresholds, points where one crosses into another realm of being or moves in a new direction. This image brings together three women with entangled histories—white, black, and mixed—as well as the suggestion that a step toward any one racial location puts different things at stake. In addition, the common aspects of the destinies of these three charac-

FIGURE 80.
*María Magdalena
Campos-Pons*,
La verdad no
mata (The Truth
Doesn't Kill You),
*1991, wood,
marble, and glass,
118″ × 78″ × 11″.
Courtesy of the
artist.*

ters are embodied in another Yoruba saying: *ògbóni méjì, o de eta*—two members, it becomes three. This refers to the *ògbóni* society of elders in Yoruba communities and their iconography, which involves two figures and the implied presence of a third. The three are connected and, in many ways, have a destiny in common. Also, the *ògbóni* iconography of two implying a potential or unseen third intimates the Hegelian idea that thesis plus antithesis equals synthesis; the male and the female unite, and their connection evokes the metaphysical third element, in their case, the force of *onile*, the earth spirit. In our case, white and

black together contain the potential for the synthetic third, the mulatto, but the third represents the destruction of the two original elements through transformation. White and black lose their racial meanings when not in opposition, as I discovered in Nigeria.

*La verdad no mata* perfectly articulates the definition of whiteness presented here—an identity defined by and dependent on its contours rather than its body—and, by implication and interpretation, the complications of miscegenation are addressed. Perhaps the artist is suggesting that the black heart has survived it all, and Goldman believes it to be a celebration of survival and the human spirit.[59] The whole drama plays out through the female body. The work testifies to the residue of colonial color consciousness and advantage remaining in postrevolutionary Cuba.

There are psychological aspects to color consciousness that extend beyond a concern for social and economic advantage, and even a superficial look at some of them may help explain attitudes and behaviors among many blacks that are self-deprecating. For example, a surprising story appeared recently in *The Source*, a magazine devoted to hip-hop culture and music, containing a brief interview with Courtney Mann, director of the Philadelphia chapter of the National Association for the Advancement of White People (NAAWP). The reporter became interested in the group, she says, while "researching literary sources on the Pro-American level. I thought it was a sound organization as far as representing what the United States is all about. It's about America and civil rights issues."[60] In the interview, Mann expressed a similar perspective to that of anti-affirmative action activist Ward Connerly: "We don't want one-sided legislation as it has been prone to discriminate against whites, such as affirmative action which was established due to the historical discrimination against Blacks. It's outlived its usefulness because it has brought about outright discrimination towards whites through the judicial system."[61] Like Connerly, Mann is black, which makes her activism just as puzzling to most blacks, many of whom feel that whites are not in need of defense from black codependency.

What would explain the persistence of color consciousness among African Americans, the persistence of blacks' calling each other "nigger," and other self-deprecating behaviors that seem to duplicate the disdain that many whites have had for blacks? What would cause some blacks to take leadership roles aiding the efforts of conservative, often racist, whites against affirmative action?[62] Thirty-five years ago Kenneth Clark, in a study of Harlem, wrote that "[t]he harmful effects of American racism on personality development and psychological balance are unmistakable."[63] Perhaps the psychological phenomenon known as the Stockholm Syndrome, in combination with sociological factors,

may help answer some of these questions and characterize some of the harmful effects of racism.

## THE STOCKHOLM SYNDROME

On August 23, 1973, a bank robbery began at the Sveriges Kreditbank in Stockholm, Sweden. When the robber met resistance and gunfire from a plain-clothes policeman, he took four hostages into the bank vault and held them there for nearly six days. At the end of the ordeal, there was an unexpected out-come: the captives had begun to identify with and think like their captor. Because the entire event had been covered live by Swedish media, this phenomenon became known as the Stockholm Syndrome.[64] It is defined in *The Penguin Dictionary of Psychology* as "[a]n emotional bond between hostages and their captors which is frequently observed when the hostages are held for a long time under emotionally straining circumstances."[65] Perhaps the most renowned example in the United States is the case of heiress Patricia Hearst, who was abducted by the Symbionese Liberation Army in the mid-1970s.

One of the crucial elements for a hostage syndrome to occur is the time in which some amiability can develop between the conquered and the aggressor. When the victim identifies with the hostage taker, it begins as a means of defense. Psychologist Phillip Pilevsky argues that "it is a means by which the self adapts to the demands of a dangerous situation," thereby promoting improved safety and chances of survival. The hostage's identification occurs without the hostage taker attempting to bring it about. "Because of this identification, the victim's attitudes and actions become congruent with the hostage taker's."[66]

Identification, a key component in Du Boisian double consciousness, is a complication that is layered for African Americans. Hostages seldom face the additional problem of stigmatization that blacks endure. Social psychologist Claude Steele writes that stigma, "the endemic devaluation many blacks face in our society and schools," is a status that "is its own condition of life, different from class, money, culture."[67] He argues that "devaluation grows out of our images of society and the way those images catalogue people. The catalogue need never be taught. It is implied by all we see around us: the kinds of people revered in advertising (consider the unrelenting racial advocacy of Ralph Lauren ads) and movies (black women are rarely seen as romantic partners, for example); media discussions of whether a black can be President; invitation lists to junior high school birthday parties; school curricula; literacy and musical canons."[68]

These imagings of society expand the devaluation of blacks and "act as the

mental standards against which information about blacks is evaluated: that which fits these images we accept; that which contradicts them we suspect."[69] Steele has constructed his argument to explain the circumstances affecting the achievement or lack of it by black students in school, but his ideas are useful for this discussion. He indicates that, "because these images [of devaluation] are conditioned in all of us, collectively held, they can spawn racial devaluation in all of us, not just the strongly prejudiced. They can do this even in blacks themselves."[70] Therefore, blacks who identify with a system or authority that devalues them have yet another impetus toward self-deprecation.

The threat of violence is a force in instilling the hostage syndrome. Violence, or its threat, was a significant element in the antebellum South, again in the segregated South after the collapse of Reconstruction, and in contemporary times with the threat of excessive or lethal force commonly used by the police.[71] Discussing the martial control of the antebellum South, historian Herbert Apthecker writes: "First, most of the U.S. Army was stationed in the South prior to the Civil War. Second, each Southern State had a well-trained and armed militia. Patrols were provided by law for the country-side and these were mounted armed men; in the cities in addition to police there existed special Guards, in some cases—as in Richmond and Charleston—armed with artillery weapons as well as swords, pistols and rifles. . . . Furthermore, each master was himself armed and so was the overseer."[72] In this climate one was constantly reminded that being enslaved was a "dangerous" or catastrophic situation. Research reveals that "when any organism is thrown into a catastrophic situation— a situation in which it cannot cope with the demands of its environment—it will feel a threat to its existence or essential values."[73] When survival conflicts with essential values, often those values are subordinated to survival practices. According to Freudian ideas, this is explained as the ego, governed by the reality principle, assuming a controlling function over the id and the superego. The demands of reality, the instinctual demands of the id, and the moralistic demands of the superego are in constant mediation. When the self is threatened, as it is in most stressful situations, the ego adapts. The goal of a healthy ego is the achievement of survival.

There are several strategies that can be taken to cope with the danger and stress. Pilevsky calls one of these the "mobilization of hope," which is the belief that the ultimate outcome will be tolerable and the suffering will end. Another defense is defiance and active resistance. A frequent coping mechanism is focusing on the good, focusing on minor gratifications.[74] In Steele's analysis, survival for black students means that they disidentify with the system that devalues them and generate an alienation from it. "This psychic alienation—the act of not caring—makes [the student] less vulnerable to the specter of devaluation

that haunts him."[75] Blackness and school success therefore become incompatible, and demoralized students pressure more successful ones to abandon their success because those blacks "who identify and try to achieve embarrass the strategy by valuing the very thing the strategy denies the value of. Thus pressure to make it a group norm can evolve quickly and become fierce."[76] The bitter irony is that alienation encourages a lack of success, which confirms the image of black inferiority that helped produce the alienation.

Studies have shown that people who maintain a faith in their own country, their leadership, or their religion cope much more successfully when they are incarcerated. All of these defenses can be found in the conduct of captive Africans and African Americans under the harsh oppression of slavery and during the subsequent period of segregation and its accompanying terrorist assault of lynching, mutilation, and murder. It can be seen in the ubiquitous religiosity blacks used to insulate themselves from slavery and postbellum oppression, nurturing the sense of a seat in Glory as liberation from the horrors of this world.

According to Pilevsky, when captives begin to identify with the captor, it "causes the hostages to internalize sympathies for them and create justifications for their actions, just as children do for their parents."[77] Because the threat of death gives the captor control, there is a dependency on the part of the captives that causes certain infantile behaviors to occur. "The very experience of being a captive puts many adults right back into a state of childhood obedience," a response that is defined as "traumatic infantilism." The result is "a regression to childlike behavior colored by short-term thinking . . . and wishful thinking." Pilevsky adds, "After much exposure to domineering, sadistic control, the victims may assume the characteristics of the aggressors. Some prisoners carry some of the character of the aggressor with them after they have been liberated."[78]

Pilevsky uses Freud's ideas of a son's identification with his father in the Oedipal complex to further explain the hostage syndrome. The goal of a child's identification is to erase the conflict with authority and close the gap between them. In Freud's view, this represents the beginning of the new sense of self. The boy's desire to be free has been thwarted by the dominant figure, but he resolves the crisis by "identification with his captor to ensure the survival of his psyche and to avoid punishment." Identification is the "means by which the hostage avoids punishment."[79] Freud's ideas deal with sexuality, and there are sexual undertones in the use of an Oedipal complex to explain a relationship. Given the sexual dominance of the white male discussed in chapter 3, black identification with the authority figure may, in some ways, replicate the sexual rivalry aspect of Freud's Oedipal complex.

There is a disturbing degree of symmetry between the hostage syndrome

and certain patterns of behavior to be found in African American history. The trauma of captivity, beginning with capture in Africa, confinement during the horror of the Middle Passage, and the constant state of captivity that defined Atlantic slavery duplicate, in many ways, the hostage conditions described above. As Clark argues, "Since every human being depends upon his cumulative experiences with others for clues as to how he should view and value himself, children who are consistently rejected understandably begin to question and doubt whether they, their family, and their group really deserve no more respect from the large society than they receive. These doubts become the seeds of a pernicious self- and group-hatred, the Negro's complex and debilitating prejudice against himself."[80]

Barbara Huddleston-Mattai and P. Rudy Mattai argue that slaves were "not merely passive and sterile in the transference of the mode of thought of the masters but sought instead to reconstruct perceptually the psyche of the master and occasionally assumed his characteristics" and at times exceeded the master's behaviors.[81] The authors call this process resocialization, and it can cause the embrace of the captor's value system as one's own. In some manifestations, this mentality engenders attempts to mimic Euro-Americans, "to dissociate from anything identifiably or perceived as identifiably African-American, and even to exhibit embarrassment when another African American demonstrates behavior that is thought to be viewed negatively by Euro-Americans."[82]

This places African Americans in a double bind. The high level of identification with whites some African Americans felt can be described as a symptom of the neurosis of hostage syndrome. Even without identification, the cumulative effects of ubiquitous devaluation reinforced by images can instill a destructive propensity for self-deprecation. It would partially explain the color consciousness and hierarchy that has bedeviled efforts at creating group unity for a century. It does not fully explain the rampant use of the word "nigger" in the vocabulary of many blacks today, but Clark's astute study shows the social reinforcement of a self-degradation that is also a by-product of identification with racist authority. The ambivalent and ambiguous qualities that we have seen in Archibald Motley's art, especially as it relates to the color line, may have resulted from the kind of pathology described above. In any case, the patterns that Steele and Clark have illuminated help explain the often troubled psychology that many African Americans have struggled with during the twentieth century.

When the young man in the market called me *òyìnbó* that day in 1991, he unearthed for me a lifelong discourse about color, stigma, discreditation, and identity, as well as a search for redemption, that had been my experience in the United States. Color lines had become increasingly unreliable and unsupport-

able in my life and had been replaced by measures of consciousness and cultural affinity. Perhaps this is the result of some lessening of the tangible rewards tied to color and race in the United States. But on that day in Nigeria I was forced to confront the absurdity of compensatory psychology and my own complicity in the maintenance of color-based identities. To define myself in racial terms was a way of renegotiating my position within the discourse of race, but it *ensured* that I would remain within it. Racial identities offer no transcendent possibilities, but they do map the terrain of power and privilege.

African Americans appropriated the concept and identity of blackness, inverted it, and tried to use it as a means of organizing a racial solidarity, a sense of Pan-Africanism, to resist racism and to affirm our worth as a people. Lamar Parker lost his life in part because of the permeability of the edges of blackness, and I was stripped of a part of my identity when I attempted to rely on it outside the context in which it had meaning. I was forced to face the reality that culture and consciousness, not race, causes people to coalesce when circumstance does not compel such unity. What did it mean to be a black man in Nigeria? What happens if there is no color line? How can one step outside the lines of the skin-tight bind?

# THE LANGUAGE OF APPROPRIATION

## FANTASIES AND FALLACIES

*vibrate*

*vibrate you very essence of the dark*

*in a wing in a throat from so much perishing*

*the word nigger*

*sprung fully armed from the howling*

*of a poisonous flower*

*the word nigger*

*all filthy with parasites*

*the word nigger*

*loaded with roaming bandits*

*with screaming mothers*

*crying children*

*the word nigger*

*a sizzling of flesh and horny matter*

*burning, acrid*

*the word nigger . . .*

   *—Aimé Césaire, "Word"*

*It's not what you call me. It's what I answer to.*

   *—African proverb*

In 1987, during a two-week visit to Egypt for a conference/tour that explored Egypt as an African civilization, I met Makeda, a woman with dreadlocks who was from Cincinnati and had been living in London for about seven years. We became friends, and three years later, when I began doing my dissertation research in London, she was gracious enough to allow me to sleep in her front room for a few days. During one of my visits I noticed that she had a number of racist kitsch items, often called black memorabilia, shelved in her kitchen. She is not a politically unconscious, middle-class woman following a recent trend. She has proven herself to be a politically savvy woman committed to a lifetime of creative work on behalf of people of African descent. Although I oppose the collection and display of these items, our long debate about them has been respectful and interesting. But the fact that black folk like Makeda and Julian Bond, among others, collect ceramic uncles and mammies reminds me that the issue is complex. Still, what am I to make of the fact that at some memorabilia shows 80 percent of the dealers and a majority of the consumers of these items are black? How do we manage the fact that black support for and consumption of such objects has caused them to be produced anew decades after black protest had diminished their presence in American society?

There are equivalences between derogatory terminology and stereotypical images, and similar strategies of appropriation have played out in the use of terms. What can one make of the public and private surge of African Americans calling themselves "nigger?" Is this act in the same class as positioning antique mammies on contemporary shelves? Is it really possible to appropriate racist images and terms and drain them of their poison?

When considering why black folk collect self-deprecating objects, or use images of them in their art, I am led to think about the sophisticated postmodernist irony attributed to the sophisticated strategies of appropriation, reappropriation, or deconstruction when folk attempt to tame their demons by taking them home. Now that many young blacks have come to call themselves "nigger" (a rampant phenomenon in rap music lyrics) as if it is a descriptive, appropriate, endearing construct, I am supposed to feel that the word has been drained like a swamp of all the disease-carrying racist pestilence of its origins and actual meaning. When ceramic mammies and uncles sit in middle-class black kitchens as historical documents and mnemonics, why am I not moved in the way I might be if a Van Der Zee photo of a Garvey parade or a black religious group (figure 81) in 1920s Harlem hung there instead? Are we all really so sophisticated now, do we really (wink, wink) get it? If so, why is there anger and tension if a white person endearingly calls me his "nigger" the way a black person might? What is really going on here?

What complicates the issue further is the African American vernacular tradi-

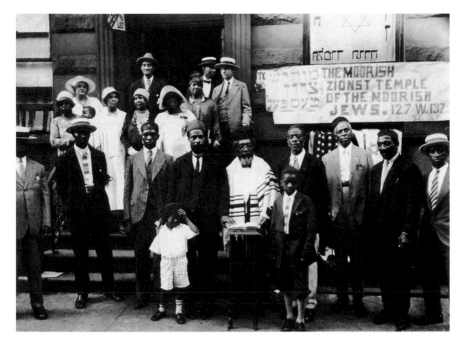

FIGURE 81.
*James Van Der Zee,* Moorish Zionist Temple of the Moorish Jews, 1929. *This group apparently did not survive, but another black Jewish community in Harlem that emerged around this time, the Commandment Keepers: Ethiopian Hebrew Congregation, is still active. Photograph © Donna Mussenden Van Der Zee.*

tion of signifyin'. Verbal strategies and subterfuges have allowed indirect jabs at something troublesome, or they have become the means of playing with circumstance. Several layers work in concert with the snap, "Ain't jo mama on a pancake box?" Here is the African proverb in action: *It's not what you call me. It's what I answer to.* There is a denial of association with the pancake mammy stereotype because of its absurdity. That is a white fantasy, and we know it. Since the undercurrent of the snap is an admonition against even the *appearance* of mammyhood, association of the sacred black mother with the mammy fantasy is so extreme that the play/performance is obvious. The linguistic slippage is inventive. If the snap draws a big laugh from bystanders, you must keep your cool and return fire with even more explosive wit. But then, when the comeback was, "Your mama is so black, she leaves footprints in a coal mine," there was a bit of psychological dross in there that went beyond mere signifyin'. When the signifyin' played with racial stereotypes, often there were undertones of self-deprecation that periodically came to the surface.

There seem to be several issues worth discussing relative to black folk playing with, appropriating, or recycling racist language and imagery. Combinations and degrees of these issues come into play when discussing the collection of racist kitsch, the imagery of artist Kara Walker, or the use of demeaning language in a first-strike effort to take control of its meanings. One is the strategy of *inversion*: turning a sign or a trope inside out, upside down, to disrupt its meaning and impact. Related to this is *recontextualization*: the Duchampian no-

tion of putting a urinal in a gallery to transform it into sculpture. Third, there is the idea of *reappropriation*: taking a weapon used against you, making it your own, and thereby controlling it and preventing it from doing further harm. Finally, in all cases we must consider the visual effect: can the application of a veneer of new interpretations overcome the subconscious impact of an image? Are these strategies truly effective or merely diversionary chimera?

## INVERSION

Can one ever appropriate or reappropriate the fantasy of another? Is it possible to devise a strategy, a cultural guerrilla raid, that incisively moves into the conceptual terrain of the oppositional Other to capture the weapons used against one? African Americans, conceived as blacks, have been misrepresented in myriad ways for almost two centuries, both verbally and visually. In the late twentieth and early twenty-first centuries a series of strategies have attempted to neutralize and undermine the harmful representations through resistance, inversion, appropriation for reinvention, and deconstruction. In his poem "Cultural Exchange," Langston Hughes uses inversion to signify, a point driven home by the final lines:

> *Dear* old
> Mammy Faubus!
> *Culture*, they say, *is a two-way street:*
> Hand me my mint julep, Mammy.
> Make haste!"[1]

Hughes is flipping the discourse on its head and giving it back with wit and sarcasm. He has not appropriated a plantation scenario but has inverted its population for effect and satire.

Recently, Texas artist Michael Ray Charles gained some notoriety for his use of stereotypical caricatures of blacks in his paintings to make social statements. He attempts to take an object of ridicule and turn it backward into a critique of those who might create or continue to accept such caricatures. In some works he seems to criticize blacks who act out the stereotypes. The works take on the appearance of minstrel or circus posters and locate themselves in the world of odd and strange entertainments where difference is the attraction. In a 1994 painting, *Beware* (figure 82), Charles has taken an old pickaninny/Sambo image and created a multilayered reference to the old carnival posters, as well as to posters for outlaws and, obliquely, runaway slave ads. The cartoonish child figure whistles through huge red lips with a greater resemblance to Mickey Mouse than to

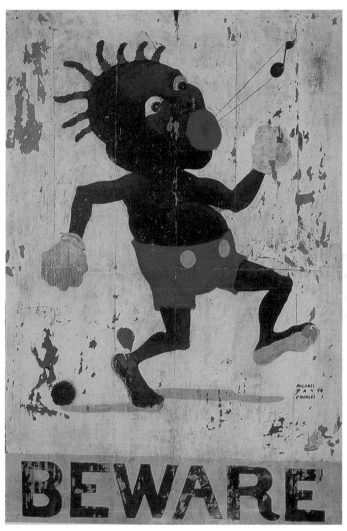

BEWARE

notions of a black brute. The references are ironic, satirical, and critical; why does this innocent figure generate fear and warnings?

In past periods of African American powerlessness, invisibility, and silence, the idea of "talking back" to white folks was carried out through subtle exaggeration, allusion, signifyin', and expressive cultural forms for all-black audiences. In blues songs, folktales, or literature by African American writers, often there was a tension between the imposition by whites of stereotypical expectations and the complicated, layered, often painful, reality that characters experienced. This was true for pale Clare Kendry who passed as white in Nella Larsen's *Passing,* as well as for Emma Lou who was deemed too black in Wallace Thurman's *The Blacker the Berry . . .* , both from 1929. Jazzman Louis Armstrong sung that same year with a self-awareness of his oppressed position when he lamented, "My only sin . . . is in my skin / What did I do . . . to be so black and blue."[2] The

very concept of the blues became a metaphor for the difficulties of life lived black. For the most part, it was only in white-dominated circumstances that blacks played the roles prescribed by white stereotypes; within the sanctuary of all-black situations folk expressed their full humanity.

Charles is not signifyin' in the sense of ironic reversal that we find in the Aunt Jemima of Jeff Donaldson or in Langston Hughes's poem of an earlier time. The sarcasm of Hughes's in-your-face "ask your mama," another line from "Cultural Exchange,"[3] is not embodied by this cartoon figure, but there is a level of sarcasm present. Marilyn Kern-Foxworth writes that Charles's works "serve as a sort of shock treatment for those who are unwilling to acknowledge the existence of stereotypes or as a wakeup call for those who are too sheltered to recognize their potential for harm."[4] Yet, one of the most striking things about the work is that it is *not* shocking. Coon and mammy imagery was ubiquitous in American culture until the 1980s in all manner of guises, disguises, and shadings, and artists have worked to supplant or destabilize them at least since the second decade of the twentieth century. Additionally, left unanswered is the question as to whether resurrecting stereotypes reinscribes their "potential for harm" or perhaps actually does harm anew. Charles says that he is "talking about the stereotypes and they are negative but yet positive. Think about the Sambo. Because of the Sambo image, blacks were allowed to get into entertainment." He says, "I really don't think I'm dealing with the negative at all. I know I'm dealing with an aspect of it. . . . I know according to the norm I'm dealing with negative images and I acknowledge that aspect about my work. But I really think I'm dealing with the positive aspect. . . . I think the whole black experience has become a caricature sort of image."[5]

There are contradictions in Charles's statements, and the differing reactions to his work by different audiences suggest something about the effect and effectiveness of the work. Charles says that his grand design is to "document the African American experience."[6] Though the artist believes his work to be rooted in the black experience and in black history, he acknowledges that "Whites generally accept the work from the beginning. Blacks have a hard time with it."[7] If we accept the premise that black stereotypes are based in white fantasy and projected onto blacks, then we can argue that Charles is playing with and complicating history and images rooted in nonblack culture. He is documenting an outside *perception* of the black experience, not the experience itself. His intention is to destabilize the images and turn them into a critique of the persistence of stereotypes as well as a celebration of black progress. The work is meant for a white audience, and it is from that audience's approval that the artist seeks his own validation. He privileges the positive reception of his work by whites — who obviously are not offended by the critical commentary — and he seems dis-

connected from the African American cultural tradition of call-and-response validation: "I feel that it is unfortunate that some blacks see my work and don't understand it. I think that someday they may. But the thing about it is, I think the work is going to have to be defined or accepted by the dominant culture of whites first and then more blacks are going to come around and say 'wow, so this is what he's doing; wow, he's a great artist.'"[8] This statement is consistent with the earlier one about minstrelsy in that it indicates a belief in the power of whites to permit black success, or to endorse it as a prelude for black acceptance.

According to a story in the *Houston Post*, Tony Shafrazi, the New York gallery owner who represents Charles, sees Charles, as he saw Jean-Michel Basquiat, providing a voice of the black experience, and the same article reports that Basquiat collectors are buying his work.[9] If these artists were legitimate representatives of "the black experience," it still would be discomforting to see non-blacks assume the authority to authenticate an African American artist in this way. It is particularly ironic if we consider Nicholas Mirzoeff's suggestion that Basquiat may have been helped in his self-destruction by "the threat that once the [white] audience tired of the novelty, they would move on to other, newer things," a premonition that proved correct.[10] Because his success was partially predicated on his being Other, it was insubstantial. Video artist Martha Rosler suggested that Basquiat was a "tamed entertainer" in the sense of a minstrel performer and that his existence outside the controlled, disciplined mainstream of whiteness generated a good deal of the fascination for him in the art world.[11] Mirzoeff argues that part of Basquiat's insecurity may have come from his continual effort to efface the racial body in his work, his critique of modernism, and his pollution of the elitist art scene with visual techniques having more in common with hip-hop music and graffiti sign-writing than with modernist painting practices and minimalist or pop art histories. The artist emerged during a period of strong conflict in New York between graffiti writers and the white establishment, who saw their intrusion as a threat to civility and rational order. Basquiat, as has been well documented, was a writer, and his tag was SAMO: Same Old S——.

Like the hip-hop expression he emerged from, Basquiat sampled fragments from a variety of sources, and his own identity suggested hybridity with its roots in Puerto Rico, Haiti, and lived middle-class experience in Brooklyn. The sampled fragments of images and language in his work were consistent with his days as a writer and fit well with postmodernist sensibilities and the rootedness of a good deal of recent art in semiotic ideas. Still, Basquiat was seen as black and primitive by many, including his so-called mentor, Andy Warhol. Despite his artistic efforts, Basquiat was unable to open sufficient space within the artis-

tic "heart of whiteness," as Mirzoeff labels it, to be an artist without a racial or ethnic adjective.[12]

If Charles is linked to Basquiat in the mind of his New York dealer, there is an implicit expectation that he be a young, hip-hop "tamed entertainer" as well. In many ways this is a new twist on the Harlem Renaissance era when whites were fascinated with black difference defined as primitivism. Patrons such as Charlotte Mason, who supported Zora Neale Hurston, Langston Hughes, and Aaron Douglas, expressed an enthusiasm for the instinctive, primitive expression of blacks. In a gesture typical of the attitude of the day, Mason had her chauffeur drive her from New York to the Barnes Foundation outside Philadelphia where Douglas had gone to study and insisted that he stop his studies immediately lest they corrupt his natural instincts.[13]

Eugene Metcalf writes that "primitivism was not only a drawing card for Harlem nightlife but also an almost obligatory concern in any art form that aspired to popularity and sought to portray black America."[14] Playing among primitives was a way for whites of the time to "liberate themselves from dull and debilitating tradition, to reinvigorate their lives," and they turned their attention to Harlem.[15] Perhaps this fascination with black expression was a reprise of the fascination at the end of the eighteenth century with black dance and song on plantations and the voyeurism contributing to the mid-nineteenth-century growth of minstrelsy. Additionally, it may have offered a similar freedom from the strictures and guilt of white society that many whites who donned minstrel masks experienced. Metcalf makes the interesting argument that "[b]y supporting and promoting black artists and their art, white patrons could believe that they were working toward a more egalitarian future, but by insisting that the black behavior and art they supported conform to the unreal and potentially pejorative myth of primitivism, they were also insuring, perhaps unknowingly, that this future would be unrealized and their own social position and power remain unchallenged."[16]

Folk art and African art meet in the concept of primitivism. Though African American artists Henry O. Tanner and Archibald J. Motley Jr. exhibited in New York galleries, it is fitting that the first African American given an exhibition at the Museum of Modern Art was folk artist William Edmondson in 1937. Black primitivism, according to Metcalf, "expressed often in terms of African origins, was discovered and celebrated by whites from all over the world."[17] In early-twentieth-century France, the fascination with *l'art nègre* was rooted in a sense of liberation because, as Jody Blake argues, "the French believed that African-American music and dance broke all the rules, or were entirely free of rules," and "challenged the decorum of an era of stiffly starched collars and tightly laced corsets."[18] Still, the craze for black music, dance, and African sculpture

"did not entail a rejection of racist stereotypes. On the contrary, it was because ragtime and the cakewalk seemed to represent the capitulation of 'civilization' to 'savagery' that Parisians embraced them."[19] So it is no wonder that when Motley was given his celebrated exhibition at New York's New Gallery in 1928, he was asked to paint several "voo-doo" paintings by the dealer for inclusion in the exhibition.[20] Motley completed several African "tribal" scenes but never returned to the subject after that experience.

It is telling that three of the most recent African American artists to experience a meteoric rise in the American art world at early ages are Jean-Michel Basquiat, Michael Ray Charles, and Kara Walker: artists whose work locates them deeply within white racial perceptions of blackness. This does not diminish, and is not a comment on, the quality of their work. However, I do wish to question the *response* to the work by many whites in an art apparatus that shows little egalitarian sincerity. If Basquiat, Charles, and, by extension, Walker represent the truth of the black experience, as Tony Shafrazi suggests, it is a perceived experience conforming to certain primitivist/Otherness expectations. If Charles, like Josephine Baker, has donned a mask to exploit white fantasy for his own benefit, he also has risked, as did Baker, helping to establish "aesthetic definitions that allowed socially powerful groups to appear to support a new and more democratic vision of American art and society while actually protecting and even augmenting their exclusive social interests."[21]

In a brief 1994 article about his work in *Vibe* magazine, a publication devoted to the world of hip-hop, Charles indicates that the stereotypes "might not be explicitly used anymore, but they still affect us unconsciously."[22] A year earlier he said, "I believe we are products of the past," and added that hiding the past is not productive.[23] Kern-Foxworth tells us that Charles "has proven that he is one of our premier 'custodians of culture'" and that he "uses historical imagery in the guise of Sambo, Aunt Jemima and other contemptible characters with large fleshy red lips, bulging eyes, and outrageous habits, to transport us back to a warped past" while forcing us to "confront the realities of today."[24] In a recent telephone conversation, Charles reiterated that he believes that African American "powerlessness continues" and that his images are a "challenge to create alternative images and representations."[25]

If we contextualize Charles on a trajectory from the primitivist history of the Harlem Renaissance, there is the risk that he can become the cultural custodian of a warped past that remains in place, in part, because of the continued acceptance of its assumptions. The question that must be asked is, whose past is being remembered here and what benefit is there in reviving it to critique the present? Does the possibility that derogatory stereotypes can be captured by their victims, inverted and played with, or commodified, indicate that they no

longer are rooted in the raw power that made them monolithic and dangerous? If that is the case, why would there be a continuing need for art that inverts or subverts derogatory images? Is it possible for common usage to give new meaning to derogatory terms or images? Are inversions more effective than subversions? Perhaps white enthusiasm for this type of work, an excitement seldom seen for art by blacks that is not rooted in racial victimization, is an effort to preserve the territorial assignments in the art canon. Blacks must act as blacks; as representatives from the primitive outside, tamed and entertaining.

If those whites who matter in museum, collecting, and gallery circles continue to position themselves as prime audiences and arbiters of taste for African American expression, they remain in control; they are the gatekeepers who can determine which amusements hold their attention and are rewarded. Images that seriously challenge racial hierarchies or that might be rooted in African cultural histories and sensibilities rarely summon the kind of attention and heat that can be found around work using demeaning black imagery even while criticizing racist histories and consciousness. As Metcalf suggests, once again the fact that work by blacks concerned with racial issues is given heat and light allows for self-congratulatory mumblings while changing nothing.

Turning to a comparison of visual art and language, we can find useful Stuart Hall's statement (discussed in the introduction): "The relation between 'things,' concepts and signs lies at the heart of the production of meaning in language."[26] If a word represents a concept in the construction of meaning, consider the inversion of the word "nigger" in contemporary vernacular speech. For the sake of argument, let us say that Charles's caricature is the equivalent of vernacular play with the word "nigger." Perhaps it is the equivalent of the affectionate saying used by many black men: "You my nigger even if you don't get no bigger." Walter Ong suggests that "concepts have a way of carrying their etymologies with them forever. The elements out of which a term is originally built usually, and probably always, linger somehow in subsequent meanings, perhaps obscurely but often powerfully and even irreducibly."[27] Because we live in a literate culture, dictionaries and texts preserve all the interpretations of a word including the original ones. If we accept this, and I do, then the inversion is never complete — never total. The origins of a concept linger, often out of view but potentially present. To affectionately call a friend "nigger" is a subconscious admission that the prevailing racial hierarchy is permanent and unassailable, or, at best, it is a sardonic admission of being located within that hierarchy. In other words, do such terms take us outside the racial box, or do they just reorganize the inside of it?

Slight variations such as *nigga*, *niggaz*, or the old *nigra* amount to subtle shifts of pronunciation or spelling but do not separate them from the original term.

There are some occasions, some contexts, wherein "nigger" reverts to its etymology, and it always iterates the persistence of a racial context because it is never meaningful without that context. It is a demeaning term that whites spat at people they were oppressing, people of color. The word contained such disreputable connotations that some whites were called "nigger lover" in disgust to indicate that they too had become demeaned by their association with blacks. In recent years white youth appropriating black speech, dress, and hip-hop culture have been derogatorily called "wiggers"—white niggers—by other whites. We must remember that for ironic inversions, like those of Michael Ray Charles, to have any meaning, they must first invoke an understanding of the original concept. You must revive the old and set it up to knock it down with the new.

Here is the turn for the worse. An artist best roots artistic expression and critique within his or her identity and sensibilities. If the work is a mirror held up to society to force a confrontation with its own ugliness, the artist positions himself as holding the mirror from a position separate from what is being reflected. Lorna Simpson's feminist racial critiques are rooted in her sensibilities as a woman of color and are pitted against masculinist, racialized histories. Can we imagine de Kooning or Warhol or Jeff Donaldson being able to make similar statements? Playwright August Wilson wrote in the *New York Times* about being an artist: "Before one can become an artist one must first be. It is this being in all its facets, its many definitions, that endows the artist with an immutable sense of himself that is necessary for the accomplishment of his task. Simply put, art is beholden to the kiln in which the artist was fired."[28]

The inversion or recycling of derogatory images carries an implicit bargain with the mainstream art establishment and the white world that the artist will implicate himself or herself in the imagery. To use such imagery ironically or satirically, one must don the cork and be the minstrel. As Bay Area artist David Huffman admitted, "[T]he minstrel theme really focused me, almost like a self-portrait. The minstrel embodied my political, psychological, emotional, and unconscious feelings about the world."[29] If we contrast this approach with that of late 1960s and early 1970s artists like Jeff Donaldson and Wadsworth Jarrell of AfriCobra, we see that they inhabited roles akin to those of political activists like H. Rap Brown and Stokely Carmichael of SNCC or imbued with the attitudes of the Black Panther Party. Playing the minstrel role is acceptable in some circles because the imagery is not problematic or uncomfortable for many white audiences and the artist inhabits a designated space appropriate to his or her racial/ethnic identity. As cultural critic Stanley Crouch states in a documentary about the making of Spike Lee's film satire *Bamboozled*: ". . . you see, the grand irony of it is minstrelsy was on its way out when the Civil War ended. But when the black people came into it, they revitalized it because they danced extremely

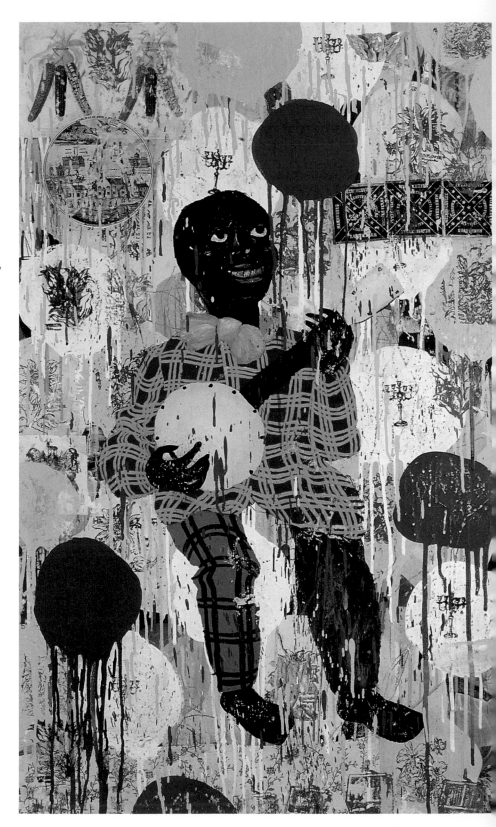

FIGURE 84.

*Wadsworth Jarrell,* Liberation Soldiers, *1972, acrylic and foil on canvas, 50" × 48". Courtesy of the artist. Black Panthers Huey Newton, Bobby Seale, and others are shown in this image to celebrate their social programs and black liberation rhetoric. See Robert L. Douglas,* Wadsworth Jarrell: The Artist as Revolutionary *(San Francisco: Pomegranate Artbooks, 1996), 38–40.*

well. They were funny. And they did sing well. So, in an interesting way, it's as though they came and reinforced the bars of the cage that they were in through their talent."[30]

Right side up, or upside down, racial imagery/language remains within racial discourse. The imagery is rooted in the white imagination, and its acceptance

offers whites the potential for self-congratulatory accolades due to an alleged sensitivity to racial issues. The dialogue between the artist and this audience remains within the discourse of race, which, of course, sustains it.

Interestingly, Michael Ray Charles's most surprising critiques may be those of NBA basketball players (figure 85), athletes he lampoons as coons acting out stereotypical behaviors and showing little social responsibility. Or, perhaps, he is suggesting that whites may perceive them in stereotypical ways. In the same sense that Aunt Jemima is transformed into "ain't jo mama," this work insults and signifies by linking the unreal and the absurd with actual people. In suggesting that the subject is linked to a stereotypical fantasy, the absurdity hits home and demands a response. Linking this type of imagery to whites is more abstract and far less visceral because of the complicated formula required to decipher a derogatory black image in a way that is harmful to whites.

Let us turn to the use of the term "black" to describe African Americans. Use of the word as descriptive of people only functions in a racial context to denote difference, though it has more potential slippage than the term "nigger." It must be remembered that it was the word "Black" in the original version *The Story of Little Black Sambo*[31] that facilitated the story's acceptance in the United States despite its references to India—tigers, after all, are found in India, not in Africa. The term "black" is virtually useless in all-black contexts other than to suggest that whites are not present. Therefore inverting it to drain it of its potential for hurt still locates one within a racial context where the potential for objectification by color still exists. Black always is dependent on the existence of white for meaning so it offers no means of transcendence. To be black and proud, or black and anything, one must remain in some conjunctive relationship with white. When the term began to be used in a Pan-Africanist sense, it functioned as a label of solidarity in opposition to white solidarity and thus served as a ploy in the racialized black Atlantic world. A marker of discreditation and exclusion became a signifier of belonging and a basis for political action. It functioned as a step in the journey from inside racial ideology toward an imagined transracial existence outside the boundaries of racial ideology. It has been a means to an end, not an end in itself.

Graphic images can be thought to harbor potential similar to that of language, and it is within graphics that we find the foundations of written language. Writing gives language the stability of being visible, and visual signs consistently recall the concepts represented. The sound event that is speech is stabilized for re-collection through visual signs evoking concepts akin to those found in speech. Is it not true that the word "mammy" and a mammy cookie jar evoke the same anachronistic complex of ideas? There can be slippage and play in speech and visual expression, but the meaning in the slippage may be de-

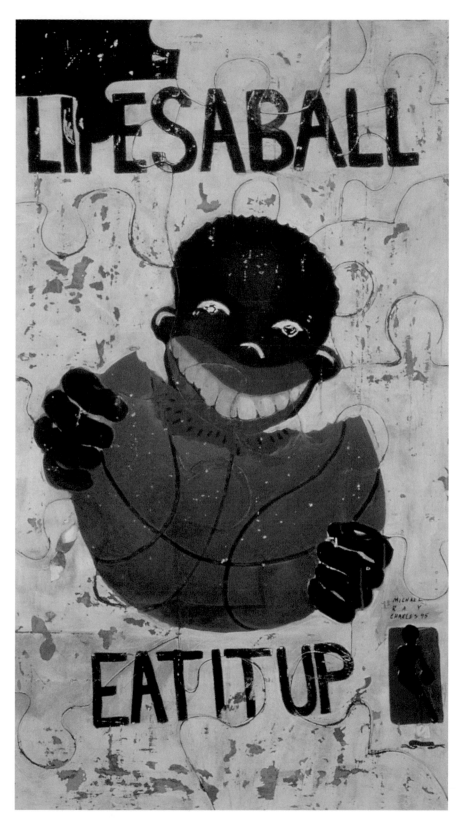

FIGURE 85. *Michael Ray Charles,* Lifesaball (Forever Free), *1995, acrylic latex, oil wash, and copper penny on paper, 60″ × 36″. Courtesy of the artist. In this image, Charles suggests that the basketball has replaced the watermelon in an updated racial stereotype.*

pendent on its conflict with the original meaning, a fact that keeps the original meaning nearby.

This is not to say that there is no value in the paintings of Michael Ray Charles or to insist that he create positive imagery. Like Basquiat, he samples images, ideas, and language from a variety of sources, and he cleverly uses signage in his attempt to create disruptive signs in the semiotic sense. It is to say that the audience for the work primarily is white, and it is an approving audience. The subject in the work, the artist himself, attempts to play a stereotypical role in the context of white power, and his critique of that power is layered underneath the minstrel song being sung. The signifyin' that functioned as a trickster critique in the nineteenth century may not be present in this performance because African American audiences, as the artist admits, often do not get it.

## RECONTEXTUALIZATION AND REAPPROPRIATION

Beginning with Aunt Jemima, stereotypical black characters have been associated with products and marketed throughout the United States. Innumerable household items were sold to decorate homes, provide humorous imagery, and increase the presence of product trademark figures in homes. These items included postcards, salt and pepper shakers, notepads, dolls, tablecloths, spoon holders, cookie jars, and so forth. The vast majority of them incorporated exaggerated imagery that was offensive to blacks. Among the familiar product names and characters were Aunt Jemima, the Cream of Wheat chef, the Gold Dust twins, Coon Chicken Inn, Sambo chocolate drink, Mammy's Soda, Nigger Hair Tobacco, Dinah Black Enamel paint, and Mammy-Ann Cane Syrup, to name just a few. Additional kitsch produced for use in homes included ceramic figurines serving as salt and pepper shakers or cookie jars that whites may have felt were cute or humorous. There were numerous children's books like *The Children's Uncle Tom's Cabin*, *Petunia Be Keerful*, *Watermelon Pete*, *Cocoa Dancer*, *Little Black Sambo*, *Ten Little Niggers*, *I'se Topsy*, *Plantation Poems*, and *Black Alice*. Then there was minstrel sheet music, still being produced in the first decades of the twentieth century, with derogatory imagery and song lyrics: "When Coonhood Was in Flower," "Bees-Wax Rag," "Jig Walk Charleston," "You'll Get All Dats Acomin' to You," "Poverty Rag," "Coffee Cooler's Tea," "I Don't Care If Yo' Nebber Comes Back," "When You Sang Hush-a-Bye Baby to Me," "Shortnin' Bread," "I Don't Know Where I'm Goin but I'm on My Way," and "Little Black Sambo and the Twins." And we should not forget those aggravating little lawn jockeys that became widespread after the Second World War.

The majority of these items were in service between 1894 and 1950, a period

of rigid segregation, lynching, and the kind of racial violence that led to the destruction of the black section of Wilmington, North Carolina, in 1898, the black section of Tulsa, Oklahoma, in 1921, and the obliteration of the all-black town of Rosewood, Florida, in 1923. From 1892 to 1931, 2,586 blacks were lynched.[32] Additionally, there was the Red Summer of 1919, with widespread racial violence across the United States, including the riots in Chicago discussed in chapter 5. The violent, oppressive acts appear to have been responses to the diminishing control over blacks that whites were experiencing and the sense of a loss of status produced by that declining control. Sociologist Steven Dubin indicates that stereotypical images "helped allay status anxiety and promoted a sense of social solidarity and superiority among whites." The violence enforced social controls, and the imagery reinforced it symbolically.[33]

If we look at these racist images and objects using Hall's model, we can argue that stereotypical imagery formed a part of the racial discourse constructing general knowledge about, and justifications for, the violence of racial oppression. A cluster of ideas, images, practices, and institutional structures constituted the discursive formation of race and defined "what knowledge was considered useful" and what "sorts of persons or 'subjects' embody its characteristics." We can think of so-called black collectibles or memorabilia as "subjects" embodying the characteristics defined by the racist discourse that constructed the oppressive discursive formation within which all of the objects, ideas, images, and acts flourished. The totality of this discursive formation was suffocating for African Americans in many ways and distorted self-images and the process of identity formation. Given this premise, it becomes very difficult to imagine how the collection of racist kitsch redeems the objects and images or inverts their meaning. It is not impossible to imagine that the meaning of blackness will shift significantly in time and that racist objects may become the pitiful evidence of discredited attitudes; the thing itself, the image embodied, would become useless rather than be given a second career with new meaning as a redemptive or transformative agent.

During a scene in *Bamboozled*, Jada Pinkett-Smith's character, Sloan, says, "I love these black collectibles. It reminds me of a time in our history, in this country, when we were considered inferior, subhuman, and we should never forget."[34] Yet one of the more important points made in the film is that these objects destructively insinuate themselves into the environment and consciousness of folk who own them; by the end of the story the character collecting the racist kitsch has donned blackface himself. The objects are fragments of the discursive formation of race, and they lack the potential for reversal to the point of becoming weapons for the disruption of that formation. They document its historical presence, just as photos of lynchings might, but they offer no redemp-

tion or salvation for their victims. If the folk behind the stereotypes have not been liberated in the past eighty years, there is little reason to believe that surrounding oneself with racist objects at home will somehow be cathartic or liberating today. There also is the question of whether liberation can ever be found within a consciousness of victimization.

These household objects—"collectibles" or "memorabilia"—that formed stereotypical images of blacks carried social implications. Dubin points out that most of the objects had some functional rather than decorative use, and work that was typical of blacks was symbolically recreated by the functional items. He suggests that, taken collectively, they might comprise a code replicating minority-majority relations and that they helped establish strong symbolic control over blacks during a period (1890–1950) when white control over blacks was diminishing.[35] Additionally, he argues that there was a concern for the accumulation and consumption of goods enhancing social status and that meaning projected onto objects helped people derive "a sense of self and their relation to others."[36]

White New York photographer David Levinthal has done a series of dramatically lit 24-by-20-inch color photos of black collectibles, which he calls "stereotypes of iconography," part of his ongoing exploration of toys, dolls, and such objects in American culture. This work, the Blackface series, problematizes the objects by presenting them in a black background completely without context or mediation. Levinthal says, "I wanted to present these things in a complex way that was beautiful and horrifying at the same time."[37] The images are produced in large formats for exhibition and have the slick, rich look of product advertisements. Levinthal suggests that the series encompasses issues of history, sexuality, alienation, and race.[38]

Though the objects have been transformed from collectibles to subjects in Levinthal's photographs, they have been taken out of any context and stand as imagery rather than as collectible objects. Any mediating forces and conceptual veneers have been removed, and we confront them as monumentalized images in pristine gallery settings or in slickly produced coffee-table books, rather than as small objects in private kitchens. This process heightens our awareness of the objects on a purely visual level, and the intention seems to be to challenge us as a society about the assumptions behind the things, about the context that could create them. Isolating and focusing on an object of this type forces us to stop and notice its visual characteristics and absurdity. We are forced to look at it closely and asked to render it meaningless. How fully does this strategy destabilize the object? And is its etymology meaningfully disturbed?

A comparison of Levinthal's photograph (figure 87) with another of the same object in Kenneth Goings's book about the history of collectibles (figure

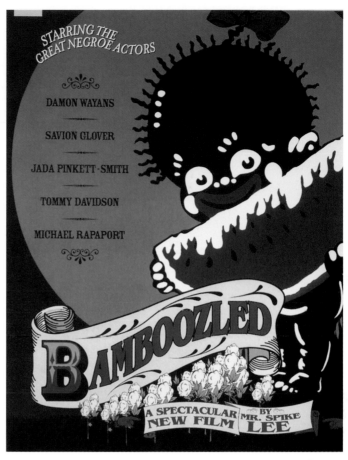

FIGURE 86.
*Cover art for DVD
of Spike Lee's*
Bamboozled.
*40 Acres and a
Mule Filmworks,
Inc., 2000.*

88) suggests that the image continues to do its original work. Levinthal's artistic photograph looks up at the face of the figure, monumentalizing it and emphasizing it as an icon. The visual and emotional effect of the work, however, remains virtually identical to the documentary image of the collectible. Interestingly, this is played out during the closing credits of Spike Lee's *Bamboozled*: the Levinthal photograph mentioned above is shown along with images and filmed segments of racist kitsch, with no distinction being made between the original objects and Levinthal's image. Both images, Levinthal's photograph and Goings's documentary image, accentuate the commercial appeal of the objects and, in many ways, fetishize them as valuable, notable, and collectible. The photographic mediation and recontextualization does not transform the piece significantly enough to alter its meaning and effect. Perhaps the American social context that initially produced the objects has changed to the point of lessening the consequences of such imagery while allowing the growth of alternative, self-representational imagery created by African Americans. Artist Fred Wilson, who has created an installation dealing with racist kitsch, has expressed con-

above left:

FIGURE 87.
*David Levinthal,
Blackface series,
1995–96. Courtesy
of the artist.*

above right:

FIGURE 88.
*Aunt Jemima
cookie jar, ca.
1930s. Collection
of Kenneth W.
Goings.*

cern that art can perpetuate an ugly icon even as it attempts a satirical critique. He says that the objects are "highly charged. Black people collect them because they think that by owning them, they can overpower them. But in my experience ownership gives you less understanding. It numbs and anesthetizes you. Living with these objects in my studio for a period of time has diminished my anger. They're insidious."[39]

It is also possible that Levinthal does not experience the emotional history of such objects, though there is nothing malicious in his intentions. He explores the aesthetic possibility of the objects and the issues and tensions they evoke, but he does so at a safe distance. He has no historical or emotional connection to the objects, and he began to work with them as part of a larger investigation of toys and dolls aimed at developing a critique of American social assumptions that could be excavated from them. Michael Ray Charles paints at a chronological distance from the original stereotypical images, separated from times when he might have faced his own reduction to and association with Sambo in his encounters with whites. Protest might have cost him his life rather than resulting in the attention of the powerful New York art world.

If we look at a sculpture, *Forever Free* by Sargent Johnson (figure 89), from the same period as the Aunt Jemima cookie jars (the 1930s), we can see that there is an unmistakable shift from the periphery to the center of African American experience and self-perception. In both Johnson's sculpture and the cookie jar, we find an attempt to simplify black physiognomy into archetypal forms, and the facial expression carries the meaning of the work. Both objects use a closed, cylindrical form to represent the figure, and there is a reliance on skin coloration for effect: one using a deep, unnatural black to match the exaggerated features and expression, and the other employing a rich brown in an acknowledged attempt to explore the diverse coloration to be found in Negro skin. Both figures are rooted in domesticity, and both are perceived as foundations of the home. Johnson's work, however, emphasizes the woman's protective, maternal qualities and her quiet, defiant, dignity. She is the foundation of her *own* home. Simply, Johnson's *Forever Free* emerges from the center of experience as self-expression, and it works as a counterhegemonic

FIGURE 89.
*Sargent Johnson,*
Forever Free,
*1933, wood with*
*lacquer on cloth,*
*h. 36", 1934. San*
*Francisco*
*Museum of*
*Modern Art, gift of*
*Mrs. E. D.*
*Lederman.*

expression counteracting the image of the mammy cookie jar. Inherent in the work is a sense of resistance to unnamed forces and obstacles. Charles has painted a *Forever Free* series that uses inversion strategies to pull imagery in from the periphery of African American experience—that place on the edge where racial or ethnic antagonisms clash and stereotypes live—to defend the center.

Levinthal's imagery plays out its entire drama on the periphery, but it is rooted in the epistemological frame of nonblack Otherness. Perhaps his identification with blacks approximates the early days of minstrelsy, when the discredited black figure became a means of identification with the outsider as a critique of the American white center and a recognition that the strategies for demeaning and controlling blacks were rehearsals for more subtle, refined use of those strategies to control certain whites. The demeaned black figure is a convenience, and the critique, as in minstrelsy, is dependent on the presence of that black figure as a demeaned sign.

One of the central points of my argument is that intention, or the imposition of transformative concepts and language, does not completely overcome the foundations (or etymology) of demeaning images or derogatory terminology. Just as the recontextualization of the mammy cookie jar through photography

does not significantly alter its visual impact, so the collection of such objects in black homes does not liberate, appropriate, or domesticate them. Their racist foundations sit beneath the facade of transformative intentions like radioactive isotopes burning through the redemptive language and releasing visual and psychological toxins into our personal landscapes. The efforts made to deal with these objects and images in ways beyond historical exploration and documentation root African Americans in who we are not rather than who we are. One might say that such efforts potentially and unwittingly allow us to be participants in our own oppression by reinforcing and naturalizing a victim status memorialized through derogatory images. The objects only have meaning in the context or history of racism, and they are rooted in the shame of barbarism toward African Americans, not in the expression, history, and triumph of people of African descent.

## RECYCLING AND REITERATION?: KARA WALKER'S GROTESQUE MINSTREL SHOW

Kara Walker is perhaps the most notable and controversial artist who has chosen to use derogatory racial imagery in art. She has won major awards, the fervent support of many collectors and galleries, the adoration of curators like Thelma Golden (formerly of the Whitney Museum and most recently the Studio Museum in Harlem), and the appreciation of art historians. She also has inspired the unprecedented disdain of artists like Betye Saar and Howardina Pindell and many others within African American cultural circles. Her work is uniquely brilliant, timely, essential, and disturbing in unusual ways. In an uncanny way, she has created in her work a confluence of race, taste, sexual mores, the excesses of contemporary art, and the postmodernist trend toward eradicating the boundaries between popular culture and high art.

Walker is noted for the creation of tableaux, installations of a sort made of silhouettes cut from black paper. The works are arranged on blank canvas or on walls, often turning corners, and the white background highlights the silhouettes and metaphorically points up the reductionist character of racial discourse into black and white terms and ideas. The work has the haunting spectacle of a fatal three-car automobile accident with its routine depiction of the unspeakable, the perverse, and the supposedly dark secrets of racial histories in the United States. Often it is grisly, but you are compelled to look at it. Here is a shadow text lurking behind the American dream that no one wants to talk about really. Yet the work is more than that because there is a gallows humor in the satire; the kind of horrid jokes one is a bit ashamed of having laughed at.

Perhaps a great deal of the enthusiasm for Walker's work comes from the recognition of its postmodern irony combined with its renovation of the old aesthetic idea of the sublime. Mirzoeff suggests that the sublime "is the pleasurable experience in representation of that which would be painful or terrifying in reality." Its task is to present the unpresentable. "Unlike the beautiful, which can be experienced in nature or culture, the sublime is the creature of culture and is therefore central to visual culture."[40] Mirzoeff cites Kant, who contrasted the sublime with the beautiful, "seeing the former as a more complex and profound emotion leading a person with a taste for the sublime to 'detest all chains, from the gilded variety worn at court to the irons weighing down the galley slave.'" The sublime presents ideas that have no correlative in the natural world such as peace, equality, or freedom—or, in Walker's case, racism.[41] This concept opens ways of seeing Walker's work from the perspective of those most moved by it.

In a sense, Walker is recycling and exaggerating antebellum thought and imagery as she pulls down curtains and reveals the darkest implications behind racist thinking. She applies late-twentieth-century sensibilities with an emphasis on sexual and scatological themes, the kinds of topics many contemporary comedians often use to generate shocking humor. In one tableau, a black woman sexually rides a horse that lies on its back. In another, people sit atop piles of excrement. In figure 90 three black women form a suckling circle while an infant below cannot quite reach her mother's breast. In others, incest, anal violation, bestiality, and other sorts of wild, Bosch-like excesses prevail. Walker's identifiably black figures tend to fulfill and extend all the wildest fears and fantasies whites have had about blacks as she seems to ask, "Is *this* what you think? Is *this* what you believe?"

The brilliance of Walker's silhouettes works in a variety of ways. She has taken a form that was popular among eighteenth-century European upper classes and ripped off the veneer of decorum, relocating the subject in the antebellum American South, and all hell is breaking loose! It has the quality of a David Lynch film panning in on a decorous, middle-class suburban idyll and moving ever closer until the viewer is near enough to see the horrific chaos beneath the respectable veneer that is undetectable from afar.

The genius of her draftsmanship is disarmingly subtle. Silhouettes require that all the information be contained on the edges of the figures, and Walker conveys complex movements and body positions while defining racial categories with her flat cutouts. The original forms were limited to static profiles often drawn from the subject's shadows cast onto a surface. The fact that Walker has depicted racialized figures in convincing postures attests to her drawing skills. Despite all the riotous miscegenation occurring in the work, the complication of mulatto characters seems to elude this format; recognizable contours

**FIGURE 90.**
*Kara Walker,*
The End of
Uncle Tom
and the Grand
Allegorical
Tableau of Eva
in Heaven, *1995,*
*cut paper and*
*adhesive on wall.*
*Courtesy of the*
*artist and the*
*Brent Sikkema*
*Gallery, New York.*

require physiognomic distinctions that are not as clear as when we are talking about one of Archibald Motley Jr.'s octoroons.

Walker has described her work as a minstrel show, and, like the original shows, her work is rooted in southern mythologies and unresolved racial conflict. As I suggested about Michael Ray Charles, she has made a bargain with the viewer to implicate herself in the imagery, and she often casts herself as a "Negress" in her constructions; on occasion she has been "Nigger Wench" or the "Free Negress." Walker says that while attending high school in the suburbs of Atlanta she "started playing little games with myself, pretending what it would be like if I were a slave."[42] "It seems like I had to actually reinvent or make up my own racist situations so I would know how to deal with them as black people in

the past did. In order to have a real connection with my history, I had to be somebody's slave. But I was in control: That's the difference."[43]

According to Julia Szabo, Walker has indicated that the Negress is a "star player in this version of history, seducing her masters as much as being molested by them," and one of her works is titled *Gone: An Historical Romance of a Civil War As It Occurred between the Dusky Thighs of One Young Negress and Her Heart*.[44] Walker has implicated herself further by admitting that she used to see herself "as someone who was locked in histories, as a nebulous, shadowy character from a romance novel, but not a novel that anyone ever remembered."[45] Additionally, she has been fascinated by slave narratives "which begin with testimonials as to the literary integrity of the author—'written by Herself,' and the like—and I often wonder if that same sentiment informs some of the folks who say they like what I do."[46] Autobiography lurks in other ways behind the work: most of the black characters and victims in her work are women. When the series began to take shape for her, she says she was "concentrating a lot on the body of black woman as exotic seductress—purveyor of failed seductions particularly—desire, miscegenation, and all the complexities and historicity of all these things."[47]

In an interview in *Flash Art*, Walker admitted to having been sexually exploited by white boys during her younger days in Atlanta and to having received notes from the Ku Klux Klan because of her interracial relationships. "I figured out I was a milestone in people's sexual experience—to have made it with a black woman was one of those things to check-off on your list of personal sexual accomplishments. That already has a slightly masochistic effect: to have just been the body for somebody's life story. I guess that's when I decided to offer up my side-long glances: to be a slave just a little bit. . . . So I used this mythic, fictional, kind of slave character to justify myself, or reinvent myself in some other situations."[48]

She says that the side-long glance is her answer to the male gaze. "It's the little look and it's full of suspicion, potential ill-will, or desire. It's a look unreliable women give."[49] Walker identifies the unreliable woman as the Negress, and she says she is that Negress, the human who is invisible behind reductionist, stereotypical perceptions. Her silhouettes build on the idea of a profile as a side-long glance, and that glance, to her, is the beginning of the back talk, the talking back, that black feminists have described. Walker's work, on some levels, is that back talk—sassy, smart-mouthed signifyin' about race relations.

Yet it seems that Walker's efforts to implicate slave women in antebellum miscegenation are overdetermined by late-twentieth-century sensibilities—and, perhaps, her own desires—and they do not account for the brutality or the threat of raw power behind sexual demands during the time of slavery. She ad-

**FIGURE 91.**
*Kara Walker,*
Untitled, *1996,*
*cut paper, water-*
*color, pencil on*
*paper mounted*
*on canvas, 68¾"*
*× 65". This work*
*presumably plays*
*with stereotypical*
*images and*
*sayings suggesting*
*that black folk*
*were virtually*
*worthless "gator*
*bait." Courtesy of*
*the artist and the*
*Brent Sikkema*
*Gallery, New York.*

mits to an ambivalence about it all, and Szabo suggests that Walker "seems to question and refute Southern mythology even as she conjures it, simultaneously celebrating and dashing it to the ground."[50] This ambivalence seems rooted in Walker's conflicted experiences in Atlanta. For African Americans, Atlanta is one of the most progressive cities in the United States, with its long history of black success, its large black middle class, and the Atlanta University complex of historically black colleges; it has also been the home of civil rights dignitaries such as Coretta Scott King, John Lewis, and the late Ralph Abernathy. Still, racial issues are never far removed, and great portions of the city form predominantly black or white residential enclaves. Walker lived in Stone Mountain, an eastern suburb; a Confederate memorial is carved into the side of the granite

"mountain," and a popular park located there used to be a meeting place for the Klan. She recognizes, as do most blacks and northern transplants, that the South "lost the War, but unable to accept this continues to replay it. . . . [T]here's the conflict between a love of the past—and of genteel whiteness as imagined to have existed in the past—and the fear of offending the sons and grand-daughters of former slaves."[51] One prominent attraction in Atlanta is the Cyclorama, a large, panoramic painting of the Battle of Atlanta set in the round and located just east of downtown near the Atlanta Zoo. In some ways, Walker's works are cycloramas narrating a surreal racial battle that continues beneath the surface in the modern South, and within the artist, as the viewer is partially encircled by her larger tableaux.

One of Walker's references is the strange southern fascination with the Civil War and the periodic re-creations of old battles. She suggests that white southerners "seem to be killing history solely in their fanatic worship of it. It turns it into absurdity."[52] So she re-creates antebellum histories that are already absurd. She uses cartoonish images, sick sexual or bathroom humor, puns, and unspeakable acts to undermine the absurdity of racism and to shock viewers in an era so overwhelmed by images and information that it requires excess to be noticed amid the chaos. She is not motivated by an Afrocentric philosophy, Pan-African sentiment, black militancy, or a powerful identification with the so-called African American community. Like many artists in her generation, she draws on her personal history and psychology as prime factors in her work, and she admits that "[t]o some extent I'm grinning while all this is happening."[53]

There is a nihilism and emotional isolationism in postmodern sensibilities: expression often is more pastiche than in-depth exploration. Anything goes because meaning is momentary and contingent. Hip-hop culture routinely samples and recycles the past, and the iconoclasm of rock and roll becomes increasingly absurd because our market-driven corporate society assimilates and commodifies every rebellious force or trend. Therefore the periphery is strikingly similar to the center. In this world where anything goes—as long as it sells, does not radically offend, and remains politically emasculated—Walker is the perfect fit. Because she is not rooted in an African sensibility and her fascination with history is not based in African American feeling and pathos, Walker's work offends many African Americans who have those roots and understandings. She has expressed an identification with several African Americans who inspire some ambivalence among older black folk, but they provide her with comfort when she is under attack. One is Jean Toomer, the brilliant Harlem Renaissance writer who struggled with his identity, passed for white, and disappeared into the Midwest. There is Butterfly McQueen whose stereotypical performance as Prissy in *Gone With the Wind*—by Atlanta native Margaret Mitchell—embar-

rassed black folk for a generation. And there is Josephine Baker, the St. Louis performer who shook up Paris by staging primitivist sexual fantasies.[54] She has linked her success to a requirement that as an African American one "must spill one's guts constantly—like the old sharecropper in Ellison's *Invisible Man* who raped his daughter and kept telling his horrible story over and over, and the white people in the town gave him things. He's an embarrassment to the educated blacks and a fascination to the whites."[55]

Walker's most controversial statement may be her claim that "[a]ll black people in America want to be slaves just a little bit. It gives people heaping teaspoons of dignity and pride." In discussing the quote, she suggests that "to be a slave runs along the lines of being a better masochist and knowing how to put up with things."[56] This brings us back to her intimation that her work is a sort of minstrel show. It is a performance for white folk reflecting back to them creatively their fantasies about, and fascination with, black people. Walker's ambivalence matches the love-terror ambivalence that many white Americans have exhibited toward blacks for several centuries. By casting herself in blackface as a Negress slave, and by subjecting black women in her work to extreme degradations and stereotypical exaggerations, she has locked herself into the racial discourse she is attempting to subvert. By identifying with slavery, she seems to trivialize it, and this has alienated her from preceding generations who have profound memories of racial violence and oppression and therefore a deep empathy for the crushing and violent consequences of slavery. Walker's southern history with a fundamental civil rights orientation influenced the work and separated her from the more militant northern histories with Pan-Africanist or black militant philosophies, Black Muslim and Black Panther strains, and the twentieth-century history of volatile urban relations with ethnic and labor strife. In other words, the debate about Kara Walker's work in the African American arts community is not entirely a generational conflict.

Some of the controversy around Walker's work emerges from larger questions of individual versus collective responsibility among African Americans. A semblance of solidarity and communal consciousness was the cornerstone for resistance movements against the rigid apartheid that ended in the South just before Walker's birth in 1969. Generations of folk with middle-class aspirations worked to avoid stereotypical associations in their appearance, speech, and public behaviors. Because of their long experience of being surrounded by demeaning imagery or being confronted with invisibility, many artists and intellectuals felt the urge to create representations that might speak truthfully to and about African Americans with all our diversity and complexity while putting our prodigious talents and potentials on view. Signifyin' about white folks was a part of that, but grinning and "shining" was not. Some reactions to Walker's

work may have been objections to the impression that she was shining—playing the minstrel—for whites. Her imagery may be a bit too close in form and effect to the silhouette from *Scribner's Monthly* of January 1872 (figure 92), making it difficult to discern whether she is laughing at us or not. How do you exaggerate a stereotype, something that already is an exaggeration? At what point does the caricature become an agent working against itself?

Yet one cannot argue that Walker's work has had a profound effect in generating discussion about racism, representations, and the social responsibility of black art and artists. Its use of the sublime has been at least as effective as the violent gore of contemporary film, particularly in the horror genre, in riveting our gaze to the spectacle.

An important element behind Betye Saar's public discomfort with Kara Walker's work was the enthusiasm with which white curators and collectors em-

FIGURE 92.
*Silhouette from* Scribner's Monthly, *January 1872.*

braced the work. Their exceptional comfort with the work suggests that the stereotypes only made blacks uncomfortable, but the truth probably is both that and more than that. There is genius in her selection of the silhouette as the form for what she does. She says that the term is named after a French finance minister, Etienne de Silhouette, "whose policies were cheap, and who also practiced the inexpensive little art . . . the word is actually an insult."[57] In the nineteenth century the form became popular, particularly before the development of photography, because it was inexpensive, but perhaps the insult did not translate across time or languages. Some whites may not recognize all the layers of satire and signification in the work. Others may illustrate Metcalf's notion that certain aesthetics allow socially powerful groups to appear to support "a new and more democratic vision of American art and society while actually protecting and augmenting their exclusive social interests."[58]

Kara Walker is not the first African American artist to use silhouettes. Aaron Douglas mastered a form of silhouette in his wonderful murals of the 1930s and 1940s. Many of them articulated Negro aspirations, histories, and legacies, but several of them confronted racial violence. *Aspects of Negro Life: From Slavery through Reconstruction* (figure 93) from 1934 provides a panoramic narrative of African American tribulations from chains to Ku Klux Klan night riders, who enter the frame on the left edge of the work. Another work from the same series of panels, *Aspects of Negro Life: An Idyll of the Deep South* (1934), has the most visible figure in the composition kneeling beneath the feet of a man who has been lynched and hangs above the picture frame except for the lowest portion of his legs. In these works Douglas developed a visual shorthand for representing African Americans using what amounted to silhouettes and a limited palette. His work, like Walker's, depends on the presence of a recognizable, stylized black physiognomy.

Walker, most of whose collectors are white, admits that she gets "a kind of giddy satisfaction that somebody has a few works in their house that could conceivably be tremendously offensive to somebody who comes over."[59] One important aspect of Aaron Douglas's murals was his continual traversal of the period of black slavery back to an African past in his imagination of African Americans. Walker has asked, "What does Africa mean anyway," and when asked what it meant to her, her answer was, "I don't know if I really have an Africa."[60] With no psychic connection to a cultural past prior to the period of slavery, Walker appears to have used slavery as a template for understanding her own experiences and origins. The humor in her roiling narratives may fall under the cliché "I laugh to keep from crying," in much the same way that gallows humor does. There is a wonderful irony in Walker's having suffered emotional humiliations and frightening threats from whites and a few years later

FIGURE 93.
*Aaron Douglas,*
Aspects of
Negro Life: From
Slavery through
Reconstruction,
*1934, oil on canvas,*
*59″ × 139″.*
*Art and Artifacts*
*Division,*
*Schomburg Center*
*for Research in*
*Black Culture,*
*New York Public*
*Library, Astor,*
*Lenox and Tilden*
*Foundations.*

receiving great acclaim and financial benefits from the art seeded in those humiliations. Conjuring up exaggerations of the most sordid possibilities of racial conflict and stereotyping, while proving cathartic for the artist, may trap her within the discourse she half-heartedly seeks to disrupt.

Ironically, Douglas was attempting to counter many of the visual stereotypes that Walker has revived. Near the beginning of what became known as the Harlem Renaissance, Alain Locke wrote that the Negro has had "to appeal from the unjust stereotypes of his oppressors and traducers to those of his liberators, friends and benefactors" and that the "day of 'aunties,' 'uncles' and 'mammies' is equally gone. Uncle Tom and Sambo have passed on, and even the 'Colonel' and 'George' play barnstorm roles from which they escape with relief when the public spotlight is off."[61] Walker has brought back all the characters whom Locke disdained and whose demise he read as a barometer of Negro liberation, and she has done so using a form akin to that of Douglas. Progress?

## FOR WHICH AUDIENCE IS THE JOKE?

Franz Fanon opens his important book *Black Skin, White Masks* (1967) with the statement: "I ascribe a basic importance to the phenomenon of language."[62] He goes on to argue that mastery of language "affords remarkable power." Significantly, he says, "Every colonized people—in other words, every people in whose soul an inferiority complex has been created by the death and burial of its local and cultural originality—finds itself face to face with the language of the civilizing nation."[63]

On a more personal level, Nigerian scholar and art historian Rowland Abiodun has written: "Though the act of calling out a person's given names generally functions to differentiate individuals, in the Yoruba religious thought system it is also believed to have the ability to arouse or summon to the surface a person's spiritual essence and cause him/her to act according to the meaning of those given names or in some other way desired by the caller. This is the basis of the Yoruba saying, Orúko a máa ro'ni: "One's name controls one's actions."[64]

If we take ourselves and such matters seriously, Abiodun's statements bring us back to the proverb "It's what I answer to." When Kara Walker and Michael Ray Charles metaphorically or allegorically don minstrel masks to create a visual theater of the absurd, when Walker names herself—even satirically—Negress or Nigger Wench, are they, in fact, summoning to the surface the social and racial etymologies that stain their souls? Does the exaggeration of exaggerated entertainments, even in new forms, prick the consciousness of the powerful, or does it provide them with a new amusement rooted in the sublime? If white collectors express a fervor and adoration for the works of satirical artists like Robert Colescott, or pay tens of thousands of dollars for works by Charles or Walker, have they been politically sensitized and moved or merely entertained?

If we consider older African concepts about language, there is another dimension to the casual use of inverted, derogatory terminology for self-description. East African writer and scholar Ngugi Wa Thiong'o suggests that the use of language has profound implications for individuals and groups. He notes that "[t]he choice of language and the use to which language is put is central to a people's definition of themselves in relation to the entire universe." Language was a factor in the division of Africa by European powers at the Berlin conference of 1885.[65] Significantly, he suggests that language "is both a means of communication and a carrier of culture."[66] The use of "black" and especially the use of "nigger" theoretically define people of African descent in some relationship to a white universe. Just as the division of Africa's geography into zones of European languages culturally circumscribed those areas, the use of white-devised terms of description culturally contains African Americans within a racial world.

Verbalization mythically recalls speaking things into existence. Committing expression to graphics may have similar potentials for creating consciousness, for "naming" something. Naming in a general sense gives human beings power to understand the things they name. Ong says that "without learning a vast store of names, one is simply powerless to understand, for example, chemistry and to practice chemical engineering."[67]

All of this suggests that speech is an act of creative force helping us understand the world but also defining our relationship and potential within it. Names and categorizations from racial discourse help create and maintain an

understanding of a racial universe. The creation of imagery can be an act of naming that helps generate and sustain our understandings of the world. My simple notion is that what may seem to be a creative act as simple as tossing a pebble into a pond may have social consequences rippling beyond the intention of the initial act.

This is a residue of the oral traditions of most African cultures, and it has some congruencies in visual expression. Ong and others have indicated that in oral cultures language is not written and retrievable at another time like literature. It is "a mode of action and not simply a countersign of thought," and therefore "oral peoples commonly, and probably universally, consider words to have great power." He suggests that this may in part come from the fact that the word is "necessarily spoken, sounded, and hence power-driven," which is why oral people "consider words to have magical potency."[68] The residue of this thought is to be found in the Christian Bible, particularly in the idea found in Genesis of God speaking things into existence, an indication that much of the biblical text was initially oral. When language becomes visible (through writing and print), it becomes less fluid and retains more of its etymology. Is this not the same for images?

Perhaps the key to penetrating Walker's work is in the nexus of visualization, orality, and literacy as means of understanding the world. The onset of literacy begins the shift to visualization that has come to define the modern (and postmodern) era. For example, economic trends or medical conditions are translated into charts and images for understanding and translation. Oral communication has been visualized through the printed page and, more recently, turned into visual experiences through movies and television. Mirzoeff argues that visual culture depends on "this modern tendency to picture or visualize existence. This visualizing makes the modern period radically different from the ancient and medieval world in which the world was understood as a book."[69] All three modes are languages of expression and are subject to the application of meaning in their interpretation. Visual forms, including written text, appear to lose some elastic potential for the transformation or subversion of meaning. Turning derogatory images in on themselves or inverting them to destabilize their meanings is not as effective as the performance of speech has been in undermining terms.

If we suggest that the art of Kara Walker and Michael Ray Charles is rooted in a subculture that negotiates orality as tradition and literacy as a context, it should easily translate into images the irony and indirect allusion of signifyin'. Because the momentum of contemporary culture has been driven by the notion that "seeing is believing," it is probable that literal and linear translations are anticipated with images and that Walker's and Charles's work disrupts this ex-

pectation. Much of the criticism of Walker's art seems linked to its literal trans-
lation. The use of the sublime to present the unpresentable conflicts with oral
tradition and its use of the adroit wit and exaggeration of signifyin'. Walker and
Charles are not tricksters, and their self-deprecation strategies can be disturb-
ing in their disruptions.

Kern-Foxworth quotes Malcolm X as advising blacks never to "accept images
that have been created for you by someone else. It is always better to form the
habit of learning how to see things for yourself." In the same essay she says,
"Charles has asked the viewer to re-envision Aunt Jemima in dualities that have
never existed before."[70] It is difficult to understand how re-envisioning the fan-
tasy mammy turns into a rejection of images created for blacks and learning to
see things for yourself. Dualities and double entendre often become labored or
ineffective when visualized.

> I would be (at the movies) to see, maybe Bob Hope or Clark Gable, or maybe
> Humphrey Bogart. And then the Stepin Fetchit character would come in and, with
> the rest of my friends, we would sort of like duck! It would be like a storm had
> come in. Like you're in this Edenic island and then all of a sudden this storm of
> black denigration would come across us, and we would wait until that storm
> would be over. We would be giggling out of self-anxiety.
> —Historian Clyde Taylor in The Making of Bamboozled (2000)

The admonitory statement by Jada Pinkett-Smith's character in *Bamboozled*—
that we should never forget how we were disdained and demeaned through im-
ages and objects—represents a philosophical outlook that roots African Ameri-
cans in our victimization. Recyling, inverting, and deconstructing racist images
have some effect in dismantling that imagery, but those strategies visually root
us in our oppression. Collecting racist kitsch does not denature the objects any
more than ownership changes the nature of a horse or an automobile; a Clydes-
dale runs no faster, and a Porsche does not become an SUV after being sold.
Most importantly, these strategies do little to transform the consciousness (or
double consciousness) of those purportedly being defended. The fact that so
many African Americans define themselves in relation to slavery, racism, and
victimhood rather than African cultural, conceptual, and historical foundations
is telling. Perhaps a better understanding of our historical existence at least two
millennia back in history might trivialize the racist projections of recent cen-
turies and return folk to the self-assuredness of "it's not what you call me."

Despite my quibbles with those who collect or recycle racist images, it must
be kept in mind that African American artists like Charles, Walker, Colescott,
Glen Ligon, Juan Logan, Carrie Mae Weems, Betye Saar, Adrian Piper, Renée

Cox, and many others continue to feel the need to address racial issues even as we move into another century. My question is about whether a particular *strategy* is more or less effective, not about the creativity or quality of their work—or their right to create what they want. In some cases, the work may not do what it intends, and sometimes it revives the caricatures it intends to destroy. Perhaps Makeda will agree with me on this . . . a little?

# TURNING IN FROM THE PERIPHERY

*My father talked to me about slavery, and his [great] grandpa who was a slave that*

*he met. He knew him! He talked to him! He taught him things. . . . He told me about*

*his [great] grandfather. He didn' t tell me about the master. Ever. Ever, ever, ever, ever,*

*ever, ever. Not one time. Never a conversation about the terrible side of the master.*

*It was about how wonderful my great-great grandfather was.*

  *—María Magdalena Campos-Pons, interview with the author (1999)*

Artist and educator Floyd Coleman remembers his first viewing of Hale Woodruff's *Amistad* murals at Talladega College when he was a young man. He was stunned. Completed in 1939 to commemorate the centennial anniversary of the revolt aboard the slaver *Amistad* led by Cinqué, the murals were not only visually captivating; here for the first time in Coleman's experience was an image of a black man winning. Whites were physically subdued by African captives in the first panel of the mural in a violent repudiation of their enslavement. This mural was completed during the midst of the horrific period of apartheid (Jim Crow) in the South and provided a visual catalog of hope and inspiration for young African Americans in Alabama. Significantly, the *Amistad* incident in 1839 inspired abolitionist activity that worked to make the event symbolic of larger issues of slavery.[1]

African Americans were ridiculed or ignored in popular media and shunned by major museums and galleries in the era before 1967 when a number of Chicago artists collaborated to create the *Wall of Respect* (figure 94) on the South Side. The mural energized many folk in the black community and inspired the outdoor murals movement in this country. The early murals were not funded by official agencies or sanctioned by government bodies. They celebrated black achievement and heroes, and they placed images of African Americans in front of a public that had been circumscribed by derogatory or acquiescent imagery for generations. The work was rooted in their lives, their beliefs, and their potentials. Many muralists from the late 1960s to mid-1970s talked about the call-and-response dynamic that existed with them and their communities. While artists worked, members of the community would come and comment about the imagery, supply food and drinks, and generally become engaged with the artists and provide them with first-hand feedback.

This work, and much that followed during the next six years, had foundations in the center of African American aspirations, achievement, and identity. The work formed an outdoor gallery that was accessible to those for whom it was intended. It was not part of an effort to impress whites, prove black worthiness, or address any issue relative to the conflicts to be found on the periphery of black culture and identity. It did not focus on black victimhood, nor did it cast the artists as minstrels or tamed primitives. Instead, this type of work rooted itself in the center of black self-definition. Similar murals followed in Detroit, Atlanta, Philadelphia, and elsewhere, giving voice to a community seldom heard in public spaces or media. The anthropological silence of the subject was broken, and the audience was assumed to be black.

Several of the artists working on the Wall of Respect became members of a group that formed in 1968 and called itself AfriCobra (African Commune of Bad Relevant Artists). It included Jeff Donaldson, Wadsworth Jarrell, Barbara

FIGURE 94.
Wall of Respect
*(original version),*
*1967, 43rd and*
*Langley, Chicago,*
*Ill. Photograph by*
*James Prigoff.*

Jones, and Carolyn Lawrence. AfriCobra worked to formalize an African American visual aesthetic that was conscious of African artistic practices, and the group still sought to reach the same audience that was touched by the mural: the people they lived among. The group heeded the 1925 call by Alain Locke for artists to look to their ancestral legacy, first voiced in the March edition of the magazine *Survey Graphic* that he edited and then in his widely read book, *The New Negro,* adapted from the magazine. Though artists during the New Negro era explored African imagery as well as black vernacular culture, AfriCobra added a political urgency and attempted to base the work on a relationship with everyday folk rather than on the integrationist ideas of a few intellectuals. This was a period when the connections between African American civil and human rights struggles and the liberation struggles of former colonies in Africa had become almost palpable. Artists began making journeys to West Africa rather than to Europe. The Black Power movement and Black Nationalist thinking articulated self-determination more than assimilation.[2]

One of the motivations behind the formation of AfriCobra was the idea that art could be a catalyst for social change. As Nubia Kai wrote in an essay about the group, the "first step was to formulate a philosophy of art derived from their ethnic heritage by examining the most essential components of African art and incorporating these elements into an atavistic style."[3] The style included certain formal principles and social responsibility. Many of the early works included language so the message would not be missed by folk in the black community unfamiliar with the iconography, symbols, or representations found in art. Most of all, the work was to be a positive representation of the history, aspira-

tions, and cultural expressions of people of African descent. The intent was to empower people, not complain about their victimization. It was a part of a project by artists of the era to reimagine and redefine black identity visually. The work used intense color, rhythmic patterns, and cultural references to energize the imagery. The ideals of the group were firmly rooted in the center of black epistemological realities and vernacular cultural practices, and the artists had cast themselves as political activists engaged in a representational call-and-response dialogue with their community.[4]

During the years since AfriCobra exploded on the scene with its notable 1970 exhibition at the Studio Museum in Harlem, a number of artists have explored their ancestral or collective identity—and some have begun to produce new artistic roles. Houston Conwill, Betye Saar, and Renée Stout have created works exploring altars, ritual objects, and ritual spaces. Stout's notable life-sized sculpture, *Fetish No. 2* (1988), was a self-portrait-as-ritual-object based on the Kongo nail figures known as *nkisi nkondi*.[5] She cast herself as the object, the artist, the ritual expert, and the client commissioning the work. Recently Stout has played with black vernacular traditions, found especially around New Orleans in the guise of Hoo Doo, in which beliefs of spiritual activism and the efficacy of objects, roots, and powders play out. She has moved from the Kongo references in *Fetish No. 2* through Congo Square in New Orleans into Delta blues culture. Willie Dixon's blues song, "Hoochie Coochie Man," presents this world:

I got a black cat bone
I got a mojo too
I got the John the Conquer root
I'm gonna mess with you[6]

A recent installation by Stout, *Dear Robert, I'll See You At the Crossroads* (figure 95), deals with the legend of blues singer Robert Johnson (1911–38), born in Hazlehurst, Mississippi. Johnson took an interest in the guitar but playing with blues greats Son House and Willie Brown proved that he was a poor player. Johnson went on the road for two years and returned as a remarkable player and singer. Son House said, "He was so good! When he finished all our mouths were open."[7] Johnson was reputed to have made a deal with the Devil or, perhaps, Papa Legba, at the crossroads and sold his soul for the new abilities. Johnson's own blues songs seemed to touch on this legend with titles like "Hellhound on My Tail," and "Crossroad Blues."

I went to the crossroad, fell down on my knee
I went to the crossroad, fell down on my knee
Asked the Lord above for mercy, save po' Bob if you please[8]

FIGURE 95.
*Renée Stout,*
Wylie Avenue
Juke, *installation*
*view,* Dear
Robert, I'll See
You at the
Crossroads,
*1994˙95.*
*Courtesy of*
*the artist.*

Perhaps the polemics of the Black Arts movement opened the space for artists to turn in from the periphery of racial identity and conflict and to explore the instrumental center of their ethnic/cultural identity and histories. Primitivist expectations held by whites were challenged and overturned. The cultural observations of Archibald Motley Jr. were replaced by voices from within Bronzeville. That is both a literal and a figurative statement because the artists

who worked on the *Wall of Respect* and the founding members of AfriCobra actually lived in Chicago's black communities. Artists like Charles Searles grew up in a Philadelphia black community, and Ademola Olugbefola, a founding member of a New York artists' collective, Weusi, a group that was contemporaneous with AfriCobra, lived in Harlem.

One approach taken in recent years roots the artist in an African American center operating as a critic of the intrusive or oppressive Other that is white. This is not to advocate an essential monolithic cultural reality. But life lived black contributes certain shared understandings and encourages the continuation of some of the approaches to life and social relations that are distinctive to those with that experience and an African heritage. Juan Logan, an artist born in North Carolina, takes a position within the experience of being black and uses signifyin', tongue-in-cheek statements and direct criticism to undermine racist attitudes and ideas. He has done a series of works using varied mammy images in critical ways. Logan says his message is "what is it going to take, since you can't recognize me and all of mine with *this* face? Since this is the one you created, would you recognize this one, then, and then treat him or her fairly based on recognition?"[9] Like Kara Walker, he is asking, "Is *this* what you think?"

One of Logan's works, *Servant II* (figure 96), takes the form of a reliquary that resembles an altar piece. The artist has combined a mammy face with six gold-leaf Madonna figures framed by squares. The Madonna squares have small symbols that refer to gambling, "everything from tic tac toe to cards." Embedded in the work is subtle commentary about some of the contradictions in the ways Christianity functions in American society. Some folk may say, "Help me, Jesus," when they are rolling dice, and Logan remembers that "the same people that enslaved us were also the teachers of Christianity."

There is a wonderful irony in Logan's pairing of the mammy and the Madonna in a reliquary, a place "where we keep our sacred things, and special things." The two are among the most powerful icons for women in this society. Both have become servants of a sort, the one being the surrogate house worker, and the other providing an idealized metaphor for southern white womanhood. Both icons simplify the complexity of the women they are supposed to represent, reducing/elevating them to a status suitable for their function in the social order. In certain ways the relation between the two figures symbolizes the relationship between white women and the servants who relieved them of work and elevated their social status by doing so.

The aged green patina on the metal sheets adorning the sculpture suggests that these icons are very old, enduring symbols, and the gold-leafing indicates enshrinement of the Madonnas. In this context, it seems that the large mammy face, though it is a stylized caricature, also has become holy. Logan, tongue

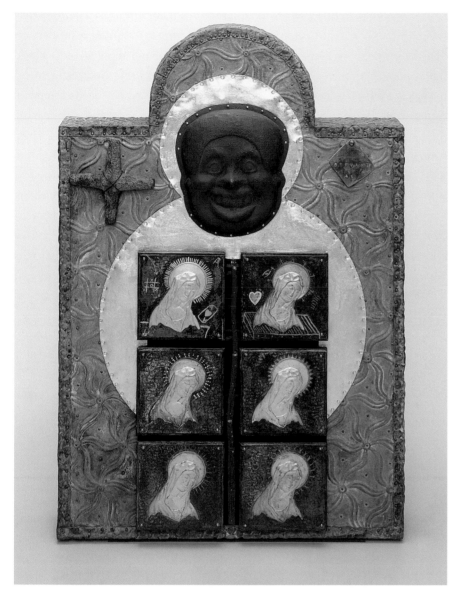

FIGURE 96.
*Juan Logan,*
Servant II, *2000,*
*mixed media,*
*25⅜″ × 16⅛″ ×*
*4⅛″. Collection*
*of the artist.*

firmly in cheek, is signifyin'. He is not trying to liberate the woman behind the
mammy mask. He is deconstructing the mask itself, contrasting it with what he
knows the women in his family to be though they were metonymically associ-
ated with the masks. He is talking back from a place within African American
experience, a place where the blues was born, with wit and sarcasm. He says,
"... we had this wonderful concept of Christianity. You pit that against the ac-
tions of Man, and the practitioners of that religion, which really seems at odds.
I mean, how do you put those two together? On one hand, it's okay to enslave,
it's okay to mistreat, it's okay to abuse, use, and at the same time say, 'But I'm
going to heaven.' How do you *do* that?"

Another work in this series of reliquary forms that critique social problems, *Grinning Is Not Always Grinning* (figure 97), attempts to capture a subtlety of black-white relations in the South. Logan says he is talking about an older black man who will "sit there and he'll say, 'Yes sir, yes sir. Oh yeah.' Soon as he turns his back, 'Damn mutha———.'... They'd be as humble as they needed to be to get by, to get along, to do what they needed to do." The work uses the same base form as *Servant II*, but the textured metal surface is peppered with beads. They work along with the dark blue coloration as indicators of protection. Logan has used blue as an indicator of protection in his work for years, a habit that is rooted in his past experiences: "We went by to see my father's cemetery up in

**FIGURE 97.**
*Juan Logan,*
Grinning Is Not
Always Grinning,
*2000, mixed
media, 23⅝″ ×
22″ × 4½″.
Collection of
the artist.*

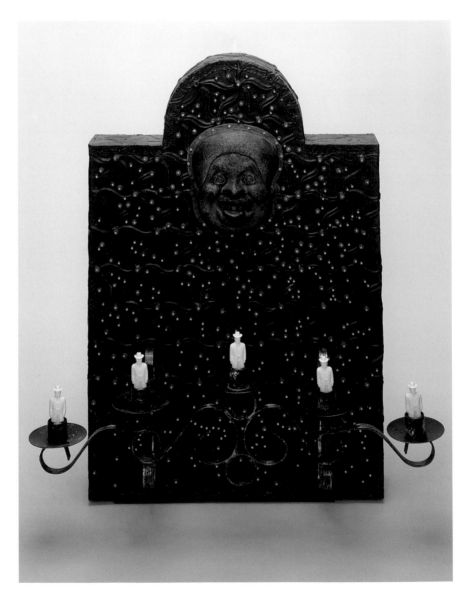

the mountains of North Carolina, up in McDowell county, and people, I don't know who, had created these bottle trees on either side of the cemetery there, but using old cobalt blue bottles. The old Milk of Magnesia bottles."

The textured metal surface on which the Aunt Jemima/mammy mask sits "is almost like a vine that's growing and protecting her." She has her tongue stuck out behind the backs of a row of southern colonel plantation figures in wax situated in a candelabra protruding from the lower portion of the work. They are vulnerable because they soon may be set afire. Her obsequious grin, ubiquitous in mammy imagery, has been replaced by the sarcastic gesture aimed at the unaware white figures who are the targets of the derisive act.

*Grinning Is Not Always Grinning* signifies from the position of folk forced to play a role, to don a mask, but it reveals the sentiments behind the mask. The artist is exploring a form and playing with relationships familiar to him from his past in rural North Carolina. He is challenging certain assumptions while defending his family and his memories of them. Because he sees the form of *Grinning* and *Servant II* as akin to reliquaries, he suggests that the mammy icon is sacred to this culture, but the icon is not what it seems to be.

Logan creates art from a position of confidence due to his connections to his forebears. He uses the verbal rhythms, the language of signifyin', from his communal foundations to comment on the disfiguring projections aimed at them through stereotypical imagery. Rooting his expression this way creates a confidence in his identity that permeates his creative expression. The uncertainty of Du Boisian double consciousness does not haunt Logan. He does not try to rescue Aunt Jemima because the conflict between her and the women in his family demarcates with certainty the line between the caricature and the women it mocks. Logan has caricatured the stereotype to further separate her from the women for whom she was a mask or a signifier for whites. He has pulled off the delicate task of creating an image that satirizes a black stereotype in ways that implicate the creators of the stereotype without replicating it. Had he recycled the originals, Logan would have risked providing a new context for them to do their old work despite his mediating intentions.

For a number of exhibitions, Logan created an installation with dozens of wax mammy masks (figure 98), many with slightly different coloration and alterations to the face for additional commentary. Some have a wishbone on the face suggesting that the mammy was a wish fulfillment for some people. On others he has replaced the facial features with a vagina as a commentary about the sexual assault and harassment so many black women faced, about their being seen as sex objects. Some, like the second image from the right on the second row in the photo, were altered to implicate the caricature of grinning black men who often were feminized in racist projections. In a gallery with 300 of these im-

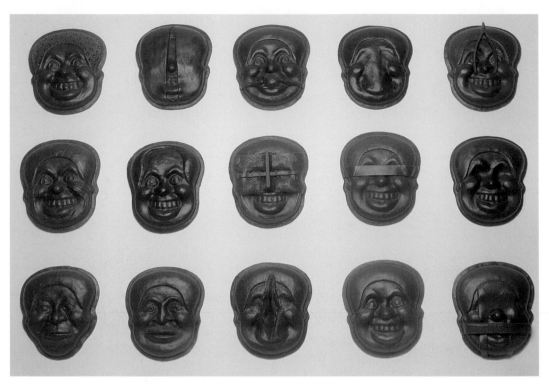

FIGURE 98.
*Juan Logan,*
*installation detail,*
*wax figures,*
*h. ca. 8" each.*
*Collection of the*
*artist.*

ages and variations, the effect is as overwhelming as it might have been for African Americans in the first decades of this century when all the Aunt Jemima and mammy imagery was to be found on hundreds of household objects and products. The effect on viewers potentially can create an empathy with folk surrounded and hounded by the stereotypes, or it can become a roomful of mocking faces critiquing the racist behavior and icons of whites.

As suggested in chapter 6, art expression makes implications about the artist, positioning him or her relative to the subject. Logan has not donned a minstrel mask, even in sardonic performance, but rather places himself autobiographically sitting on a front porch signifyin' about white folks' ways.

## HITTING A STRAIGHT LICK WITH A CROOKED STICK

Camille Billops, an artist living in New York, has done several works dealing with racism and stereotypes. Her recent short film, *KKK Boutique Ain't Just Rednecks* (1994), satirizes racism in American society and expands its definition to include more than whites. She says that "KKK Boutique is a metaphor for the place in which we entertain racist thoughts."[10] Billops believes that "this engine that drives racism involves everybody in some form or another. Although some-

times I know in black America we perceive of our not being capable of racism because it requires power. Well, racism, the act itself is so powerful."

She suggests that the hair-straightening industry and the skin-bleaching industry are connected to a form of self-racism and that they help "reinforce how you will *never* be wonderful because you never liked who you were." Noliwe Rooks notes that early advertisements for skin-lightening products and hair straighteners by white companies "suggest to blacks that only through changing physical features will persons of African descent be afforded class mobility within African American communities and social acceptance by the dominant culture."[11] One manufacturer asserted that black "advancement may be had only by changing the hair's texture. Not education, wealth, social position, morals or breeding will be effective."[12] This type of advertising regularly appeared beginning in 1866.

Billops may be best known for her series of images dealing with minstrelsy and its music. One of these works, *Zip Coon Verse 2* (figure 99), presents a mammy figure in blackface wearing a red-and-white bandanna. The figure is wearing long black gloves with painted fingernails to cover the hands, but behind the mask we see that we are looking at a strawberry blonde, blue-eyed white male. The minstrel is setting a plate of chicken feet while another minstrel in a simianlike mask looks on. The work, like the rest in this series, is backgrounded by a sheet of minstrel music. Billops explained her rationale behind these works: "I am going back to some things that I perceived of as major injuries to me, to me as a black person. It's not that I think that white people are bad people. That's not the point. I'm trying to re-address some things that put me on the wrong track. That's what I'm doing. And I'm going back to that old stuff and trying to pull it apart so we see how things started."

Billops feels an empathy with those black performers who had to wear blackface and suggests that many younger artists "don't know the suffering behind that. The horror. The absolute horror that black actors had to dress up like that to be on stage." She has taken the music, satirized the white performers behind the minstrel masks, and disconnected herself from them. The works were in an exhibition at the New Museum in New York, where a female guard told the artist that it saddened her when whites came in and laughed at the works. She told the woman, "Why? That's not you." The woman, like many blacks, had taken the stereotypes to heart. By showing a white person behind the masks in these works, Billops removes the potential for African Americans to feel the need to take them home and liberate a supposed black woman behind the mammy mask. That is, in her mind, taking it to heart. Like Logan, Billops has separated the stereotypes from the people they were supposed to represent. African Americans often were forced to don stereotypical masks and to behave

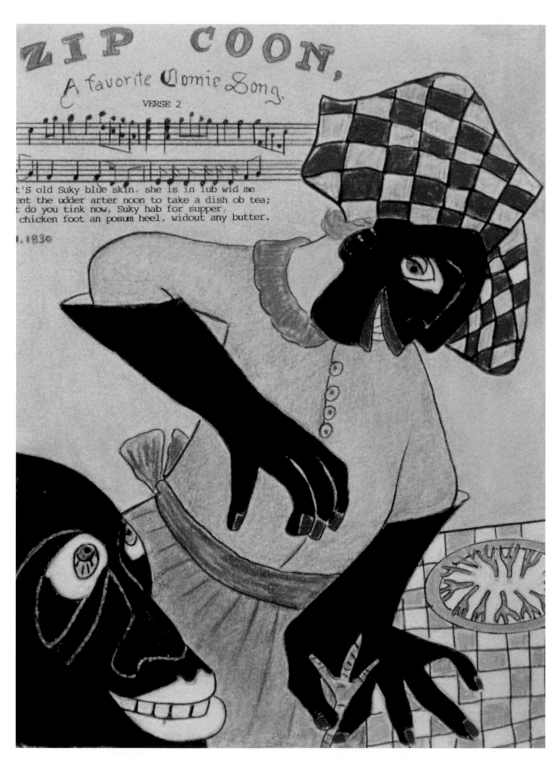

FIGURE 99.
*Camille Billops, Zip Coon Verse 2, Minstrel Series, 1990,
colored pencil on paper, 11" × 8½". Collection of the artist.*

in ways commensurate with the caricatures, but these images bore little resemblance to the actual people. They were images from the white psyche, and Billops is very clear about this in her work.

Another work in Billops's minstrelsy series, *Mammy's Little Coal Black Rose* (figure 100), has a mammy figure with blue eyes wearing blackface sitting on a bench holding a blonde, blue-eyed child, who is also in blackface and wearing black gloves on her hands. The background is sheet music and lyrics from the minstrel song published in 1916. This mammy is wearing a yellow bandanna, but, by holding a child, she sits in the middle of southern associations of mammies with child-rearing. Billops has complicated the representation by giving what is obviously a white child a blackface mask. She is signifyin' about the whole scenario being a drama peopled by whites. As she told the museum guard, these fantasies do not represent African Americans. Her commentary is about whites, but it is not necessarily aimed at a white audience.

Interestingly, when Billops depicted white minstrels in blackface in this series, she stylized the imagery in a satirical manner but successfully eluded close association with stereotypical representations of blacks. She captured the spirit of minstrelsy without subjecting herself to its caricatures. By doing this, she adroitly pointed her wit and commentary at whites and cast herself as she intended: a black woman critiquing the stereotypes whites have created and deployed against African Americans. We are backstage looking at a performance conceived and executed by whites.

Billops and Logan have isolated black stereotypes from the people they purport to represent. Neither takes the derogatory characterizations to heart in ways that cause them to implicate themselves in the imagery. They neither resurrect nor renovate the old imagery. Both transform it and turn it back on its creators in ways that target whites for critiques that do not miss.

## ROOTEDNESS

*It seems to me interesting to evaluate Black literature on what the writer does with the presence of an ancestor.*

*It was the absence of an ancestor that was frightening, that was threatening, and it caused huge destruction and disarray in the work itself.*

*—Toni Morrison, "Rootedness: The Ancestor as Foundation" (1984)*

Los Angeles artist Alison Saar has developed a singular style and approach to sculpture that owes certain foundations to her mother, artist Betye Saar, and to childhood experiences with her father who worked in art restoration. Like her

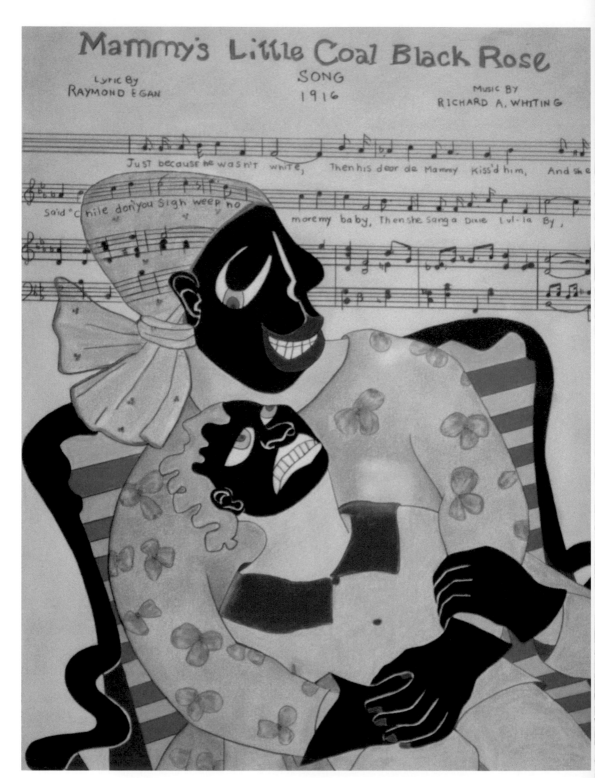

FIGURE 100.
*Camille Billops,* Mammy's Little Coal Black Rose, *Minstrel Series, 1992, colored pencil on paper, 22" × 30". Collection of the artist.*

mother, Saar gathers found objects and creates constructions that can have social, feminist, and/or mystical implications. One of her early works, *Sweet Thang* (1983; figure 101), was a harbinger of Saar's command of materials and her ability to quickly convey meaning in her powerful sculpture.

Saar says that *Sweet Thang* was done during her tenure as an artist-in-residence at the Studio Museum in Harlem. Her early figures from this period had eyes and clothing, and this work is smaller than many of her more recent sculptures, rising only nineteen inches. The woman in the bright yellow dress appears to have a hand on her hip and is lifting her dress with the other hand, showing a good deal of attitude. Less noticeable are her feet, which are bloodied from standing on shards of glass. Saar says that the work

> is really about survival; *Sweet Thang* is about stereotypes and surviving and utilizing stereotypes for survival as well. It's also about martyrdom, sacrifices to survive and sacrifices to help your family survive.
>
> A lot of the work is about women's resistance to pain and the ability to go beyond the pain. . . . So she's all dolled up; she's got her nails done and her toenails done, but you know she's still struggling.[13]

The woman may be a streetwalker, or she may reflect back to those black women in earlier eras who sacrificed their bodies, dreams, and pride doing demeaning work and enduring sexual exploitation. *Sweet Thang* confronts stereotypes about sexualized black women who have been seen as mammies or Jezebels, with few possibilities in-between. The work is an homage to the ability of black women to endure and survive such fallacies and fantasies. The title, a term of sexual objectification, contextualizes the pain experienced by women who have played the role of a sexual object—women reduced to using their charms to get by in a world offering limited options.

Two more recent works by Saar use women's hair to create commentary. One, *Chaos in the Kitchen* (figure 102), refers to "the curly part of your hair that's always breaking the teeth out of your comb."[14] It suggests hot combs in the kitchen as women straightened their hair to untangle it and make it easier to comb and maintain, as well as to add styling options. When Alison was young, her mother would tell her a story about a girl who would not brush her hair, with the result that all kinds of things began to accumulate and live in it. She says, "I like it because it's like a spirit catcher in a way, and that it catches your fears and it catches your dreams, it tells of your occupation."[15] This is a part of the discourse on hair denied mammy figures by the bandanna they typically are depicted wearing. The wire hair on this work contains scissors, brushes, washtubs, fast cars, and an Eiffel Tower. They indicate a history of experiences and a dream of going to Paris.

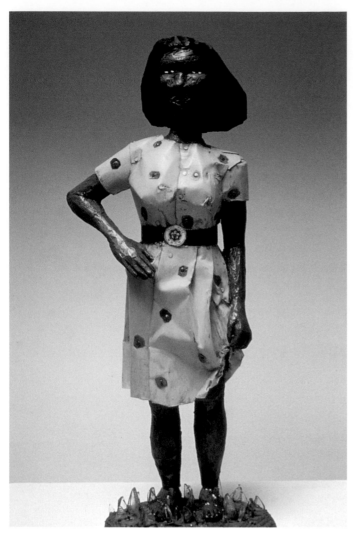

The eyeless face of the figure is covered with textured metal having a warm brown patina. The effect of the textured metal, a type of repoussé Saar says comes from old ceilings in Harlem, gives a sense of the scarification used to beautify and adorn the skin of many African women. The expression is one of cool repose and strength. By suggestion, the work appears to be rooted in the beautification histories and practices of black women. Saar is expressing certain cultural consistencies from a place of knowing. She is telling an inside story rooted in self-perception and shared experience.

The discourse around hair takes an interesting turn in the work *Delta Doo* (figure 103). This figure has a face and patina that is similar to *Chaos in the Kitchen,* but the skin is not textured. Saar says that this work has a southern sense of style "that also incorporates and recognizes the spirit world." The figure's hair has been turned into the branches of a bottle tree filled with old

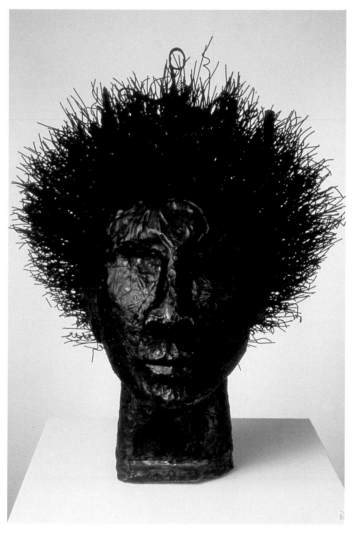

FIGURE 102.
*Alison Saar,*
Chaos in the
Kitchen, *1998,*
*wood, wire, tin,*
*tar, and objects,*
*h. 23". Courtesy*
*of the artist.*

medicine and cough syrup bottles. Murky and mysterious, those bottles are meant to attract and capture spirits, many of whom would be benevolent.

Bottle trees are linked to old Kongo grave decoration practices that were translated into North American vernacular culture. Robert Farris Thompson has documented that African American graves in places like St. Helena Island, Georgia, were decorated with the last article used by the departed. This was to satisfy the spirit and keep it from following one back to the house. He says, "The arrest of the spirit in last-used objects (*kanga mfunya*, literally, 'tying up the emanations or effluvia of a person,' or in another translation, 'tying up the anger of the dead') directs the spirit in the tomb to rest in peace and honors its powers on earth."[16] Bottle trees protected the household by either capturing spirits attracted to their flash or by serving as charms to invoke or placate them.

Kongo peoples are well known for their practices of using charms and ob-

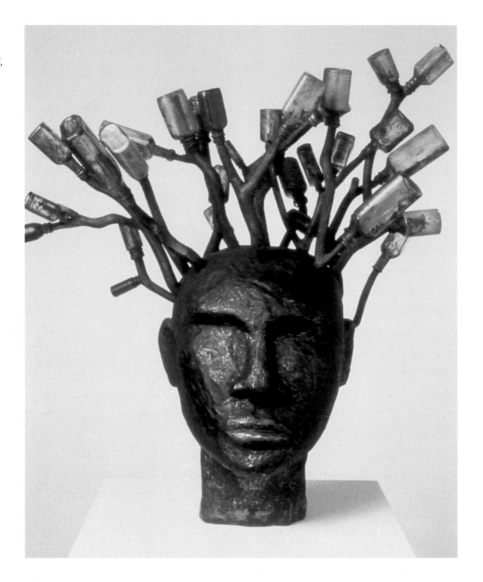

**FIGURE 103.**
*Alison Saar,*
Delta Doo, *1998,*
*wood, copper,*
*mixed media,*
*h. 31". Courtesy*
*of the artist.*

jects called *nkisi* (plural: *minkisi*). Thompson notes that each *nkisi* contains medicines and a soul to give it life and power. They contain spirit-directing medicines that "instruct the spirit in the *nkisi*—by way of puns and symbols—how to hunt down evil or, say, make a person more decisive in daily affairs."[17] Perhaps the best-known *minkisi* are the nail figures of Kongo art found around the world in many museums with major collections of African art. The idea of objects having spirit-directing efficacy is highly evolved in Kongo culture, and many *minkisi* figures have a mirror or some other light-reflecting material contained around the navel. *Nkisi* often involve things tied in packets to suggest a containment of spiritual or medicinal force, and these ideas flow nicely into the concept of bottle trees, which is similarly animated by a belief in the presence of spirits and the efficacy of the use of objects to invoke or placate them.

By invoking this realm of ideas and history through the hair of *Delta Doo*, Saar is again pointing out how important the discourse on hair has become for women of African descent. Hair has metaphorical importance in the indication of status and belief, and it became a threshold through which women like Madam C. J. Walker stepped into a position of self-assertive independence. Rooks argues that the hair-care industry allowed a number of women "one generation removed from slavery, [to begin] a conscious process of positioning African American women's identity within their communities through advertisements for hair-care products."[18] She says that, through advertising, they "engaged in the production of culture at the level of advertisements that 'talked back' to dominant culture's undergirding premises about connections between race and the possibility of physical beauty."[19]

Saar constructed an installation, *Afro-Di(e)ty* (figure 104), for an exhibition at the Getty Museum in Los Angeles that was intended to "respond to the lack of anything like it *in* the Getty." It was a specific response to the Lansdowne Herakles: "If you look historically at Hercules's 'heroic' acts, such as the slaying of the Queen of the Amazons—so much that Western culture idealizes I find offensive—it's about men dominating women. The Getty needed a strong female figure that wasn't being raped or seduced. That was the basic inspiration, those two things combined."[20]

*Afro-Di(e)ty* is an homage to the Yoruba *òrìṣà* Yemaya (*Yemoja*), a deity associated with the sea, rivers, and childbirth. A nude, the figure is standing in a washtub and has a blue-green patina. She is behind five basins of water mounted on piles of salt. She holds an *abebe*, a fanlike object often associated with the Yoruba goddess Oṣun. Her hair is made of coral, an item from the sea that was used as an accoutrement of royalty in the kingdom of Benin, a realm related and adjacent to the territory of Yoruba-speaking people in Nigeria. Saar used the coral because devotees of gods of the sea wore coral headdresses and hair to signify the red of childbirth. The work uses blue and white, colors associated with Yemaya. The cloth coming from her hand and flowing around the basins signifies a river, and the salt, obviously, is a reference to the sea. The water in the basins is freshwater. Childbirth is announced by the breaking of water. Water has liminal significance—it is a space of transition—an idea totally appropriate for the notion of spirits crossing over into the world of the living through the womb. Additionally, the sea became a transitional space for Africans and, in some cases, their deities as they moved unwillingly from Africa to the Western Hemisphere during the Atlantic slave trade.

The cloth behind the figure is the result of a collaboration between Saar and her husband, Tom Lesser. It was designed on a computer with a video still of a lake in Maine, to which was added images of starfish, sand dollars, and cowrie

shells. It was meant to suggest simultaneously the world underwater and the moon and stars from the sky, items she says appear on shrines to Yemaya.[21]

The figure has a circular form in the area of the navel and womb that resonates with Kongo *nkisi nkondi* figures and points up the incorporation in this work of references to a particular deity as well as to iconography and signs from outside a Yoruba context. The fact that she is standing in a washtub links the figure to New World working women, just as the Yoruba deity Yemoja has transatlantic links to Yamaya or Yemanja in Caribbean and South American contexts. Perhaps, like some Yoruba òrìṣà, this is a deified ancestor whose unique, outstanding abilities and activities in life have lifted her through lore.

We find the presence of the ancestor in a number of works by Alison Saar. This is a rootedness that places her in the center of a cultural foundation casting occasional glances at the periphery, but not donning masks that only exist there and showing little of the Du Boisian double consciousness that is evidence of a powerful preoccupation with that disdaining, disapproving stare from without.

Toni Morrison has written: "If anything I do, in the way of writing novels or whatever I write, isn't about the village or the community or about you, then it isn't about anything. I am not interested in indulging myself in some private exercise of my imagination . . . which is to say yes, the work must be political."[22] As the quote by Cuban artist María Magdalena Campos-Pons that opens this chapter suggests, there is health in centering expression within oneself and one's communal existence. Morrison argues that the disconnection from one's ancestral existence is destructive and disorienting. This is not to suggest a prescription for art by artists of African descent. Artist Carrie Mae Weems told me in a recent conversation that she believes every work of art has a sense of mission, but the social responsibility of the artist is to work. She says that "the more precise a work is, the more it opens up possibilities."[23] What I find different in the work of the artists in this chapter from those in chapter 6 is an empathy based on a rootedness within the center of African American cultural sensibilities and ancestral connections.

None of these artists has been able to completely escape his or her racial being or body, but their work should not necessarily be labeled "black art." It would be more apt to say that their work is rooted in their cultural being and the experiences of life lived black. Their rootedness and empathy has influenced the way that they address racial issues and the language they use to do so. They address the periphery of African American experience where racial antagonisms collide and play out, but they do so from the center. Their identity does not float on the periphery with shifting meanings and ephemeral significance. It is connected to histories and cultural patterns and practices. These connections hu-

opposite:
**FIGURE 104.**
*Alison Saar,
Afro-Di(e)ty,
2000, wood,
copper, coral,
mixed media,
h. 74". Courtesy
of the artist.*

manize them and allow for feelings of empathy that can energize their creative expression. Their connections are not defined by essentialist racial "blood" associations. Instead their work emanates centrifugally out from common cultural foundations through diverse individual perspectives.

The overt communal focus and nationalist ideologies of the Black Arts movement have subsided. Formal segregation has been eradicated in American society, and African American artists increasingly have become visible in the international and national art worlds. Definitions of what constitutes black art have not been resolved, but curator Thelma Golden and artist Glen Ligon have collaborated in conceiving the notion that young artists in the new century are creating something that is "post-black" art. This contradictory term, Golden writes, gained its impetus from "artists who were adamant about not being labeled as 'black' artists, though their work was steeped, in fact deeply interested, in redefining complex notions of blackness. . . . Post-black was the new black."[24] Work in this mode is characterized by "an individual freedom that is the result of this transitional moment in the quest to define ongoing changes in the evolution of African American art" and in the "ongoing redefinition of blackness in contemporary culture."[25]

Many younger artists have no experiential means of identification with their racial/ethnic histories and feel no compulsion to root themselves in them. Gary Williams, an artist on the Studio Museum in Harlem's exhibition list, says, "I feel no obligation to the community. . . . There's this romantic idea about the Harlem Renaissance, and that's pure garbage to me. I can't live in the past like that."[26] Nadine Robinson, an artist included in the celebrated Studio Museum exhibition "Freestyle" (2001), says, "I find it liberating to admit that I love straight hair," a statement made in reference to a self-portrait in the form of a large work created from extensions made of Chinese hair. Bay Area artist David Huffman, whose work was in "Freestyle," has tried to use minstrelsy as a means to get at deep psychological feelings about his own racial identity. He says:

> Mostly the minstrel made me feel sick and degraded. The image of the minstrel is visually haunting; it's a public display of degradation.
>
> Pain was subverted through that smiling face. At the same time, it was healing for me because I could deal with the unconscious pain.[27]

In the same *Freestyle* exhibition catalog where Golden's comments about post-black art appear, Hamza Walker grapples with his identity and the problematics for him in the shift from "black" to "African-American." He wrestles with the issue of collective responsibility in art and his feelings about its being a threat to his individuality: "Just as representations of blackness mediated black-white relations they also mediated black-black relations and ultimately the rela-

tionship I had to myself. Each and every image of someone black was speaking to me, at me and for me. A 'we' was assumed, imposing itself on whatever meager sense of self I could muster."[28]

Kara Walker is listed by Golden as a 1990s predecessor to the post-black artists, but her disconnection from a sense of community is similar to theirs. Michael Ray Charles, in fact, does feel a communal obligation and has admitted to Murry DePillars that DePillars's *Aunt Jemima* was an inspiration to him in devising his effort to undermine stereotypes. Perhaps it is useful to link these ideas and attitudes with older debates and philosophical expression. In the essay where Du Bois presented his idea of double consciousness, he said that the Negro generally "would not Africanize America" but simply "wishes to make it possible for a man to be both a Negro and an American."[29] In his 1926 essay "The Negro Artist and the Racial Mountain," Langston Hughes wrote that a promising young Negro poet "said to me once, 'I want to be a poet—not a Negro poet,'; meaning, I believe, 'I want to write like a white poet'; meaning, subconsciously 'I would like to be a white poet.'"[30] Hughes indicated that the Negro artist worked against "an undertow of sharp criticism and misunderstanding from his own group and unintentional bribes from the whites. . . . 'Be stereotyped, don't go too far, don't shatter our illusions about you, don't amuse us too seriously. We will pay you,' say the whites."[31] Hughes was describing the tendency at that time for African American artists to shy away from their own vernacular culture as inspiration and subject matter. He wrote that "[a]n artist must be free to choose what he does, certainly, but he must also never be afraid to do what he might choose."[32]

While some young artists confront and play with racist ideas and images as a strategy to disempower them, others seek refuge from them within their own individual humanity with the freedom to be or not be black, to remove the hyphen in "African-American" and to make "African" or any other ethnic designation arbitrary. They seem to prefer that their cultural identity be incidental so as to preclude having their work tossed into categorical ghettos.

In some ways the term "post-black" is a contemporary formulation of the ideas of James Porter and his disagreement with Alain Locke. In his 1943 book, *Modern Negro Art*, Porter wrote that Negro intellectuals justified an "alliance of art with primitive mentality" and for "the clearest formulation of this apology we cite Dr. Locke's essay 'The Legacy of the Ancestral Arts' in *The New Negro*."[33] Porter argued that the insistence on a racial heritage would cause "such self-conscious pursuit of the primitive [that] inevitably would stress a separate and singular existence for the American Negro"; that "this view of Dr. Locke and others would set apart, even if unintentionally, the form and content of Negro art"; and that this would not necessarily "make Negro art more acceptable to

the white public."[34] Porter seems to have categorized the African as a primitive, and undoubtedly he was reacting to the impulse of whites during that era to view all black expression as primitive and in a category separate from mainstream art and music. Porter felt that drawing from Negro subject matter was different than pursuing ancestral "blood" associations, but his optimistic projection of an escape from this categorical ghetto proved more difficult to attain than he envisioned: "The opportunities afforded Negro painters and sculptors so far through the WPA Federal Arts Projects raise the hope that equal opportunities will soon appear through private and commercial patronage and that the prejudice and mistrust that have restricted the Negro artist and warped his milieu will be abolished."[35]

*New York Times* columnist Holland Cotter has defined the dilemma that artists of color have faced in recent decades relative to their marginalization or inclusion in the mainstream art world. "Culturally specific shows offered more artists more opportunities to exhibit, find an audience and develop a commercial base. But they also reinforced certain narrow and distorting views of ethnic identity that 'diversity' should have dispelled."[36] He argues that racial or ethnic identity was a source for gaining power but also a trap. He suggests that a term like "post-black" or "post-ethnic" "offers a path out of the identity corner but keeps identity politics as a viable content."[37] Still, he warns that the art world has entered a very conservative phase; that the ideals of post-blackness and post-ethnicity "could easily end up being yet another exercise in control from above, a marketing label of greatest benefit to the privileged"; and that "a wholesale rejection of identity-based art at the behest of a white-dominated art market and critical establishment would seem, to say the least, short sighted."[38]

My own idea, sans an organizing label, is that artists are free to be as creative as their society and patronage will allow, but work rooted in their experiential and epistemological existences connects them to energies that deepen the expression while offering universal identification through the specific. It is true, as Golden asserts, that young artists "live in a world where their particular cultural specificity is marketed to the planet and sold back to them"[39] and that the black community of 1967 is today more of a metaphor in many places than a physical reality. Still, an artist is well served by the construction of an identity that takes into account the cultural and historical foundations of his or her forebears. Art rooted in the center of that identity is often more effective in confronting the conflicts on the periphery because, rather than facing hostility or problems by adopting their modes, contexts, and definitions, artists can use their own sensibilities to devise strategies that preserve their own artistic personality.

Because art is rooted in cultural and epistemological assumptions, I see the abandonment of an ethnic frame as moving the artist into a frame that, by its

seeming invisibility, closely resembles the way naturalized whiteness functions. The payoff, individuality, may be elusive and illusionary for those artists mapping movement from the margins to the center of the mainstream art world. Few artists of any ethnicity are given entrée to that world: often the price is to be cast in a prescribed role such as minstrel or primitive, and quite often attempts are made to strip the artist of his or her ethnic identity.

What complicates all of this is that the lived experience of blackness is changing, and it is differently nuanced in New York, where a great deal of the defining rhetoric is generated, than it is in Atlanta, Chicago, Oakland, and places in between. Globalization, television, and the triumph of capitalism have created an impetus toward homogenization and the declining significance of locality. Racial/ethnic identities now are more significant in marketing strategies aimed at target audiences than in identity formation unless conscious efforts are made to connect with the cultural histories associated with a particular ethnicity.

Juan Logan and Camille Billops engage in signifyin', a black vernacular practice full of wit, double entendre, social critique, and verbal adroitness in its various forms. In his book *The Signifyin' Monkey* (1988), Henry Louis Gates Jr. attempted to devise a formal critical literary theory using signifyin' as a paradigm. Several of Toni Morrison's novels have used black folklore as their organizing principle. Perhaps this is somewhat of a reprise of Du Bois's Hegelian use of *Freiheit*, the vernacular spirit of a people, as a foundation for formal analysis and theory, but it roots Gates and Morrison within the idiom more firmly than was the case with Du Bois. Logan and Billops, like Jeff Donaldson and Murry DePillars, are operating from within that spirit, a locus that allows them to feel the empathy that marks their expression. They emphatically refuse to take racist stereotypes to heart, and they feel for those who came before them and had to endure the original re-presentations of themselves as caricatures over which they had no control. Such artists are reinforcing the space between themselves and those images, not traversing it.

Alison Saar has done marvelous things with the presence of the ancestor, which lifts her work beyond the ephemeral and endows it with timeless qualities. That presence adds diachronic and synchronic aspects to her work because she has connected with ancestral sources and practices, thus linking her to experiences among people of African descent elsewhere in the diaspora who have dispersed from the same sources. She has done this with empathy for the struggles of individuals in *Sweet Thang* and *Chaos in the Kitchen* and with certain cultural and mythical metanarratives in *Delta Doo* and *Afro Di(e)ty*. Morrison suggests that the treatment of artists by the people for whom they speak is of some interest when the artist is "one of them" and there is an implied "we" in a narra-

tion. She says that this "is disturbing to people and critics who view the artist as the supreme individual. It is disturbing because there is a notion that that's what the artist is—always in confrontation with his own society."[40] The "we" in Saar's work includes women past, present, and divine. Her creativity emanates outward from a communal and humanistic foundation. The communal imperative in Saar's work is a celebratory identification, not the imposition described by Hamza Walker or a lament of victimization.

Connection to ancestral presences and memories by its very nature links the artist to larger aspects of his or her identity without threatening diversity or individuality. When an artist is rooted in the center of his or her own epistemological reality, there are secure assumptions about who the artist is: his or her role will be self-determined. The minstrel mask, like being black in Africa, has no meaning there. Art with ancestral and individual qualities can have a powerful impact on people, as Floyd Coleman can attest.

# CODA

*To discover how my ancestors dreamed their world makes it easy for me to cope
with the world in which I am today. It makes it easy for me to encounter the world
of others, the world dreamed by others, and to compare and see the differences
and the similarities.*

— *Chinua Achebe, interview quoted in* The Short Century *(2001)*

My views about the recycling or collection of derogatory images are known
among my friends and peers, and they occasionally give me things they en-
counter that tie in to my issues and ideas relative to the items. One such item is
a seven-inch-tall cotton bale music box from Mississippi. If you wind the key on
one side it plays "Dixie." The thing is so ludicrous as to be funny; but when that
cotton bale plays "Dixie," there is a part of me that just cannot laugh.

Perhaps this *thing* represents the state of contemporary American society;
we have moved from meaning to merchandise and marketing. Perhaps the on-
slaught of visual culture has numbed our surface sensibilities. Storytelling as a
means of preserving and conserving histories and collective identities may have
lost force and presence as more and more space has been taken by cable televi-
sion programming, the Internet, electronic gadgets (including the ubiquitous
cell phone), and shopping malls as social gathering places.

On some level, however, I believe that images still do their work silently and
persistently. Images are unruly. They resist containment and rational controls,
often doing unintended things despite the intentions of their owners. Art is
propaganda, espousing a position, an aesthetic, an approach to life, or some-
thing of the sort. Perhaps more innocently, it is evidence and autobiography. It
tells the story of the artist, the society within which he or she creates and what
expression is permissible or encouraged therein. It speaks of the physical, psy-
chological, emotional, and mental journeys and experiences of the artist. It is
language in a particular discourse. Still, images very often convey more or less
than intended. Importantly, images are a part of the process of identity for-
mation and visual representation and can have force and impact in the lives

of people. Stuart Hall has written that identity is a production that "is never complete, always in process, and always constituted within, not outside of representation."[1]

Historically, visual representation has been used in the service of ideology, belief, and values. It has served to create, document, and maintain racial definitions and boundaries. It has been construed to re-present, and to represent as a proxy, people of African descent as a means of subverting our self-representation. Beginning in the late nineteenth century, popular media became more and more important in the construction of significant imagery with social and personal impact, and in the last quarter of the twentieth century high art and popular culture began to overlap in increasing numbers of ways.

African American responses to the oppressive presence of derogatory imagery and stereotypes suggest that this presence was fortified by power and affected the lives of people in complicated but tangible ways. The power until recent decades could be absolute. One friend from Chicago confided that his mother had been sent from Mississippi to Chicago while she was young to prevent her from being raped by some white man who may have had an urge one day. The reality at the time was that white males could barge into your home and rape your mother if they were so inclined, and one was helpless to intervene because there were virtually no options available. The legal system was blind to this behavior, and physical resistance might result in your being lynched.

This kind of activity requires that the rapist dehumanizes his victim, and in the process he dehumanizes himself. Though this is an extreme example, the nexus of black-white tension and racial antagonism has been a site where struggles relative to definitions of humanity have been fought. Historically, blacks have used creative expression as a means for humanizing how they were perceived. Henry Louis Gates Jr. has argued that African slaves used demonstrations of writing to inscribe their "membership in the human community." Gates, in examining the earliest texts written by blacks in English, concludes that "the production of literature was taken to be the central arena in which persons of African descent could establish and redefine their status within the human community."[2] During the Enlightenment, reason was privileged "over all other human characteristics, and writing was taken to be the visible sign of reason."[3] Since the Renaissance, Europeans believed that their possession of reason separated them from the people of color they encountered in their discovery and exploration of the unknown world, and, as we have seen, they regarded a grasp of correct language as a signifier of one's civility.

The effort to inscribe Africans and African Americans within the realm of reason and civility persisted through the Harlem Renaissance, and it seems fair to say that images approximated texts in the sense that they were a means of

writing the African self into history and culture. As Gates says about literary production, slaves and ex-slaves could meet "the challenge of the Enlightenment by writing themselves into being."[4] There is a risk in calling images "texts" because it implies that they can be read similarly. Often the process of literary perception is a linear translation as meaning is encoded in language and interpreted by the reader back into action, images, and concepts. Images and symbols can convey meaning centrifugally by using concrete, physical information to evoke understandings within the viewer.

French scholar R. A. Schwaller de Lubicz writes that "the conventional symbol replaces long sequences of reasoning."[5] Rather than encoding or dictating information, the symbol is an exterior object "which awakens innate knowledge through the senses."[6] The abstracted image does not represent particular moments in time, but it appeals to human consciousness in ways that can transcend simple reason. Schwaller de Lubicz argues that Being, as existence, "manifests only through relationship, that is, the interchange between the two component complements of Being." It is the relationship that is the symbol of Being. The visual symbol "links complements, demonstrates Being," and "must always be considered as a *relationship* between two abstract and complementary elements."[7] The potential for the symbolic to represent and convey a metaphysical sense of Being indicates an efficiency that was suitable for the early African writing system of Egypt now called hieroglyphics.

Gates's argument about Africans writing themselves into Being is a microcosm of these larger philosophical and theological ideas, and linking the two would seem to imply that images function similarly because, after all, the first literature was one using images rather than phonetic symbols to communicate meaning. Images might also complement the idea prominent in oral cultures of speaking something into existence. The act of speech may be generational, containing the seed of physical reality, and is exemplified by theological concepts of God uttering Creation into existence, a notion that is not limited to Judeo-Christian belief.[8]

John Biggers provides an interesting example of self-inscription in his work *Shotguns, Fourth Ward* (figure 105). In this painting Biggers has provided the ancestral rootedness suggested by Toni Morrison, a foundation in the vernacular cultural experiences he had growing up in Gastonia, North Carolina, and an abstraction of the imagery that lifts the image above genre into the realm of the symbolic. Biggers has taken the modest shotgun houses common in the South, which are linked by their structure to some West African architecture, and transformed them into temples held up by black women as caryatids. The gables of the houses coalesce to form a pattern not unlike one that might be found on an African American quilt. Next to the women are the kinds of pots and wash-

boards that were in use during Biggers's childhood. Obvious references to living across the tracks from whites are embodied by the railroad tracks in front of the houses.

The women on the porches have a solidity and stylization resembling African sculpture—perhaps a Yoruba *ibeji* or a Baule other world lover. Biggers in 1957 journeyed to Ghana and several other nations in West Africa, becoming one of the first African American artists to do so, and that experience affected his work for the remainder of his life. In the upper right corner of the work, there is a bird with its head turned toward its tail; this may be a sly reference to the Ghanaian *sankofa* symbol, indicating the need for ancestral and historical recognition. A spiderweb on the lower left area of the railroad tracks must suggest the trickster figure from Ghana, *ananse* the spider. In the two doorways above the center woman, one can see silhouettes of an Akan *akua ba* comb with a circular head similar to that of the Asante *akua ma* doll.

With pattern, symbolism, cultural elements, and ancestral references, Biggers has extracted cosmic significance from his humble foundations in a southern black community. He has transformed meager physical circumstances into a site of metaphysical importance and suggested that the people within the setting are participants in an ancient continuum. Unlike the ex-slaves whose narratives Gates investigates, Biggers is inscribing his Being as a celebration of his unquestioned humanity. He is not burdened by racial constructs in ways causing him to seek redemption from white condemnation. Encoded in this symbolic image are indicators of the material effects of racial degradation, but also there is evidence of cultural persistence and triumph. In this confluence of complementary elements, we find an embodiment of Schwaller de Lubicz's idea about the relationship as the manifestation of Being. Tales of victimization do not tell the whole story.

In an article about Jean-Michel Basquiat, bell hooks writes about the self-erasure that can occur if an artist risks connections to his or her rootedness through mainstream ambitions. She argues that "assimilation and participation in a bourgeois white paradigm can lead to a process of self-objectification that is just as dehumanizing as any racist assault by white culture. Content to be only what the oppressors want, this black image can never be fully self-actualized."[9]

hooks cites James Baldwin in *The Fire Next Time* declaring that for the horrors of black life there has been almost no language. He indicated "that it was the privacy of black experience that needed 'to be recognized in language,'" and, according to hooks, Basquiat's work "gives that private anguish artistic expression."[10] Basquiat, unlike Biggers, roots his work in the private pain of the black experience as a critique of white racist histories. The primitivist interpretations of his work misunderstand his somewhat privileged, comfortable background

opposite:
FIGURE 105.
John Biggers,
Shotguns,
Fourth Ward,
*1987, acrylic and
oil on board,
41¾" × 32".
Collection
of Hampton
University
Museum,
Hampton, Va.*

in Brooklyn and the sophistication of his symbolic visual expression. The calligraphic elements of graffiti and the transgressive, outsider posture and position of writers in 1970s and 1980s New York made it possible for Basquiat to be categorized in ways that made his presence in the New York gallery world as much a primitivist fascination as a Dahomean woman in a hut at the 1893 World's Columbian Exposition, or the African pygmy, Ota Benga, housed at the Bronx Zoo in New York during the first decade of the twentieth century.[11] Yet Basquiat's work is no less symbolic than that of Biggers, although it is more morbid and painful. Basquiat's work became symbolic of his personal struggle with success in an art world that generally excluded people of color. Still, he is embraced by many whites as the greatest black painter more often than as a talented, innovative artist who has influenced people like Cy Twombly and Ouattara.

Hilton Als wrote that "Jean-Michel was one of the only true artists of his generation. I don't think it's possible for the art community to understand his work because a lot of it is in code, and a lot of it is expressly for colored people, and a lot of it comes out of being colored."[12] For example, the crowns appearing so often in his work have been interpreted by many as having complex metaphorical associations with royalty, but they simply may be a "shout out" to his graffiti writing days when great writers were known as kings.

The conflict between Basquiat's artistic aspirations and success and his "colored" cultural and familial foundations created a tortured relationship that destroyed him. This relationship and its graphic articulation in his art has become the way in which we define his Being. The terrible irony of his life is that he died renting a carriage house from the Andy Warhol estate for $4,000 a month, owning a $300,000 Picasso, having a taste for $200 bottles of French wine, and suffering a $1,000-a-day drug habit. His star had been fading in the New York art market, and he became associated in 1987 with Vrej Baghoomian, who is seen as a "second-string dealer," after breaking with the Mary Boone Gallery.[13]

Despite his remarkable success, Basquiat was cornered by racial histories and assumptions. He had to assume a particular social position to play to the bright lights. As happened with the primitivist fascinations in France in the first three decades of the twentieth century, and those in Roaring Twenties' New York, white interest in black expression came at a price for Basquiat. His works were colored by these realities, and his life was stained by them.

As W. E. B. Du Bois predicted, the color line remained the major American domestic question during the twentieth century. That line became a metaphor, a symbol, of the relationship between blacks and whites. Often the relationship between competing groups of people is used to define and confirm group identity. Visual representations have been used to reinforce the conflicts and con-

trasts between groups as well as to articulate exemplary characteristics of the group devising the image. The effects of visual representations created to contain and control people of African descent in the nineteenth century continued to occupy folk at the end of the twentieth century, even as segregation faded from view and a growing, highly educated African American middle class became more visible in American society. Kara Walker's racial imagery electrified audiences and propelled her to star status. Director Spike Lee directed and produced a film, *Bamboozled*, in the year 2000 that satirized network television as a new form of minstrelsy and suggested that the trade in stereotypical images, a burgeoning activity among middle-class blacks, offered little redemption and many potential risks. One of the subtle ironies of the film is that the main white character is like an uncorked minstrel in his adoption of black hip hop language and his collection of African art and photographs of black athletes and heroes. Blackness becomes an affectation, a commodified style that anyone can adopt.

Perhaps the "post-black" idea seeks to cut through this identity confusion accentuated by the globalization reality that has taken identity, destabilized it through capitalism and information technology, and reinterpreted it as market share and target audience demographics. *New York Times* art critic Holland Cotter said that, with this term, Thelma Golden "may have located a paradigm shift in contemporary art."[14] It does not seem to do so, and explanations of it seem as rootless as the affectations spoofed in *Bamboozled*. Thelma Golden has been quoted as saying that "Freestyle," the exhibition for which she coined the label, was "post-multicultural, post-identity, post-conceptual, and post-black."[15] Perhaps this means that the art in the exhibition was without identity, concept, and cultural diversity and that the artists were no longer black. However, to suggest that race is no longer visualized, meaningful, or problematic seems to be incorrect and fanciful. As Cornel West has aptly phrased it, race matters. Our understanding of its American incarnations are so deeply ingrained that artists like Walker can exaggerate racism's past horrors and everyone gets it. Basquiat is paternally labeled as the greatest black artist, and his blackness is deemed far more significant to his assessment than Robert Rauschenberg's or Jackson Pollock's ethnicity. When have we read that de Kooning was the greatest Dutch American painter? Can we name America's greatest gay artist? Race matters.

Perhaps "post-black" is a declaration of independence from categorical ghettos and collective responsibility. No longer do post-black artists speak for more than themselves as artists. Could it be the triumph of individualism over group identification? Perhaps, but my preference would be for the transcendence of racial categorization to encompass an ancestral rootedness that circumvents false identities like Aunt Jemima. That transcendence would be one that does not seek to avoid identity but, instead, embraces the complex histories that

make up contemporary African American identity. It is in cultural, familial, and experiential foundations that include the vernacular and the elite, blues and jazz, the multicultural, and the African that we find the freedom foundation for visual representation unburdened by double consciousness or double binds. With that foundation, we may develop the multivalent vision that will synthesize, syncopate, and rekey the racial world that has been visualized these past two centuries. One can imagine being able to act your age and not your color and have no self-deprecation implied.

> *(Rhythm fade-in)*
> There's a natural mystic flowing through the air
> If you listen carefully, now, you will hear
> This could be the first trumpet . . .
> —Bob Marley, "Natural Mystic"

# NOTES

INTRODUCTION

1. The Greek is *melaina eimi (ego) kai kale*, which translates to "Black am I and beautiful." The Latin translation by Jerome (d. 420) used "but" (*Nigra sum* sed *formosa*) and the first Catholic English translation, the Douai-Reims of 1582–1689, followed the Latin Vulgate and ignored the Hebrew. My colleague James McKinnon, whose help was invaluable in this inquiry, stated that "The King James Version of 1611 made serious use of the Hebrew, so I'm puzzled that they too used 'but' instead of 'and.'" James McKinnon to Michael Harris, October 20, 1998. Thanks as well to classics scholar and colleague William Race who also confirmed these translations.

2. Nicholas Mirzoeff, *Bodyscape: Art, Modernity and the Ideal Figure* (London: Routledge, 1995), 17.

3. "Momma Phoebe," *Scribner's Monthly*, November 1871, 62.

4. Ibid., 63.

5. "Out of the Depths," *Scribner's Monthly*, November 1871, 61.

6. "Momma Phoebe," 62.

7. Stuart Hall, *Representation: Cultural Representations and Signifying Practices* (London: Sage Publications, 1997), 6.

8. Ibid., 17.

9. Ibid., 18–19.

10. Ibid., 21.

11. Robin G. Kelley, *Yo' Mama's Disfunktional!: Fighting the Culture Wars in Urban America* (Boston: Beacon Press, 1997), 1.

12. For an excellent discussion of the debates about what African Americans were to call themselves, see Sterling Stuckey, *Slave Culture: Nationalist Theory and the Foundation of Black America* (New York: Oxford University Press, 1987), 193–244.

13. See Alain Locke, "Enter the New Negro," *Survey Graphic* 6, no. 6 (March 1925): 631–34.

14. Mechal Sobel, *The World They Made Together: Black and White Values in Eighteenth-Century Virginia* (Princeton, N.J.: Princeton University Press, 1987), 15.

15. James Baldwin, "My Dungeon Shook: Letter to My Nephew on the One-hundredth Anniversary of the Emancipation," in *The Fire Next Time* (1962; reprint, New York: Dell, 1968), 18–19.

16. W. E. B. Du Bois, *The Souls of Black Folk* (1903; reprint, New York: New American Library, 1969), 45.

17. For an in-depth discussion of Du Bois's ideas and their relationship to Hegelian thought, see chapter 4 in Joel Williamson, *The Crucible of Race: Black-White Relations in the American South since Emancipation* (New York: Oxford University Press, 1984).

18. Ibid., 404.

19. Ibid. Willie Dixon's blues song written for Muddy Waters illustrates this idea:

On the seventh hour
On the seventh day
On the seventh month
The seven doctors say
He was born for good luck . . .

20. Williamson, *The Crucible of Race*, 403.

21. Barbara Groseclose, *Nineteenth-Century American Art* (Oxford: Oxford University Press, 2000), 2.

CHAPTER ONE

1. Akua McDaniel, personal conversation with author, Atlanta, Ga., April 9, 1995.

2. Corrine Jennings, telephone conversation with author, March 7, 1998.

3. Bobby E. Wright, "Mentacide: The Ultimate Threat to the Black Race" (unpublished paper, ca. 1979).

4. Na'im Akbar, telephone interview with author, tape recording, May 5, 1999.

5. Oppressed populations of nations have, in the twentieth century, devised visual strategies to represent themselves. These have included the populist murals by Mexican artists like Diego Rivera and José Orozco and by

African American artists like Aaron Douglas and Hale Woodruff during the 1920s to the 1940s. In the late 1960s and early 1970s community murals began to appear widely in the United States, and the 1980s brought work by graffiti artists into visible prominence in urban centers all over the globe.

6. Akbar, interview.

7. Mechal Sobel, *The World They Made Together: Black and White Values in Eighteenth-Century Virginia* (Princeton, N.J.: Princeton University Press, 1987), 16–20.

8. Ibid., 50

9. Ibid., 44–45.

10. Elizabeth O'Leary, *At Beck and Call: The Representations of Domestic Servants in Nineteenth-Century American Painting* (Washington: Smithsonian Institution Press, 1996), 10.

11. Sobel, *The World They Made Together*, 21–25.

12. John Hope Franklin, *From Slavery to Freedom: A History of African Americans*, 7th ed. (New York: Alfred A. Knopf, 1994), 56–58.

13. Karla Holloway, *Codes of Conduct: Race, Ethics, and the Color of Our Character* (New Brunswick, N.J.: Rutgers University Press, 1995), 105–6. This useful definition has been complicated by the 2000 U.S. Census, which defines race as self-identification.

14. K. Sue Jewell, *From Mammy to Miss America and Beyond: Cultural Images and the Shaping of US Social Policy* (London: Routledge, 1993), 5.

15. Michael Gomez, *Exchanging Our Country Marks: The Transformation of African Identities in the Colonial and Antebellum South* (Chapel Hill: University of North Carolina Press, 1998), 6.

16. V. Y. Mudimbe argues that the African "has become not only the Other who is everyone else except me, but rather the key which, in its abnormal differences, specifies the identity of the Same." V. Y. Mudimbe, *The Invention of Africa: Gnosis, Philosophy, and the Order of Knowledge*, (Bloomington: Indiana University Press, 1988), 12. Additionally, Werner Sollors writes, "Does not any ethnic system rely on an opposition to something 'non-ethnic,' and is not this very antithesis more important than the interchangeable content (of flags, anthems, and the applicable vernacular)?" Werner Sollors, "Introduction: The Invention of Ethnicity," in *The Invention of Ethnicity*, ed. Werner Sollors (New York: Oxford University Press, 1989), xiv.

17. See, for example, Stephen Jay Gould's discussion of the disastrous shift in Western thinking about race in the work of eighteenth-century German thinker Johann Blumenbach in Stephen Jay Gould, "The Geometer of Race," *Discover*, November 1994, 65–69; and, in the same issue of *Discover*, Jared Diamond, "Race without Color," 82–89.

18. Barbara J. Fields, "Slavery, Race and Ideology in the United States of America," *New Left Review*, May/June 1990, 118.

19. "Dolled Up Postage Stamps Commemorate Precious Collectibles," USPS *Postal News* press release, July 7, 1997.

20. Richard Dyer, "White," *Screen* 29, no. 4 (Autumn 1988): 4.

21. Jan Nederveen Pieterse, *White on Black: Images of Africa and Blacks in Western Popular Culture* (New Haven: Yale University Press, 1992), 9.

22. Ibid., 179.

23. "We first encounter the widespread use of the term 'nigger' during this period. . . . As much of the rest of empire-building, the use of 'nigger' was borrowed from the Indian Empire. The word was in use there much earlier than in Africa." Dorothy Hammond and Alta Jablow, *The Africa That Never Was: Four Centuries of British Writing about Africa* (New York: Twayne, 1970), 100. Recent entries in the *Oxford English Dictionary* suggest that the word first was used in the late seventeenth century as a derogatory term applied to blacks. A 1933 version of the dictionary indicated that the word, primarily referring to a "negro," also "[l]oosely or incorrectly applied to members of other dark-skinned races." *Oxford English Dictionary* (Oxford: Clarendon Press, 1933), 7:137.

24. Stuart Hall, "What Is This 'Black' in Black Popular Culture," in *Black Popular Culture* [a project by Michele Wallace], ed. Gina Dent (Seattle: Bay Press, 1992), 22–23.

25. Kobena Mercer, *Welcome to the Jungle: New Positions in Black Cultural Studies*, (New York: Routledge, 1994), 9. Mercer argues that transformation of the center has begun through antagonism and resistance from the margins; another factor is the presence in the geographical power centers of people and ideas from the outlying places that have come under European imperial or hegemonic domination. What has developed is an unpredicted and unpredictable hybridity. Mercer correctly suggests that ethnic and national identities have begun to collapse and that long-term transformations of old "givens" are already in motion.

26. John Thornton, *Africa and Africans in the Making of the Atlantic World, 1400–1680* (Cambridge: Cambridge University Press, 1992), 43–53.

27. John Hope Franklin writes: "At a time when the other countries were granting monopolies to powerful government-supported trading companies, Portugal elected to leave her trade in the hands of merchants who proved ineffective matches for their competitors from other countries. Not until 1692 did Portugal license the Portuguese Company of Cacheo. By that time several strong companies from other countries had so monopolized the slave trade that Portugal did not have an opportunity to garner more than the proverbial crumbs from the table." Franklin, *From Slavery to Freedom*, 33. Thornton concurs by writing, "In the case of the northern Europeans after 1600, the state's role was vested in the hands of parastatal chartered companies, such as the Dutch West India Company, the English Royal Africa Company, or the French Senegal Company, which made their own arrangements with private traders." Thornton, *Africa and Africans*, 55. The Spanish were excluded from Africa by the papal arbitration of 1493 but granted rights to carry slaves to her colonies by the system of *asientos*.

28. For a case study where property issues became central, see Melton A. McLaurin, *Celia, a Slave* (New York: Avon Books, 1991), especially chap. 6.

29. Herbert Aptheker, *"One Continual Cry": David Walker's "Appeal to the Colored Citizens of the World," 1829–1830, Its Setting and Its Meaning* (1965; reprint, New York: Humanities Press, 1980), 18–19.

30. For a detailed look at the role of economics in the development of racist ideology, see Ira Berlin, *Many Thousands Gone: The First Two Centuries of Slavery in North America* (Cambridge, Mass.: Harvard University Press, 1998).

31. John Michael Vlach, *Back of the Big House: The Architecture of Plantation Slavery* (Chapel Hill: University of North Carolina Press, 1993), 5.

32. Ibid., 21.

33. Roger Abrahams, *Singing the Master: The Emergence of African American Culture in the Plantation South* (New York: Pantheon, 1992), 34.

34. Robert St. George, introductory remarks to Dell Upton, "Black and White Landscapes in Eighteenth-Century Virginia," in *Material Life in America: 1600–1860*, ed. Robert Blair St. George (Boston: Northeastern University, 1988), 357–66.

35. McLaurin, *Celia, a Slave*, 7–8.

36. Vlach indicates that by 1860 there were over 800,000 slaves on 46,274 plantations and that only 24 percent of the southern white population actually owned slaves. The dependency on the system and the defense of

white supremacy by other whites was instrumental in its continuation. Vlach, *Back of the Big House*, 7–8.

37. Aptheker, *"One Continual Cry,"* 20.

38. Ibid.

39. Ibid., 24.

40. Ibid., 29.

41. Ibid., 48.

42. T. P., "Observations: On the Early History of the Negro Race," *African Repository*, March 1825, 7–8. The publishers of this journal were not egalitarian; they favored instead manumitting slaves and setting them up in their own colonies back in Africa.

43. Drew Gilpin Faust, *James Henry Hammond and the Old South: A Design for Mastery* (Baton Rouge: Louisiana State University Press, 1982), 162.

44. Drew Gilpin Faust, *The Ideology of Slavery: Proslavery Thought in the Antebellum South, 1830–1860* (Baton Rouge: Louisiana State University Press, 1981), 4–5.

45. In 1774 Edward Long responded to early antislavery arguments with his *History of Jamaica* (London, 1774), a virulently racist publication that tried to prove that blacks were a distinct species naturally inferior to *homo sapiens*. The section of the book that discussed race was reprinted in the United States in *Columbian Magazine* in 1788. Cited in Hugh Honour, *The Image of the Black in Western Art*, vol. 4, *From the American Revolution to World War I* (Cambridge, Mass.: Harvard University Press, 1989) 32, 309.

46. American proslavery advocates were not isolated from European ideas. South Carolina planter John Henry Hammond, a leading proslavery spokesperson retired from Congress and traveled to Europe for a year for health reasons in 1836. His journey slowed the growth of his ideas about an American aristocracy, and he used his observations of the poor conditions endured by the working and servant classes of England and Europe to strengthen his arguments about the benevolence of slavery. However, European ideas of racial hierarchies were readily available to him. See Faust, *John Henry Hammond and the Old South*, especially chap. 10.

47. Faust, *The Ideology of Slavery*, 14–15.

48. Anthea Callen, "Anatomy and Physiognomy: Degas' *Little Dancer of Fourteen Years*," in *Degas, Images of Women* (Liverpool: Tate Gallery, 1989), 11–12. Pieterse indicates that Camper died in 1789, but he dates his example of Camper's chart from 1791, and Callen's example is from 1821. Apparently the influence of Camper's ideas long outlived him. See Pieterse, *White on Black*, 46–47.

49. ". . . nas raças selvagens, o angulo facial e pouco aberto." *Lello universal: Dicionário enciclopédico em 2 volumes* (Porto, Portugal: Lello Editores, n.d.), 1001.

50. Fredrickson discusses Samuel George Morton's *Crania Americana* (1839), in which he published his findings from years of measuring the skulls of whites, Native Americans, and blacks, asserting as "fact that the ancient crania from a given race did not seem to differ from those of their modern descendants. Morton concluded that the races had always had the same physical characteristics and, by implication, the same mental qualities." Fredrickson, *The Black Image in the White Mind: The Debate on Afro-American Character and Destiny, 1817–1914* (New York: Harper Torchbooks, 1972) 74–75.

51. See Martin Bernal, *Black Athena: The Afroasiatic Roots of Classical Civilization*, vol. 1, *The Fabrication of Ancient Greece 1785–1985* (New Brunswick, N.J.: Rutgers University Press, 1987). There has been some criticism of Bernal's book, but I find his discussion of a new historical model to be useful to my discussion of racial motivations.

52. Ibid., 213.

53. Ibid.

54. Gould, "The Geometer of Race," 66–67.

55. Mudimbe writes that early "anthropology and philology and all social sciences can be really understood only in the context of their epistemological region of possibility. The histories of these sciences as well as their trends, their truths as well as their experiences, being derived from a given space, speak from it and, primarily, about it." Mudimbe, *The Invention of Africa*, 18.

56. John Woolman, *Some Considerations on the Keeping of Negroes: Recommended to the Professors of Christianity, of Every Denomination* (1754); cited in Sobel, *The World They Made Together*, 238.

57. Richard Colfax, *Evidence against the Views of the Abolitionists, Consisting of Physical and Moral Proofs of the Natural Inferiority of the Negroes* (New York: James T. M. Bleakley, 1833), 8.

58. Samuel A. Cartwright, "Diseases and Peculiarities of the Negro," in *The Industrial Resources of the Southern and Western States*, ed. J. D. B. De Bow (New Orleans, 1852), 2:318–24; cited in Fredrickson, *The Black Image in the White Mind*, 57.

59. Callen, "Anatomy and Physiognomy," 12.

60. Ibid., 14.

61. Toni Morrison, *Playing in the Dark: Whiteness and the Literary Imagination* (New York: Vintage Books, 1993), 17.

62. Avrahm Yarmolinsky, *Picturesque United States of America 1811, 1812, 1813, Being a Memoir on Paul Svinin* (New York: William Edwin Rudge, 1930), 21.

63. Pavel Svinin, *Traveling across North America, 1812–1813: Watercolors by the Russian Diplomat, Pavel Svinin*, trans. Kathleen Carroll (New York: Harry N. Abrams, 1992), 60–61.

64. Morrison, *Playing in the Dark*, 6: ". . . speculations have led me to wonder whether the major and championed characteristics of our national literature—individualism, masculinity, social engagement versus historical isolation; acute and ambiguous moral problematics; the thematics of innocence coupled with an obsession with figurations of death and hell—are not in fact responses to a dark, abiding, signing Africanist presence."

65. Patricia Hills, *The Painters' America: Rural and Urban Life, 1810–1910* (New York: Praeger, 1974), 58.

66. Pieterse, *White on Black*, 177.

67. Morrison, *Playing in the Dark*, 45.

68. Guy McElroy, *Facing History: The Black Image in American Art 1710–1940* (San Francisco and Washington, D.C.: Bedford Art Publishers and Corcoran Gallery of Art, 1990), 35.

69. Richard J. Powell, "Cinqué: Antislavery Portraiture and Patronage in Jacksonian America," *American Art*, Fall 1997, 54–55.

70. Ibid., 60–62

71. Ibid., 58–59.

CHAPTER TWO

1. David Dabydeen, *Hogarth's Blacks: Images of Blacks in Eighteenth Century English Art* (Athens: University of Georgia Press, 1987), 26.

2. Elizabeth Johns, *American Genre Painting: The Politics of Everyday Life* (New Haven: Yale University Press, 1991), 105–6. See also, Guy McElroy, *Facing History: The Black Image in American Art 1710–1940* (San Francisco and Washington, D.C.: Bedford Art Publishers and Corcoran Gallery of Art, 1990), 19.

3. "In the corn shucking, the slaves found that if they were willing to assume the role of happy workers, the planters would provide them with a feast and dance that would be remembered by both blacks and whites almost a century later." Roger Abrahams, *Singing the Master: The Emergence of African American Culture in the Plantation South* (New York: Pantheon, 1992), 4.

4. Ibid., 18.

5. Solomon Northup, *Twelve Years a Slave* (Auburn, New York: Derby and Miller, 1853), 216–17; cited in Abrahams, *Singing the Master*, 129.

6. Karen Mary Adams, "The Black Image in the Paintings of William Sidney Mount," *American Art Journal* 7, no. 2 (1975): 44; cited in Lizzetta LeFalle-Collins, "The Portrayal of the Black Musician in American Art," in *The Portrayal of the Black Musician in American Art*, ed. Nancy McKinney (Los Angeles: California Afro-American Museum, 1987), 14.

7. LeFalle-Collins, "The Portrayal of the Black Musician," 15.

8. Johns, *American Genre Painting*, 131. Johns points out that antebellum images of women similarly depicted them populating the edges of the male world—and most often one to an image.

9. Captain Frederick Marryat, *Diary in America*, ed. Jules Zanger (Bloomington: Indiana University Press, 1960), 273.

10. John Davis indicates that this work "effectively launched his career when it was first exhibited at the National Academy of Design in 1859." John Davis, "Eastman Johnson's *Negro Life at the South* and Urban Slavery in Washington, D.C.," *Art Bulletin* 80, no. 1 (March 1998): 67–73.

11. Johns, *American Genre Painting*, 128.

12. *Negro Life at the South* helped establish Johnson's reputation, and—as happened with Mount after he won regard for *Rustic Dance After a Sleigh Ride*—it got him elected an associate academician at the National Academy of Design. Jo-Ann Morgan, "Mammy the Huckster: Selling the Old South for the New Century," *American Art* 9, no. 1 (Spring 1995): 108 n. 13.

13. Davis, "Eastman Johnson's *Negro Life at the South*," 70.

14. Ibid., 79. This portion of the painting was significant enough that Johnson copied it twice in smaller works, one of which, *Confidence and Admiration*, was completed in 1859 and presently is in the collection of the Mead Art Museum at Amherst College in Amherst, Massachusetts.

15. Ibid., 80–81.

16. The painting was partially reproduced with the whites to the right cropped out to illustrate the sheet music for James Bland's "Carry Me Back to Old Virginny" (1875).

17. Barbara Groseclose, *Nineteenth-Century American Art* (Oxford: Oxford University Press, 2000), 26.

18. Johns, *American Genre Painting*, 104.

19. For detailed information and analysis of Homer's work, see Peter H. Wood and Karen C. C. Dalton, *Winslow Homer's Images of Blacks: The Civil War and Reconstruction*

*Years* (Austin: The Menil Collection and University of Texas Press, 1988).

20. Michael Hatt "'Making a Man of Him': Masculinity and the Black Body in Mid-Nineteenth-Century American Sculpture," *Oxford Art Journal* 15, no. 1 (1992): 21–22.

21. Ibid., 24.

22. W. T. Lhamon Jr., *Raising Cain: Blackface Performance from Jim Crow to Hip Hop* (Cambridge, Mass.: Harvard University Press, 1998), 22.

23. Ibid., 29.

24. Ibid., 44.

25. Cain was the first angry young man who took action against "preferential differentiation." As an outsider bearing a mark of discreditation, he came to be linked to blacks but also became the signified of blackface signification that allowed whites metaphorical identification with minstrels. Ibid., 118–26.

26. Abrahams, *Singing the Master*, 47.

27. Ibid., 137.

28. Ibid., 132.

29. Ibid., 152–57.

30. Ibid., 142.

31. Mark Twain, *The Autobiography of Mark Twain*, ed. Charles Neider (New York: Harper and Row, 1966), 64–65; cited in Abrahams, *Singing the Master*, 135.

32. Mechal Sobel, *The World They Made Together: Black and White Values in Eighteenth-Century Virginia* (Princeton, N.J.: Princeton University Press, 1987).

33. Ibid., 51.

34. Robert C. Toll, *Blacking Up: The Minstrel Show in Nineteenth-Century America* (New York: Oxford University Press, 1974), 65.

35. Abrahams, *Singing the Master*, 134.

36. Alexander Saxton, "Plantation Minstrelsy," in *Inside the Minstrel Mask: Readings in Nineteenth-Century Blackface Minstrelsy*, ed. Annemarie Bean, James V. Hatch, and Brooks McNamara (Hanover, N.H.: Wesleyan University Press, 1996), 70.

37. Toll, *Blacking Up*, 66.

38. Lhamon, *Raising Cain*, 75–76.

39. Toll, *Blacking Up*, 76.

40. Eric Lott, "Introduction: Blackface and Blackness: The Minstrel Show in American Culture," in *Inside the Minstrel Mask*, ed. Bean, Hatch, and McNamara, 9–11.

41. Toll, *Blacking Up*, 71.

42. Saxton, "Plantation Minstrelsy," 68–69.

43. Ibid., 76.

44. *Frank Leslie's Illustrated Newspaper*, January 5, 1856, 54.

45. To place the numbers used here in perspective, according to U.S. Census Bureau statistics, Boston's population would reach 177,840 in 1860, and New York, Philadelphia, and Brooklyn—the nation's three most populous cities—would combine for a population of only about 1,645,000.

46. *Cosmopolitan Art Journal*, June 1859; cited in Johns, *American Genre Painting*, 130.

47. Toll, *Blacking Up*, 73.

48. Marian Hannah Winter, "Juba and American Minstrelsy," in *Chronicles of the American Dance*, ed. Paul Magriel, (New York: Holt, 1948), 44; cited in Abrahams, *Singing the Master*, 148.

49. Toll, *Blacking Up*, 236.

50. "'76," *Harper's Weekly*, July 15, 1876, 574.

51. Johns, *American Genre Painting*, 131.

52. Eugene Lawrence, "Louisiana and the Rule of Terror," *Harper's Weekly*, October 3, 1874, 813.

53. Groseclose, *Nineteenth-Century American Art*, 74–75.

54. "Aping Bad Examples," *Harper's Weekly*, March 14, 1874, 242.

55. Frank Luther Mott, *A History of American Magazines*, vol. 2, *1850–1865* (Cambridge: Harvard University Press, 1938), 479–80.

56. Ibid., 480.

57. Harry T. Peters, *Currier and Ives, Printmakers to the American People* (Garden City, New York: Doubleday, Doran, 1929), 79–82.

58. Ibid., 82.

59. Karen C. C. Dalton, "Currier and Ives's Darktown Comics: Ridicule and Race" (paper delivered at "Democratic Vistas: The Prints of Currier and Ives" symposium, Museum of the City of New York, May 2, 1992).

60. Ibid., 4.

61. Stuart Hall, "What Is This 'Black' in Black Popular Culture?," in *Black Popular Culture* [a project by Michele Wallace], ed. Gina Dent (Seattle: Bay Press), 32.

62. Toll, *Blacking Up*, 235.

63. Ibid., 245.

64. C. Vann Woodward, *The Strange Career of Jim Crow*, 3d rev. ed. (New York: Oxford University Press, 1974), 69; cited in Dalton, "Currier and Ives's Darktown Comics," 9.

65. Sol Eytinge Jr.'s *Virginia One Hundred Years Ago* appeared in *Harper's Weekly* on August 19, 1876. *Harper's* commented that the visiting master and mistress are "greeted with respectful affection as they pass." Supporting the myth of happy slaves under the benevolent stewardship of planters, the image supposedly presents "the faces of the slaves [that] express content, and tell of kind treatment." *Harper's Weekly*, August 19, 1876, 1220.

66. Wood and Dalton, *Winslow Homer's Images of Blacks*, 94.

67. Richard J. Powell, "Introduction: Winslow Homer, Afro-Americans, and the 'New Order of Things,'" in Wood and Dalton, *Winslow Homer's Images of Blacks*, 9–10. Powell found the quote from Homer in a letter to Thomas B. Clarke, New York, 23 April 1892, Winslow Homer Papers, Special Collections, Bowdoin College Library, Brunswick, Me.

68. Marilyn Kern-Foxworth, *Aunt Jemima, Uncle Ben, and Rastus: Blacks in Advertising, Yesterday, Today, and Tomorrow* (Westport, Conn.: Greenwood Press, 1994), 63–67.

69. Reid Badger, *The Great American Fair: The World's Columbian Exposition & American Culture* (Chicago: Nelson Hall, 1979), 7.

70. Robert W. Rydell, "Rediscovering the 1893 Chicago World's Columbian Exposition," in Carolyn Kinder Carr and George Gurney, *Revisiting the White City: American Art at the 1893 World's Fair* (Washington, D.C.: National Museum of American Art/National Portrait Gallery, 1993), 20.

71. Donald Miller, *City of the Century: The Epic of Chicago and the Making of America* (New York: Simon and Schuster, 1996), 503.

72. J. A. Mitchell, "Types and People at the Fair," in Frank D. Millet, J. A. Mitchell, Will, H. Low, W. Hamilton Gibson, F. Hopkinson Smith, *Some Artists at the Fair* (New York: Charles Scribner's Sons, 1893), 43–45.

73. Cited in Rydell, "Rediscovering," 43–44.

74. Ibid., 38, 43; Millet et al., *Some Artists at the Fair*, 43.

75. Rydell, "Rediscovering," 44.

76. Jno. Gilmer Speed, "The Midway Plaisance," *Harper's Weekly*, May 13, 1893, 442.

77. Frederic Remington, "A Gallop through the Midway," *Harper's Weekly*, October 7, 1893, 963.

78. Arna Bontemps and Jack Conroy, *They Seek a City* (Garden City, N.Y.: Doubleday, Doran, 1945), 68–69.

79. Rydell, "Rediscovering," 54–55.

80. Bontemps and Conroy, *They Seek a City*, 69.

81. "Impressions of the White City," *The Outlook*, July 1, 1893, 19–20; cited in Rydell, "Rediscovering," 54.

82. Bontemps and Conroy, *They Seek a City*, 72.

83. Miller, *City of the Century*, 503.

84. Montgomery Breckinridge Pickett, "Procession of Foreign Peoples," *Harper's Weekly*, July 1, 1893, 629–30.

85. "The Johnson Family Visit the Great White City," *Harper's Weekly*, July 15, 1893, 681.

86. "The Johnson Family Visits the Village of the South Sea Islanders," *Harper's Weekly*, September 23, 1893, 914.

87. Richard Harding Davis, "The Last Days of the Fair," *Harper's Weekly*, October 21, 1893, 1002.

88. Only the fairs of 1876 in Philadelphia, 1893 in Chicago, 1901 in Buffalo, 1904 in St. Louis, and 1915 in San Francisco were considered World's Fairs. Badger, *The Great American Fair*, appendix A, 131.

89. Rydell, "Rediscovering," 35.

90. Olisanwuche Esedebe, *Pan-Africanism: The Idea and Movement, 1776–1991*, 2d edition (Washington, D.C.: Howard University Press, 1994), 39. Sterling Stuckey has shown that Pan-Africanist sentiment can be found a century earlier in the United States and that such sentiment may have been the foundation for the movement to formalize it at the end of the nineteenth century. Sterling Stuckey, *Slave Culture: Nationalist Theory and the Foundations of Back America* (New York: Oxford University Press, 1987).

91. Michael Gomez, *Exchanging Our Country Marks: The Transformation of African Identities in the Colonial and Antebellum South* (Chapel Hill: University of North Carolina Press, 1998), 2–3.

92. Tanner's middle name, Ossawa, was a shortened version of Osawatomie, the name of the town in Kansas where John Brown in 1856 killed proslavery vigilantes who were attacking antislavery homesteaders. Bishop Benjamin Tanner, Henry's father, was an active and prominent member of the AME Church, and it was through him that Henry became involved with the Conference on Africa. Romare Bearden and Harry Henderson, *A History of African-American Artists, from 1792 to the Present* (New York: Pantheon, 1993), 79, 87.

93. Judith Wilson, "Lifting 'The Veil': Henry O. Tanner's *The Banjo Lesson* and *The Thankful Poor*," *Contributions in Black Studies* 9/10 (1990–92): 41.

94. Ibid.

95. Statement in Tanner's hand in the files of the Pennsylvania School for the Deaf, Philadelphia; cited in Dewey F. Mosby, *Henry Ossawa Tanner* (Philadelphia: Philadelphia Museum of Art, 1991), 116.

96. Bearden and Henderson, *A History of African-American Artists*, 78–109. Tanner painted portraits of his parents during his 1897 visit to the United States from

Paris, and the theme of older men teaching boys appeared first in *The Bagpipe Lesson* (1892–93) and again in *The Young Sabot Maker* (1895).

97. Stuckey writes: "In general, slave masters in the nineteenth century paid little attention to African ethnicity, which was of immense value in the process of Pan-Africanization—of Africans, despite ethnic differences, becoming a single people,—since masters did not attempt to maintain ethnic barriers." Stuckey, *Slave Culture*, 3, 359 n. 1.

98. Richard Dyer, *White* (London: Routledge, 1997), xiii.

CHAPTER THREE

1. The story of Aunt Jemima as a product icon is well documented in Kenneth W. Goings, *Mammy and Uncle Mose: Black Collectibles and American Stereotyping* (Bloomington: Indiana University Press, 1994); Marilyn Kern-Foxworth, *Aunt Jemima, Uncle Ben, and Rastus: Blacks in Advertising, Yesterday, Today, and Tomorrow* (Westport, Conn.: Greenwood Press, 1994); Arthur F. Marquette, *Brands, Trademarks, and Good Will: The Story of the Quaker Oats Company* (New York: McGraw-Hill, 1967); and Diane Roberts, *The Myth of Aunt Jemima: Representations of Race and Region* (London: Routledge, 1994). Jo-Ann Morgan has written an important article discussing the mammy and Aunt Jemima in the larger political and social context of late-nineteenth-century America. Jo-Ann Morgan, "Mammy the Huckster: Selling the Old South for the New Century," *American Art* 9, no. 1, (Spring 1995): 87–109.

2. M. M. Manring, *Slave in a Box: The Strange Career of Aunt Jemima* (Charlottesville: University of Virginia Press, 1998), 61.

3. Marquette, *Brands, Trademarks, and Good Will*, 143.

4. "Old Aunt Jemima" (1875). Kern-Foxworth writes that "by 1877 Kersands had performed the song more than 3,000 times and had developed three different improvisational texts for his audiences." Kern-Foxworth, *Aunt Jemima, Uncle Ben, and Rastus*, 64–65.

5. Robert C. Toll, *Blacking Up: The Minstrel Show in Nineteenth-Century America* (New York: Oxford University Press, 1974), 260.

6. Ibid., 246.

7. Sterling Stuckey, "Through the Prism of Folklore," *Massachusetts Review* 9, no. 3 (Summer 1968), 424; cited in Manring, *Slave in a Box*, 70.

8. Geo. L. Rousseau, "Jemima Susianna Lee" (Saint Paul: John A Weide, 1876).

9. Mechal Sobel, *The World They Made Together: Black*

and White Values in Eighteenth-Century Virginia (Princeton, N.J.: Princeton University Press, 1987), 43.

10. David P. Gamble, *Gambian Wolof–English Dictionary* (Brisbane, Calif.: D. P. Gamble, 1991), 58, 74, 78, 100. Wyatt MacGaffey indicates that KiKongo does not yield standard names but that names are compound words expressing a specific meaning. Wyatt MacGaffey, telephone conversation with author, 1999.

11. Nosson Scherman, ed., *The Stone Edition Tanach* (Brooklyn, N.Y.: Mesorah Publications, 1996), 1678 n. 42.

12. Free Negro Register, Sussex County, Va.

13. Circuit Book C., Fayette County, Va., 65.

14. "Colored Householders," in *The Baltimore Directory*, comp. R. J. Matchett (Baltimore, Md., 1847).

15. The Bible proved to be a prominent resource for the names of slaves. Beyond the commonly used David, John, Joseph, and Mary, one can find a variety of less common biblical names, including Amos, Beulah, Ebeneezer (Ebenezer), Elijah, Enoch, Enos, Ephraim, Gabriel, Gamaliel, Hezekiah, Israel, Isaac, Jeremiah, Josiah, Nehemiah, Solomon, and one Job Ben Solomon. John Blassingame, ed., *Slave Testimony: Two Centuries of Letters, Speeches, Interviews, and Autobiographies* (Baton Rouge: Louisiana State University Press, 1977).

16. Charles L. Rutt, "The Story of Aunt Jemima Pancake Flour" (unpublished paper, November 28, 1929).

17. Marquette, *Brands, Trademarks, and Good Will*, 144.

18. Allan H. Spear, *Black Chicago: The Making of a Negro Ghetto, 1890–1920* (Chicago: University of Chicago Press, 1967), 29.

19. Morgan, "Mammy the Huckster," 94–97.

20. Albert Morris Bagby, *"Mammy Rosie"* (New York: Albert Morris Bagby, 1904), 3.

21. Ibid.

22. Elizabeth O'Leary, *At Beck and Call: The Representations of Domestic Servants in Nineteenth-Century American Painting* (Washington: Smithsonian Institution Press, 1996), 5.

23. Jan Nederveen Pieterse, *White on Black: Images of Africa in Western Popular Culture* (New Haven: Yale University Press, 1992), 126.

24. O'Leary, *At Beck and Call*, 18.

25. Ibid., 34.

26. George F. Carroll, *Mammy and Her Chillun* (New York: Comet Press Books, 1958), 1.

27. Ibid., 4.

28. Morgan, "Mammy the Huckster," 96.

29. June O. Patton, "Moonlight and Magnolias in Southern Education: The Black Mammy Memorial Institute," *Journal of Negro History* 65 (Spring 1980): 150; cited in Kern-Foxworth, *Aunt Jemima, Uncle Ben, and Rastus*, 89.

30. Goings, *Mammy and Uncle Mose*, 64.

31. Juliette Bowles, telephone conversation with author, March 16, 1998. Bowles also pointed out that in her research she found that elaborate turbans became a symbol of status at one point in South Carolina.

32. Judith Wilson, "Beauty Rites: Towards an Anatomy of Culture in African American Women's Art," *International Review of African American Art* 11, no. 3 (1994): 13.

33. Ibid., 14–15.

34. David M. Lubin, *Picturing a Nation: Art and Social Change in Nineteenth-Century America* (New Haven: Yale University Press, 1994), 232–33.

35. Ibid., 245. Older men's fascination with young girls is not confined to the West. A recent news article indicated that fifteen-year-old schoolgirls have become the sexual fantasy of a great many contemporary Japanese men, and there is a new magazine, *V-Club*, filled with pictures of naked elementary schoolgirls. Masao Miyamoto, a Japanese psychiatrist, believes that many men are threatened by adult women as a result of changes in society empowering women, making them more informed and sophisticated and less dominated by males. This has many implications for understanding the phenomenon in Western societies in the nineteenth and twentieth centuries. Nicholas D. Kristof, "A Plain School Uniform as the Latest Aphrodisiac," *New York Times*, April 2, 1997.

36. Elizabeth Johns, *American Genre Painting: The Politics of Everyday Life* (New Haven: Yale University Press, 1991), 140.

37. Donald Miller, *City of the Century: The Epic of Chicago and the Making of America* (New York: Simon and Schuster, 1996), 504.

38. Maud Howe Elliott, "The Building and Its Decoration," in *Art and Handicraft in the Woman's Building of the World's Columbian Exposition, Chicago, 1893*, ed. Maud Howe Elliot (Chicago: Rand, McNally, 1894), 35–36.

39. Ibid., 46–47.

40. Martha Banta, *Imaging American Women: Ideas and Ideals in Cultural History* (New York: Columbia University Press, 1987), 2; cited in Lubin, *Picturing a Nation*, 227–28.

41. Carroll, *Mammy and Her Chillun*, 13.

42. Morgan, "Mammy the Huckster," 105.

43. Ibid., 88.

44. "The show stopper of the Baker & Farrell act was a jazzy, rhythmic New Orleans style cakewalk to a tune called 'Aunt Jemima' which Baker performed in the apron and red-bandanna headband of the traditional southern

cook." Marquette, *Brands, Trademarks, and Good Will*, 143. This account differs slightly from Kern-Foxworth's detailed account that lists the black minstrel Billy Kersands as the performer; see note 4 above. Black minstrel performance was a black renovation of white performance caricaturing black performance. It was not, on its face, black performance.

45. Morgan, "Mammy the Huckster," 90.

46. Marquette, *Brands, Trademarks, and Good Will*, 146.

47. Ibid., 146–47.

48. Ibid., 148. Kern-Foxworth claims only five cents were required to redeem the doll with a box top. Kern-Foxworth, *Aunt Jemima, Uncle Ben, and Rastus*, 73.

49. Kern-Foxworth, *Aunt Jemima, Uncle Ben, and Rastus*, 72–76.

50. Mildred Grenier, "Aunt Jemima . . . the Trademark That Was Brought to Life," *St. Joseph Magazine*, July 1977, 11.

51. Marquette, *Brands, Trademarks, and Good Will*, 148–49.

52. Goings, *Mammy and Uncle Mose*, 66.

53. Jeff Donaldson, telephone conversation with author, December 17, 1997.

54. Moyo Okediji, *The Shattered Gourd: Yoruba Forms in Twentieth Century American Art* (Seattle: University of Washington Press, 2002).

55. Jeff Donaldson, "Background Statement," in *Jeff Donaldson: 1961–1981* (Washington, D.C.: Howard University Press, 1981), 1; cited in Okediji, *The Shattered Gourd*, 157.

56. For a discussion of Overstreet's relationship with contemporary art and artists, including his study with Richard Diebenkorn and Clyfford Still, see Ann Gibson, "Strange Fruit: Texture and Text in the Work of Joe Overstreet," in *Joe Overstreet: Works From 1957–1993* (Trenton: New Jersey State Museum, 1996), 26–40.

57. Mary Schmidt Campbell, *Tradition and Conflict: Images of a Turbulent Decade, 1963–1973* (New York: Studio Museum in Harlem, 1985), 52.

58. Joe Overstreet, telephone conversation with author, March 7, 1998. Subsequent quotations are from this conversation.

59. Murry DePillars, telephone conversation with author, January 4, 1998. Subsequent information and quotations are from this conversation.

60. W. E. B. Du Bois, "Of Our Spiritual Strivings," in *The Souls of Black Folk* (1903; reprint, New York: New American Library, 1969), 50.

61. John Lockard, telephone conversation with author, December 12, 1997. Subsequent quotations are from this conversation.

62. Henry Louis Gates Jr., *The Signifying Monkey: A Theory of African-American Literary Criticism* (New York: Oxford University Press, 1988), 52.

63. Ibid.

64. Langston Hughes, "Cultural Exchange," in *Ask Your Mama: 13 Moods For Jazz* (New York: Alfred A. Knopf, 1961) 8.

65. Cindy Nemser, "Conversation with Betye Saar," *Feminist Art Journal* 4, no. 4 (Winter 1975–76): 20.

66. Betye Saar, telephone conversation with author, May 21, 2002.

67. Nemser, "Conversation with Betye Saar," 20.

68. Betye Saar, "Unfinished Business: The Return of Aunt Jemima," in *Betye Saar: Workers and Warriors, The Return of Aunt Jemima* (New York: Michael Rosenfeld Gallery, 1998), 3.

69. Gates, *The Signifying Monkey*, 52.

70. Betsy Towns, "The Use of Sambo" (unpublished essay, 2000), 10.

71. Stuart Hall, introduction to *Representation: Cultural Representations and Signifying Practices*, ed. Stuart Hall (London: Sage Productions, 1997), 6.

72. Steven C. Dubin, "Symbolic Slavery: Black Representations in Popular Culture," *Social Problems* 34, no. 2 (April 1987): 131.

CHAPTER FOUR

1. "English idiom readily suggests parallels between acts of conquest and of sex, between the conquered country and the raped woman. It is, therefore, not surprising that one of the frequent metaphors should depict Africa as the ravished dark woman." Dorothy Hammond and Alta Jablow, *The Africa That Never Was: Four Centuries of British Writing about Africa* (New York: Twayne, 1970), 148.

2. Ibid., 150.

3. Cited in Marilyn Jiménez, "Naked Scene, Seen Naked: Performing the Hott-en-tot," in *Looking Forward, Looking Black*, ed. Jo Anna Isaak (Geneva, N.Y.: Hobart and William Smith Colleges Press, 1999), 11.

4. Sander L. Gilman, "Black Bodies, White Bodies: Toward an Iconography of Female Sexuality in Late-Nineteenth-Century Art, Medicine, and Literature," in *"Race," Writing, and Difference*, ed. Henry Louis Gates Jr. (Chicago: University of Chicago Press, 1986), 228. The sexual implications of this work are also heightened by the presence of the barely visible black cat on the right edge

of the painting, not only through its linguistic association with sex in male contexts ("pussy") and the verbal play of "tomcatting" but also because the cat's tail thrusts upward with phallic suggestion. Theodore Reff, *Manet: Olympia* (New York: Viking Press, 1977).

5. Hammond and Jablow, *The Africa That Never Was*, 152–53.

6. She also was known as Saat-Jee, Sarah Bartmann, and the "Hottentot Venus." Gilman, "Black Bodies, White Bodies," 232–35.

7. Jan Nederveen Pieterse, *White on Black: Images of Africa in Western Popular Culture* (New Haven: Yale University Press, 1992), 40.

8. David Hume, "Of National Characters" (1742/54); cited in Pieterse, *White on Black*, 41.

9. Edward Long, *The History of Jamaica*, 3 vols. (London, 1774); cited in Pieterse, *White on Black*, 41.

10. Mary Pardo indicates that this interpretation of the subject as a courtesan is accepted in the "literalists" camp of scholarship; but another group she calls "allegorists" feel that she is "the goddess Venus descended into a legitimate domestic interior, where she personifies lawful marital bliss and the promise of fecundity." Mary Pardo, "Artifice as Seduction in Titian," in *Sexuality and Gender in Early Modern Europe: Institutions, Texts, Images*, ed. James Grantham Turner (Cambridge: Cambridge University Press, 1993), 59.

11. Ibid., 60.

12. Ibid., 68.

13. Pierre Loti, *The Marriage of Loti*, trans. Wright Frierson and Eleanor Frierson (Honolulu: University Press of Hawaii, 1976), 8.

14. Paul Gauguin, *Noa Noa*, trans. O. F. Theis (New York: Greenberg, 1927), 21–22.

15. Gauguin is known to have painted a copy *Olympia* in 1891 while it hung in the Luxembourg Museum.

16. As Patricia Leighten points out, Picasso was part of a group of artists with anarchist leanings as a protest against authority and French culture. Primitivism represented an escape route, and the use of masks was meant as a protest against scandalous colonial policy in the French Congo at that time. Picasso not only misinterpreted the meaning of the African sculpture he saw on a trip to the Musée d'Ethnographie (as told to André Malraux), but he also used the language of derision toward Africans to articulate his aesthetic protests against their abuse. Leighton, "The White Peril and *L'Art nègre*: Picasso, Primitivism, and Anticolonialism," *Art Bulletin* 72, no. 4 (December 1990): 609–30.

17. David M. Lubin, *Picturing a Nation: Art and Social Change in Nineteenth-Century America* (New Haven: Yale University Press, 1994), 258.

18. Hammond and Jablow, *The Africa That Never Was*, 154.

19. Ibid.

20. Manring, *Slave in a Box*, 20–21.

21. Darlene Clark Hine, "Rape and the Inner Lives of Black Women in the Middle West," *Signs* 14 (Summer 1989): 912; cited in Melton A. McLaurin, *Celia, a Slave* (New York: Avon Books, 1991), 24.

22. McLaurin, *Celia, a Slave*, 24.

23. James Mellon, ed., *Bullwhip Days: The Slaves Remember—An Oral History* (1988; reprint, New York: Avon Books, 1990), 296. Mellon has edited a number of interviews conducted between 1934 and 1941 by interviewers from the Federal Writers' Project, an adjunct of the Works Progress Administration. Michael Gomez has addressed the problematics associated with these slave testimonies, one of which was the fact that whites interviewed former slaves in the context of the segregated South. However, the fact of such dynamics, while raising questions about the documentation of African cultural ways, makes statements such as the ones given here all the more remarkable. Michael Gomez, *Exchanging Our Country Marks: The Transformation of African Identities in the Colonial and Antebellum South* (Chapel Hill: University of North Carolina Press, 1998), 5, 297–98 n. 12.

24. Mellon, *Bullwhip Days*, 297.

25. W. E. B. Du Bois, "Of Our Spiritual Strivings," in *The Souls of Black Folk* (1903; reprint, New York: New American Library, 1969), 50.

26. G. W. Featherstonhaugh, *Excursion through the Slave States* (London: John Murray, 1844), 267–68.

27. Ibid., 268.

28. Arna Bontemps and Jack Conroy, *They Seek a City* (Garden City, N.Y.: Doubleday, Doran, 1945), 99.

29. Hemings was in France from 1787 to 1789. Annette Gordon-Reed, *Thomas Jefferson and Sally Hemings: An American Controversy* (Charlottesville: University of Virginia Press, 1997), 23.

30. Jessie Carney Smith and Carrell Peterson Horton, eds., *Historical Statistics of Black America* (New York: Gale Research, 1995), 1431–32.

31. Mary Boykin Chesnut, *A Diary from the South*, ed. Ben Ames Williams (Boston: Houghton Mifflin, 1949), 122; cited in Roger Abrahams, *Singing the Master: The Emergence of African American Culture in the Plantation South* (New York: Pantheon, 1992), 52. Chesnut was the

wife of James Chesnut Jr., a senator from South Carolina (1859–61) and afterward an aide to Jefferson Davis in the Confederate army. Her diary was first published in 1905.

32. Andrea Barnwell, "Like the Gypsy's Daughter, or Beyond the Potency of Josephine Baker's Eroticism," in *Rhapsodies in Black: Art of the Harlem Renaissance* (Berkeley: University of California Press, 1997), 84.

33. Jean-Paul Goude, *Jungle Fever*, ed. Harold Hayes (New York: Xavier Moreau, 1981), 102.

34. See the photo "Roseland 1978" in ibid., 116–17.

35. Ibid., 105.

36. See Bennetta Jules-Rosette, "Two Loves: Josephine Baker as Icon and Image," *Emergences* 10, no. 1 (2000): 55–77.

37. Goude, *Jungle Fever*, 102

38. Ibid., 107.

39. bell hooks, "Talking Back," in *Women: Images and Realities, A Multicultural Anthology*, ed. Amy Kesselman et al. (Mountain View, Calif.: Mayfield Publishing, 1999), 14–17.

40. Dana Gibbons, "Afrofemcentric 'Back Talk': Re-articulating and Re-visioning the Representation of African-American Women" (unpublished paper, 2000), 4–5.

41. Ernest Larsen, "Between Worlds," *Art in America*, May 1999, 124.

42. Charnelle Holloway, telephone interview with author, tape recording, May 7, 1999. Subsequent quotes are from this conversation.

43. Karla F. Holloway, *Codes of Conduct: Race, Ethics, and the Color of Our Character* (New Brunswick, N.J.: Rutgers University Press, 1995), 21.

CHAPTER FIVE

1. The suffix *-bo* refers to something with the skin peeled from it, so in Ọyọ dialect the term used for whites more often is *eebo*, something that is peeled. In the Ekiti dialect, the term is *oyibo*, something peeled by the wind. *Oyinbo* is a term from generic Yoruba, so its spelling and its meaning shift slightly from dialect to dialect.

2. Christopher Quinn, "A Night He Can't Forget, and a Lifetime of Regret," *Cleveland Plain Dealer*, June 27, 1999.

3. E. Franklin Frazier, *Black Bourgeoisie* (1957; reprint, New York: Simon and Schuster, 1997), 13–14.

4. Census figures show that in 1850 the South had a free black population of 235,569, and 101,308 of them were considered mulattoes. For the entire nation, there were 434,495 free blacks (12 percent of the total), 159,095 of whom were classified as mulattoes. Of 3,204,313 slaves,

only 246,656 were classified as mulattoes. Jessie Carney Smith and Carrell Peterson Horton, ed., *Historical Statistics of Black America* (New York: Gale Research, 1995), 2:1819–20.

5. Frazier, *Black Bourgeoisie*, 136.

6. Ibid., 20

7. Ibid., 14.

8. Carter G. Woodson, *A Century of Negro Migration* (Washington, D.C.: Association for the Study of Negro Life and History, 1918), 147–66.

9. Jontyle Theresa Robinson, "The Life of Archibald J. Motley, Jr.," in Jontyle Theresa Robinson and Wendy Greenhouse, *The Art of Archibald J. Motley, Jr.* (Chicago: Chicago Historical Society, 1992), 2.

10. Archibald Motley Jr., interview by Dennis Barrie, tape recording, Chicago, January 23, 1978, Archibald J. Motley Jr. Papers, Archives and Manuscripts Collection, Chicago Historical Society.

11. Elaine D. Woodall, "Looking Backward: Archibald J. Motley and the Art Institute of Chicago: 1914–1930," *Chicago History*, Spring 1979, 54.

12. Alan H. Spear, *Black Chicago: The Making of a Negro Ghetto, 1890–1920* (Chicago: University of Chicago Press, 1967), vii.

13. Allan Spear points out that between July 1917 and March 1921 there were fifty-eight racially inspired bombings, most of which were directed at the homes of Negroes to force them out of disputed residential areas and back into the black belt. See ibid., chap. 11.

14. St. Clair Drake and Horace R. Cayton, *Black Metropolis: A Study of Negro Life in a Northern City* (1945; reprint, New York: Harper and Row, 1962), 55.

15. Spear, *Black Chicago*, 25.

16. Ibid., 54.

17. Robinson, "The Life of Archibald J. Motley, Jr.," 8.

18. Spear, *Black Chicago*, 109.

19. Archibald J. Motley Jr., "How I Solve My Painting Problems" (n.d.), Archibald J. Motley Jr. Papers, Archives and Manuscripts Collection, Chicago Historical Society, 3.

20. Contrary to previous authors, Dennis Reverty writes that Motley's grandmother married a Frenchman. Dennis Reverty, "The Self as Other: A Search for Identity in the Paintings of Archibald J. Motley Jr.," *International Review of African American Art* 18, no. 2 (Spring 2002), 28.

21. Motley, interview by Barrie, January 23, 1978.

22. U.S. Department of Labor, *Negro Migration in 1916–17* (Washington, D.C.: Government Printing Office, 1919), 33. Cited in Spear, *Black Chicago*, 137.

23. Spear, *Black Chicago*, 137.

24. Motley, "How I Solve My Painting Problems," 5.

25. Nella Larsen, *Quicksand; and, Passing*, ed. Deborah E. McDowell (1928; reprint, New Brunswick, N.J.: Rutgers University Press, 1986), 171.

26. Motley, interview by Barrie, January 23, 1978.

27. Motley, "How I Solve My Painting Problems," 1–2.

28. Robinson and Greenhouse, *The Art of Archibald J. Motley, Jr.*, 71.

29. Richard J. Powell, "Re/Birth of a Nation," in *Rhapsodies in Black: Art of the Harlem Renaissance* (Berkeley: University of California Press, 1997), 21.

30. Motley, "How I Solve My Painting Problems," 2.

31. Archibald Motley Jr., interview by Dennis Barrie, tape recording, Chicago, March 1, 1979, Archibald J. Motley Jr. Papers, Archives and Manuscripts Collection, Chicago Historical Society.

32. Motley, interview by Barrie, January 23, 1978.

33. Archibald J. Motley Jr., "The Negro in Art," *Chicago Defender*, July 18, 1918.

34. Willard B. Gatewood, *Aristocrats of Color: The Black Elite, 1880–1920* (Bloomington: Indiana University Press, 1990), 14.

35. Motley, interview by Barrie, January 23, 1978.

36. Motley, interview by Barrie, March 1, 1979.

37. Motley, interview by Barrie, January 23, 1978.

38. Motley, "How I Solve My Painting Problems," 5.

39. For a discussion of this phenomenon in the context of female beauty in the first several decades of the twentieth century, see Kathy Peiss, *Hope in a Jar: The Making of America's Beauty Culture* (New York: Metropolitan Books, 1998), especially chap. 7, which deals with African American women and the political discussion around fade cream and hair-straightening products.

40. Herbert Aptheker, *"One Continual Cry": David Walker's "Appeal to the Colored Citizens of the World," 1829–1830, Its Setting and Its Meaning* (1965; reprint, New York: Humanities Press, 1971), 11.

41. Motley, "How I Solve My Painting Problems," 5.

42. Kenneth B. Clark, *Dark Ghetto: Dilemmas of Social Power* (1965; New York: Harper Torchbooks, 1967), 21.

43. Gatewood, *Aristocrats of Color*, 9.

44. Archibald J. Motley Jr., "The Negro in Art," *Chicago Defender*, July 13, 1918.

45. Woodall, "Looking Backward," 55.

46. Reverty points out that "the manner in which [Motley] discusses his subjects and his audience is largely detached. He refers to his fellow African Americans not as 'us' but 'them.'" Reverty, "The Self as Other," 25.

47. Motley, "How I Solve My Painting Problems," 3.

48. Bessye Bearden was a prominent member of New York Negro society. She was a secretary to School Board 12, eventually becoming chairman of the board. She helped form the women's auxiliary of the Negro Democratic Club, and eventually she became national treasurer of the Council of Negro Women and a member of the executive board of the New York Urban League. Myron Schwartzman, *Romare Bearden: His Life and Art* (New York: Harry N. Abrams, 1990), 66–67.

49. "That group of New York artists they're as jealous of me as they can be. That was due to the exhibition I had down there." Motley, interview by Barrie, March 1, 1979.

50. Serge F. Kovaleski, "In Jamaica, Shades of an Identity Crisis," *Washington Post*, August 5, 1999.

51. Ibid.

52. Peiss, *Hope in a Jar*, 212.

53. Kovaleski, "In Jamaica."

54. Peiss, *Hope in a Jar*, 232.

55. Ibid., 234.

56. Thurman, *The Blacker the Berry . . .* (1929; New York: Scribner Paperback Fiction, 1996), 21.

57. Ibid.

58. Shifra M. Goldman, "Modern Art of the Spanish-Speaking Caribbean," in *Caribbean Visions: Contemporary Painting and Sculpture* (Alexandria, Va.: Art Services International, 1995), 76.

59. Ibid.

60. Theresa Howard, "Talkin' White," *The Source*, March 1998, 34.

61. Ibid.

62. Often, whites who would not consider themselves racist have positions of white supremacy because they uncritically accept certain assumptions embedded in a culture that was founded on notions of racial hierarchy. For example, the assumption that affirmative action denies opportunity to whites in order to favor less qualified nonwhites is a white supremacist assumption. The tests, and the systems that prepare students for tests, are weighted in favor of middle- and upper-class whites. Research has shown that test scores are an unreliable predictor of performance in college. Also, affirmative action does not reward unqualified people, but it selects people of color, or women, from a pool of *qualified* applicants in an effort to diversify opportunity. To assume that American society is not weighted in its structures and institutions toward whites is to accept that structure as the norm, to accept that whites are in a dominant position from merit and supremacy and that nonwhite Others are

in the margins because of their inherent inadequacy. That is an erroneous and racist assumption.

63. Clark, *Dark Ghetto*, 82.

64. Phillip Pilevsky, *Captive Continent: The Stockholm Syndrome in European-Soviet Relations* (New York: Praeger, 1989), 3–5.

65. Arthur S. Reber, *The Penguin Dictionary of Psychology* (New York: Viking, 1985), 735.

66. Pilevsky, *Captive Continent*, 16.

67. Claude M. Steele, "Race and Schooling of Black Americans," *Atlantic Monthly*, April 1992, 69.

68. Ibid., 72.

69. Ibid.

70. Ibid., 74. Steele argues that another strategy of survival occurs in this process, particularly in schools, where blacks "disidentify" with the society or the school, producing a devastating alienation affecting performance and probably (I suspect) social behavior.

71. The Rodney King beating case in Los Angeles, the vicious abuse of Abner Louima, and the shooting of Amadou Diallo in New York are just three of the more publicized cases of police violence against blacks. Recently, there has been increasing discussion of DWB—Driving While Black—because black males are stopped on highways by police in numbers that show racial targeting.

72. Aptheker, *"One Continual Cry,"* 12.

73. Pilevsky, *Captive Continent*, 17.

74. Ibid., 20–24.

75. Steele, "Race and Schooling," 74.

76. Ibid., 75.

77. Pilevsky, *Captive Continent*, 35.

78. Ibid., 35–38.

79. Ibid., 38–43.

80. Clark, *Dark Ghetto*, 64.

81. Barbara Huddleston-Mattai and P. Rudy Mattai, "The Sambo Mentality and the Stockholm Syndrome Revisited: Another Dimension to an Examination of the Plight of the African-American," *Journal of Black Studies* 23, no. 3 (March 1993): 346.

82. Ibid., 350.

CHAPTER SIX

1. Langston Hughes, "Cultural Exchange," in *Ask Your Mama: 12 Moods For Jazz* (New York: Alfred A. Knopf, 1961), 9.

2. Louis Armstrong, "(What Did I Do To Be So) Black and Blue," music and lyrics by Thomas "Fats" Waller, Harry Brooks, and Andy Razaf, recorded July 22, 1929.

3. Hughes, "Cultural Exchange," 8.

4. Marilyn Kern-Foxworth, "Painting Positive Pictures of Images That Injure: Michael Ray Charles' Dueling Dualities," in *Michael Ray Charles, 1989–1997: An American Artist's Work* (Houston: Blaffer Gallery, University of Houston, 1997), n.p.

5. Don Bacigalupi and Marilyn Kern-Foxworth, "An Interview With Michael Ray Charles," in *Michael Ray Charles*, n.p.

6. Ibid.

7. Ibid.

8. Ibid.

9. Susan Chadwick, "Texas Artist Bursts onto N.Y. Art Scene," *Houston Post*, June 14, 1994.

10. Nicholas Mirzoeff, *Bodyscape: Art, Modernity and the Ideal Figure* (London: Routledge, 1995), 166. Mirzoeff indicates that Basquiat's declining stature reversed after his death and that once again he was granted a position of favor in the art world. Judd Tully writes that in "August 1988, after a brutal diet of drugs and hurtful reviews, Basquiat succumbed to an overdose" and that "[o]nly his headline- and myth-making death resurrected Basquiat's moribund market." Judd Tully, "The Legacy of Basquiat," *Art and Auction* 15, no. 3 (October 1992): 115.

11. Mirzoeff, *Bodyscape*, 166.

12. Ibid., 162–89.

13. Charlotte Mason was the wife of Rufus Osgood Mason, a surgeon who believed hypnosis and psychic powers were healing agents. He believed that great spiritual powers resided in "primitive" and "child races," terms he used to describe Native Americans and African Americans. Charlotte Mason shared these beliefs. Romare Bearden and Harry Henderson, *A History of African-American Artists: From 1792 to the Present* (New York: Pantheon, 1993), 129.

14. Eugene W. Metcalf, "Black Art, Folk Art, and Social Control," *Winterthur Portfolio* 18, no. 4 (Winter 1983), 277.

15. Ibid., 276.

16. Ibid., 277.

17. Ibid., 276.

18. Jody Blake, *Le Tumulte noir: Modernist Art and Popular Entertainment in Jazz-Age Paris, 1900–1930* (University Park: Pennsylvania State University Press, 1999), 21.

19. Ibid., 18.

20. George Hellman, owner of the New Gallery in New York, wrote to Motley: "My general suggestion to you would be that during the summer you paint some pictures showing various phases of negro life in its more dramatic aspect—scenes, perhaps, in which the voo-doo ele-

ment as well as the cabaret element—but especially the latter—enter." George S. Hellman to Archibald J. Motley Jr., May 9, 1927, Archibald J. Motley Jr. Papers, Chicago Historical Society.

21. Metcalf, "Black Art, Folk Art, and Social Control," 280.

22. Daniel Pinchbeck, "Sampling Sambo," *Vibe*, September 1994, 114.

23. Susan Chadwick, "Artist Updates Black Images of Yesteryear," *Houston Post*, July 13, 1993.

24. Kern-Foxworth, "Painting Positive Pictures," n.p.

25. Michael Ray Charles, telephone conversation with author, February 5, 2001.

26. Stuart Hall, *Representation: Cultural Representations and Signifying Practices* (London: Sage Publications, 1997), 18–19.

27. Walter J. Ong, *Orality and Literacy: The Technologizing of the Word* (1982; reprint, London: Routledge, 1995), 12.

28. August Wilson, "Sailing the Stream of Black Culture," *New York Times*, April 23, 2000.

29. Patricia Sweetow, "Interview with David Huffman, Artist," (San Francisco: Patricia Sweetow Gallery, May 30, 1999).

30. Stanley Crouch, in Spike Lee (writer and director), *The Making of "Bamboozled,"* on the DVD of *Bamboozled* (40 Acres and a Mule Filmworks, 2000).

31. Helen Bannerman, *The Story of Little Black Sambo*, illustrated by Helen Bannerman (1898; reprint, New York: Fred Stokes Co., 1900). Bannerman wrote this story for her children, from whom she was separated while in India. Given the usual assumptions about the story, it is ironic to find that Sambo is in fact a trickster figure and that his mother, Mumbo, completes his victorious encounter with several tigers by serving them, after they have melted, as butter on pancakes.

32. From 1882 to 1891, more whites than blacks were lynched (751 to 732). However, from 1892 to 1931, only 531 whites were lynched.

33. Steven C. Dubin, "Symbolic Slavery: Black Representations in Popular Culture," *Social Problems* 34, no. 2 (April 1987): 122.

34. Lee, *Bamboozled*.

35. Dubin, "Symbolic Slavery," 123–31.

36. Ibid., 122.

37. Quoted in Richard B. Woodward, "Color Bind: White Artist + Black Memorabilia = No Show," *Village Voice*, June 25, 1996.

38. Charles Stainback and Richard B. Woodward,

*David Levinthal: Work from 1975–1996* (New York: International Center of Photography, 1997), 180.

39. Quoted in Woodward, "Color Bind," 79.

40. Nicholas Mirzoeff, "What Is Visual Culture?," in *The Visual Culture Reader*, ed. Nicholas Mirzoeff (London: Routledge, 1998), 9.

41. Ibid., 9.

42. Julia Szabo, "Kara Walker's Shock Art," *New York Times Magazine*, March 23, 1997, 50. Walker was born in Stockton, California, but moved to Atlanta just before beginning high school.

43. James Hannaham, "Pea, Ball, Bounce," *Interview*, November 1998, 119.

44. Szabo, "Kara Walker's Shock Art," 50.

45. *Kara Walker: Upon My Many Masters—An Outline* (San Francisco: San Francisco Museum of Modern Art, 1997), n.p.

46. Ibid.

47. Ibid.

48. Jerry Saltz, "Kara Walker: Ill-Will and Desire," *Flash Art*, November/December 1996, 86.

49. Ibid., 82.

50. Szabo, "Kara Walker's Shock Art," 50.

51. *Kara Walker*, n.p.

52. Saltz, "Kara Walker," 84.

53. Ibid.

54. Jessica Kerwin, "Kara Walker," *W*, February 2000, 117.

55. Christina Elizabeth Sharpe, "Kara Walker and Michael Ray Charles," in *Looking Forward, Looking Black*, ed. Jo Anna Isaak (Geneva, N.Y.: Hobart and William Smith College Press, 1999), 41.

56. Saltz, "Kara Walker," 86.

57. *Kara Walker*, n.p.

58. Metcalf, "Black Art, Folk Art, and Social Control," 280.

59. Szabo, "Kara Walker's Shock Art," 50.

60. Saltz, "Kara Walker," 84–85.

61. Alain Locke, "Enter the New Negro," *Survey Graphic* 6, no. 6 (March 1925): 631.

62. Frantz Fanon, *Black Skin, White Masks* (New York: Grove Press, 1967), 17.

63. Ibid., 18.

64. Rowland Abiodun, "Introduction: An African(?) Art History: Promising Theoretical Approaches in Yoruba Art Studies," in *The Yoruba Artist: New Theoretical Approaches to African Art*, ed. Rowland Abiodun, Henry Drewal, and John Pemberton (Washington, D.C.: Smithsonian Institution Press, 1994), 42.

65. Ngugi Wa Thiong'o, *Decolonising the Mind: The Politics of Language in African Literature* (1986; reprint, London: James Currey, 1991), 5.

66. Ibid., 13.

67. Ong, *Orality and Literacy*, 33.

68. Ibid., 32.

69. Mirzoeff, "What Is Visual Culture," 6.

70. Kern-Foxworth, "Painting Positive Pictures," n.p.

## CHAPTER SEVEN

1. The American Missionary Association became involved, and it later was responsible for the opening of more than 1,000 schools and colleges for blacks in the second half of the nineteenth century. One of those schools was Talladega College, and, according to Woodruff, the mural was a gesture of appreciation by the school. Michael D. Harris, "Urban Totems: The Communal Spirit of Black Murals," in Robin Dunitz and Jim Prigoff, *Walls of Heritage, Walls of Pride: African American Murals* (San Francisco: Pomegranate, 2000), 24.

2. For an overview and historical contextualization of AfriCobra—which I joined in 1979—and the Black Arts movement, see Edmund Barry Gaither, "Heritage Reclaimed: An Historical Perspective and Chronology,"in *Black Art, Ancestral Legacy: The African Impulse in African-American Art* (Dallas: Dallas Museum of Art/Harry N. Abrams, 1989), 17–34.

3. Nubia Kai, "AfriCobra Universal Aesthetics," in *AfriCobra: The First Twenty Years* (Atlanta: Nexus Contemporary Art Center, 1990), 6.

4. It should be noted that a number of artists during the late 1960s and the 1970s produced work imbued with sensibilities and African visual elements similar to those found in the work of AfriCobra members. Among others, these artists include Charles Searles, Ademola Olugbefola, Alfred Smith Jr., and Edgar Sorrells-Adewale.

5. I have written more extensively about Renée Stout in "Resonance, Transformation, and Rhyme: The Art of Renée Stout," in Wyatt MacGaffey and Michael D. Harris, *Astonishment and Power* (Washington, D.C.: Smithsonian Institution Press, 1993), 105–55.

6. Willie Dixon, "Hoochie Coochie Man" (Bug Music 0/13/0, Hoochie Coochie Music, BMI).

7. Quoted in Marla C. Berns, "On Love and Longing: Renée Stout Does the Blues," in *Dear Robert, I'll See You at the Crossroads: A Project by Renée Stout* (Santa Barbara: University Art Museum, University of California, Santa Barbara, 1995), 38.

8. Robert Johnson, "Crossroad Blues," in *Woke Up This Mornin': Poetry of the Blues*, ed. A. X. Nicholas (New York: Bantom Books, 1973), 95.

9. Juan Logan, interview with author, tape recording, Chapel Hill, N.C., May 23, 2000. Subsequent quotations are from this interview.

10. Camille Billops, interview with author, tape recording, New York, N.Y., August 22, 2000. Subsequent quotations, unless otherwise noted, are from this conversation.

11. Noliwe M. Rooks, *Hair Raising: Beauty, Culture, and African American Women* (New Brunswick, N.J.: Rutgers University Press, 1996), 26.

12. Ibid., 33–34.

13. "Conversing Forms: A Dialogue between Artist Alison Saar and Curator Mary Nooter Roberts," in Mary Nooter Roberts and Alison Saar, *Body Politics: The Female Image in Luba Art and the Sculpture of Alison Saar* (Los Angeles: UCLA Fowler Museum of Cultural History, 2000), 18 19.

14. Ibid., 30.

15. Ibid.

16. Robert Farris Thompson, *Flash of the Spirit: African and Afro-American Art and Philosophy* (New York: Vintage Books, 1984), 134.

17. Ibid., 117–18.

18. Rooks, *Hair Raising*, 10.

19. Ibid., 15–16.

20. "Conversing Forms," 27–28.

21. Ibid., 28.

22. Toni Morrison, "Rootedness: The Ancestor as Foundation," in *Black Women Writers (1950–1980): A Critical Evaluation*, ed. Mari Evans (Garden City, N.Y.: Anchor Press/Doubleday, 1984), 339.

23. Carrie Mae Weems, conversation with author, Eatonville, Fla., August 25, 2001.

24. Thelma Golden, introduction to *Freestyle* (New York: Studio Museum in Harlem, 2001), 14.

25. Ibid., 15.

26. Deborah Solomon, "The Downtowning of Uptown," *New York Times Magazine*, August 19, 2001, 46.

27. Patricia Sweetow, "Interview with David Huffman, Artist," (San Francisco: Patricia Sweetow Gallery, May 30, 1999) n.p.

28. Hamza Waker, "Renigged," in *Freestyle*, 17.

29. W. E. B. Du Bois, "Of Our Spiritual Strivings," in *The Souls of Black Folk* (1903; reprint, New York: New American Library, 1969), 45.

30. Langston Hughes, "The Negro Artist and the Racial Mountain," *The Nation*, June 23, 1926, 692.

31. Ibid., 693.

32. Ibid., 694.

33. James Porter, *Modern Negro Art* (1943; reprint, New York: Arno Press, 1969), 99.

34. Ibid., 100.

35. Ibid., 133.

36. Holland Cotter, "Beyond Multiculturals, Freedom?," *New York Times*, July 29, 2001.

37. Ibid.

38. Ibid.

39. Golden, introduction to *Freestyle*, 15.

40. Morrison, "Rootedness," 343.

CODA

1. Stuart Hall, "Cultural Identity and Cinematic Representation," *Framework* 36 (Winter 1986): 69.

2. Henry Louis Gates Jr., "Introduction: The Talking Book," in *Pioneers of the Black Atlantic: Five Slave Narratives from the Enlightenment, 1772–1815*, ed. Henry Louis Gates Jr. and William L. Andrews (Washington, D.C.: Civitas, 1998), 1–2.

3. Ibid., 3.

4. Ibid., 4.

5. Schwaller de Lubicz distinguishes between "symbolism," which he defines as "technique," and "the symbolic" as a "form of writing of a vital philosophy." R. A. Schwaller de Lubicz, *Symbol and the Symbolic: Ancient Egypt, Science, and the Evolution of Consciousness*, trans. Robert Lawlor and Deborah Lawlor (1949; New York: Inner Traditions International, 1978), 42–44.

6. Ibid., 62.

7. Ibid., 64–65.

8. For a fascinating explication of the power of divine speech in Yoruba culture, see Rowland Abiodun's discussion of the concept of òrò in Rowland Abiodun, "Verbal and Visual Metaphors: Mythical Allusions in Yoruba Ritualistic Art of Orí," *Word and Image* 3, no. 3 (July–September 1987): 252–70.

9. bell hooks, "Altars of Sacrifice: Re-membering Basquiat," *Art in America*, June 1993, 71.

10. Ibid., 72.

11. See Phillips Verner Bradford and Harvey Blume, *Ota Benga: The Pygmy in the Zoo* (New York: Dell, 1992).

12. Quoted in Judd Tully, "The Legacy of Jean-Michel Basquiat," *Art and Auction* 15, no. 3 (October 1992): 146.

13. Ibid., 115.

14. Holland Cotter, "Beyond Multiculturalism, Freedom?," *New York Times*, July 29, 2001.

15. Jerry Saltz, "Post-Black," *Village Voice*, May 16–22, 2001.

# INDEX